TECHNIFIED MUSES

# TECHNIFIED
## *Muses*

Reconfiguring National Bodies
in the Mexican Avant-Garde

Sara A. Potter

UNIVERSITY OF FLORIDA PRESS

Gainesville

This book will be made open access within three years of publication thanks to Path to Open, a program developed in partnership between JSTOR, the American Council of Learned Societies (ACLS), University of Michigan Press, and The University of North Carolina Press to bring about equitable access and impact for the entire scholarly community, including authors, researchers, libraries, and university presses around the world. Learn more at https://about.jstor.org/path-to-open/

Publication of this work made possible by a Sustaining the Humanities through the American Rescue Plan grant from the National Endowment for the Humanities.

*Cover art*: *CyberVenus*, by Bernardo Fernández (BEF), 2023.

Copyright 2024 by Sara A. Potter
All rights reserved
Published in the United States of America

29 28 27 26 25 24    6 5 4 3 2 1

Library of Congress Cataloging-in-Publication Data
Names: Potter, Sara A., author.
Title: Technified muses : reconfiguring national bodies in the Mexican avant-garde / Sara A. Potter.
Description: 1. | Gainesville : University of Florida Press, 2024. | Includes bibliographical references and index. | Summary: "In this volume, Sara Potter uses the idea of the muse from Greek mythology and the cyborg from posthuman theory to consider the portrayal of female characters and their bodies in Mexican art and literature from the 1920s to the present, examining genres including science fiction, cyberpunk, and popular fiction"— Provided by publisher.
Identifiers: LCCN 2023050532 (print) | LCCN 2023050533 (ebook) | ISBN 9781683404323 (hardback) | ISBN 9781683404408 (paperback) | ISBN 9781683404477 (pdf) | ISBN 9781683404552 (ebook)
Subjects: LCSH: Muses (Greek deities) in art. | Muses (Greek deities) in literature. | Art, Mexican—Women. | Mexican literature—Women. | Women in art. | Women in literature. | BISAC: LITERARY CRITICISM / Caribbean & Latin American | LITERARY CRITICISM / Science Fiction & Fantasy
Classification: LCC N7763.M87 P68 2024 (print) | LCC N7763.M87 (ebook) | DDC 709.72—dc23/eng/20231204
LC record available at https://lccn.loc.gov/2023050532
LC ebook record available at https://lccn.loc.gov/2023050533

University of Florida Press
2046 NE Waldo Road
Suite 2100
Gainesville, FL 32609
http://upress.ufl.edu

In memory of my grandmothers,
Henrietta Mulder and Marion Potter

# CONTENTS

Acknowledgments    ix
List of Abbreviations    xiii

Introduction: Invoking the Muse    1

1. Mechanized Muses of the New Metropolis: Mexico City after 1920    13

2. Surrealist Muses in Exile: The Mexican Years of Leonora Carrington and Remedios Varo    55

3. The Medicalized Muses of Tlatelolco: Juan García Ponce's Mariana/María Inés and Fernando del Paso's Estefanía    85

4. Muses of the Virtual Metropolis: Fragmented Bodies, Cities, and Selves in Bernardo Fernández (BEF)'s *Gel azul,* Guadalupe Nettel's *El huésped*, and Karen Chacek's *La caída de los pájaros*    119

Conclusion: Of Crossroads, De/Constructions, and Choices    158

Notes    163
Bibliography    175
Index    193

# ACKNOWLEDGMENTS

This is my favorite part to write. Even as I worry that I will forget someone (I will, and I'm sorry), it is a gift to look back and reflect upon the relationships and experiences that have made *Technified Muses* possible. As with the rest of the book, it was written while sitting by myself at my desk; as with the rest of the book, it could not exist without the guidance and support of a veritable village of friends, family, and colleagues.

My deepest thanks go to Ignacio Sánchez Prado (Nacho) for his friendship and mentorship. Much of the theoretical skeleton of this book can be traced back to classes I took during my first year at Washington University in Saint Louis (Wash U), taught by Nacho, J. Andrew Brown, and Akiko Tsuchiya; I remain grateful for their expertise, their guidance, and their incisive and rigorous feedback. Conversations with and feedback from Tabea Linhard, Javier García Liendo, Angela Miller, and Anca Parvalescu were invaluable in shaping the path this project eventually took.

A Fulbright García Robles grant allowed me to spend an academic year in Mexico City for research purposes, laying the groundwork for personal and professional relationships that I treasure to this day. This book owes a great debt to the archivists, curators, librarians, and scholars at the Universidad Iberoamericana, the Colegio de México, the Biblioteca Nacional and the Centro de Investigaciones Estéticas at the UNAM (Universidad Nacional Autónoma de México), the Archivo General de la Nación, the Museo de Arte Moderno, and the Museo Nacional de Antropología in Mexico City, the USBI (Unidad de Servicios Bibiotecarios y de Información) in Xalapa, and the Centro Cultural "Luis Mario Schneider" in Malinalco, as well as the archives at the Princeton University Library. The Friday mornings spent in Coyoacán with the Diana Morán Workshop (Taller Diana Morán) were wonderful sources of inspiration, discussion, and debate, and I thank Gloria Prado Garduño and the other members for welcoming me to the table. My continued thanks go to Evodio Escalante, Bernardo

x · Acknowledgments

Fernández (BEF), Sara Poot Herrera, Elissa Rashkin, José Ramón Ruisánchez, Michael Schuessler, and Lois Parkinson Zamora. I am especially and unendingly grateful to BEF as the artist of the gorgeous cybernetic Venus that you see on the book's cover. Alexandra Gruen and Stephen Zamora are sadly no longer with us, but I am glad to have known them and remain forever indebted for their time and their generosity.

The financial support from the University of Texas at El Paso (UTEP) was essential to the completion of this book, from startup funds to a departmental subvention that aided in covering various printing-related costs. I would like to thank my coworkers, past and present, from the Department of Languages and Linguistics at UTEP, particularly Janet Davis, Matthew Desing, Jane Evans, Sandra Garabano, Lowry Martin, Kirsten Nigro, and María Socorro Tabuenca. I am grateful for conversations, collaborations, and writing sessions with my colleagues outside the department as well, including Larry Lesser, Marion Rohrleitner, and Barbara Zimbalist.

Several chapters or parts of chapters were presented as works in progress at various academic conferences over the years, most notably the Congreso de Literatura Contemporánea Mexicana at UTEP, the UC-Mexicanistas conferences at UC-Irvine and UC–Santa Barbara, and the Latin American Studies Association Conference. I value the challenges, debates, and friendships that have emerged from them, including with David Dalton, Miguel Ángel Fernández Delgado, M. Elizabeth Ginway, Emily Hind, Miguel López, Rielle Navitski, Anna Nogar, Brian Price, Carmen Serrano, Stephen Tobin, Santiago Vaquera-Vásquez, and John Waldron. Extra special thanks to the Lady Locusts, Rebecca Ingram, Rebecca Janzen, Ilana Luna, Amanda Petersen, and Cheyla Samuelson, for your brilliance, kindness, and love.

As a first-time author, I am especially grateful for my experience working with the University of Florida Press. My deepest thanks to acquisitions editor Stephanye Hunter for her expertise, support, and patience. I am grateful to the anonymous readers, whose careful readings and thoughtful feedback greatly strengthened the project.

Outside the academic sphere, I would like to thank my family for their love and their unflagging belief that I would finish The Book. My parents cheered me on even as they skewered my overlong chapter titles, my brother and sister-in-law allowed me to take refuge in their spare room to finish a much-needed revision, and my nephew entertained me with stories about battling zombies on the beach. (Needless to say, I am delighted that he appears to share Auntie Sara's fascination with the posthuman.)

Thanks to my partner, Carlos, for his encouragement, understanding, and silly memes when I needed a laugh. My elderly German shepherd mix, Rex, had nothing to do with the book but was very good at putting his head on my knee and reminding me to take a break. I could not have done this without any of you.

* * *

Unless otherwise indicated, all English translations are mine.

# ABBREVIATIONS

CNT       Central Nacional de Trabajadores
MORENA       Movimiento Regeneración Nacional
MPE-68       Movimiento Popular Estudiantil
PAN       Partido Acción Nacional
PRI       Partido Revolucionario Institucional
PRM       Partido de la Revolución Mexicana
PRUN       Partido Revolucionario de Unificación Nacional
UNAM       Universidad Nacional Autónoma de México

# Introduction

## Invoking the Muse

In the wake of the Mexican Revolution, the country found itself at a political and cultural crossroads. This was never so clear anywhere else as in Mexico City, where the population was growing exponentially, newly purchased automobiles and a rapidly growing network of streetcars thrilled and terrorized pedestrians and passengers alike, and debates raged regarding the cultural, political, intellectual, and economic construction and cohesion of the postrevolutionary nation and its inhabitants. With so much attention paid to the construction of *lo mexicano*, that is, of an idealized and therefore impossible male mestizo subject, it is striking when a female body—a body that is neither Malinche nor Guadalupe, neither maternal figure nor interpreter nor virgin—becomes interwoven with the emerging rhythms and technologies of the constantly transforming city.[1]

In his 1922 short novel *La Señorita Etcétera,* avant-garde Estridentista (Stridentist) author Árqueles Vela recounts the young male narrator's interactions with the city in comparison to those of a woman to whom he only refers as she, as *ella*. Both characters are transformed by the "vida casi mecánica de las ciudades modernas" (almost mechanical life of modern cities) and the "vida eléctrica del hotel" (electric life of the hotel) (95) that is the closest thing the narrator has to a home. His transformation is marked by a loss of awareness in which he no longer strolls but sleepwalks through the busy city streets. She, meanwhile, laughs, socializes, and joins a union; even her physical gestures take on an explicitly feminist nature as she incorporates herself into the city. Her gait, like his, is transformed, but hers becomes a dance, as she walks with "pasos armónicos, cronométricos de figuras de fox-trot" (harmonious steps, chronometric fox-trot patterns) and her gaze acquires "una fijeza incandescente" (an incandescent steadiness) that indicates engagement and awareness. It is through the female body's assimilation of technological discourses of the era that Vela com-

municates a more nuanced sense of the excitement and unease provoked by the structural and political changes that confronted Mexico, and most particularly Mexico City, than other Estridentista texts or visual art would admit. More significantly yet, Vela does so from the margins of the Mexican canon and from an individual, nonhegemonic perspective that lives in the present, cannot forget the past, and looks to the future with fear and anticipation in equal measure. Indeed, it is the mysterious *ella* (she) who most unsettles the narrator, provoking him to reflect on his lack of engagement with his capital, his country, or his compatriots. This intersection of the female body, technological discourse, and historical perspective that does not line up with official versions of events forms the basis of my analysis in this book.

*Technified Muses* examines the representation of various female figures in avant-garde Mexican art and literature at four key moments of rupture or tension from 1920 to the present: the post-Revolution; the beginning of the "Mexican Miracle" in the 1940s; the period following the 1968 student movement; and the post-NAFTA and post-Zapatista revolution period beginning in 1994, which also encompasses the period of political transition from the PRI (Partido Revolucionario Institucional [Institutional Revolutionary Party]) to the PAN (Partido Acción Nacional [National Action Party]) to the PRI again and, perhaps most significantly, to MORENA (Movimiento Regeneración Nacional [National Regeneration Movement]) with Andrés Manuel López Obrador's presidential victory in December 2018. My use of "avant-garde" refers to a cultural mode rather than to the historical avant-garde period (ca. 1920–68) and draws in part from Peter Bürger's formulation of the avant-garde as an attack on art as an institution. Another aspect of avant-garde theory that is fundamental to my analysis comes from Hal Foster's genealogy of art and culture in *The Return of the Real*, particularly regarding the dynamic and interactive relationship of avant-garde cultural production with time and with history. "[E]ven as the avant-garde recedes into the past," Foster states, "it also returns from the future, repositioned by innovative art in the present" (x). This constant negotiation between past, present, and future, as well as the implication that avant-garde production can be reshaped and transformed as it engages with other works of art over time—which, in turn, suggests actively engaged and engaging forms of artistic and cultural production, interaction and intertension on a historical and social scale—significantly shape my approach to and analyses of the texts in my corpus. Technological elements are also important to consider alongside artistic production since, as Naeif

Yehya reminds us, both are "un reflejo de la sociedad que [los] produce" (6; a reflection of the society that produces [them]). As such, they cannot be read as neutral or universal and require careful attention to the historical, aesthetic, and cultural contexts that produce them and are produced or influenced by them.

This book is divided into two halves: in the first two chapters (set in the post-Revolution era and the post–World War II era, respectively), Mexico is facing the challenges of the process of modernization. In chapters 3 and 4, meanwhile, Mexico is establishing and negotiating its place on the world stage culturally and economically, from its hosting of the Olympic Games in 1968 to the implementation of NAFTA in 1994 to the present. I pose that the female figures who create or are represented in the texts in my corpus do so in engagement with predominant currents and conversations in the country's intellectual sphere, which frequently revolve around constructions of national identity and history. In response to these events, technified and textual female bodies emerge in avant-garde texts of the corresponding era and act as muses—not as a passive inspiration to a male writer or artist but rather as active and frequently disruptive participants in predominant currents and conversations of their own time, space, and place. More specifically, these muses complicate and problematize utopic constructions of national identity and history, creating nonhegemonic counternarratives that are in productive tension with idealized visions and constructions of the nation-state and its citizens.

At first glance, the muse may seem to be a passive figure, given that her role is to inspire and that such a role is generally not chosen but bequeathed by the person inspired. The mythological and theoretical origins of the muse, however, suggest otherwise. In Greek mythology, the nine Muses are the daughters of Zeus, king of the gods, and Mnemosyne, one of the Titans and the personification of memory, implying profound ties between power, memory, and the fine arts. French philosopher Jean-Luc Nancy suggests that the muse's function resides in her very etymology: "The Muse animates, stirs up, excites, arouses. She keeps watch less over the form than the force. Or more precisely: she keeps watch forcefully over the form" (1). Her power and seismic force take on a particular significance in response to the sudden onslaught of modernization in Mexico City that followed the Revolution and to the "Revolution to Evolution" hegemonic discourses that were produced in its aftermath.[2]

Finally, since the texts in my corpus address the complex and increasingly intimate relationship between humans and technology, I contend that

these are *technified* muses, each of whom incorporates discourses of technology, modernization, history, and identity into her very being. This act of incorporation produces hybrid, cyborgian, and/or virtual (but always gendered) beings and establishes a powerful connection between memory and technology that is rooted in the female-identified body. Despite the science fiction (SF) connotations of the cyborgian and the posthuman, most of the texts in this book are not categorized as SF, with Bernardo Fernández's *Gel azul* (Blue gel) and Karen Chacek's *La caída de los pájaros* (The fall of the birds) as notable exceptions. As J. Andrew Brown notes in the introduction to *Cyborgs in Latin America*, "When one speaks of cyborgs and the posthuman, one usually thinks of works of speculative fictions that present future realities that have yet to occur" (3). However, as he and I both observe, interactions with technology occur on a daily basis and have done so long before the first wave of cyberpunk literature emerged in the early 1980s. My interest is in the everyday interactions of the female body, technology, and technological discourses in a selection of literary texts that navigate the ever-shifting social realities of Mexico City in the postrevolutionary period.

The connection between the female body, memory, and technology was inspired in part by Donna Haraway's "The Cyborg Manifesto" and N. Katherine Hayles's *How We Became Posthuman*, which situate the technologically mediated, previously "other" female body on the borderlines of gender, history, and memory. In so doing, they provide a potentially disruptive perspective from which to observe and contest the ways in which gender, history, memory, and national identity are valued and constructed. This is particularly suggestive if we follow Anne Balsamo's assertion that transformations of the social order take place with the female cyborgian body at its center. As a being that encompasses the discursive and the material, Balsamo states, this stubbornly embodied, hybrid, and gendered figure becomes "the site at which we can witness the struggle between systems of social order" (39). This vantage point makes her particularly well-suited for looking at and looking back upon major events in a nation's history.

The female cyborgian muse's location at the center of social transformation—in the eye of the cultural storm, so to speak—takes on a particular significance if examined in the context of postrevolutionary Mexico. The narratives she occupies in this national and historical context suggest a dialogue with José Ramón Ruisánchez Serra's notion of renarration and topology in Mexican literature in the last half of the twentieth century. Rather than a cartographic overview that purports to be distant and all-seeing,

this topologic location and locus of narrative production "elimina la posilbiidad de un afuera neutro y neutralizador" (13; eliminates the possibility of a neutral and neutralizing external perspective). Furthermore, these topologically situated re/narrative processes have the objective of exploring and recounting "otros poderes y otros saberes" (17; other powers and other ways of knowing) that would otherwise be silenced by monolithic master narratives. These kinds of topologically situated texts do not only deal with a single isolated event but also examine it in conjunction with the events and elements that lead up to and stem from the event in question. The cyborg-muse's relationship with technology and history places her in the center of this dynamic topology, while her muse-nature indicates that she is forcefully involved and engaged with these "other powers and other ways of knowing," suggesting that she always has something to gain (or to lose) in doing so.

The accounts and subjectivities of each muse are individualistic, nonhegemonic, and located at the margins of political and cultural power. She never presents her story as a monolithic master narrative; indeed, the very existence of her story implies that there must be other stories that are different or even contradictory, making her version of events necessarily fragmentary and incomplete. This is important, since all of the events to which she responds are officially considered to be part of a generative arc of the history and construction of *lo mexicano* or "Mexicanness" that began with the end of the Revolution and the rise of the political party that would become the PRI.

The muses' stories, meanwhile, form a parallel and contradictory postrevolutionary narrative that reads these same events as fragmentary, even destructive. Rather than a constructive "Revolution to Evolution" narrative, this parallel counternarrative paints the entire postrevolutionary era as one of constant crisis. Elements of crisis may be seen in the muse-figures as well, as their engagement and location imply a degree of physical and psychological vulnerability that does not always lend itself to a triumphant cyber/feminist reading. These sorts of crises may be productive, however, if we recall Alfonso Reyes's "Literatura nacional, literatura mundial" (National literature, world literature), which explores a notion of crisis that does not deny the existence of pain or trauma but one that also includes the potential for transformation. In this spirit, a theoretically constructive tension is produced between the hegemonic discourses of the post-Revolution era and the individual, fragmentary histories that emerge alongside and around them in parallel counternarratives that appear in all four chapters.

6 · Technified Muses

I do not wish to suggest that these discourses are naturally identified with the trajectory of any particular party or ideology but rather that they form part of a larger arc of Mexican cultural and political history.

The construction of this muse may seem a bit like Frankenstein's monster, as this muse-creature is assembled from various theories, philosophies, and mythological accounts of the muse. While this may be, it is also worth noting that the unfortunate doctor originally created his monster with beauty in mind. Furthermore, in the context of this book, the muse is a very much a monster in the sense that Haraway indicated in the introduction to *Simians, Cyborgs, and Women*. While posthuman and cyberfeminist theorists from Balsamo to Braidotti to Du Preez agree that these gendered cyborgs are, as Haraway states, "odd boundary creatures," these muses in avant-garde Mexico do more than simply destabilize master narratives of history, politics, culture, and identity. Following Haraway, they are "literally, *monsters*, a word that shares more than its root with the word, to *demonstrate*. Monsters signify" (Haraway 2, original emphasis). If, as Jeffrey Cohen observes in his seven theses in "Monster Culture," these monsters are necessarily cultural and necessarily embodied, they serve to signify borders, "others," and differences. In doing so, these monster-muses are situated on the edge of transformation or becoming, engaging the reader as much as they themselves are engaged in reevaluating and rewriting narratives of major events that continue to demand responsibility, reflection, and action on the part of the reader. The distance between muse, monster, and cyborg is not so very great, as they all destabilize the very art forms that they watch over and unsettle and provoke the audiences who would consume them.

All of the works that appear here were written in response to major upheavals in Mexican history, produced during moments of great violence and sociopolitical transformation. As such, these posthuman figures require retroactive readings as well, since their posthuman nature tends to emerge in hindsight, with cyborgian or posthuman elements "only visible from a current point of view" (Gray, Figueroa-Sarriera, and Mentor 6; see also Dalton 16–18). Neil Badmington takes the idea of retroactive reading one step further, noting that "humanism is forever rewriting itself as posthumanism" (16). It is not only location (recalling Ruisánchez Serra's topology and renarration) but also the very status of posthumanism itself that makes this hindsight all the more important, since posthumanism also involves a *rewriting* of the past and thus of historical narrative and of the subjects that observe and participate in that past.

It is also important to note that all of the works from my corpus are products of urban space and avant-garde culture. As Anne Lambright and Elisabeth Guerrero rightly point out in *Unfolding the City*, the city "plays a particularly important role in Latin America, where urban areas hold a near monopoly on centralized political and economic resources and [. . .] [provide] a panoramic vantage from which we can view the sociocultural landscapes of Latin America" (xi). Even more importantly, as Marcy Schwartz reminds us in the same collection, "social relations, including, importantly, gender relations, are constructed and negotiated spatially and are embedded in the spatial organization of place" (5). These relations, constructions, and negotiations cannot occur without impacting and questioning the ways in which national history or identity is defined or perceived.

It is also significant that Mexico City is the backdrop to all of these disruptive stories, since its status as the nation's capital plays into the kinds of disturbances that I explore in this book. As Jeremy Tambling puts it in his essay on city-theory and writing, "capital cities [. . .] have complex relations to the country they represent: they embody its nationalism, but since they attract disparate populations, [. . .] they produce a plurality threatening to undo all nationalism" (2). It stands to reason, then, that the unruly nature of the capital city, and of this particular capital city, creates an ideal place and space in which to form and to push back against hegemonic constructions of national identity.

The choice to begin this textual exploration of Mexico immediately after the Revolution is a deliberate one, for several reasons. First, I follow Horacio Legrás's declaration that "[w]hile the revolution uncovered the total extension of Mexico, the act of imagining the nation was mostly a Mexico City affair" (5). This is telling for two reasons: First, although the postrevolutionary nation-state was not exclusively imagined from the capital city, Legrás's assertion begs the question of the larger consequences and ramifications of imagining a large nation such as Mexico primarily from its capital, where (recalling Tambling) nationalism and plurality are in constant tension with one another. This tension could only be heightened in the aftermath of a decade-long internal conflict as the Mexican intelligentsia strove to produce an idea of unified nation-state in the midst of a major wave of urbanization and of rural to urban migration. Second, Legrás's observation suggests that Mexico City is an ideal place from which to produce narratives that run counter to those hegemonic imaginings, since these muses and their narratives destabilize and contest such hegemonic imaginings from their very centers of production. Lastly, as Ageeth

Sluis reminds us in *Deco Body, Deco City*, this wave of rural to urban migration included a "drastic influx of female migrants" during and after the armed phase of the Revolution (1). Tabea Linhard's *Fearless Women in the Mexican Revolution and the Spanish Civil War* offers a similar assessment regarding the significant uptick in female migration to Mexico City. As such, Linhard observes, the Revolution "signified the massive penetration of women into the public sphere" (33), which, as she and Sluis both suggest, offers women greater participation in economic and political activity (Linhard 33; Sluis 1–2). This new and unsettling feminine presence only deepened the tensions in play between nationalism and pluralism and the attempts at creating a unified Mexican subject.

In the context of Mexico City, I focus on various bodies—textual, physical, and illustrated or graphic—and the ways in which they act and are acted upon by each other in this urban environment. My focus on gender, the body, and the city as interlinked concepts is not new; Elizabeth Grosz describes the city as "one of the crucial factors in the social production of (sexed) corporeality: the built environment provides the contexts and coordinates for contemporary forms of the body" (104). Culturally and physically speaking, few cities have been in a state of flux as constant and as active (one could almost say volcanic) as Mexico City from 1920 on. If, as Grosz proposes, the relationship between bodies and cities is neither causal nor representational but rather that of an interface—that is, of mutual and reciprocal production, construction, deconstruction, and transformation—then the added examination of the dialogues that those female bodies establish with technological discourses in this body-technology-city interface adds an extra layer of involvement, participation, and disturbance on the part of the muses as they engage with constructions of national (official) history and Mexican identity. Finally, this focus on women and history is particularly important in the postrevolutionary era, as Carlos Monsiváis notes: "During the revolutionary stage from 1910 to 1940 or 1950, [. . .] women were seen in an ahistoric light; they existed on the margin of the optics of political and social prestige" and, as such, "did not form part of History" ("When Gender Can't Be Seen" 5). These muse-figures' interactions with their histories and the nation's Histories in the city that Monsiváis describes as "the country's most free or least intolerant space" form the foundation of this book (2).

My first chapter looks at the Estridentistas (Stridentists) and the Contemporáneos (Contemporaries), two avant-garde groups that emerged almost simultaneously in the aftermath of the Mexican Revolution. Read-

Introduction: Invoking the Muse · 9

ing their female figures from the intersection of gender and technology more clearly reveals the ambivalence expressed by both groups regarding Mexico City's rapid modernization in the postrevolutionary period in a series of short narrative works: Estridentista Árqueles Vela's three short novels compiled under the title *El café de nadie* (Nobody's café), and Contemporáneos Xavier Villaurrutia and Gilberto Owen (*Dama de corazones* [Queen of hearts] and *Novela como nube* [Novel like a cloud], respectively). Each text offers a revealing stance on questions of gender, modernity, and the role of art in a postrevolutionary avant-garde context. While the Contemporáneos' interactions with modernization and technology are not as pronounced as those of the Estridentistas, their muses, like Vela's disturbing women, reflect a peculiar inscription or absorption of the mechanical. The retroactively cyborgian women at the center of these narratives offer fragmented and individual stories that allow for a level of nuance and ambivalence that was not or could not be explored in the dominant genres of the time (the novel of the Revolution and explicitly nationalistic narrative).

The second chapter considers the interactions between Leonora Carrington and Remedios Varo, two flesh-and-blood muses in exile, with alchemic and mechanical discourse. They formed part of a small but dynamic cadre of female Surrealist artists who came to Mexico in the post–World War II era and stayed, enjoying periods of commercial and aesthetic success that would not have been possible for them in Europe. I read Leonora Carrington's memoir, *Down Below*, and her novel *The Hearing Trumpet* alongside two of Remedios Varo's writings that accompany two of her visual works: *Au bonheur des dames* (The ladies' delight) and *Homo Rodans*. Carrington's and Varo's texts and art are informed by and constructed with language and imagery drawn from their alchemic studies in a way that allows them to redefine André Breton's Surrealism to their own ends or leave it behind entirely. More specifically, I am interested in the connections between their work as artists and writers and the cultural and political climate in Mexico while they lived and worked there, as well as their relationships with Mexican historical discourse and explorations of identity.

The third chapter addresses the aftermath of the student massacre in the Plaza de las Tres Culturas (Plaza of the Three Cultures) in Tlatelolco, Mexico City, in October 1968. I limit myself to two texts here due to the length and complexity of each: at 650 and 1,500 pages, respectively, Fernando del Paso's *Palinuro de México* (Palinuro of Mexico) and Juan García Ponce's *Crónica de la intervención* (Chronicle of the intervention) are ambitious,

sprawling works of fiction. In Del Paso's case, the muse appears in the form of Estefanía, Palinuro's cousin. García Ponce, meanwhile, uses several female characters (two of whom appear to occupy the same physical body) over the course of his gargantuan novel. In this chapter, the muse figures of Fernando del Paso and Juan García Ponce interact with medical discourse as a response to the intellectual and political aftermath of the student massacre. The discourses produced by these muses offer potentially liberating possibilities for identity formation and insist upon multiple and simultaneous national histories in the demoralizing aftermath of the tragedy. The literary approach of both authors is an unusual response to traumatic events, but in doing so, Del Paso and García Ponce sidestep some of the more problematic issues generated by testimonial approaches.

The fourth chapter engages with a period of dissolution and revolution that began with the passing of the North American Free Trade Agreement (NAFTA) in 1994 and the simultaneous Zapatista rebellion. In this final chapter, the muses are drawn from twenty-first-century explorations of cyberpunk, speculative fiction, and the fantastic genre in Mexico City. Bernardo Fernández (BEF)'s *Gel azul* (Blue gel) (2005), Guadalupe Nettel's *El huésped* (The guest) (2006), and Karen Chacek's *La caída de los pájaros* (The fall of the birds) (2014) explore issues of violence and trauma in the urban and political space of Mexico City, isolating or untethering it from the rest of the country and turning it into a geographically isolated microcosm. In so doing, Mexico and all of the history and mythology that accompany the construction of the nation are destabilized to the point of dissolution, though globalism has endured in the form of multinational corporations and symbols woven throughout the narrative fabric of each text. As such, all three novels take on aspects of personal and political corruption in the metropolis in a virtual and historical sense. Fernández, Nettel, and Chacek make their female characters' bodies the battlegrounds in, on, and through which to grapple with the personal and political crises of the protagonists and the country. By so doing, they establish a connection between the female body, the state, and its history that is as deep and intimate as it is uncomfortable and disruptive, creating a platform from which to approach issues of guilt, memory, trauma, and the price of rebellion against the hegemonic state structure and mythology.

This book is part of a larger current in the field of Mexican studies, which for the last twenty years or so has been very interested in the ways in which Mexico has tried to define and unite the nation and its citizens during and after the intense internal conflict of the Mexican Revolution, as

well as the effects of these attempts at unification and self-definition in the last century. As Rebecca Janzen reminds us in *The National Body in Mexican Literature*, it is precisely these marginal bodies, the bodies that do not fit into the Mexican state's postrevolutionary vision of the national body, that "allow us to imagine an alternative non-hegemonic collective body that might begin to challenge this state" (4). *Technified Muses* continues in this vein with an explicit focus on gender and technology in urban space, as well as the capacity of the technified muses in each of the texts examined to engage the evolving discourses of the postrevolutionary state on their own terms. In this way, the book proposes not only a dissolution of utopian ideals but an explicit rejection of utopia as a way of combating the erasure of gender within these ideals.

# 1

# Mechanized Muses of
# the New Metropolis

## Mexico City after 1920

In the aftermath of the Mexican Revolution, Mexico found itself in a cultural and political clearing, albeit an uneasy one. The revolutionary leadership was immediately confronted with two problems, the first economic and the second ideological. With an economy devastated by a decade of armed conflict, Mexico needed to find ways to promote economic growth, and quickly.[1] Ideological debates raged over which revolutionary ideals were to be put into practice; that is, whether to prioritize agricultural development (and thus the rural population) or industrial development in urban centers. As Diane Davis notes in *Urban Leviathan,* "political factions oriented toward a broad variety of urban populations prevailed [. . .] such that the development policy of choice in those critical early years [. . .] was urbanization-led industrialization, not rural development" (21). This is not to say that concerns about rural development and agrarian reform were entirely erased from postrevolutionary politics, however. President Álvaro Obregón's political authority (and that of his newly formed Mexican Labor Party) was staked on "the state's representation of itself as the will of the popular classes," which included urban factory workers as well as rural *campesinos*, or peasants, many of whom were female (Gabara 98; Sluis 1–2). Consequently, Mexico was in a rush to fill the perceived political and cultural void and to create the impression of a united Mexican nation-state, as well as a construction and definition of *lo mexicano* in this brave new world.

As with other nation-building projects in Latin America, Mexico's analogies of union were strongly gendered. As Rebecca Biron has aptly noted, these analogies are tied to notions of a benevolent patriarchal nuclear family. While "happy, healthy, productive, and patriotic" women are important to the overall composition of this national family portrait, officialist literature and governmental rhetoric frequently "code active citizenship

as male" (1). Joane Nagel articulates a similar argument on a more global scale: although women have important roles to play in the un/making of a nation-state, "the scripts in which these roles are embedded are written primarily by men, for men, and about men" (243). As such, the types of masculinities in play during these episodes of nation-building must be considered alongside the presence or absence of women in discussions of gender in politics, as well as the ways in which notions of gender shape politics. While Biron ties the analogy of family/nation to Doris Sommer's suggestive notion of foundational fictions in nineteenth-century Latin American literature (linking narratives of heterosexual romance and marriage to those of nation-building), Robert McKee Irwin proposes narratives of male homosocial bonding as "a parallel allegorical strategy for constructing nationhood" alongside Sommer's fictions, most specifically in postindependence Mexico (xxvii). Biron, Irwin, and Héctor Domínguez-Ruvalcaba all note that these ties between masculinity and the nation "can be conceived only through paradoxes" (Domínguez-Ruvalcaba 2): that is, they are conceived in opposition to notions of femininity and to various othered categories of sexuality, class, race, etc. (Biron 12; Domínguez-Ruvalcaba 4–5 and 97–111; Irwin xix–xxi and 116–86). Domínguez-Ruvalcaba and Irwin address Mexican masculinity specifically, while Biron's analysis addresses twentieth-century Latin America at large. While neither they nor I wish to suggest that the relationship between masculinity and dominance is unique to Latin America or to Mexico, it is very much worth continuing to complicate (as Biron, Domínguez-Ruvalcaba, Irwin, and others have before me) the ways in which this relationship has played out in postrevolutionary Mexico and to carefully examine the ever-shifting "messy web of contradictions" (to use Irwin's term) that results (xx).

Mexico City was ground zero for much of the intellectual and political activity surrounding this process of constructing a new identity for postrevolutionary Mexico and Mexicans.[2] Vicente Quirarte captures the spirit of the time and the place in his literary biography of the metropolis, notably feminizing the city as he does so. In 1921, he writes, "[e]l aún breve, promiscuo, multifacético escenario llamado Ciudad de México ensaya nuevas formas de concebir el mundo" (the still-brief, promiscuous, multifaceted stage called Mexico City rehearses new ways of conceiving the world) (441). By extension, the city also rehearses new ways of conceiving itself, albeit often in contradictory fashion.[3] One of the most central places in which this battle over *lo nacional* played out was the literary arena.[4] The demand for taxonomy through literature was heightened considerably af-

ter the Revolution, when José Vasconcelos kicked off his public education crusade in the 1920s (Díaz Arciniega 45; Palou, *El fracaso* 14). As indicated by the religious language of crusades and missionaries that surrounded Vasconcelos's educational project, it is no exaggeration to say that cultural development through education was considered a cornerstone of the nation's very salvation in the wake of a decade-long internal conflict.[5] Furthermore, that cultural development provided a primary platform for the construction of *lo mexicano*, of the unification of a fragmented nation.[6] Despite Enrique González Martínez's famous declaration that it was necessary to "wring the swan's neck" and dispense with Latin American Modernismo, the Mexican Academy remained bogged down in Modernista themes and concerns almost in spite of itself.[7] The break from the institution had to come from elsewhere—from a younger generation, from those individuals who moved to the capital from the *provincia* (countryside) in search of a better life, and from nascent but rapidly growing avant-garde movements that would transform the role of the writer and the artist in Mexico as the country hurtled headfirst into the twentieth century.

### *"Se prohíbe fijar carteles"* (Post No Bills): Manuel Maples Arce and the Birth of Estridentismo

In *Actual No. 1,* the first Estridentista manifesto, the poet and lawyer Manuel Maples Arce outlines the temporal perspective of his movement: "Nada de retrospección. Nada de futurismo. Todo el mundo, allí, quieto, iluminado maravillosamente en el vértice estupendo del momento presente." (272–73; No retrospection. No futurism. Everyone is here, motionless, marvelously illuminated on the stupendous apex of the present moment.) The moment was December 31, 1921, and the ink was likely still wet on Maples Arce's law degree from the Escuela Libre de Derecho (Free University Law School) in Mexico City. His thesis, significantly, was on agrarian law (Rashkin, *The Stridentist Movement* 6). By plastering that audacious manifesto all over Mexico City and by publishing his Estridentista works in various national and international periodicals, Maples Arce drew in writers and artists such as Árqueles Vela, Luis Quintanilla, and Germán List Arzubide, and would soon attract admirers and collaborators within and beyond Mexico, including Tina Modotti, Edward Weston, Diego Rivera, Nahui Olin/Carmen Mondragón, Pablo Neruda, Miguel Angel Asturias, Jorge Luis Borges, and John Dos Passos (Rashkin, *The Stridentist Movement* 61–77). The group's reception in Mexico was decidedly mixed: journalist Carlos Peña González

wrote off the movement as nothing more than an "enfermizo hongo que apareció en el recio tronco de la literature" (a sickly toadstool that appeared on the hardy trunk of literature).[8] Nonetheless, the movement served as an intellectual, literary, and even political spark plug as it sought to breathe new life into a country that was clearly at a cultural crossroads.

Estridentismo was formed out of Maples Arce's impatience with the stagnant literary and cultural atmosphere in Mexico. Though the Ateneo de México (Mexican Cultural Association) had dissolved in 1914, its writers still seemed to be at a loss as to how to truly break out of Modernismo, which emphasized natural beauty and harmony as an aesthetic escape from an increasingly dissonant and violent world. As Pedro Ángel Palou notes, the country's institutions had not been transformed by the Revolution; it took no more than a glance at the Mexican academy in those years to see that "era la institución donde *no* se había dado ningún relevo generacional" (*La casa del silencio* [The house of silence] 85, my italics; it was the institution in which *no* generational shift had taken place). A generation gap was in effect, as indicated by the fact that the important writers of the 1920s (such as José Gorostiza, Carlos Pellicer, and Salvador Novo) would not reach the Academy themselves for another three decades. Enrique González Martínez suggested wringing the swan's neck (the swan being a popular image in Modernist poetry), but the only replacement he could come up with in his 1910 sonnet "Tuércele el cuello al cisne" (Wring the swan's neck) was an owl. In a fit of impatience at the perceived lack of change in Mexican letters, Maples Arce began to write what would become *Actual No. 1,* saying to himself, "No hay más remedio que echarse a la calle y torcerle el cuello al doctor González Martínez" (*Soberana juventud* [Sovereign youth] 123; There is nothing else to do but to go out and wring Dr. González Martínez's neck). The medical language of the manifesto's subtitle (*Comprimido Estridentista de Manuel Maples Arce* [Manuel Maples Arce's Stridentist pill]), established Estridentismo as a cure for the intellectual stagnation into which he believed Mexico had sunk. At that point, as Luis Mario Schneider observes, the group itself had not yet taken shape. The seeds of the movement were in the flyer-manifesto itself, issuing "un llamado público a los intelectuales mexicanos a constituir una sociedad artística amparada en una necesidad de testimoniar la transformación vertiginosa del mundo" (Schneider, *El estridentismo* 11; a public call to Mexican intellectuals to create an artistic society supported by the need to testify about the dizzying transformation of the world). Maples Arce's call to arms resounded with other intellectuals who, like him, were drawn to the

capital in the aftermath of the Revolution. His second manifesto, *Actual No. 2*, reached out past the capital to Puebla with the help of Germán List Arzubide, who was a vital lynchpin in the composition of the Estridentistas as a group (Corte Velasco 20–21; Schneider, *El estridentismo* 15–19; Pappe, *La historia* 79–94). Rafael Heliodoro Valle and Árqueles Vela were among the first to write positive reviews of Maples Arce's Estridentista texts in *El Universal Ilustrado*, which by August 1922 included three manifestos (all titled *Actual*) and his first collection of poems, *Andamios interiores: Poemas radiográficos* (Interior scaffolding: Radiographic poems).

Maples Arce's Estridentismo (an invented word in Spanish) contains various elements: an abundance of auditory and textual noise in performative, oral texts (many of which were written to be read out loud in public gatherings), the previously mentioned concept of *actualismo*,[9] and an oscillating, contradictory, and conflictive nature. "Era necesario que alguien se incomodara con la nueva teoría" (We had to make people uncomfortable with the new theory), Germán List Arzubide insists in "El movimiento estridentista" (The Stridentist movement) (17), and the prose of *Actual No. 1* does just that, zigzagging from topic to topic, now verbose, now pointed and concise, now absurd, now deadly serious. Technology, aesthetics, literature, national ideals, and identity are all jumbled together in Maples Arce's text:

> "Un automóvil en movimiento, es más bello que la Victoria de Samotracia." A esta aclactante afirmación del vanguardista italiano Marinetti, exaltada por Lucini, Buzzi, Cavacchioli, etcetera, yuxtapongo mi apasionamiento decisivo por las máquinas de escribir, y mi amor efusivísimo por la literatura de los avisos económicos.

> (42; "An automobile in motion is more beautiful than the Winged Victory of Samothrace." To this acclexultant phrase from Italian avantgardist Marinetti, exalted by Lucini, Buzzi, Cavacchioli, et cetera, I juxtapose my decisive passion for typewriters and my extremely effusive love for the literature of economic advice.)

Maples Arce's first manifesto is the anti–*La suave Patria* (*Suave Patria*: Sweet Land), a deliberate and complete departure from Ramón López Velarde's celebration of a fatherland that is "impecable y diamantina" (diamantine, impeccable) and its corn, countryside, and cacti (78, trans. Peden 79). The contrast between the two texts is greater still since both were published in 1921. López Velarde disparages the capital city and urban development

as exhausting and decadent, whereas Maples Arce celebrates "la belleza actualista de las máquinas, de los puentes gímnicos reciamente extendidos sobre las vertientes por músculos de acero, el humo de las fábricas [y] las emociones cubistas de los grandes transatlánticos" (43; the actualist beauty of the machines, of the gymnastic bridges sturdily extended over the slopes by steel muscles, the smoke of the factories [and] the Cubist emotions of the great ocean liners). The machine aesthetic celebrated by Maples Arce and the other Estridentista writers was far from unique—indeed, it was a shared component of European, Latin American, and North American avant-garde movements that emerged after World War I,[10] but the emergence and consequent manifestation of this aesthetic varied in important ways in each country. Many of the historical avant-garde movements that emerged in Latin America during the 1920s and 1930s shared this infatuation with the mechanical, but Estridentismo was among the first, coming into being just after Huidobro's *creacionismo* (creationism) in Chile (which Maples Arce considered exemplary in theory and uninspiring in practice),[11] and alongside Argentine *ultraísmo* (ultraism) and Brazilian *antropofagia* (anthropophagy).[12]

While the Estridentista movement was relatively short-lived (1921–27), it served as a point of departure from which new discursive possibilities were created in Mexico and in other parts of Latin America. For many years, the movement was dismissed as an immature and insubstantial flash in the pan[13] (with scholar Luis Mario Schneider as a major exception). The mid-1960s, however, saw the beginnings of a significant critical reevaluation and reestimation of Estridentismo that would lead to a veritable boom in Estridentista criticism, exhibitions, and studies by the late 2000s, establishing it as a groundbreaking and provocative literary, political, and cultural movement whose influence would continue long after the movement had officially ended.[14] The emergence of ¡30–30!, a group of artists who took on the Academia de la Pintura (Academy of Painting) in 1928, and publications such as *Forma* (Form), *Norte* (North), and *Crisol* (Crucible) continued to engage with the modern urban imaginary that the Estridentistas had so passionately promoted (Pappe, *Estridentópolis* 16–17). Maples Arce embraced an intimate combination of aesthetic innovation and political action that would prove to be a common element among Latin American avant-garde movements, and it was from this intersection of art, innovation, and action that Maples Arce articulated his response to the contentious question of how to live up to the ideals of the Revolu-

tion. The result was a utopic vision that, as Silvia Pappe indicates, "permite [. . .] miradas y observaciones que iluminen aspectos y experiencias apenas perceptibles en otros discursos" (12; includes [. . .] visions and observations that illuminate aspects and experiences that are scarcely present in other discourses). While the Estridentistas were formed in the crucible of 1920s Mexico City, most of its key figures were born elsewhere: Maples Arce hailed from Veracruz, and Árqueles Vela was born in either Chiapas or Guatemala, depending on the source consulted. Germán List Arzubide came from Puebla; Luis Quintanilla del Valle (Kyn Taniya) from Paris, France; and Salvador Gallardo from San Luis Potosí. The movement's influence and impact quickly reached beyond the capital city, spreading to Puebla, Zacatecas, and, most famously, to Xalapa.[15]

Alongside the poetic celebrations of noise, speed, streetcars, union workers, typewriters, telephones, and other trappings of modernization,[16] female characters figure predominantly in several Estridentista works. The representations of the feminine in Estridentismo stand in stark contrast to those found in Latin American Modernismo, in which woman (not women) "is the symbol of the *ars poetique* [. . .] and represented poetic creation or the search for it" (Martínez 26). These avant-garde representations of women and of gender as a whole are all the more telling if we recall that Mexico was caught up in an ongoing series of gender crises rooted in issues of masculinity, national identity, and literary representation that dates back to the postindependence era.[17] In the early 1920s, the ever-growing schisms in Modernista artistic ideals open up more aesthetic and political possibilities for the nascent avant-garde in Mexico, which suggests that there are also schisms and possibilities in the presentation and function of female figures in Estridentista literature that go beyond the intentions of the authors themselves. These characters may have been more prone to these sorts of schisms in the first place, given that femininity was already an "other" in opposition to ill-defined "natural" notions of masculinity (Irwin 123; Domínguez-Ruvalcalba 3–7; Nagel 243; Biron 5). Evodio Escalante underscores this suggestion in *Elevación y caída del estridentismo* (Rise and fall of Stridentism), noting that the transformation of the Mexican subject in the Estridentista movement—that is, from the archaic subject to the modern subject—requires a libidinal and specifically female sacrifice to become part of the virile metropolist that Maples Arce celebrates: "La mujer, objeto romántico por excelencia, será sacrificado en favor de un nuevo sujeto, anónimo y multitudinario: la ciudad" (55; The woman, the

romantic object par excellence, must be sacrificed in favor of a new subject, anonymous and multitudinous: the city). As Escalante reminds us, however, the sacrifice is an imperfect one, since "el peso de lo muerto continúa gravitando sobre la economía del poema en la forma de una Resistencia" (55; the weight of her death continues to gravitate around the economy of the poem in the form of resistance). The Estridentista authors' attempts to sacrifice or erase her are futile; rather than disappearing into thin air, her death/absence creates a narrative and psychological center of gravity within the text. Escalante makes no reference to haunting, but her continued presence after her death certainly lends itself to such a reading.

While these Estridentista texts were published several decades prior to the emergence of the urban new-wave or second-wave feminist movement in Mexico City in the mid-1970s, these persistent female figures may easily be read as precursors to what Emily Hind refers to as spectral feminism: while "feminism appears to have been an easy kill," she observes wryly, it still "requires an ongoing exorcism" to stay dead (*Boob Lit* 5). Indeed, some of these characters are even described as feminists (as in Árqueles Vela's "La Señorita Etcétera"), though he does not describe what that means, nor are the women connected to any of the movements active in Mexico at that time, such as the First Feminist Congress in Mérida, Yucatán, in 1916.[18] I would like to go a step beyond these observations and explore *how* she has resisted, at least in part, her own sacrifice to modernity. Each of the female figures analyzed in this chapter engages in an anxiety-producing resistance to her sacrifice through the same mechanisms of aperture and disruption that are intended to erase her, principally via her successful integration with the modernization process of the capital city through the adaptation to and assimilation of recently developed technology, primarily through the newest forms of communication and transportation.

To that end, I focus on three works by Árqueles Vela, one of the earliest adherents to Estridentismo and the movement's only novelist. After writing an enthusiastic review of Maples Arce's 1922 *Andamios interiores: Poemas radiográficos* (Interior scaffoldings: Radiographic poems) in *El Universal Ilustrado* (The illustrated universal), Vela jettisons his own previous writing style, which had been more romantic in nature, in order to embrace the avant-garde.[19] The novels, "El café de nadie," "Un crimen provisional," and "La Señorita Etcétera," are frequently published in a single volume under the name *El café de nadie*.[20] While they are usually grouped in reverse chronological order (the pieces were first published in 1926, 1924, and 1922, respectively), I think it important to analyze them in the order in which

they were written, as this reveals a significant evolution of the female figure over the course of the novels. Vela's attempts to sacrifice his female characters become less and less successful as each one becomes more lively, slippery, and elusive. Rather than becoming so fragmented that she eventually disappears, she becomes more solid, grounded, and active over the course of the novels, to the point that she even has a proper name in "El café de nadie," the last of the novels: Mabelina.[21]

Keeping in mind the historical, political, and cultural context in which Vela's texts were written, I read his female figures from three perspectives: first, from the past, in light of the female representations produced by Pablo Picasso in his work *Les Demoiselles d'Avignon* (1907). The choice of this particular painting was inspired in part by a comment made by Evodio Escalante: "Si Picasso pintó con *Les Demoiselles d'Avignon* los primeros senos cuadrosos de la historia de la pintura, Árqueles Vela capta los primeros senos eléctricos en la historia de la novela de México. Y el primer abrazo 'hertziano,' además." (88; If Picasso painted the first square breasts in the history of painting with *Les Demoiselles d'Avignon*, Árqueles Vela captures the first electric breasts in the history of the Mexican novel. And the first "Hertzian" embrace as well.) Both artists created fragmented, disfigured, and haunting female bodies in early artistic contributions to a relatively new avant-garde movement; reading these works side by side allows for a greater exploration of how these women haunt their creators while engaging the viewer/reader.

Vela's frequent references to technology and mechanization inspired my second analytical approach; that is, in terms of her increasingly mechanical and protocyborgian characteristics, along the lines that Donna Haraway elaborates in her essay "A Cyborg Manifesto."[22] Despite differences in context, Haraway's definition of the cyborg, along with her analyses of gender, sexuality, and identity, offer useful ways to read and understand the ambivalent production of the Estridentista female figure. In his book *Mestizo Modernity,* David S. Dalton makes a convincing argument regarding the usefulness of these sorts of out-of-context readings, as they allow for a broader definition of cyborg identity in postrevolutionary Mexico. This wide-lens approach offers a "specialized vocabulary of that theoretical tradition" as a way of "untangling the intimate relationships between race, gender, technology, and the body" that are represented in officialist and avant-garde literature in the years that followed the Mexican Revolution (Dalton 16–17). That said, Dalton and I agree that such readings must be undertaken with care and nuance, as the use of cyborgian theory avant la

lettre requires an attentive and in-depth consideration of historical, political, and social context.

In *Cyborgs in Latin America,* J. Andrew Brown observes that events in late twentieth-century Latin America require a contextually specific reading and rereading of manifestations and theorizations of the posthuman (4). Strikingly, the events he describes—the aftermath of oppressive governmental regimes, major economic changes, and an explosion of new technology that would significantly impact the speed and sound of everyday life—have fairly close parallels in the first decades of that same century in Mexico City. These, too, warrant more careful examination of interactions between technology, gender, and the body in the midst of rapid and significant social transformation. Lastly, the focus on social transformation makes a gendered reading of the cyborg particularly important since, if we follow Anne Balsamo's argument in *Technologies of the Gendered Body* that "[a]s a cyborg, simultaneously discursive and material, the female body is the site at which we can witness the struggle between systems of social order" (39). These technified female muse bodies are transformed but still profoundly embodied beings, troubling and complicating modernist oppositions of mind and body as well as evolving notions of post/human identity rooted in a specific sociopolitical context.

The explicit connection drawn by Escalante between the bodies of *Les Demoiselles* and "La Señorita Etcétera" is grounded in the ways in which they shape the female bodies in their works: fragmented, distorted, and sexualized. The comparison seems particularly appropriate given that *Les Demoiselles* and "La Señorita Etcétera" are considered the first artistic productions in a new style or movement; in Cubism and in Estridentista narrative, respectively. Indeed, various aspects of Cubism—multiple and simultaneous representations of perspective, demanding that the reader engage with the work, and its refusal to live in the shadows of other artists or artistic movements—appear in much of the Estridentistas' writing and art.[23] There are many parallels between Picasso and Vela, beginning with their defiance toward artistic tradition that each expressed through potentially violent artistic techniques. As Anna Chave suggests regarding *Les Demoiselles,* "the painting's ruptured aspect made it serve the purpose of signifying a moment of rupture particularly well" (600–601). These ruptures, however, came at the cost of the female form, as Picasso integrated her with her surroundings by blurring the lines between her body and the city around her. He exoticized and depersonalized them even further by denying two of them a human face, instead giving them features that re-

sembled those of a tribal mask. Even so, these *demoiselles* established a center of gravity of their own in the painting in a way that contradicted the artist's own intentions.

Meanwhile, in "La Señorita Etcétera," Vela's first novel, the author paints an anguished portrait of two Mexican cities in which bodies, identities, and narrative are dislocated, fragmented, and incoherent (Escalante, *Elevación* 82). Vela's cities are not much more defined than Picasso's Avignon; there are no street names or landmarks to orient the reader. The fragmentation and disorientation begin with the title itself, as Katherina Niemeyer indicates:

> "La señorita" hace esperar un nombre propio [. . .] o una frase relativa caracterizadora, expectativa burlada por "etcétera," que proyecta las connotaciones de 'arbitrariedad,' 'insignificancia,' y 'de sobra conocido'—o sea, 'carente de individualidad.'

> (74–75; The "Miss" makes one expect a proper name [. . .] or a descriptive phrase, an expectation mocked by "et cetera," which projects connotations of "arbitrariness," "insignificance," and "overly familiar"—that is, "lacking in individuality.")

While I concur with Niemeyer in terms of the impact of the title on the reader, my interpretation of Vela's "etcétera" is more optimistic than hers. This "etcétera" may also denote the desire to create an opening or space in the intellectual sphere in which the Estridentistas worked, and a refusal to close that space once it had been opened.[24]

The origins of Vela's "etcétera" can plausibly be found in Maples Arce's Estridentista manifestos, since all end with "etcétera," ellipses, or "siguen más firmas" (more signatures follow) (Maples Arce 282). Regardless of the connotations of the Estridentista "etcétera," in Vela's work, it is another point of disorientation that does not decode the meaning of the title or give any indication as to what kind of story will follow. The title requires as much interpretation as the text itself, leaving the reader at a loss before they can even begin.

The reader's sense of disorientation is increased by the fact that there is no mention of any *señorita* until the last few lines of the novel; until then, Vela only uses the feminine pronoun *ella*. While there may be multiple *ellas* in the text, Vela gives no proper names and offers little in the way of physical description to confirm or deny this possibility. Like *Les Demoiselles*, Vela does not orient the reader in space and time, leaving us as confused as

the narrator. At first, the narrator seems to include the reader in his tale by the use of the first-person plural: "Llegamos a un pueblo vulgar y desconocido. [...] Caminábamos un poco medrosos y el frío nos hacía más amigos, más íntimos, más sensibles." (89; We came to a common and unfamiliar town. [...] As we walked timidly along, the cold made us friendlier, more intimate, more sensitive.) While the reader could be part of Vela's *nosotros,* the first-person plural could just as easily apply only to the narrator and to *her,* whoever she is, but Vela never resolves the question. After the first paragraph, the first-person singular dominates; she, meanwhile, is always and only she.[25] On impulse, the narrator steps off the train to meet her. He seems to enjoy their first meeting: "Sentado junto a ella, en medio de la soledad marina y de la calle, me sentía como en casa. Disfrutaba un poco de música, de un poco de calor, de un poco de ella." (89; Sitting beside her, amid the solitude of the seaside and the street, I felt at home. I enjoyed a bit of music, a bit of warmth, a bit of her.) In their later encounters in the capital, however, his enjoyment gives way to anxiety; by the end, she is no longer an enjoyable companion but has grown "[c]ompleja de simplicidad, clara de imprecisa, inviolable de tanta violabilidad . . ." (98; original ellipses; complex from her simplicity, clear from her imprecision, inviolable from so much violability . . .) It is also noteworthy that the narrator only enjoyed their time together in a place that is *not* Mexico City, as indicated by the seaside atmosphere.

As the phrase cited above implies, she has been violated (the Spanish *violar* implies both rape and violation) so many times that she can no longer be hurt. She has had so many identities projected onto her that she has lost her own. Nonetheless, she shows signs of independence and agency: she is a unionist, a feminist, and sexually assertive, capable of frequent and even electric orgasm (Vela 95). These transformations of identity, the text implies, are strongly linked to her interactions with technology, as she has integrated it into her own organic being.

> Ahora era otra. Había seguido las tendencias de las mujeres actuales. Era feminista. [...] Su voz tenía el ruido telefónico del feminismo... [original ellipses] Era sindicalista. Sus movimientos, sus ideas, sus caricias estaban sindicalizadas... [original ellipses]

> (96; Now she was someone else. She followed the trends of today's women. She was a feminist. [...] Her voice had the telephonic noise of feminism . . . She was a unionist. Her movements, her ideas, her caresses were unionized . . .)

The anxiety exhibited by Vela's narrator mirrors that of Mexican leaders of the 1920s and 1930s, who fretted over the notion of "free women"—flappers, activists, and other women in the public sphere—as threatening to the very fabric of society itself (Sluis 2). The difference, however, is that Vela's narrator does not condemn her, nor does he describe her as a threat to the future of the nation. She just makes him really, really uncomfortable.[26]

Vela's narrator may have been trying to erase her as a way of coming to grips with his own feelings of ambivalence and alarm toward the great modern city, but she does not disappear; rather, she melds with other elements of the urban environment, many of which are linked with social interaction and communication. She interacts with telephones, typewriters, telegrams, and phonographs so seamlessly that even her laughter takes on a metallic sound (95). Rather than evaporating, she seems to be everywhere, having successfully integrated herself into the new urban matrix that leaves the narrator feeling isolated from everyone, even from himself.

This representation of indecisive, anxiety-prone masculinity did not go unnoticed by Vela's fellow Estridentistas, particularly Germán List Arzubide. In his 1926 essay *El movimiento estridentista,* he celebrates Maples Arce's *machismo estridentista* while insulting Vela and his representations of women. Calling them "sus muñecas" (his dolls), List Arzubide states that "son ellas las que le dictan sus novelas" (272; they are the ones who dictate his novels to him). List Arzubide goes on to point out that, while the few women mentioned in Maples Arce's texts are anonymous, disposable sexual conquests, Vela's female characters dominate and symbolically castrate him, stripping him of his authorial agency. By describing the female characters as dolls kept in boxes, List Arzubide dehumanizes them while also femininizing and infantilizing Vela: rather than producing "real" virile literature, the essay suggests, Vela plays with dolls as a (female) child might.

Of all of Vela's female characters, List Arzubide seems particularly upset by La Señorita Etcétera, describing her as "la más real de sus muñecas" (the most real of his dolls) and insisting that her value has decreased: "es la mujer estridentista de $1.000.000 hoy rebajada a $500.00" (272–73; she is the million-dollar Estridentista woman who is now on sale for $500). Tellingly, the worst way he can think of to insult Vela is by insulting the character, stating that Vela cannot control her, her comings and goings, or even her sexuality: she is frequently out in public (List Arzubide describes her as a "muñeca dueña de todos los caminos" [doll-owner of all streets]) who has cheated on him with several other (apparently more macho) Estridentistas (273). Vela's reaction to the essay is unknown (unfortunately), but I con-

cur with Ángela Cecilia Espinosa's assessment that List Arzubide's attack on Vela in general, and the character of La Señorita Etcétera in particular, points to a sense of masculinity in crisis that is further exacerbated by the mere presence of women in the public sphere (404). To take Espinosa's reading one step further, I draw upon Ageeth Sluis's observations about the ways in which Mexican modernity clashed with the revolutionary agenda (13–16) and extend them to the avant-garde sphere. Maples Arce's notion of Estridentista literary production was exaggeratedly masculine to the point of being homophobic and even homosocial, particularly if we take him at his word when he declares that "Ser estridentista es ser hombre" (To be an Estridentista is to be a man) in *Actual No. 2*. After five years of insisting upon the importance of embracing novelty, noise, speed, and modernity, and of equating this embrace with masculinity, it comes as a nasty shock for the Estridentistas to be confronted with the ways in which "women's mobility in urban, public spaces appeared a requisite for modernity" (Sluis 15). For all, that is, except Vela, whose Señorita indicates that he had recognized that connection between women and modernity from the beginning.

To return to the comparison between Picasso and Vela, the slippery, anxiety-provoking unruliness of the female figure is a predominant element in both works. As mentioned previously, both Picasso's *demoiselles* and Vela's señorita(s?) are the products of violent artistic techniques, and therefore feature fragmented, disjointed, and potentially violated bodies. Even so, Anna Chave's reading of Picasso's painting observes that "[the] women he depicted [. . .] come to assume a kind of autonomous agency" (596). Chave's description of Picasso's *demoiselles* could just as easily be referring to Vela's señorita(s): "these women can be had, of course, but on another level they are not for the having" (596), a description that strongly recalls the señorita who was "inviolable de tanta violabilidad." It is precisely the inviolability of these women that "puts the client-viewer in a position of nerve-wracking uncertainty" (Chave 598–99) and subverts the power of the male gaze and all that would imply: mainly, the evaluation of the women for purchase (either in the painting or in real life, as it is well known that Picasso's *demoiselles* were sex workers). Consequently, the possibility of ownership is disrupted and the position of power of the male creator is destabilized. Indeed, all three of Vela's novels may be read as "functionally feminist texts" (a term taken from María Elena de Valdés's *The Shattered Mirror: Representations of Women in Mexican Literature*). Regardless of the author's intentions, de Valdés argues, a literary text like Vela's that "undermines the discourse of power in Mexican society" also has a subver-

sive social function, as it questions sexist social discourses of male power (51–52).[27] Picasso and Vela deliberately set out to break with artistic tradition via specific techniques of representation; in this sense, both works are intentional disruptions of existing symbolic structures, each one in and against its own time, place, and tradition. By using the female figure to symbolize these disruptive processes, the very artistic mechanisms meant to subvert tradition also subvert the works themselves.

Unlike Picasso's *demoiselles*, Vela's narrator engages in more direct and uncomfortable contact with the woman/women of "La Señorita Etcétera" much of which is intimately intertwined with their surroundings in the capital city and the new technology of the era. Both characters fit the definition of the cyborg that Donna Haraway offers in *Simians, Cyborgs, and Women:* "a cybernetic organism, a hybrid of machine and organism, a creature of social reality as well as a creature of fiction" (149). Haraway is less interested in how cyborgs come to be than in what they might do (that is, what they might challenge, disrupt, or question). Writing as he does from the 1920s, Vela's focus is on the transformation of the narrator and the Señorita and how their bodies interact with and are transformed by the modern urban environment. The mutual mechanization of the Señorita and the narrator (or, more precisely, "el yo narrador/narrado" [the narrating/narrated self]) is most thoroughly explored in the fifth section or chapter of the novel.[28] Here, the narrator describes the hotel he occupies and its effect on him. His use of the verb "to occupy" rather than "to live" or "to inhabit" is deliberate, since he never actually uses the room, instead spending his days and nights in "lugares inusitados" (95; unusual places). He only feels as though he lives in the hotel on the occasions "cuando ella penetró, con sus pasos medidos, en el asensor" (95; when she, with her measured steps, penetrated her way into the elevator). It is only when she *penetrates* the elevator (and, by extension, the narrator) that he begins to think or to feel. As Martínez observes, "[t]his image of the artist's connection to the muse, or the receiving of creative interpretation, is in direct contrast to sexual imagery used by the Modernistas. Here a 'she' 'penetrates' *he*, the male artist" (26; original italics). Without the muse's presence, however, the urban environment has a sinister effect on him: "La vida casi mecánica de las ciudades modernas me iba transformando. [. . .] Encerrado en un coche, paseaba sonambúlico, por las calles. [. . .] *Me volvía mecánico.*" (Vela 95; my italics; The almost mechanical life of modern cities was transforming me. [. . .] Confined in a car, I traveled through the streets like a sleepwalker. [. . .] *I became mechanized.*)

28 · Technified Muses

The narrator's use of the imperfect tense implies that his disoriented somnambulism is a constant or habitual state. His unease stands in direct opposition to the Señorita's reaction to the city. For her, the city means activity, conversation, companionship, and social agency, and she has happily integrated herself into it. As Elissa Rashkin observes, she is not only integrated but "inseparable from [. . .] public places that challenge patriarchy's traditional confinement of women to the domestic sphere" (*The Stridentist Movement* 138). Additionally, her new cyborg-like status has not disconnected her from her body or her sense of self. "Just as women never speak, write, or act outside of their bodies," Balsamo notes, "cyborgs never leave the meat behind" (40). Balsamo, Carlen Lavigne, and other cyberfeminist writers attribute this stability to the essentially embodied nature of the female cyborg, which serves as an anchor for identity. M. Elizabeth Ginway, however, reminds us that the embodiment of the gendered (and particularly female) cyborg can be tied to Latin American cultural traditions as well, since there is a tendency to "resist the idea of the mind without a body" (*Cyborgs* 1). Vela's narrator maintains his body but loses control over it: he has become absorbed in (or by) the city, sleepwalking mindlessly through the same streets that are so full of life for the Señorita(s).

It is not clear *how* he has become mechanized; we only know that the narrator becomes increasingly disconnected from his sense of self as the novel progresses. She, meanwhile, is invigorated by her new hybrid state. The narrator describes her thus:

> Era en realidad, ella, pero era una mujer automática. Sus pasos armónicos, cronométricos de figuras de fox-trot, se alejaban de mí, sin la sensación de distancia; su risa se vertía como si en su interior se desarrollara una cuerda dúctil de plata.
>
> (95; It was, in fact, her, but she was an automatonic woman. Her harmonious steps, chronometric fox-trot figures, moved away from me without the sensation of distance; her laughter flowed out as if a ductile silver thread were unreeling inside her.)

Their courtship is equally electrical and mechanized. The male narrator and the *señorita* are simultaneously close together and far apart, though it is not clear if the distance is physical, psychological, or both. "Nos escuchábamos desde lejos. Nuestros receptores interpretaban silenciosamente, por contacto hertziano, lo que no pudo precisar el repiqueteo del labio." (Vela 95; We listened to each other from a distance. Silently, by Hertzian contact,

our receptors interpreted what the clattering of lips could not express). It is as if language itself has evolved beyond the interpretative capacity of the organic human body; therefore, their mechanical "receptors" must take on the job of interpreting the new signs and signifiers that human speech is incapable of communicating.

Even the sex between them is mechanized; orgasm is achieved, but the distance remains. "Cuando ella desató su instalación y sacudió la mía impasible, nos quedamos como una estancia a oscuras, después de haberse quemado los conmutadores de espasmos eléctricos . . ." (Vela 95, original ellipses; When she unleashed her installation and shook mine impassively, we were left there like a dark room after the switchboard has been burned out by electric spasms . . .). In the narrator's eyes, she is even more mechanized, disjointed, and dehumanized than before, first by the city and its technology and now by her sexual contact with the narrator. They orgasm together, but instead of growing closer, their climax has the opposite effect: it burns out the switchboard that allowed them to communicate, leaving them together yet alone in the dark. He laments the distance between them, which initially suggests that they are too far apart, but his anxiety indicates just the opposite: they are far too close for (his) comfort.

The closeness of the technified "mujer actual" to the narrator recalls Haraway's suggestion that the cyborg may not signal isolation after all; instead, she describes a cyborgian existence that encourages or even requires "disturbingly and pleasurably tight coupling" (Haraway 152). Vela's narrator struggles with the idea of being One (man) and joining with the other (woman), with potentially catastrophic consequences. As Haraway explains, "To be One is to be autonomous, to be powerful, to be God; but to be One is an illusion, and so to be involved in a dialectic of apocalypse with the other. Yet to be other is multiple, without clear boundary, frayed, insubstantial. One is too few, but two are too many" (177). Alone, the male narrator could maintain his illusion of autonomy, or what Emily Hind calls the "contradiction of a networked loner" that is frequently performed by male writers (*Dude Lit* 100). Once joined with the Señorita(s) and the mechanical elements of the ever-growing city, however, his delusion is revealed and his attempts at apocalypse (that is, at destroying her) are thwarted.

Thus does the Señorita resist her own death in Vela's novel, in "tight coupling" with the narrator. While he was the first to show interest in her, the dynamic between the pair shifts over the course of the novel. He begins to feel threatened as her indeterminacy reveals the fragility of his own sense of self; she changes constantly, yet leaves him permanently marked:

"Ella me había tatuado" (She had tattooed me), he confesses with alarm.[29] While it is not clear if the tattoo is real or metaphorical, the act of tattooing still has significant implications in terms of gender identity. In *Bodies That Matter*, Judith Butler writes that "the category of sex is, under the conditions of compulsory heterosexuality, always feminine (the masculine remaining unmarked and, hence, synonymous with 'universal')" (18). The reference to a literal mark in the form of a tattoo tells us that she has irrevocably transformed the narrator, making him into an individual who can no longer be considered a universal representative of masculinity. The permanent modification of the narrator's body in the form of a tattoo also creates greater awareness of that body, which in turn produces somatophobia, or fear of the body, a concept that Butler refers to in passing in *Bodies* and that Susan Bordo unpacks in greater detail in *Unbearable Weight* (1993, 2003). For one experiencing somatophobia, the body is alien, confined, limited, the enemy, and, most of all, the locus that threatens attempts at control (144–45). If we read Bordo's notion outside of its historical context—that is, as a construction that reaches beyond her focus on the pathology of late twentieth-century weight-loss culture—the Señorita's act forces him to acknowledge his individuality and his body. In so doing, she further lays bare his fear of the inability to control his life and his surroundings. If we further extend these readings of Butler and Bordo to constructions of nationality, his tattoo also marks his separation from the universal male ideal of *lo mexicano* that was under construction in the postrevolutionary era.

The idea of a threatening, anxiety-producing, mechanized female figure stretches back centuries, from fifteenth-century Jewish golem mythology to E. T. A. Hoffmann's Olimpia in *The Sandman* (1816) to Villiers de l'Isle-Adam's *The Future Eve* (1886) to Eduardo Holmberg's "Horacio Kalibang or the Automata" (1879).[30] For my purposes, I am interested in the way this figure was employed during the 1920s in prose narrative of the decade as well as in visual art and in film in the Americas and Europe. These mechanized avant-garde women emerge from anxieties over technology that date back to the previous century and that are intensified during moments of extreme flux or conflict. To that end, I find it useful to compare Vela's *Señorita* with a nearly contemporary European work, Fritz Lang's silent film *Metropolis* (1927). While Lang could not have been a direct influence on Vela, he responds to the "machine-cult of the 1920s" (to use Andreas Huyssen's term) in Europe in ways that are strikingly similar to Vela's reaction to Estridentismo's futurist-inspired embrace of ever-louder and faster machines (*After the Great Divide* 67).

Technology in *Metropolis*, Andreas Huyssen observes, is "embodied in a female robot, a machine-vamp who leads the workers on a rampage and is subsequently burned at the stake" (*After the Great Divide* 67). The industrialist Joh Frederson conspires with the inventor Rotwang to create a mechanical woman with the face of Maria, a saintly woman who preaches peace and harmony to the laborers of the Workers' City. The robot Maria, however, is aggressively sexual and disruptive, provoking lust and murder among the men who watch her dance. Later, in a passionate speech to the workers, she convinces them to abandon their jobs and even their children. *Metropolis* is, Huyssen dryly observes, one of numerous "male mystifications of female sexuality as technology-out-of-control" (*After the Great Divide* 78). In the end, the children are protected and returned to their parents by the virginal, organic Maria. Employing a centuries-old solution to a futuristic problem, the provocative robot-Maria is burned at the stake, the workers return to their posts, and order is restored.

*Metropolis* "vacillates between two opposing views of technology which were both part of Weimar culture" (Huyssen, *After the Great Divide* 67): initially, the film presents onerous, assembly-line technology that endangers the workers' bodies and souls; later, it declares that technology is an indicator of social progress; later still, the technology that created the rebellious robot-Maria is considered the work of a madman and must be destroyed (81). Technology, it would seem, is to be embraced only if it does not become too human, too messy, or too liberating.

Vela displays anxiety toward the sexually active Señorita as well, but his feelings toward her are part of his discomfort with the process of modernization as a whole. The Señorita's unsettling nature stands in opposition to the ways in which the virginal-organic and seductive-robot Marias threaten order and progress. The Señorita is not menacing or as openly seductive as Lang's robot-Maria, but her adaptability to her environment and her comfort with initiating consensual sex provoke plenty of masculine anxiety all the same, as they defy idealized Mexican notions of women as abject, self-sacrificing mothers of the nation. Furthermore, while the robot-Maria looks human, the Señorita's mechanical elements are evident in her overall presentation and her sexual pleasure, as indicated by her metallic voice, her "senos temblorosos de 'amperes'" (breasts trembling with "amperes") and her "abrazos hertzianos" (Hertzian embraces) (95, original quotation marks). While Vela takes care to tell us that she is a unionist, she never becomes a public figure or rabble-rouser like Lang's Marias. "La Señorita Etcétera" and *Metropolis* were produced in radically

different national and political contexts; Lang was inspired by a 1924 visit to New York City and filmed *Metropolis* during the height of the Neue Sachlichkeit (New Objectivity) movement during the Golden Age of the Weimar Republic. Vela, meanwhile, wrote his novel in a nation that was still reeling from a decade-long civil conflict and that had only just begun the difficult work of political, economic, and aesthetic renovation and reconstruction.

The discourse in "La Señorita Etcétera" tilts distinctly cyborgian and contains many of the characteristics that Haraway lists in her manifesto. It is fragmented, written from the interface between the flesh that is becoming mechanized and the machine that is acquiring organic, if not always human, characteristics (as we see in Vela's descriptions of car horns that sniff after traveler's tracks like a dog or an insect).[31] The novel and its characters are precariously located between the past and the future. Also, it offers a hybrid discourse that defies a single, stable, definitive reading. Furthermore, the Estridentistas' rejection of the past suggests that their discourse is without parentage, since it is the first of its kind. In "La Señorita Etcétera" and Vela's other novels, there are few proper names and no last names, indicating a lack of (parental) origin. The only exception is in "Un crimen provisional" when the doorman offers the detective various cards, each with a different name and occupation, but all are fictitious identities that belong to no one.

The cyborgian discourse also becomes productively unmoored in terms of time as well as identity. N. Katherine Hayles observes that human notions of time and history clash with mechanical discourses and what she calls "machine values of assembly and disassembly" ("The Life Cycle of Cyborgs" 322). Since the cyborg cannot be reduced to human or machine, neither can these temporal conflicts be resolved. This irresolution places the cyborg in a productive location, however, since, as Hayles reminds us: "*Standing at the threshold separating the human from the posthuman, the cyborg looks to the past as well as the future*" ("The Life Cycle of Cyborgs" 322, original italics). The cyborg's location and double nature grant a particular perspective that includes a level of engagement, agency, and potential to enact change. It is, Hayles concludes, "precisely this double nature that allows cyborg stories to be imbricated within cultural narratives while still wrenching them in a new direction" (322). This double nature is particularly advantageous if the cyborg is also female, which (if we recall Balsamo) places her at the center of social transformation—a position that provides excellent leverage to "wrench cultural narratives in a new direction."

Despite the Estridentistas' efforts to deny the past, Estridentismo could not exist in any other way except in reaction to that past. The conflict in Vela's novels, particularly in "La Señorita Etcétera," is based on mechanized, cyborgian characters that are irrevocably located between two radically different eras, pulling away from Latin American Modernismo and the Mexican Revolution and launching themselves toward a political and artistic future that is as unknown as it is inevitable.

### Athletic Laughter, Technological Magic, and Multiplying Muses in "Un crimen provisional"

Two years later, in 1924, Vela published "Un crimen provisional." While "La Señorita Etcétera" was left dissolved, open and yet also closed off to everything, the female figure in "Un crimen provisional" continues, even after death, to resist her sacrifice. The novel coincides with the arrival of the Surrealist movement in France, so it is no surprise to find a mannequin in this work.[32] There is more humor here than in "La Señorita Etcétera," but it is a particular kind of humor, along the lines of Foucault's shattering laugh from the introduction to *The Order of Things*. This aspect of the laughter he discusses is even more evident in Alan Sheridan's translation, since "shattering" implies an impact that not only shakes tradition (as suggested by the verb *secouer* from the original French) but smashes it to pieces. "Un crimen provisional" levels its mockery at everyone and everything from the detective novel to the muse-figure, showing us a detective who does not even realize that the "murder victim" is only a mannequin.[33] Vela himself elaborates on this laughter in his essay "La sonrisa estridente" (The Stridentist smile):

> Nuestra sonrisa es una sonrisa deportista. Usamos las raquetas del humorismo para mantener los conceptos y las frases en el aire idealista de los campos intelectuales, en una reciprocidad admirable, sin tocar la red de la realidad.

> (9; Our smile is an athletic smile. We use the rackets of humor to keep concepts and phrases in the idealistic air of intellectual fields, with admirable reciprocity, without touching the net of reality.)

In "Un crimen provisional," Vela is more reserved, smiling rather than laughing outright. Even so, both actions are fleeting and irretrievable, much like the Estridentismo *actualista* in question. None have much last-

34 · Technified Muses

ing value; that is, that which makes one smile changes quickly. A joke rarely remains funny for very long after it is told, and it needs to be rethought or told in a different way to provoke a smile or laughter. Even then, the reaction to a joke retold is not nor can it be identical to the first time it is heard. Germán List Arzubide refers to laughter as a weapon in a 1926 letter to fellow Estridentista Salvador Gallardo in which he describes the city of Xalapa as "equilibrista y estridente, apuntalada con mis risas rebeldes" (reproduced in Schneider 1970, 144; a strident aerialist, held up by my rebellious laughter). Laughter, then, does not only destroy but also (re) builds the foundations upon which something new can be built—which is particularly significant when articulated from the city most commonly associated with Estridentópolis, where the Estridentistas moved to try to put the ideals of their movement into action.

Vela's "sonrisa deportista" (athletic smile) suggests a playful stance toward literature and the language used to create it: he tends to create words by combining elements of two existing words to increase and expand their expressive potential. In his critique of Maples Arce, Vela explains the requirements to understand him and Estridentismo as a whole:

Para comprender a Maples Arce hay que disgregarse. [. . .] Sólo así se podrá vislumbrar el bólido errante de su pensamiento. Su gemialarido [*sic*] que canta detrás del horizonte.

(50; To understand Maples Arce, it is necessary to destroy oneself. [. . .] This is the only way to discern the wandering fireball of his thoughts, his moan-shriek that sings beyond the horizon.)

Vela poses that the goal of this self-directed violence is to capture Maples Arce's way of thinking, which is expressed through a "gemialarido." The combination of "gemido" (moan) and "alarido" (shriek, scream) increases the sense of pain that both words imply. As such, I find it particularly significant that Maples Arce uses this sound to *sing*. The combination of singing and pain suggests the presence of beauty in spite of or even because of the pain involved in the creative process.

At other times, Vela's hybrid words are employed to more disturbing ends. In "Un crimen provisional," the victim of the crime is described as having experienced "an *ethereal* death," her body marked only by "la huella de una caricia sutil que había contucccionado [*sic*] la gracia de su cuerpo y sacudido la alegría de su sonrisa . . ." (242, original ellipses; the trace

Mechanized Muses of the New Metropolis · 35

of a subtle caress that had bruise-designed the grace from her body and shaken the happiness from her smile . . .). The hybrid nature of the word "contuccionado" (contusionado + confeccionado [bruised + designed/tailored]) allows for an economy of expression that is characteristic of Vela's prose. The implications are troubling: *confeccionado* could refer either to the woman's body, implying that it has been arranged and assembled like a dress from a pattern, or it could suggest that the death itself has been planned out beforehand, leaving the (il)legible evidence on her body.

This Estridentista laughter of "Un crimen provisional" is, characteristically ambivalent, simultaneously serious and ironic. The Detective (Vela's capitalization) who finds the dead woman's body concludes that the "murder" was committed by a hypnotist or a magician, stating gravely: "Parece que una corriente eléctrica la hubiese desencajado" (242; It seems that an electric current has disconnected her). For the Detective, the causes are obvious: either magic or electricity (that is, technology). Both are equally probable and feared, since neither one fits "en el catálogo de [sus] observaciones" (242; in the catalogue of [his] observations). Through the Detective, Vela mocks the suspicious and awed attitude toward the new technology that had emerged in Mexico City, even as he recognizes that same awe and suspicion in himself.

Just as the mechanized woman of "La Señorita Etcétera" has resisted her dissolution, the feminine figure from "Un crimen provisional" persists as well. In the end, the only "body" we are shown is a mannequin, which allows for various interpretations. In her reading of "Un crimen provisional," Elizabeth Coonrod Martínez suggests that "[t]he muse of the past—voluptuous woman—had to be killed, and the muse (creative spirit) of the twentieth century helps the detective [*sic*]" (29). While her argument is logical and congruent with Estridentista ideology, Martínez's conclusion leaves more loose ends than it ties up. Killing the former literature/muse was not enough; for Martínez, she also had to be "supplanted by a new literature and a new muse—a 'frenetic' muse representing the new age" (30). The muse who helped the Detective, however, does so calmly and is not in the least "frenetic," which begs the question, are there *two* new muses for this new age?

To answer this question, one must keep count of the female figures in the novel, an apparently simple task rendered difficult by Vela's aversion to giving proper names to his characters. In my reading of the novel, there are three women: first, the dead woman/voluptuous woman/mannequin;

second, the woman who calmly helps the Detective and tells him about the murder; and finally, the frenetic woman.[34] The only character with a name is the man/murderer, but he assumes so many names and identities that the reader has no idea which, if any, are real. The fact that he keeps trying out new personalities implies that he is as fragmented as the *Señorita* of the previous novel; furthermore, he deliberately fragments *himself* in order to please the frenetic woman as he shifts from one identity to another. The presence of the mannequin, meanwhile, could imply the escape of the old muse from the masculine gaze (that is, she leaves a mannequin in her place, knowing that the man will not notice the difference); on the other hand, the old muse may have turned into a mannequin after spending so much time under the Modernista masculine gaze.[35] At any rate, the end is inconclusive: either the murderer was rehearsing his crime and using the mannequin as a prop or he has already committed the murder. Even the final sentence trails off: "Que este crimen provisional, que puede ser precursor del verdadero, quede en silencio absoluto . . ." (250, original ellipses; may this provisional crime, which might be a precursor to the real one, remain in absolute silence . . .). It is never entirely clear if Vela has successfully "sacrificed" her or not, but the final opening created by the ellipses at the end of the text provides various possibilities of resistance or escape for the sacrificed female figure.

## The Final Escape: Mabelina in "El café de nadie"

By 1926, in "El café de nadie," there are no more sacrifices. Vela's athletic smile remains present, although it is more subdued than in "Un crimen provisional." In the café, the female figure is more solid than ever: although she still has no last name, implying a lack of parentage, the act of giving her the proper name "Mabelina" already provides her with more substance than her anonymous precursors. In her interactions with her companion, Mabelina occupies a place similar to that of the narrator of "La Señorita Etcétera," except that now her masculine companion is the one who seems to be coming undone. Like the murderer in "Un crimen provisional," he is conscious and even proud of his constant transformations. As they sit in the Café de Nadie, he brags to her:

> Soy un individuo que se está renovando siempre. Un individual que no podrás estabilizar nunca. Un individuo al que engañarás diariamente conmigo mismo por esa mutabilidad en que vivo.

(226; I am an individual in a constant state of renovation. An individual that you will never be able to stabilize. An individual whom you will betray every day with me, myself, due to the mutability in which I live.)

Rather than being impressed by his words or offended by his half-joking accusation of infidelity, Mabelina is bored. "No hagas frases. ¿No quieres mejor besarme?" (226; Don't be ridiculous. Wouldn't you rather kiss me?) Like the Señorita Etcétera, like the woman who helps the Detective, Mabelina remains calm, reasonable, and assertive in the face of her companion's excitability.

On the wall of the café where they meet, a list of Estridentistas is posted, ending with "etc., etc., etc." (30). Mabelina reads it over and over again; notably, *her* reading and *her* gaze shape the text and the names listed there: "Recordando unos, olvidando otros, se esfumaban unos sobre otros, yuxtaponiéndose, formando un nombre impronunciable, indescifrable" (231; Remembering some, forgetting others, some disappeared over others, juxtaposed among themselves, forming an unpronounceable, indecipherable name). Mabelina impassively observes her own dissolution as well: "Se iba apagando, perdiendo, envolviendo en la difusividad" (232; She was fading, lost, wrapped in diffusive-effusiveness). She writes her name on the table over and over to inscribe it in time and space, but with each iteration of her name, she alters the letters, stretching them out until they are rendered illegible. Her thoughts, which she speaks aloud to herself, are unusually defiant for one of Vela's female characters. What is even more unusual is that, for the first and only time in these three novels, he relates her thoughts to the reader. The feelings she articulates bear a strong resemblance to Vela's own exhortations to understand Estridentismo: "Hay que gastar, que despilfarrar la vida—se decía—para defraudar a la muerte. [. . .] Que nos encuentre exhaustos, muertos, inútiles, inservibles." (232; You've got to spend life, to squander it, she said to herself, in order to cheat death. [. . .] Let them find us exhausted, dead, useless, used up.) Having said this, she stays a few minutes longer, closes her bag, and goes out into the dawn of a new day (233). Whatever else happens, she realizes she cannot stay in the Café de nadie, in the café where she cannot be herself. All of the characters in the story are left fragmented, but it is Mabelina who makes the decision to leave the café in search of the place where she can be "la que es" (222; who she is). Vela, however, cannot or will not define what that is. Instead, she gets up and leaves the story, entering into daylight and into urban public

space. The implication is clear: it is there, and not in the domestic sphere, where Mabelina can be herself.

It is no coincidence that this shift in perception coincides almost exactly with the Estridentistas' relocation from Mexico City to Xalapa, Veracruz, in 1925, at which time they "came into closer contact with social movements, including women's organizations" (Rashkin, *The Stridentist Movement* 138). As a result, Rashkin notes, "progressive views on women's rights began to appear in their publications," which might explain the relative solidity of Mabelina compared with Vela's other female characters (138). Furthermore, another degree of progression may be seen in the absence of the cultural stereotypes that tend to plague representations of women in Mexican letters (Valdés xi). Emily Hind observes similar issues more than a decade after Valdés's text, as she notes that "three main archetypes for Mexican womanhood: La Malinche, la Virgen de Guadalupe, and Sor Juana" are still in wide circulation in the twenty-first century (*Boob Lit* 27). Given the persistence of the archetypes and stereotypes that Valdés and Hind discuss, Vela's representation of his female characters is all the more unusual and noteworthy. Vela's women are all sexual creatures, and while this disturbs his male narrators, the women are never condemned on moral grounds or threatened with annihilation; none end up disgraced or insane. "El café de nadie" also appears in the aftermath of the 1925 polemic over the virility of Mexican literature and concerns regarding its so-called feminization. The main players were the Estridentistas on one side and the Contemporáneos on the other, a debate that I will explore in the next section.

## El grupo sin grupo (The group without a group): The Contemporáneos

The Contemporáneos, along with other literary groups of the era,[36] wrote during what Rubén Gallo called "the other Mexican Revolution": amid the sudden onslaught of cultural transformations that took place due to the new media and technology that landed in Mexico City after 1920 (1). They did not share the Estridentistas' enthusiasm for revolution and nationalism, but neither did they retreat from conflict. Xavier Villaurrutia notes in a letter in 1934 that it was a group formed "por diferencias más que por semejanzas" (Capistrán xi; more through their differences than their similarities). Many of the Contemporáneos began to publish in the late 1910s

and early 1920s but did not coalesce into anything resembling a group until the mid to late 1920s, though several of them collaborated on aesthetic projects such as the Teatro Ulíses (Ulysses Theater) and the literary magazines *Ulíses* and *Contemporáneos*. Nearly all of them had been intellectually "initiated" in the Escuela Nacional Preparatoria (National Preparatory School), even though, like the Estridentistas, many came from the countryside: Jorge Cuesta (Córdoba, Veracruz), José Gorostiza (Grijalva, Tabasco), Gilberto Owen (Rosario, Sinaloa), Carlos Pellicer (Villahermosa, Tabasco), and Rodolfo Usigli (San Juan de Letrán, Puebla). Salvador Novo, Jaime Torres Bodet, and Xavier Villaurrutia were Mexico City's native sons, though the three had radically different perspectives on the metropolis.

The Contemporáneos also maintained ties to the intellectual and cultural old guard that the Estridentistas were so vigorously trying to abandon. While Maples Arce's *Actual No. 1* reads as a direct rejection of Ramón López Velarde's *La suave Patria (Suave Patria: Sweet Land)*, López Velarde's poetic and aesthetic influence is evident among the Contemporáneos, particularly Salvador Novo and Xavier Villaurrutia.[37] In 1921, just before Maples Arce set about plastering his first Estridentista manifesto throughout the city, Jaime Torres Bodet had taken a position as José Vasconcelos's personal secretary while Vasconcelos was rector of the UNAM and in the midst of his educational crusade throughout Mexico. Indeed, the Contemporáneos' ties to the Ateneo de México (Atheneum of Mexico) in the early 1920s (principally to Pedro Henríquez Ureña, Alfonso Reyes, and José Vasconcelos)[38] present them as heirs to the same intellectual tradition that Maples Arce and his followers were trying to renovate. This was not the case, as there were ideological schisms in the Atheneum and among the Contemporáneos, but the Estridentistas still saw them as clinging to the stagnant old guard and holding back the nation's intellectual and political progress.[39]

While the Contemporáneos were known and criticized for being an apolitical, cosmopolitan group interested only in aesthetics, Octavio Paz convincingly underlines the group's formation and production as a reaction to "ciertas experiencias de la vida Mexicana" (*Xavier Villaurrutia* 22; certain experiences of Mexican life), most particularly the Revolution. As opposed to the Estridentistas, the Contemporáneos did not allow themselves the luxury of idealism. Having witnessed the physical violence of the Revolution and the structural violence of its aftermath, the group chose to isolate themselves in their own private world "poblado por los fantasmas

del erotismo, del sueño y la muerte" (22; populated by the ghosts of eroticism, dreams, and death). The group was never as politically or aesthetically distanced as originally indicated by Monsiváis, Paz, Sheridan, et al.; indeed, I read their supposedly apolitical stance as a deliberately provocative gesture in a political and cultural environment in which the literary and cultural formation of *lo mexicano* and corresponding associations of masculinity had taken on a new and overwhelming importance.

According to *Contemporáneo* Jorge Cuesta, all of the writers of the *grupo sin grupo* (also dubbed an "archipiélago de soledades" [archipelago of solitudes] by Torres Bodet and a "grupo de forajidos" [group of outlaws] by Cuesta) were united only by "la desconfianza, la incredulidad. [. . .] Nacieron en crisis y han encontrado su destino en la crisis: una crisis crítica." (Cited in Sheridan 1985, 12; mistrust, incredulity. [. . .] They were born in crisis and have found their destiny in crisis: a critical crisis.) The environment in which the Contemporáneos worked is similar to the kind of aesthetic crisis that Alfonso Reyes describes in "Literatura nacional, literatura mundial" (national literature, world literature): "La crisis representa una ansia de objetividad, de nuevo alimento terreno, una sed de contenido. [. . .] Bienvenidas, pues, sean las crisis, que nada tienen de común con la muerte y que, si ciertamente traen peligros, son los peligros inherentes al mismo ritmo ascensional." (26; A crisis represents an anxiety of objectivity, of new earthly nourishment, a thirst for content. [. . .] Let us welcome these crises, then, which have nothing in common with death; although they do bring certain dangers, these are the dangers inherent to ascendant rhythms.) From Reyes's viewpoint, this kind of crisis and the polemics in which the Contemporáneos and the Estridentistas were immersed served as an intellectual vaccine against aesthetic stagnation in the postrevolutionary period, and as a deliberate and constant destabilization of the cultural field in which those groups operated.

In 1925, Mexico was entrenched in the first of six important polemics that would take place after the Revolution: in this case, the debate over "effeminate" versus "virile" literature (Díaz Arciniega 54–62; Irwin 116–86; Sheridan, *Los Contemporáneos ayer* 179–221). Concerns of virility in Mexican literature were not new; writer, lawyer, and poet Ignacio Ramírez had lodged complaints about the "hermaphroditic literature" that was contaminating national expression in Mexico as early as 1868 (Irwin 1). In both cases, the concerns over perceived masculinity in literature corresponded with periods of national upheaval—in the case of Ramírez, Benito Juárez had just restored the Mexican Republic the year before, toppling the Em-

peror Maximilian I in 1867. The preoccupations with literature, nation, and masculinity arose again after the Revolution, this time as a way of obtaining distance from the Porfiriato.

The first shots in the battle between the two groups were fired by Estridentista founder Manuel Maples Arce in his 1923 manifesto *Actual No. 2* as he proclaimed, "[s]ólo los eunucos no estarán con nosotros" (50; only the eunuchs will not be with us). In 1925, Maples Arce indirectly condemned the Contemporáneos as "asaltabragetas literarios" (literary crotchgrabbers) in his poem "Urbe," in reference to the fact that a number of the Contemporáneos were homosexual or bisexual. While the Estridentistas' drive to find a new literature to reflect and support the tenants of the Revolution is admirable, the manifestos read today as exaggerated and reductive in their homophobia. Furthermore, their push for a "masculine" literature has never been particularly well defined. "Virile" meant "good," while "effeminate" meant "bad," but any more nuanced definitions involved getting into such a complicated cultural thicket that many writers (among them Alfonso Reyes, Xavier Villaurrutia, Martín Luis Guzmán, and José Juan Tablada) avoided the debate entirely (Irwin 119).

The association of virility with social transformation in revolutionary discourse proved to be a methodology with unfortunate side effects, since, as Jean Franco observes in *Plotting Women*, it "marginalized women at the very moment when they were, supposedly, liberated" (102). If virility was a necessary element for social transformation, the hyperbolic masculinity, homophobia, and even femiphobia of Maples Arce's manifestos begin to make sense, given that femininity is associated with social stagnation and weakness in these debates. María Elena de Valdés argues that this fear of the feminine "is fundamentally about power [. . .] [and] the symbolic demonstration of power is made manifest by the veneration and abuse of women" (58). Examined in the immediate postrevolutionary context, this rejection of perceived femininity in letters read as a coded claim to or demonstration of power in the rush to stabilize the nation's political climate.

In *Naciones intelectuales* (Intellectual nations), Ignacio Sánchez Prado revisits this binary and complicates it, suggesting that the terms "virile" and "effeminate" "no representan un concepto estético particular, sino que emergen como metonimias intercambiables a términos como 'nacional' y 'extranjerizante'" (35; do not represent a particular aesthetic concept, but rather emerge as metonymies that are interchangeable with terms like "national" and "foreign"). In other words, the virile/effeminate construction is not simply metonymic of postrevolutionary Mexico but also serves as a

smoke screen to suggest and simplify other binaries: nationalist/cosmopolitan, Mexican/European, etc. Rather than simplifying both sides of the debate, however, these substitutable signifiers become so loaded down with meaning that the concepts and debates surrounding the binaries intersect and become hopelessly tangled.

There was little love lost between the Estridentistas and the Contemporáneos, but it would be inaccurate to say the two groups had nothing in common, or that there was no overlap in their political, cultural, and theoretical positions. The Estridentistas assumed an übermasculine and nationalistic stance but also defined themselves as cosmopolitan, while the Contemporáneos followed Alfonso Reyes's example and expressed their Mexicanness by omission; that is, by *not* forcing their texts into nationalist contortions. As Villaurrutia puts it:

> Qué importa que alguien pida que pongamos etiquetas de Made in Mexico a nuestras obras, si nosotros sabemos que nuestras obras serán mexicanas a pesar de que nuestra voluntad no se lo proponga, o, más bien, gracias a que no se lo propone.

> (cited in Ortega 158; What does it matter if someone asks us to put Made in Mexico labels on our works if we know that our works will be Mexican in spite of the fact that we do not propose to make them so, or rather, because we do not propose to make them so.)

In terms of their political and aesthetic positions, the two warring groups formed two sides of the same coin: both sought to upend stagnant Mexican artistic and literary traditions, to find a truly Mexican style of writing, and thus to define Mexicanness. As they did so, their uses and examinations of gender in this new postrevolutionary reality were fundamental to their aesthetic and political quests. Indeed, the two texts that I analyze here—Xavier Villaurrutia's *Dama de corazones* (Queen of hearts) and Gilberto Owen's *Novela como nube* (Novel like a cloud)—resemble Árqueles Vela's "La Señorita Etcétera" (Miss Etcetera) in that they do not explicitly signal where or when the text was produced or where the story is set.[40] Even so, all three could only have been written from the specific time and place that they were produced. In all three, the female figure inspires attraction and anxiety, and all three tie this attraction, anxiety, and the anxiety-inspiring muse figure to the onset of modernity and its technological implications in the urban Mexican context. The two Contemporáneos texts in this section respond to the Mexican Revolution and its aftermath in a way that Vela's

novels do not, offering a more complex examination of Mexico's recent past, its turbulent present, and hopes and fears for its future. They do this by writing *around* the Revolution rather than about it, creating a hole in the text that attracts attention by dint of its absence.

*Dama de corazones* and *Novela como nube* were published in 1928, a year in which, according to Guillermo Sheridan, narrative prose dominated in the normally poetry-heavy group. This is significant since, for Sheridan, narrative was the genre in which the Contemporáneos manifested "una combatividad que corría pareja a su ánimo innovador" (*Los Contemporáneos ayer* 304; a combativeness that flowed alongside their innovative spirit). Sara Sefchovich has denied the use of prose in both novels, proposing that they be read as poetry instead (86), while Carol Clark D'Lugo reads them as an avant-garde manifestation of a larger current of fragmented narrative that emerged in Mexican letters after the Revolution (40–79). As both approaches offer valuable insight into Villaurrutia's and Owen's works, I read them from the crossroads of poetry and narrative to more fully recognize the hybrid genre that Owen and Villaurrutia employ in these texts.

It is also useful to read both pieces in the larger framework of the Latin American avant-garde novel, a genre that Gustavo Pérez Firmat situates between 1926 and 1934. Fellow Contemporáneo Jaime Torres Bodet declared that the novel was "un género de ayer" (a genre of yesterday) in his "Reflexiones sobre la novela" (Reflections on the novel), which was published in 1928 along with *Dama de corazones* and *Novela como nube*, both of which are considered novels by their authors and are widely read and analyzed as such. Although Pérez Firmat devotes considerable attention to the inconsistencies in Torres Bodet's essay, that does not negate the importance of the avant-garde novel as a site of tension and debate during a turning point in Mexican cultural history and production. Margarita Vargas, meanwhile, convincingly proposes that the Contemporáneos' narrative be read as "texts of bliss" (textos de goce), in accordance with Roland Barthes's *The Pleasure of the Text*. While Barthes does not address these specific texts, both novels are neatly summed up by Barthes's terminology in that both create a "subtle and nearly untenable discourse" in which "narrativity is dismantled yet the story is still readable" (9). Most suggestive of all is Barthes's definition of a text of bliss as a text that "unsettles the reader's historical, cultural, psychological assumptions, the consistency of his tastes, values, memories, [and] brings to a crisis his relation with language" (14). I would like to take Vargas's suggestion one step further and examine

how Villaurrutia's and Owen's texts deliberately unsettle and provoke crisis in the midst of the polemic over Mexican/non-Mexican and virile/nonvirile literature. Although neither Vargas nor Barthes pursues a gender-based analysis, such a consideration is essential here, as the Contemporáneos' texts revolve around examinations and subversions of gender roles in Mexico City in the late 1920s. These examinations and subversions, in turn, are essential instruments in Villaurrutia and Owen's attacks on (or alternatives to) the novel of the Revolution, and by extension the hegemonic constructions of national history and Mexican postrevolutionary identity.

*Dama de corazones* and *Novela como nube* have a great deal in common, to the point that Guillermo Sheridan juxtaposes various paragraphs from each to reveal the thematic similarities between them. Despite their notable differences, "manejan exactamente la misma situación argumental de fondo" (*Los Contemporáneos ayer* 306; they have exactly the same underlying storyline): a young man encounters a pair of unsettling women and must choose one for a lover or wife, knowing that he will regret any choice he makes. The Proustian influence in both, Sheridan observes wryly, is unmistakable (*Los Contemporáneos ayer* 308). Christopher Domínguez Michael notes that both authors strove to emulate the immorality of the French author André Gide, though Domínguez Michael declares that these efforts were thwarted by the authors' sexual and intellectual repression. Consequently, both "reproducen tensiones añejas, no resueltas, que datan de nuestro precario romanticismo y del juego modernista que lo superó" (231; reproduce old, unresolved tensions that date from our precarious romanticism and from the modernist game that surpassed it). The female figures in both novels are drawn from the feminine ideals of Latin American Modernismo, which in turn indicates turning to the muse-figure as a textual and narrative resource through which to recount the narrators' experiences. However, both Villaurrutia and Owen tweak these figures in a way that is congruent with Jean-Luc Nancy's definition of the muse as a forceful and disruptive figure, endowing the muse characters and the texts with more critical and satirical malice than Domínguez Michael's analysis would indicate. At the same time, the narrators' unmistakable anxiety and even anguish regarding their fate indicate deep ambivalence toward the brave new world into which both have been thrust. These Contemporáneos texts and their muses share a number of similarities with Estridentista Árqueles Vela's novels, to the point that Pedro Ángel Palou considers the latter two texts to be literary descendants of Vela's work (*La casa del silencio* 89): all three authors portray anxious, semi-autobiographical, and first-

person male narrators who are initially fascinated and later discomforted or repelled by one or more female figures in an increasingly mechanized and mechanizing urban milieu.

At the beginning of *Dama de corazones*, Villaurrutia's narrator, Julio, is awake but longs to be unconscious, fearful of reentering a world that may no longer be his: "Temo abrir los sentidos a una vida casi olvidada, casi nueva para mí" (571; I am afraid to open my senses to a life that is almost forgotten, almost new to me). The darkness in the room keeps him from seeing anything even though his eyes are open; it is only when his eyes are closed that "me reviven las luces del puerto lejano, en la noche, a bordo" (571; the lights of the distant port revive me, at night, on board). In the morning in his room, however, he is blind (even though his eyes are open) and trapped, buried literally (in self-inflicted fashion under his bedcovers) and psychologically (in his fear and his memories). The narrator had arrived home the night before from Harvard, where he had been studying. No one was awake to welcome him due to the late hour; as the morning dawns, he wonders how his family (his aunt and two female cousins) will receive him and how they will have changed in his absence. His anxiety over being in Mexico is clearly expressed, even though he does not indicate specifically to which homeland or *patria* he is referring at first: "Hasta para regresar a la patria es triste partir de un lugar en el que, si todavía no nos sucede algo importante, presentimos que un día u otro sucederá. Así en Harvard." (573; Even if it is to return to one's homeland, it is sad to leave a place in which, even if nothing important has happened to us yet, we sense that one of these days it will. That's how it was at Harvard.)

That feeling of hope for the future does not exist in Julio's Mexico, which reflects the author's own feelings about his homeland even though he had not yet left it at that point in time. Villaurrutia still was a few years away from the Rockefeller scholarship that would take him to Yale to study theater in 1935–36, but his skeptical attitude toward the country was firmly in place, shaped by the violence of the Revolution, the corruption of the revolutionaries, and the new government's alarming downslide into "a coarse and greedy plutocracy" (Paz, *Xavier Villaurrutia* 22). Villaurrutia's Julio is similarly reticent upon his return home, though he does not share the author's experiences of the Revolution and its aftermath. At first, when he meets his cousins and aunt for the first time in a decade, their identities are blurred: the cousins look so much alike that he cannot tell them apart—he only knows that one is "impetuosa" (impetuous) and the other "serena" (serene) (574). They begin an awkward exchange of pleasantries in which

46 · Technified Muses

the women's questions are answered with other questions or are answered falsely: "Tres veces me han preguntado cuántos años tengo. Tres veces he contestado improvisando la cifra." (574; Three times they have asked me how old I am. Three times I have responded by making up a number.) His aunt and the "impetuous" cousin (Aurora) do not remember and therefore do not notice. The serene one (Susana) is more observant, but she only smiles kindly and says nothing.

Memory is a slippery and evasive thing throughout the novel: the meeting scene is full of questions, but the answers are promptly forgotten; the women (or at least the aunt and the impetuous cousin, Aurora) repeat their questions because they cannot remember having asked them, meaning they cannot hear or retain the answer. Julio, meanwhile, is at least aware that he will need to ask the same questions again at a later date. "[N]o consigo grabar las respuestas" (574; I cannot record the answers), he confesses, and leaves the dining room after breakfast with no memory of having eaten. When he speaks to his cousins, his speech has become "impuro, mezclado con frases en inglés" (575; impure, mixed with English phrases), further underlining the extent of his familial and linguistic disconnection from his homeland.

The aunt, Mme. Girard, displays memory issues of a different sort. Her nostalgia for the past is so strong that Julio describes her as always absent, even though she never leaves the house: "Inmóvil, viaja en el tiempo abandonándose a la memoria, sin itinerario, confiada en las asociaciones de ideas que le despiertan las cosas, los sonidos, los colores, las horas, los paisajes" (576; Immobile, she travels through time, abandoning herself to memory without an itinerary, trusting in the associations of ideas that will awaken objects, sounds, colors, hours, landscapes). The unknown present, meanwhile, terrifies her: "Sólo un disco de jazz la hace abrir los ojos y temblar de pies a cabeza despertándola a otro mundo que no es el suyo porque no puede recordar nada" (577; A mere jazz record will make her open her eyes and tremble from head to foot, awakening her to another world that is not hers because she cannot remember anything in it). Indeed, Mme. Girard's most recent memory comes from 1895; any encounter with her twentieth-century present leaves her confused and terrified.

Unlike Mme. Girard, the other women in *Dama de corazones*—his cousins Susana and Aurora, his American ex-girlfriend Ruth, and even the nuns from the nearby convent—are engaged in the world around them, and all interact with various aspects of technology as they do so. Ruth is only present as a distant and evasive memory; she sends Julio carefully

posed photos of herself in which she wears clear (nonprescription) glasses to appear more scholarly. The nuns work and play with a "gracia maquinal" (machine-like grace); Aurora and Susana form a "delicious trio" with the narrator while singing opera together, but he cannot "humanize" it, suggesting that, while all three are mechanized, he is the only one aware enough to notice and to wish their sound were more human or organic. He does not explain what that would mean or require, only that he is incapable of doing so (580–81). Later, when Susana playfully reads his palm, his hand is transformed under her gaze, first becoming a "carta geográfica" (geographical map) and then changing into "el plano ferroviario de una región industrial" (the railway map of an industrial region) which only she knows how to read (582–83). She will not explain to him what she sees there, though it seems to sadden her. Shortly thereafter, the narrator abruptly leaves the house to travel around the world, implying that her reading was the impetus for his flight. Sometime later, Mme. Girard's death draws him reluctantly home again.

The only other male figure, Aurora's fiancé, M. Miroir, is a cipher, a reflection, as his last name would indicate, and he is further dehumanized by his lack of a first name. Both he and Julio show signs of physical weakness; Julio mentions to Aurora that he could not serve in World War I due to a heart condition (575), while M. Miroir leans heavily upon Aurora "como en el brazo de una enfermera" (as if upon a nurse's arm) as they go into the house together (578). This depiction of the male characters as sickly or weak supports Guillermo Sheridan's theory about the Contemporáneos' narrative, particularly in the mid- to late 1920s, as a calculated response to and rejection of "la Novela de la Revolución como 'género' ilustrativo del nuevo país naciente de sus propias cenizas" (*Los Contemporáneos ayer* 244; the novel of the Revolution as an illustrative "genre" of our country being born from its own ashes). While I agree with Sheridan up to this point, I disagree regarding the absence of the Revolution from the Contemporáneos' narrative.

Both *Dama de corazones* and *Novela como nube* are novels that make minimal references to time or place. A careful reading shows, however, that they are nonetheless deeply specific to the time and place that produced them. Evodio Escalante, for example, notes that Julio's attempt to enlist to fight in World War I allows the reader to deduce the date via a reference to an international event ("Espectralidad" 101), suggesting that he left Mexico for the United States in 1914 or shortly thereafter. Villaurrutia notes that Julio stays away for ten years, which places him back in Mexico

City in roughly 1924. He returns to a family that was evidently part of the Porfirian elite, as indicated by his aunt's attachment to all things French and her violent emotional and physical reactions to anything that reminds her of the current century. Her horror at the sound of jazz music emerging from a record player and her avoidance of technology in general aligns with Porfirian-era views in which, as David Dalton observes, "the spread of technology" was viewed as "telltale symptoms of a decadent society" (*Mestizo Modernity* 4). Once Villaurrutia establishes that Julio is writing from Mexico City between 1925 and 1926 (Escalante, "Espectralidad" 100), the Revolution becomes impossible to ignore; the memory of that decade-long conflict irrevocably transforms the interpretation of the text for the informed reader.

In a similar vein, Gilberto Owen's *Novela como nube* makes various references to Mexican cities and songs that establish the national space in which the novel unfolds. Like Villaurrutia, Owen uses international events to establish historical and temporal context. Rather than using an international war as Villaurrutia does, Owen maps out time through references to American cinema. For example, Owen's nameless narrator imagines a scene in which he defends a man from an attack by Wallace Beery, an American actor known for playing villains in the late 1910s and early 1920s. Notably, one of Beery's early roles was Pancho Villa in the 1917 film *Patria* (Fatherland). Shortly thereafter, Owen mentions Thelma Hill and Elsie Tarron, two of director Mack Sennett's famed "bathing beauties" who appeared in his films from 1912 to 1915 (160). The brevity of these references suggests that these directors, actors, and films are already familiar to the reader and thus function as a kind of pop cultural wallpaper, offering contemporary film references to illustrate the narrator's impressions, fears, and dreams while also creating clear connections to historical events of the period.

Later, in chapters 19 and 20, Owen brings the reader to Pachuca, capital city of the Mexican state of Hidalgo, which is where the Revolution lasted longest. Its inhabitants are submerged in "un terror ancestral, natural, ya fisiológico" (an ancestral, natural terror that has become physiological); the city is so dry and arid that its landscape is rendered as more cubistic than cubism itself (173). Here, Owen's narrative voice shifts into first person to wink at the specter of the Revolution while denouncing the novel of the Mexican Revolution as a genre: "Pero ahora caigo en la pedantería de esta página que acabo de escribir. [. . .] Lo único que deseo es dibujar al muñeco Ernesto y a dos muchachas lo mismo de falsas que él, y confieso

trampa el haberme detenido en ese fondo algo barroco." (174; But now I am falling into the pedantry of this page that I have just written. [. . .] All I want is to draw the Ernesto-doll and the two girls who are just as false as he is, and I confess to falling into the trap of having paused in this somewhat baroque backdrop.) Owen's text is undeniably Mexican in nature and is also interwoven with cosmopolitan elements—the plot is set in various cities in the country, with local songs intermingling seamlessly with references to North American and European film, art, and literature.

Both Contemporáneos novels also show a deliberate consideration of Mexican masculinities, presenting various versions of what it could mean to be a man—that is, an educated, bourgeois, mestizo man in Mexico City in the mid- to late 1920s. I would not go so far as to say that Villaurrutia and Owen present in-depth analyses of Mexican femininities here, but they do pay attention to their male characters' responses to and perceptions of the women around them, presenting impressions of these evolving femininities in the swirling avant-garde milieu. One could read Villaurrutia's and Owen's narrators as autobiographical projections in which they engage with a disturbing new world and the women who have changed with it; indeed, Pedro Ángel Palou has placed Villaurrutia's and Owen's texts within a range of Mexican avant-garde/bildungsroman novels published from 1922 to 1931.[41] The novels are not mere explorations of the self, however, but also serve as platforms from which to explore alternative masculinities, and by extension alternative forms of narrative and of identity, in response to the virile *mexicanidad* embodied in the novels of the Revolution.

Villaurrutia's Julio and Owen's Ernesto confuse or mingle love with fear when speaking of their feelings for the female characters in both novels, and both explicitly admit to fearing them. These narrators are more self-consciously constructed and distanced from the authors than Vela's Estridentista narrators, perhaps due to their desire to represent male characters who do not conform to gender norms of the time. Villaurrutia begins *Dama de corazones* with the narrator cowering in bed and hiding from his elderly aunt and his young female cousins—hardly a macho act. Their effeminate nature does not make them immune to misogyny or misogynistic behavior toward the women in their lives, and the women are not always sympathetically portrayed. They are not protofeminist representations of the postrevolutionary woman: rather, these characters are set against the template of the feminine ideal in Modernismo in which the women were silent and their physical bodies frequently presented in close-up in a pastoral setting.

50 · Technified Muses

Compared to Villaurrutia's Julio, Owen's Ernesto is even more explicitly portrayed as the antithesis of the postrevolutionary masculine ideal, from his physicality to his fashion sense. He wears beautiful flowered ties that have contaminated him with "un gusto por las flores hasta en los poemas: rosas, claveles, [. . .] narcisos sobre todo" (146; a preference for flowers in everything, even in poems: roses, carnations, [. . .] daffodils most of all). The reference to the *narciso* (daffodil) implies that Ernesto, like Narcissus, is vain and beautiful. He is small in stature and seems unbothered by his uncle's declaration that "siempre será sólo un niño" (he will always be only a child) or by his engineer friend's rebukes for Ernesto's lack of facial hair, as if it were a personal failing on his part (146). Even his professional aspirations are not appropriately masculine; he considers becoming a poet, a millionaire, or perhaps a midlevel bureaucrat, but expressly refuses to become a politician, an activist, or a soldier. Owen does a fair bit of name-dropping in the second paragraph, all European (Socrates, Gide, Shakespeare), quoting from Gide's *Les Nourritures terrestres* (*The Fruits of the Earth*) in French and wondering who could possibly *not* have read Gide (146). Within the first two paragraphs, it is as if he has gone down the checklist of complaints against the "effeminate" Contemporáneos to construct Ernesto as the perfect antimacho narrator. Owen situates this vain, cosmopolitan man-child in Mexico City and, later, Pachuca and finally dooms him to a heterosexual marriage with Rosa Amalia, a woman he does not love. The only thing he will pass on to his child—a son—is a "caudal de amargura" (wealth of bitterness) that will consume him throughout his married life and spill over into Rosa Amalia's child (and his, though he does not emphasize his role in the procreation) (185–86).

Owen is also more explicit than Villaurrutia in the fragmentation, solidification, denaturalization, and mechanization of his female characters. Like Vela, Owen blurs their identities by denying them last names and, especially in the first part, by deliberately muddling their identities. It is never clear if there are two or three characters named Eva in the novel since he confuses them with other women; for example, the third Eva might in fact be the first Elena (159). In a wink at the biblical creation narrative, the first Eva in the novel has apples, and indeed, Owen devotes an entire chapter to those apples. In the biblical story, Eve tempted Adam with the apple, which would give them knowledge of good and evil but also expel them from the Garden of Eden. Owen goes several steps further and denatures the apples, making them into instruments and synesthetically confusing senses and objects: tastes become sounds; sounds become musical instruments. He

Mechanized Muses of the New Metropolis · 51

then connects the apples with stories from ancient Greek, Roman, and Asian mythology (Atalanta, Hesperides, Ceylon), weaving a complicated hermeneutic web around the apples: Eva's collection of apples embodies temptation, fertility, wisdom, knowledge, deception, sensuality, life, defeat, and, ultimately, death (153–54).

Eva's apples are also another representation of otherness, as illustrated by their foreign origins. Ernesto suggests that they may be an "alimentación sintética" (synthetic food) that will leave the younger generations toothless and confuse their senses but also teach them to savor smells properly (154). His own senses are in agony, making it difficult to understand Eva's words or actions: "necesitan, cada una, de un asterisco, para explicar al margen la significación esotérica especial que tienen, en su boca" (154; each one needs an asterisk, in order to explain in the margin the special esoteric meanings they have in her mouth). Indeed, he confuses this Eva with a new character, Elena, in the very next chapter.

In the last chapter of the first half of the novel, Ernesto follows the first Eva (or perhaps another Eva, or perhaps someone else entirely) into a movie theater. He is seized with the desire to kiss her, but the narrator becomes exasperated with him: "¿No ha aprendido aún que aquí, por fuerza, terminan todas las películas?" (162; Hasn't he learned yet that this is where all movies are supposed to end?) His ignorance of cinematic plot formulae actually puts him at risk since, if Ernesto kisses her, the movie of his life must end also. Ernesto's movie/life is apparently ended when he is shot by El Hombre (The Man), Eva's companion. It is not until the next chapter, which begins the second part of the novel, that we discover whether Ernesto has survived. The denatured Eva, for whom Ernesto was shot, disappears in the second part without a trace. Ernesto/Ixion moves from earth to Olympus, or from the life he knows to a hospital, where he is cared for by two sisters, Elena and Rosa Amalia.

The sisters are the most developed characters in the second half of *Novela como nube*. They are also the most mechanized, as they constantly interact with medical technology to care for the wounded Ernesto. The intelligence of both women disturbs him; even in his weakened state, he criticizes Elena for thinking too much: "Tú has pensado en cosas trascendentales hoy, Elena, y eso no está bien, te envejece" (166; You've been thinking of transcendental things today, Elena, and that's not good; it ages you). He enjoys listening to her sister, Rosa Amalia, read aloud to him, but he listens only to the sound of her voice; the words do not interest him. It is here, as he is trapped in the hospital and surrounded by these mechanical women,

52 · Technified Muses

that we hear any kind of critique or mention of the Revolution, which takes up two entire sections of the last part of the novel (19, *Pachuca*, and 20, *la víctima* [*the victim*] [*sic*]). After devoting so much space to the time, space, and psychology of the Revolution in Pachuca, a part of the *provincia* that was hardest hit during the conflict, the narrator's self-mocking renunciation of those two chapters is completely and deliberately unconvincing.

While connections between mechanization and history are made largely through filmic references in the first part of *Novela*, the second half focuses on more interpersonal technologies, as when the characters converse on the telephone or interact with modern medicine. Jennifer González's observation in "Envisioning Cyborg Bodies" becomes especially pertinent in the context in which the story was written: "even the most spontaneous cyborgs cannot float above the lingering, clinging past. [. . .] *They will always function as evidence*" (272, my italics). The cyclops-men that terrorize Pachuca (made so by constantly squinting in order to aim their firearms) and the overmedicated and oversugared hypochondriac victims of Pachuca remain as incontrovertible evidence of what has happened there.

On a more personal scale, Rosa Amalia and Ernesto remain as mechanized evidence of the ambivalent present. He admires her greatly as a "normal woman," the narrator tells us, but "se propone no fijarse sino en lo felino, en lo eléctrico, lo que desentona en ella un poco" (184; he decides not to notice anything but her feline and electrical nature, anything about her that is a bit out of place). She is nothing like the women in the first part of the novel, and her constant forward movement disturbs him: "hasta cuando estaba acostada la sentía caminar, como si todos los lechos se convirtieran, al tocarlos su cuerpo eléctrico, en asientos de automóvil o divanes de pullman [*sic*] en movimiento" (184; even when she was lying down I could feel her walking, as if all the beds touched by her electric body had been turned into automobile seats or Pullman divans in motion). Rosa Amalia is the most outspoken of Owen's women; interestingly, she indicates that both she and Ernesto are distanced from Mexico—that is, from Pachuca, from San Luis Potosí, and from the Revolution—in a way that the other characters are not. She can only lay claim to him, she explains, because "los de México *ya no te retenían consigo*" (185, my italics; the Mexicans *would not keep you with them any more*). She could be referring to Mexico City instead of the entire country, but the ambiguity is never resolved, marking both of them as foreign and strange.

As previously mentioned, the women in "La Señorita Etcétera," *Dama de corazones*, and *Novela como nube* do not fall within the typical storylines

for modern women in the 1920s, in Mexico or elsewhere. The anxiety they provoked tended to result in reactionary stories of women as submissive, maternal, domestic types who were needed to raise the men of the new nation, or as fallen women who did not conform to feminine or maternal ideals and ended up dead, destitute, or insane. That is not to say that avant-garde female characters' relationships with modernity and technology are always positive: Owen's Ofelia, for example, is dragged rudely toward her window by the sound of a streetcar each time it passes her house, and Villaurrutia's Aurora ends up in a loveless marriage with M. Miroir. However, their unfortunate situations are not presented as punishments for bold engagement with modernity or masculine spheres. On the contrary, Aurora enters into the marriage with M. Miroir deliberately, knowing it will be a passionless but stable marriage that will allow her to support her sister Susana. After Mme. Girard's death, "Aurora [. . .] se prepara a ser la madre, la Mme. Girard de su hermana. La veo sonreír con la sonrisa helada que equivale exactamente a un sollozo." (590; Aurora [. . .] prepared herself to be a mother, her sister's Mme. Girard. I see her smile an icy smile that is exactly like a sob.) While it could be argued that Villaurrutia uses Aurora's unfortunate situation to criticize the Porfiriato class and social structures that obligate Aurora to take her aunt's place, she is not punished for being too curious or too engaged with modernity—that is, she does not end up dead, disgraced, or insane as many "transgressive" women characters did in the previous century. Nor is she ridiculed or shown to be at odds with modernity, as literature of that period tended to depict.[42] Owen's Rosa Amalia ends up in a loveless marriage of her own choosing as well: she declares her love for Ernesto and claims him as hers, though her love is not reciprocated. The narrator's greatest concern is for the child that will emerge from this forced union, which could be read as a concern for the future of the country. Despite the dreamlike imagery of Owen's and Villaurrutia's texts, the stories engage with unsettling and intellectually fertile crises to articulate complicated and multifaceted responses to cultural and national debates in the country at the end of the 1920s.

## Conclusion

As the 1920s drew to a close, the activities of both groups flared up and died out relatively quickly. Maples Arce left Mexico City in 1925 for his native Xalapa to take a position with the government of General Horacio Jara and brought many of his fellow Estridentistas along with him. After

two active and tumultuous years, Jara was deposed and Maples Arce fired, which marked the end of Maples Arce's avant-garde activity in the literary sphere.[43] The end of the Contemporáneos group is more difficult to pinpoint as it was never particularly unified to begin with, but it is generally agreed that whatever movement there was had largely died out by 1932.[44]

The Teatro Ulises, which counted Villaurrutia, Novo, and Owen among its founding members, dissolved in 1929, and the *Contemporáneos* magazine ceased publication in 1931. Shortly thereafter, some (Owen, Villaurrutia) left the country; others met unfortunate ends (Cuesta, who died by suicide), and still others became more involved in government positions (Torres Bodet, J. Gorostiza). Although the Contemporáneos' works had more staying power in the Mexican canon than those of the Estridentistas throughout most of the twentieth century, the early years of the twenty-first century saw a significant uptick in academic, critical, and public interest in the texts and the aftereffects of the Estridentista movement.[45] As the 1920s gave way to the 1930s and 1940s, however, there was a clear sense of the end of an era of Mexican avant-garde production.

As Mexico passed through the tumultuous 1930s and into the era of uneven but significant economic prosperity known as the Mexican Miracle, the country would become an attractive location for European artists seeking refuge from the horrors of the Spanish Civil War and World War II. The Surrealist expatriate community, and particularly Leonora Carrington and Remedios Varo—two rebellious muses who would come to claim the country as home—are the focus of chapter 2.

# 2

## Surrealist Muses in Exile

### The Mexican Years of Leonora Carrington
### and Remedios Varo

In the summer of 2008, Mexico City hosted an outdoor art exhibit of English-Mexican artist Leonora Carrington's paintings along the part of the Paseo de Reforma that runs through the Bosque de Chapultepec (Chapultepec Forest, a large national park in the heart of the city). Normally such temporary exhibits are mounted on the fence that separates the sidewalk from the park and the cultural sites inside, but these were right in the middle of the path, turning the sidewalk into an obstacle course that required pedestrians to weave through the reproductions of her paintings (printed onto metal and plastic signs to resist the city's seasonal afternoon rains) to get wherever they were going. One need only walk another kilometer or so along Reforma toward the city's historical center to spot another, more permanent mark on the city's artscape, where Carrington's darkly playful sculpture *How Doth the Little Crocodile* was installed in 2006. Passersby of all ages are free to take selfies, sit on it, or play on it—and many do.

In the spring and summer of 2017, the Library of Mexico celebrated the centennial of the artist's birth by hosting the exhibit *100 años de una artista* [100 years of an artist]: *Leonora Carrington*, with 180 pieces that included her paintings, photographs, and sculptures, as well as some of her books and correspondence with fellow Surrealist artists such as André Breton and Alice Rahon. Carrington's work, along with that of other European Surrealists in exile working in Mexico in the post–World War II era, have embedded themselves—sometimes literally, as in the case of Carrington's sidewalk exhibit and sculpture—into the cultural, literary, and artistic fabric of Mexico City.

Artists such as Gunter Gerzso, Wolfgang Paalen, Benjamin Péret, Alice Rahon, Bridget Tichenor, and Remedios Varo came to Mexico in the late 1930s and early 1940s and formed an intense relationship with art, with

each another, and with the Mexican intelligentsia and art scene. The artistic affinities and collaborations between Carrington and Varo in art, writing, and theater were and remain particularly compelling. The number of exhibits and publications on Leonora Carrington and Remedios Varo's work in Mexico that have emerged over the years (with a notably strong concentration between 2010 and 2020) made it clear that both women have been embraced as Mexican artists, sometimes to the point that their birthplaces (England and Spain, respectively) are not included on exhibit cards. Carrington in particular is often listed as Mexican rather than English or English-Mexican, perhaps since she obtained Mexican citizenship in 1943.

Remedios Varo came to Mexico City just before Carrington, in late 1941. At that time, Mexico had scarcely emerged from the economic ravages and class struggles of the 1930s, the rise and fall of Cardenismo, and was entering a three-decade period of imbalanced but noteworthy economic prosperity that would later be called the Mexican Miracle.[1] General Manuel Ávila Camacho had just begun his *sexenio* as president after a dirty war waged against the Almazanistas, supporters of the PRUN (Partido Revolucionario de Unificación Nacional [Revolutionary Party of National Unification]) candidate Juan Andrew Almazán, further entrenching the PRM (Partido de la Revolución Mexicana, or Mexican Revolutionary Party, which would later become the PRI) in power.[2] Thanks to a new wave of industrial development that was largely situated in Mexico City, the capital's infrastructure and industrial production grew exponentially, which contributed to the city's growing middle class.

Culturally speaking, Mexico was at the peak of its cinematic Golden Age, with figures like Cantinflas, Dolores del Río, and María Félix gracing the silver screen in films that captured the changes in architecture, fashions, and "pockets of opulence" in the capital (Davis 103). Carlos Monsiváis observes that the state-sponsored Mexican film industry of those years "cree ser la única voz autorizada de la sociedad que se desdobla en la pantalla" (*Aires* 58; believes itself to be the only authorized voice of the society that unfolds on the screen); to that end, the film industry would attempt to teach *modos de ser* (ways of being) to its public that would reinforce the image of *lo mexicano* that the state was attempting to construct. This was, as Daniel Chávez indicates in "The Eagle and the Serpent on the Screen," "a cinema of modernization in which the rural environment was subject to the transforming will and direct material intervention of the state" (119), marking what Chávez, Joseph, Rubenstein, and others have agreed was

"the last important moment of revolutionary transformation" from 1934 to 1940 (Chávez 119). Chávez rightly problematizes the relationship between the state, the film industry, and the public reception of this Golden Age period of film production, given that the "mystifying-indigenous" tendencies he locates in many of those films are shaped, idealized, and manipulated from urban centers of power. David Dalton's *Mestizo Modernity* explores this pedagogical bent in Mexican Golden Age film from the intersection of race, gender, and technology in films directed by Emilio "El Indio" Fernández: *María Candelaria* (Xochimilco, 1943), *Río Escondido* (Hidden River, 1948), and *The Torch* (1950, an English-language remake of his 1946 film *Enamorada*).[3] Dalton makes a compelling case for Fernández's role in inventing postrevolutionary Mexico and the ways in which race, gender, and technology were represented in order to construct this idealized citizenry during the early years of the Mexican Miracle. The body is still at the center of these debates as it was during the avant-garde years, but visual representation (primarily cinematic) has rapidly gained influence since the Mexican film industry hit its stride in the mid-1930s.

In Mexican historiography, 1940 is widely considered a turning point in many regards: by now, the identitarian discourse of *lo mexicano*, however problematic, was firmly established in popular and official discourse. Women were still more than a decade away from being able to vote, and any stirrings of feminist movements in the 1930s were absorbed by the PRM and then ignored by Ávila Camacho's administration (Agustín 43). Literature did not occupy the same position in the national/ist conversation that it had during the 1920s and 1930s; as the country's political parties shifted from the socialist Cárdenas administration to the more openly capitalist Ávila Camacho presidency, a number of institutions would arise that would, in turn, grant greater autonomy to literature as cultural debates became more deeply rooted in the academic sphere.

The idea of the nation and its historical narrative shifted, as Ávila Camacho established in his inaugural speech, reframing the past not as a time of struggle and violence but rather as a rich cultural heritage that nurtured a nation headed toward a prosperous future. Indeed, Aguilar Camín and Meyer propose that "[l]a idea ferviente de la nación como depositaria moderna de un legado histórico sin fisuras se inició quizás con Ávila Camacho" (191; [t]he fervent idea of the nation as the modern guardian of a seamless historical legacy may well have begun with Ávila Camacho). Furthermore, as Ignacio Sánchez Prado explains in *Naciones intelectuales*, it was dur-

ing this *sexenio* that the locus of cultural debates on literature and culture shifted from the political sphere to the ivory tower (140). In other words, the academic and political spheres would no longer overlap on cultural issues as they had in the previous two decades. This change, along with the influence of the arrival of a number of Spanish exiles,[4] marked two great foundational shifts in the conversation surrounding *lo mexicano* in the postrevolutionary period.

Across the Atlantic, the Spanish Civil War (1936–39) had ended, but Spain was still reeling from the conflict; the first decades of the Franco dictatorship were marked by political repression and severe economic hardship brought on by the country's geographical, political, and economic isolation. World War II was raging in the rest of the Europe, and Japan had just entered the conflict with its attack on Pearl Harbor. The United States declared war on Japan, which prompted Germany and Italy to declare war on the United States, escalating the conflict to global proportions. Even the countries that were not part of the Allies or the Axis powers were impacted by the sheer economic scale of the conflict, and many sent volunteers to fight on one side or the other. Mexico sided with the Allies, officially beginning its participation in the war in 1942, and was also an important silent partner of sorts, particularly to the United States.[5] It was then that Mexico decided to open its doors to European refugees without requiring documentation, which allowed for the Surrealist exodus to Mexico, a land that Surrealist founder André Breton would famously call "el lugar surrealista por excelencia" (the Surrealist place par excellence) in a 1938 interview with Honduran writer and historian Rafael Heliodoro Valle (Heliodoro Valle 6).

A number of the female Surrealist artists who came to Mexico chose to stay permanently, even after their partners or husbands had returned to Europe. Leonora Carrington, Kati Horna, Alice Rahon, Bridget Tichenor, and Remedios Varo are among the painters, writers, and photographers who came to Mexico in the early to mid-1940s and embarked on periods of great artistic creativity and productivity that would not have been possible for these women had they remained in Europe. Even if one takes into consideration the turmoil of World War II in the 1940s, it is noteworthy that none of these women returned to Europe on a permanent basis. This, then, begs the question, why Mexico? What was going on in a predominantly macho society that nonetheless granted such artistic autonomy and recognition to these women—women whose artistic work was frequently

ignored or discounted in their own countries of birth?[6] I do not wish to imply that their autonomy was easy, complete, or idyllic, but it is significant that all were recognized for their work in Mexico in ways that their contemporary Frida Kahlo was not until decades after her death.[7]

More specifically, I am interested in the connections between Carrington and Varo's art and writing and the cultural, historical, and identitarian discourses in progress in Mexico at that time. This runs contrary to the assumption—fostered in part by statements from the artists themselves—that the Surrealist exiles did not interact with the artistic scene in Mexico. Once in Mexico, Carrington and Varo interact with mechanical, scientific, and alchemic discourses in their paintings and writings in ways that complicate and contest Surrealist constructions of the idealized female figure. Their writings—explorations of the self and attempts to explain and heal past trauma—explored notions of gender roles that drew from a plurality of cultures, thus neatly sidestepping many of the binaries in effect in the disputes over *lo mexicano* that emerged in the early aftermath of the Revolution—rural/urban, barbarism/civilization, Malinche/Guadalupe, etc. (Bartra, *La jaula* 159–64). It is worth noting, however, that their privilege as white European expatriates allowed them greater freedom to question these sorts of binaries in the first place. The cultural and aesthetic ramifications of their writing reach beyond their supposedly insulated artistic circle, engaging with many of the technological discourses that occupied the Estridentistas and the Contemporáneos in the 1920s as part of their own evolving approaches to Surrealism, artistic production, and self-expression.

André Breton published his *Manifesto of Surrealism* in 1924, the same year Estridentista novelist Árqueles Vela published "Un crimen provisional"—in which, as noted in chapter 1, a mannequin plays an important role. One could plausibly read a wink at the Surrealist movement into that gesture, given that the Surrealist fixation on mannequins was common knowledge and that Mexican artists and intellectuals were well aware of Surrealist works and writings in the 1920s and 1930s.[8] While the Estridentistas and the Surrealists shared an interest in communism and poetic revolution as an impetus to concrete political change, Breton's Surrealist concept of revolution explicitly rejected any form of nationalism: "For us," he wrote in his 1925 manifesto *La Révolution d'abord et toujours!* (Revolution now and forever!), "France does not exist." In her work on Surrealist masculinities, Amy Lyford suggests that the Surrealists' use of mas-

culinity was "a crucial element in the group's effort to dismember postwar dreams of rebuilding France" (8). The construction of alternative masculinities and of alternative gender norms on a larger scale as a way to undermine hegemonic national/ist constructions of an idealized postwar subject accompanied a number of Surrealist artists to Mexico from the mid-1930s to the mid-1940s. It was then that Surrealism (which by that time was in decline in Europe) truly came into contact with other artistic and avant-garde movements in Mexico.

While much critical attention has been devoted to their artwork, Carrington and Varo's written production has not garnered quite as much interest. This is especially true in the case of Remedios Varo, since a critical edition of her written work was not published until 2010; of these, only two of her texts (*De Homo Rodans* and *El caballero Casildo Martín de Vilboa* [The Knight Casildo Martín de Vilboa]) were published while she was alive. In collections of both women's paintings, it is far too common for others, often men (Octavio Paz, André Breton, etc.) to put words in Carrington's and Varo's mouths while ignoring the artists' words, writings, and even their original titles for their own works. In 1966, Octavio Paz and Roger Caillois collaborated to publish *Remedios Varo*, one of the first printed collections of her artwork. The book is significant for its efforts in compiling Varo's paintings—no small task, as Varo tended to sell her paintings as soon as she finished them, which meant that many were scattered among private collections—and for the distribution of those works to the general public. I take issue, however, with how the artist and her works are presented. Varo's titles are not even included with the works; they appear in an index at the end. Indeed, her titles are the only words chosen by Varo herself to appear in the entire collection; apart from the index, she is constructed posthumously by Paz's running commentary and an assortment of literary quotations that he scatters underneath her paintings. Rather than struggle with reality as some painters do, Paz informs us in the introduction, "Remedios la volatiliza: por su cuerpo ya no circula sangre sino luz" (9; Remedios volatizes it: it is no longer blood that circulates through her body, but light). In describing her as a creature of light, Paz robs Varo of her physical substance, presence, and voice, thus effacing her own "struggle with reality."

Through their interactions with medical and alchemical discourse in their written and visual work, Carrington and Varo acted as flesh-and-blood muses who resisted and subverted the status of ethereal, otherworldly *femme-sorcière* or *femme-enfant* that Breton, Paz, and others were deter-

mined to attach to them. Analogous claims have been developed by others before me: Whitney Chadwick, Susan Aberth, Lois Parkinson-Zamora, Edith Mendoza Bolio, Janet Kaplan, Teresa Arcq, and Natalya Lusty are only a few of the scholars who have dedicated their time and research to one or both of these disturbing muses. My primary points of focus in this chapter are on Carrington's and Varo's interactions with the body, with technological and alchemical discourse, and with the national context in which they chose to live and work, in their visual and written corpora. In other words, I read their aesthetic productions as representations of their vision, which, as Donna Haraway reminds us in "The Persistence of Vision," "can be good for avoiding binary oppositions" (581). Carrington and Varo express visions that are never intended to be universalizing or prescriptive but rather what Haraway calls "situated knowledges," history and knowledge related from a specific time, place, and gendered body (581, 590). This framework of situated knowledges is particularly important during their first few decades in Mexico, as their personal searches and artistic and political projects interacted with contemporary national discourses on history and identity in post–World War II Mexico.

## In the Beginning Was the (Automatic) Word: The Origins of Surrealism in Europe

The term *sur-réalisme* was first used by Guillaume Apollinaire in 1917, though the movement did not really hit its stride until 1924 with Breton's first Surrealist manifesto. The movement coincided in many ways with Dadaism, which had emerged in 1914: both advocated dispensing with social conventions to embrace the unconscious and the irrational, and both were born of the profound intellectual disillusionment that resulted from the political and economic trauma of World War I in Europe. The primary difference in the movements is Surrealism's explicit and enthusiastic embrace of psychoanalysis and Freudian ideas on dreaming and the unconscious, an emphasis that would travel across the ocean to Mexico with Breton and the other Surrealists even as the movement began to die out in Europe in the late 1930s and early 1940s.

While Apollinaire may have coined the word for the movement, it was Breton who defined it in his 1924 manifesto:

SURREALISM, *n.* Pure psychic automatism in its pure state, by which one intends to express—verbally, in writing or in any other manner—

the actual functioning of thought. Dictated by thought, in the absence of any control exercised by reason, exempt from any moral concern. (*Manifestoes* 26)

As would be seen in Antonin Artaud's addresses to various figures of religious authority (the pope, the Dalai Lama, and the schools of Buddha) that were published in the third issue of Breton's journal *La Révolution surréaliste* (The Surrealist Revolution) (1925–29), the movement emphasized liberation, revolution, and anti-imperialism.[9] Although Breton moved away from politics and toward explorations of love, eroticism, the subconscious mind, hysteria, and attacks on bourgeois ideals, the movement remained divided between Breton's and Artaud's objectives and perceptions. As with the Mexican Contemporáneos, conflict often proved to be productive, as indicated by Gérard Durozoi's observation that "the succession of international crises became the surest means of self-renewal" for a group formed in the aftermath of World War I and that continued to evolve in Paris and beyond (258). Indeed, the influence of the movement has continued long after its official death in 1969, particularly the Surrealist insistence on expanded awareness of inner and exterior realities.[10]

If the Surrealist movement seems woefully bereft of women artists and writers, it is—at least in much of the historical and critical literature on Surrealism until the mid-1970s. In fact, artists such as Renée Gauthier, Simone Kahn, Denise Lévy, and Valentine Penrose had been active in the movement since Breton's first manifesto in 1924. In Spain, María Teresa León published beautiful Surrealist fiction during the period just before the Civil War; her 1934 children's story "Rosa-Fría, patinadora de la luna" (Rosa-Fría, moon skater) seamlessly melds the waking and dreaming worlds of her young protagonist and is filled with avant-garde imagery. Unfortunately, her name is rarely connected with Surrealism or any other avant-garde movement and is not mentioned in any of the manifestos that emerged while León was active.[11] As Gwen Raaberg points out, "It was not that the original generation of male Surrealists had ignored women. [. . .] No women, though, had been listed as official members of the original surrealist movement, nor had they signed the manifestos" (1–2). Robert Belton goes so far as to argue that the Surrealist movement was so "relentlessly male" that there is no room for women artists in the movement proper (12). Rather, he suggests that the work of Carrington, Varo, and the other women in their cohort can be more accurately described as post-

Surrealist since they did not begin to play an important role in Surrealist art until the movement was already in decline (12). Belton's declaration, however, conflates Breton's notoriously exclusive notion of Surrealism with the Surrealist movement as a whole. Decentering Breton allows for a more inclusive definition of the movement that does not diminish the work of the women who participated in and contributed to it. Rather than aesthetic limitations, I suspect that ideology and geography were primary factors in the increased participation of women artists, since many of the Surrealist women who wished to become artists or writers in their own right only did so after separating themselves from Breton and his group.

While Breton and Éluard wrote that "La pensée n'a pas de sexe" (Thought has no sex) in their *Notes on Poetry* in 1929 and argued for the open celebration of sexuality and sexual freedom. In all other regards, however, their actions and attitudes suggest a tacit agreement with the surge of antifeminism that followed World War I (Belton 8). Belton and Amy Lyford both argue that Surrealism emerged at a time in which masculinity and its place in the social order was under intense scrutiny (Belton xviii; Lyford 1–14). While the objectives of the Surrealists were diametrically opposed to those of the postrevolutionary avant-garde movements in Mexico—that is, with the intention to dismantle notions of a national self rather than to build it—both reactions came in response to a sense of threat to gender norms. Consequently, the movement's internal contradictions must be kept in mind in any explorations of gender issues in Surrealism, particularly when the movement relocates across the Atlantic and away from its Parisian home base in the late 1930s and early 1940s.

## "Le pays le plus surréaliste dans le monde": The Surrealists in Mexico

Mexico, or at least the Surrealist conception of Mexico, was part of the Surrealist imaginary before any of them ever set foot there, largely due to the Surrealist interest in revolutionary politics and ethnography.[12] Artaud was the first Surrealist to come to Mexico in 1936; according to Melanie Nicholson, his presence there energized the "languid early reception of Surrealism in Mexico" (107). Other critics assert that Breton's four-month visit in the spring and summer of 1938 marks the arrival of (European) Surrealism to Mexico.[13] The critical corpus is divided regarding Breton's impact on the intellectual and artistic circles in the country (principally in Mexico City) and vice versa. Fabienne Bradu avers that Mexico did not impact or

change Breton's ideas or his artwork but that his visit was an influential one for artists living in the country, whereas Ida Rodríguez Pampolini and Courtney Gilbert suggest the opposite (Bradu 9; Rodríguez Pampolini 53; Gilbert 176–77). What is clear, however, is that the Surrealist connection with Mexico was well forged by the time Breton returned to Europe. As the Spanish Civil War raged to a close and as World War II began to gain momentum, this artistic connection, along with President Cárdenas's established policy of welcoming European refugees—particularly artists—would attract a number of well-known European Surrealists to Mexico in the following years.

After Breton and Artaud paid their respective visits, Wolfgang Paalen, Benjamin Péret, Alice Rahon, and Bridget Tichenor joined Carrington and Varo in the small but active group of Surrealist expatriates who took up residence in the Mexican capital in the early 1940s. "For women, whether they be artists or writers," Linda Nochlin observes, "the conditions of exile have especially ambiguous or even ambivalent implications" (318). This ambivalence would yield complex and multilayered results for Carrington and Varo, particularly when their writings are examined alongside their paintings. They brought the painful memories of wartime with them: Carrington had escaped from an involuntary commitment to a mental institution in Spain, while Varo endured various bureaucratic and personal complications before she was able to set sail for Mexico with Péret. Even so, the journey was significant for both of them. As Janet Kaplan wrote, "Exiled from her homeland, [Varo] embarked on a spiritual pilgrimage, committing herself to a search for self-knowledge, restlessly looking in any direction that might offer new ways of knowing" ("Remedios Varo" 14). The statement applies equally to Carrington, as both women read, painted, traveled, and explored the city and the country as well as their own psyches. Those searches for knowing in the Mexican intellectual and artistic environment of the 1940s and 1950s resulted in productive, creative, and lucrative years for both artists.

## Putting Down Roots: Arrival and the Fertile Ground of the Galeria de Arte Mexicano

The cultural infrastructure and gallery space that permitted the European Surrealists—particularly the women—to have the exposure and the careers that they did in Mexico preceded their arrival by only a few years, as there

were few official venues in which to show modern works in Mexico in the late 1930s. Consequently, when Mexican editor, writer, and translator Carolina Amor founded the Galería de Arte Mexicano (Gallery of Mexican Art) in 1935, the gallery was perfectly poised to act as a launching pad for modern art and for artists who might not have painted commercially otherwise, or at least not as successfully.[14] The Galería, directed by Carolina's sister Inés Amor, "became a center for the avant-garde [. . .] [and] set the precedent on which, in the 1940s and 1950s, a network of galleries was established" (Arcq, "In the Land of Convulsive Beauty" 67). It is also important to note that this fundamental gallery was founded and directed by women, and I agree with Tere Arcq's observation that the Amor sisters not only "played an important role in shaping a commercial system for the sale of artworks" but also "offered a space for women artists, who had been excluded from official venues" (67).

A few years after the Galería was founded, director Inés Amor teamed up with André Breton and Peruvian poet and painter César Moro to organize the *International Exhibition of Surrealism* in Mexico City in 1940. Curiously, while Melanie Nicholson considers the exhibition to be one of the most important outcomes of Breton's visit, she does not mention Amor's role in the event, nor does she mention the Amor sisters' contribution to the Mexican artistic scene of the era (121). Women artists were still a minority in these exhibitions, and there were conflicts over the few whose work was chosen: curator Wolfgang Paalen included works by Frida Kahlo even though she repeatedly disavowed any connection between her art and European Surrealism; Mexican artist María Izquierdo was excluded despite the fact that both Artaud and Alice Rahon thought highly of Izquierdo's work and considered it to be representative of the Surrealist movement. These problems notwithstanding, doors were opened and artistic communities forged that would result in fruitful collaborations for decades to come. It was at this 1940 exhibition that Remedios Varo would get her foot in the door with her painting *Recuerdo de la Walkyria* (Memory of the Valkyries) (1938); she, her then-husband Benjamin Péret, Hungarian photographer Kati Horna, and exiled Spanish poet José Horna formed a tight-knit social and artistic group that would welcome her friend and collaborator Leonora Carrington when she arrived in Mexico a few years later.

Carrington and Varo met in France but did not become close until they were reunited in the Surrealist community in Mexico City. Once they did, their friendship became legendary. They were united by a mutual interest

in magic, alchemy, and the occult, and their studies were further enriched by their new surroundings. As Janet Kaplan observes, "Mexico proved a vibrant influence on Varo and Carrington, for whom the power of spells and omens was already very real" (*Unexpected Journeys* 96). Like Breton, they were intrigued by Mexico's precolonial past in ways that were both productive and problematic, particularly regarding issues of race. Unlike Breton, however, Carrington and Varo sought to evolve in aesthetic, personal, spiritual, and political directions that allowed for deep reevaluations and restructurings of visions of the self and of personal history, with an ever-present consideration of gender roles and of ways to shake off the influence of religion, tradition, and trauma.

In terms of her written works, Carrington has a much larger published corpus than Varo; fortunately, many of Varo's notes and letters have been published to make her writing available to the public. Neither Carrington nor Varo explicitly asks, "Who am I?" as Breton's Nadja did, although both undertake profound searches of the consciousness and the self. Both artists practice what Susan Ruben Suleiman has dubbed a "double allegiance," which is "an allegiance to the formal experiments and some of the cultural aspirations of the historical male avant-garde" as well as "to the feminist critique of dominant sexual ideologies, including the sexual ideology of those same avant-garde artists" (xvii). If these double allegiances produce "disorder and a certain clutter," to use Suleiman's phrasing, so much the better (xvii). The disorderly and disturbing elements of their work lead toward different ends as the women play irreverent yet deadly serious intellectual games with concepts of identity, art, and the self on their own terms. In so doing, they provoke readers to ask themselves the same probing questions as well.

In the sections that follow, I place Leonora Carrington's memoir *Down Below* alongside and into dialogue with her later novel *The Hearing Trumpet*. The first text is orally recounted in French, transcribed and later translated into English and Spanish; the second is a work of fiction that Carrington penned herself. I read them as two bookends of the same project—that of overcoming trauma and achieving true self-expression by working with and against Breton's rigid and exclusionary construction of Surrealism, as well as engaging with the debates on Mexican identity that ran contemporary to her own work. Indeed, if Surrealist constructions of masculinity and of gender were attempts to undermine the notion of an idealized national subject, Carrington and Varo's exploration of gender norms were more disruptive still, as they worked against the Surrealists'

infamously antifeminist and misogynistic constructions of women and the feminine in their written and artistic production.

## Breaking on Through and Telling It Slant: Leonora Carrington, Alchemy, and Identity

Emily Dickinson's famous poem advises: "Tell all the Truth, but tell it slant— / Success in Circuit lies." It was not until Leonora Carrington arrived in Mexico as a refugee from World War II that she was finally afforded the space to tell her truth—which she then told, not only slant, but also upside down and as if infused with hallucinogens. On its surface, her memoir *Down Below*, first published in the New York–based journal *VVV* in 1944, is a Surrealist's dream: a journey to the other side of sanity and back again as recounted by a woman who had already captured the attention and admiration of Max Ernst, André Breton, and other founders of European Surrealism. Carrington, however, refused to present her time in a mental hospital in Spain as a dreamy elevation of consciousness; instead, she recounts a brutal encounter filled with pain, violence, and abuse that she describes with images drawn from her studies of alchemy. In her novel *The Hearing Trumpet*, written two decades later, Carrington crosses over "to the other side" again, but this time to a region of her own making. Both trips and texts are informed by and constructed upon varying degrees of autobiography and fantasy, allowing her to redefine Breton's Surrealism to her own ends or leave it behind entirely.

In his 1924 "Manifesto of Surrealism," André Breton celebrates madness as a "sacred fever," calling it the purest form of freedom and consciousness that one can hope to achieve. Following the general wisdom of the era, he and the other male Surrealists believed that "regressed" individuals— women, children, and the insane—were not as restrained by reason, logic, and bourgeois morality as men, which allowed them to experience a state of unfettered imagination that was at the heart of Surrealism. If all three conditions (womanhood, youth, and madness) were combined in a single body, so much the better. Natalya Lusty explains that, for Breton, "it was specifically *female* madness that came to define surrealism's revolt against the Cartesian subject of bourgeois, liberal ideology" ("Surrealism's Banging Door" 335, my italics). Breton particularly celebrated "that special kind of child-woman who has always enthralled poets, because time has no hold over her" (*Surrealism* 157). This might explain why the Surrealists' female lovers or wives were generally younger than their male part-

ners, as well as why they were frequently traded in for newer, younger models.

Breton's 1928 semi-autobiographical novel *Nadja* is an extended episode of a discarded *femme-enfant*, abandoned when her insanity goes too far and she is institutionalized. He does not give up on her because she is mad (or so he tells the reader) but rather because she is now at the mercy of psychiatry, for which he has only contempt (*Nadja* 141). It is, he says, her own fault; to paraphrase Breton's winding prose, Nadja should have understood the need to limit her moments of eccentricity, thus making her responsible for her own institutionalization. To Breton, her excessive (or perhaps merely unattractive) insanity was proof that he and Nadja had not achieved the "mysterious, improbable, unique, bewildering, and *certain* love" that would have allowed "the fulfillment of a miracle" (136, original italics). Whether that miracle was their happiness, his fulfillment, her mastery of a Surrealist-approved level of insanity or simply keeping Breton's interest—no small feat, as he was notorious for becoming intensely fascinated with women, growing bored, and discarding them—is left for us to ponder.

It is no surprise, then, that *Nadja* and Leonora Carrington's 1944 memoir *Down Below* have been read side by side before. Natalya Lusty suggests that "the figure of Nadja [occupies] a ghostly presence within both Breton's and Carrington's texts" in that Carrington writes "against Breton's problematic reification of the madwoman's experience" ("Surrealism's Banging Door" 336–37). While I agree that Carrington is writing against Breton in several ways (in terms of her chosen writing style, imagery, etc.), I propose that Carrington is not so much haunted by Nadja as attempting to solidify her. After Nadja is institutionalized, she vanishes from Breton's novel; we are only left with his thoughts about her. Carrington, meanwhile, undercuts Breton's presentation of her fellow muse as an ethereal child-woman-sorceress by bringing the reader into the mental hospital with her, writing an explicit and unsparing description of her involuntary institutionalization. By insisting on the concrete and corporeal nature of her own experience of insanity, Carrington directly contradicts Breton's recounting of Nadja's institutionalization, thus questioning his version of events as well as his theories on female madness.

Carrington's 1941 painting (also titled *Down Below*), which was completed either at the institution in Santander or in New York shortly after her release, is less effective, or perhaps less disturbing, in this particular situation. Carrington's skill and technique are unmistakable, as is the

nightmarish beauty of the Bosch-inspired cast of human-animal hybrid creatures that populate the painting. Despite her undeniable artistic talent, Carrington was most successful in contesting Breton's romanticized conception of female madness when she articulated, in her own words, the harsh realities of her breakdown and of the institution's interior workings.

Carrington agrees to Breton's request to recount her experience, but in doing so she drags him to the very place that he so carefully avoided in *Nadja*, forcing him to experience her journey from an uncomfortably close viewpoint. She rarely takes any narrative distance from the tale or from her delusions. As Carrington explains at one point:

> I was being put through purifying tortures [being bound hand and foot for hours and given seizure-inducing Cardiazol injections] so that I might attain Absolute Knowledge, when I could live "Down Below." That pavilion was for me the Earth, the Real World, Paradise, Eden—and also Jerusalem. [. . .] I was an androgyne, the Moon, the Holy Ghost, a gypsy, an acrobat, Leonora Carrington and a woman. (40)

Carrington's delusions are surreal and full of imagery drawn from alchemy, Christianity, and her unconscious mind, but she brings her physical, "leaking" body into it as well, so that readers must also know about periods of vomiting, defecation, and convulsions that caused "grimaces" that "were repeated all over [her] body" (36).[15] While many analyses considered Carrington's convulsions to be exaggerations or metaphorical connections to Breton's idea of Surrealism as "convulsive beauty," Ann Hoff's 2009 article makes clear that Carrington's descriptions of her time in the Spanish institution, particularly regarding her treatments with Cardiazol, were clinically accurate (92). Hoff reminds us that the story begins "with the gruesome images of war that seem surreal in their very reality" (88)—that is, that Carrington's experience was not simply the result of being a woman and thus "naturally" open to insanity. Rather, Carrington's symptoms are consistent with those of acute mental illness brought on by severe trauma—in her case, the onset of war, the internment of her lover Max Ernst in a concentration camp, the experience of being raped by Spanish soldiers, and the indignities to which she was submitted in the sanitarium itself. Once committed, she was given medications that caused hallucinations, confusion, poor judgment, slurred speech, hypersexuality, and other symptoms that mimic mental illness or incapacity.

While Carrington takes no distance from the events of her story, she separates herself from the narrative in other ways. She related her story orally to Jeanne Megnen, wife of Surrealist surgeon Pierre Mabille, in French—a language that Carrington spoke fluently, having studied it since childhood, but still her second language. Her choice makes sense, given that Mabille and Breton were native French speakers. Nonetheless, Carrington's choice adds an extra layer of linguistic and narrative complexity to an analysis of the original French or the translated English text, as we must rely on Megnen for the transcription of Carrington's story in French (even though the "you" whom she addresses is Mabille and not Megnen) and also on Victor Llona, who translated the text from French to English in 1944 (Gambrell 88). Carrington produces the text from the emotional distance of her second language and from the fleeting nature of oral discourse; her words, once spoken, will be recorded, and she need not repeat them. In this way, she protects herself even as she revisits the site of her trauma. When she leaves the asylum at the end of her story, it is with the tears of José, one of the workers, as a backdrop. Carrington walks out, lucid and, as she said in a later interview, "determined never to be insane again" (Eburne 217). In this sense, Breton's *Nadja* is turned on its head: Carrington frames her narrative so that the desiring male subject is left in the asylum, sobbing, while the desired female subject walks out to her freedom.

Carrington's escape to Mexico sounds like something out of a spy thriller: her family had arranged to send her to another institution in South Africa, but she evaded her guardian, ducked out a back door, and took a cab to the Mexican embassy, since she knew the Mexican ambassador, Renato Leduc, from her days in Paris. She married Leduc to be able to leave the country and sailed with him to Mexico in 1942. Once settled in Mexico, Carrington and Leduc amicably ended their marriage of convenience, and she married Hungarian photographer Chiqui Weisz in 1946. Shortly after her arrival, Carrington was adopted into the circle of Surrealist exile friends, particularly Remedios Varo and her husband, Benjamin Péret. The friendship between the two women was a potent and productive one, as they experimented with different techniques and styles and collaborated on plays and other artistic pieces. The next decade in Mexico was a happy one; Elena Poniatowska calls the 1950s "años de gran producción" (years of great production) in which "las pintoras echan carreras" (the female painters launch their careers), referring to Varo as much as to Carrington

(*Leonora* 368). That was also the decade in which Carrington seized the pen herself this time and proceeded to cross over to the other side again.[16]

## Here Begin the Terrors, Here Begin the Marvels: Leonora Carrington's Grail Quest

The most canonical Christian version of the Grail legend begins this way: "This is the book of thy descent. Here begins the book of the Holy Grail. Here begin the terrors; here begin the marvels" (cited in Godwin 201). Leonora Carrington's interest in magic and the occult, in "terrors and marvels," dated back to her time in Paris and London with Max Ernst and found its oldest roots in the Gaelic stories her Irish nanny told her as a child. Carrington's version of the Grail legend was greatly influenced by the Celtic branch of stories surrounding the quest for the Grail, both in terms of plot and imagery.[17] It was also in Mexico that Carrington read Robert Graves's 1948 essay *The White Goddess*, a scholarly study of archaic goddess religions; this, too, would make its presence known in *The Hearing Trumpet*.

*The Hearing Trumpet* was written in English sometime between the late 1940s and the 1960s; the novel was first published in French in 1974 and in English in 1976 (García Ochoa 125). It tells the story of Marion Weatherby, a ninety-two-year-old grandmother whose family decides to have her committed to Lightsome Hall (also called the Institute). Using a magical hearing trumpet given to her by Carmella (a fictionalized version of Remedios Varo, as indicated by her many cats and her red hair), she discovers her family's plan. While Marion does not avoid institutionalization, she remains aware of events in such a way that allows her to save herself and her friends at the Institute as the story twists, turns, and eventually becomes a powerful rewriting and reclamation of the Arthurian legend of the Grail. It is here that Carrington continues the work she began with *Down Below*; that is, the work of revisiting trauma and claiming experience as she shapes the story to her own ends.

The novel has a sharp, parodic wit that, in some ways, recalls the irreverent Medusa-like laughter of Carrington's earlier short stories. If, as Hélène Cixous poses in her classic essay "The Laugh of the Medusa," women were long "riveted [. . .] between two horrifying myths: between the Medusa and the abyss" (885), Carrington rejects the abyss by claiming the monster and the monstrous in her work; she writes, paints, and sculpts her

72 · Technified Muses

sense of self and her body to her own ends. Yet in *The Hearing Trumpet*, the female body that Carrington writes is still laughing, but very deliberately not beautiful—at least, not conventionally so. Marion Weatherby, Carrington's deaf, toothless nonagenarian protagonist, defies all conventions for the idealized Surrealist *femme-enfant*. She even sports a beard (which, as Marion tells us, she personally finds "rather gallant"), explicitly embracing that which "conventional people would find repulsive" from the very first pages of the novel (5). For Marion, such repulsiveness is a gift: "Beauty is a responsibility like anything else, beautiful women have special lives like prime ministers but that is not what I really want, there must be something else . . ." (*The Hearing Trumpet* 20, original ellipses). Shortly after arriving in Mexico, Carrington would issue a proclamation much like Marion's, distancing herself—perhaps somewhat ironically—from her own youth and beauty. As she wrote in a 1945 letter to publisher Henri Parisot, "I am no longer the Ravishing [*sic*] young girl who passed through Paris, in love—I am an old lady who has lived a lot and *I have changed*" (cited in Eburne 217, original italics). She would have been about twenty-eight years old at the time. Her insistence on being old has a purpose, however, as she explains to Parisot: "I seek to understand Death in order to have less fear; I seek to empty the images that have made me blind" (217). For Carrington, youth and beauty as she had experienced them meant blindness and fear, along with her experiences of being exploited and underestimated as an intellectual and an artist. As such, she constructs a journey and a persona in which she embraces age instead of fearing it.

In *The Hearing Trumpet*, the most powerful figures in the novel are maternal crones who are terrible, fearless, and, quite frequently, laughing. By taking on the persona of a laughing crone goddess, Carrington not only abandons the ethereal *femme-enfant* ideal from Surrealism, but she also writes against the concept of the ideal Mexican woman as a chaste, self-sacrificing mother or schoolteacher, as presented in essays, literature, and film of the period. Delving into Celtic, pagan, and precolonial mythology and symbolism, Carrington's Marion embarks on a carnivalesque quest to find a laughing triple goddess with a group of old crones who literally turn the world on its axis, flipping the poles to bring an intense Ice Age to the planet (*The Hearing Trumpet* 148–49). Carrington's growth as a writer is on display here; the narrative layers of the novel and its quests are far more complex than anything else in her oeuvre up to that point. Tracking down each of the threads of the Grail legend would be a daunting endeavor that lies far beyond the scope of this chapter. Even so, the novel's construction

and content display Carrington's considerable knowledge of and interest in Eastern and Western philosophy, religions, and mythologies, as well as her willingness to tweak or parody established narratives to her own creative and personal ends.

*The Hearing Trumpet* consists of several quests, all intermingling and overlapping as the story progresses. First, Marion's quest for liberty and survival takes her on a journey through old manuscripts and stories as well as magic ceremonies with the other women of the Institute, leading her to the underworld, death, and renewal through a confrontation with herself and an encounter with a cauldron. The manuscripts Marion consults tell the story of the second quest: Doña Rosalinda, a diabolical winking abbess, sets out to rescue the Grail from the Knights Templar and return it to the Goddess Barbarus, "who was known to be bearded and a hermaphrodite" but who nonetheless uses she/her pronouns (91). Thirdly, the old women, animals, poets, and other refugees from the sudden winter band together to recover the Grail for the bee goddess Hekate Zam Pollum. The bee is one of several cross-cultural symbols in *The Hearing Trumpet*, as it is significant in the Mayan pantheon (Carrington had studied the Popol Vuh and the books of Chilam Balam) as well as in ancient Greece and ancient Egypt. While its meaning varies, the bee generally symbolizes a nourishing connection between mortals and the gods; that is, between spheres of existence. The bee also indicates a reclamation of Venus and of the long-lost female element to human spirituality.[18]

In addition to taking on Surrealism, Carrington's novel takes satirical aim at Russian mystics G. I. Gurdjieff (1866–1949) and P. D. Ouspensky (1878–1947), founders of a school of mystical thought that was active in Paris in the 1930s. With the help of a few committed disciples, a branch of the school was opened in Mexico in 1951. While Carrington and Varo were initially drawn to Gurdjieff and Ouspensky's concept of an interconnected universe that requires the development of a higher level of consciousness to perceive the various levels of existence, both women quickly came to dislike Gurdjieff and his Institute for the Harmonious Development of Man.[19] Carrington's representation of Lightsome Hall, the Institute in which Marion is placed, is drawn from her time at the spiritual retreat founded by Rodney Collin Smith, a loyal follower of Gurdjieff, in the late 1940s, and *The Hearing Trumpet*'s sinister Dr. Gambit is generally considered to represent Gurdjieff. Carrington's memories of the Institute so closely parallel her descriptions of Lightsome Hall that she does not even bother to change the names of some of her fellow attendees (Arcq, "The Esoteric Key" 36–37;

74 · Technified Muses

Poniatowska 399–406; Swanson 699). She engages in Suleiman's "double allegiance" with the useful elements of Surrealism and Gurdjieff's brand of Russian mysticism from a feminist standpoint while also critiquing abuses of power within the male-dominated movements. Carrington and Varo were interested in Gurdjieff and Ouspensky's search for a more evolved consciousness to reach higher planes of existence (called "the fourth way"), but both also recognized the need to maintain the presence and balance of the feminine alongside the masculine. Carrington did so through a myth- and fairy tale–soaked narrative with unmistakably autobiographical elements; Varo, meanwhile, would engage in her search for balance through a variety of textual and artistic masks, armed with a sharply ludic eye, pen, and paintbrush.

### Strapping It On: Technological Extensions and Social Critique in the Work of Remedios Varo

Though born in Spain, Remedios Varo is widely accepted and embraced as a Mexican artist, since it was in Mexico that she had the space and time that she needed to do her work. In this sense, her trajectory is similar to that of her countryman Luis Buñuel, who arrived in Mexico a few years after she did in 1946.[20] It would be inaccurate to present the situation as idyllic, however, as the reasons that drove her to paint during those early years in Mexico were primarily economic. Varo arrived with her husband, Benjamin Péret, and, as art historian Teresa Arcq notes, while "Péret and his friends spent their time discussing poetry, politics and art, Remedios Varo's more practical spirit compelled her to find a way to make a living" ("Remedios Varo and Her Work for Bayer" 6). One of her early jobs was with the pharmaceutical company Bayer, which resulted in beautiful, disturbing, and thought-provoking pieces for their advertisements. In her Bayer commissions in Mexico and Venezuela (1943–49), Varo developed many of the forms, themes, and iconography that would characterize her later work. Mexico was also the place that offered her the most artistic and economic success, and where most of her work and personal papers are held to this day.[21]

Varo's paintings exhibit a connection with technology that is as powerful as it is playful. She was influenced by her father, a hydraulic engineer who taught her about mathematics and engineering, and by her own interest in alchemy and the occult. She took courses in anatomic and scientific drawing at the Academia de San Fernando in Madrid, and the rigorous for-

mal training she received there is very much in evidence in her paintings as well. Varo's interests and education manifested themselves in a number of hybrid beings in her paintings, many of which combine organic and mechanical elements. These strange creatures and her playful, absurdist approach to art and writing comprise a contrapuntal response to discourses of avant-garde, gender, and technology in the male-dominated intellectual community in Mexico. In this way, Varo liberates herself artistically and intellectually from the patriarchal influence of the European Surrealist expatriate community and from the Mexican intellectuals' debates on nationalism and identity from the same time period.

When speaking of strap-ons, the sexual implications are inevitable. Varo had a distinctly picaresque sense of humor, and her sexuality is expressed and explored much more openly in her writing than in her paintings. Here, the term "strap-on" refers to and encompasses prosthetics, technological extensions, and body-machine meldings and fusions in Varo's paintings. Some of her paintings are intimately connected to her writing, and two of them—*Au bonheur des dames* and *Homo Rodans*—are examined in detail in this chapter. In her writing, Varo plays with a variety of narrative voices and styles, using invented words, names, quotations, and sources, all of which are appropriated for the sake of play, communication, rebellion, and self-expression. These, too, are her strap-ons.

I do not wish to imply that Varo is trying to take on a masculine persona with these strap-ons, or to abandon a sense of femininity in order to write or paint "like a man"—quite the contrary. A strap-on, at least for the purposes of this chapter, is that which is used for penetration. My definition of penetration builds upon a quote from Minge and Zimmerman's article "Power, Pleasure, and Play," in which they describe penetration as "desire passed between, into, through, and with bodies" (331). While Minge and Zimmerman are primarily referring to physical human bodies, I would like to expand this definition to include bodies of text, bodies of discourse, and, since we are talking about Remedios Varo, bodies of art. In this sense, Judith Butler's *Bodies That Matter* is useful here, particularly her revelation that she "could not *fix* bodies as simple objects of thought" (103, original italics). The body as a slippery signifier is not a new idea, of course, but Butler's ideas regarding boundaries and the transgression (or perhaps merely the traversal) of those boundaries are profoundly connected to the conception of the body. As Butler observes, "Not only did bodies tend to indicate a world beyond themselves, but this movement beyond their own boundaries, a movement of boundary itself, appeared to be quite central to

76 · Technified Muses

what bodies 'are'" (103). This integral connection of a body to "a world beyond [itself]"—which, Butler pointedly reminds us, is a body that "comes in genders" (111), has suggestive connections to Varo's studies of alchemy and esotericism. Indeed, one of the epigraphs to the introduction of *Bodies That Matter* is a provocative question from Donna Haraway's "Manifesto for Cyborgs": "Why should our bodies end at the skin, or include at best other beings encapsulated by skin?" (cited in Butler i). The bodies in Varo's writing and art extend past the skin as they seek connections to worlds beyond themselves, transgressing their own organic bodies to do so.

The four works discussed here are drawn from what Janet Kaplan, Teresa Arcq, and other scholars refer to as Varos's "Mexican years": 1955–63. The bone sculpture *Homo Rodans* and the painting *Animal fantástico* (Fantastic animal) interact with the accompanying text, "De Homo Rodans," to offer a complex and intelligent parody of archaeological and scientific discourse that offers ways to break down gender binaries and gender norms. Two other paintings, *Au bonheur des dames* (The ladies' delight) and *Visita al cirujano plástico* (Visit to the plastic surgeon), serve as visual, contextual, and thematic bookmarks to the *Homo Rodans* series, with *Au bonheur* preceding them and *Visita* following. I am most interested in the relationship between the bone sculpture and the written text: rather than a text about the sculpture, the "re-created" skeleton instead serves as a pretext to continue a discourse established in Varo's previous paintings, with its critiques of gender norms and behavior couched in absurd, pseudoscientific language. Finally, I will explore her ideas and concerns on gender and the body as manifested in *Visita al cirujano plástico*.

The work produced after Varo's arrival in Mexico can be divided into two eras or categories. The "incubation period," 1941–55, was a period of adjustment and evolution that included intensive study of alchemy and esotericism as well as a two-year stint in Venezuela painting ads for Bayer. As mentioned at the beginning of the chapter, her work had been exhibited in Mexico City as early as 1940 in the *International Exhibition of Surrealism* in the Galeria del Arte Mexicano (Gallery of Mexican Art), but she was unable to find steady paying work in the country immediately afterward. In 1952, Varo married Walter Gruen, which Arcq, Andrade, Castells, Kaplan, and others agree marked another turning point in her art, since, as Tere Arcq observes, this union "provided her with the economic means and safe environment that would allow her to focus her activities exclusively on her painting" ("The Esoteric Key" 22). Three years later, Varo had her first solo exhibit at the Galería Diana in Mexico City, which was a resounding

success, both creatively and economically. "Estoy más rica que un torero" (I'm richer than a bullfighter), she exults in a letter to her mother shortly after the exhibit (June 27, 1957, Gruen Collection). In this and following letters, Varo writes often and passionately about being able to provide her mother with whatever she wants or needs, and it is clear that Varo was driven by a sense of responsibility to financially support herself and her mother. As such, her economic drive intermingled with her equally strong desire for artistic autonomy, creativity, and self-expression; there is no indication that she played it safe or compromised her own artistic expression to guarantee that a piece would sell.

While the roots of Varo's artistic and intellectual development are in Europe (in Madrid, where she trained, as well as in Barcelona and Paris), it was only after her arrival to Mexico that she had the time, space, safety, and resources to develop her art. This was due in part to the creation of a system of galleries in Mexico City that was explicitly welcoming to art created by women, and particularly to the work created by the Surrealist exiles, as in the case of the aforementioned Galería del Arte. As corroborated by Arcq and Kaplan, Varo embarked on a period of artistic and creative development that lasted roughly from 1942 to 1954, and she did so in a way that was influenced and inspired by, yet increasingly distant from, the two intellectual currents in which she was most heavily involved: Surrealism and studies of esotericism and alchemy. Drawing from Suleiman, Janet Kaplan notes that Varo, like Carrington, maintains a "double allegiance" that valued the Surrealists' "subversive/parodic energy" while critiquing its negative attitudes. As might be expected, Varo's critiques were most pointed around issues regarding women (*Catálogo razonado* [*Catalog raisonné*] 38–39). In the same vein, although Varo was inspired by the ideas of Russian esotericists Gurdjieff and Ouspensky, she tended to use their tools and ideas to her own ends, removing them from their original ideological context and putting them at the service of her own aesthetic, artistic, and spiritual intentions.

*Au bonheur des dames* is accompanied by a short text, which Varo wrote on the back of a photograph of the painting that she sent to her brother Rodrigo in Venezuela. She describes it to him is as follows:

> Criaturas caídas en la peor mecanización; todas las partes de su cuerpo son ya ruedecillas, etcétera. [. . .] Criaturas de nuestra época, sin ideas propias, mecanizadas y próximas a pasar al estado de insectos, hormigas en particular. (Cited in Mendoza Bolio 171)

[Creatures fallen into the worst mechanization; all of their body parts are now little wheels, etc. (. . .) Creatures of our era, without any ideas of their own, mechanized and about to become insects, ants in particular.]

The description reflects various elements of Russian esotericism: in Gurdjieff's thought, any man who is unenlightened or unaware is nothing more than a machine, an automaton consumed by the increased mechanization of modernized life. (My use of the masculine is deliberate, as women are entirely absent from his philosophy.) Though Gurdjieff does not blame technology alone for this mechanizing process, he believes that it is a factor—concerns that are notably similar to those of Vela, Villaurrutia, and Owen discussed in chapter 1. Man, Gurdjieff says, must first be aware that he is asleep and then must take steps to awaken. This awakening requires work in order to balance the parts of the self (the physical, the mental, and the intellectual) to reach a new level of self-awareness and connection with the universe.

Varo explores Gurdjieff's ideas in *Au bonheur des dames* by using *frottage*, a Surrealist technique that is supposed to lead to automatic painting. Around the splotches, however, the rest of the painting is detailed, orderly, and carefully plotted, defying Breton's exhortation to engage in "psychic automatism in its pure state [. . .] exempt from any aesthetic or moral concern" ("Manifesto of Surrealism" 26). Furthermore, Varo names the department store "Au bonheur des *citoyens*"—*citizens* rather than *ladies*—and her wheel creatures are clearly identifiable as male or female. Departing from Émile Zola's 1883 novel of the same name, the only implied romance is with economic consumption. The subjects are all equally at fault, equally in need of self-discovery and awareness. Notably, the painting was completed in 1956, in the middle of the decade that Joseph, Rubenstein, and Zolov refer to as "a Golden Age of consumption, and thus belonging" (10), with a patriarchal culture at its core (12). Varo's creatures are cloaked in either red or green, the colors of the Mexican flag, which offers a reading of the painting as a culturally specific critique of the notion of citizenship through consumption that was prevalent during that period.

Varo develops the wheeled creatures to more satirical and critical ends a few years later, which I will treat as one work in three parts: *Animal fantástico* and *Homo Rodans* refer to the painting and the sculpture, respectively. The third work, *De Homo Rodans*, refers to Varo's written text and is the part to which I will devote most of my attention in this section, since

the text has rarely been discussed critically. It was one of only two texts that Varo ever intended for publication. The others, most of which have been compiled by Isabell Castells, Janet Kaplan, and Edith Mendoza Bolio, were short texts that read precisely as Varo herself described them in the title of Mendoza Bolio's 2010 critical compilation *A veces escribo como si trazase un boceto* (Sometimes I write as If I were sketching)—like a *boceto*, an outline or sketch. This informal writing-as-sketching stands in stark contrast to Varo's paintings, which were exhaustively planned out. By the time she considered a work finished, she would have made a number of preliminary sketches and paintings to achieve the desired level of precision in terms of angles, symbols, use of color, and so on. In her writing, Varo was much more relaxed and her sense of humor more evident. She could be pointed, dark, or even bawdy, which none of the men who write her elegies—including Walter Gruen, Octavio Paz, André Breton, and Alberto Blanco—ever seem to recognize.

*De Homo Rodans* is a clever spoof on archaeological discourse, as Kaplan, Mendoza Bolio, and others have noted. What I would like to address here is Varo's playful take on gender roles and sexuality as part of her free-wheeling pseudoscientific discourse. While the wheels in *Au bonheur des dames/citoyens* were symbols of sleep, automatism, and repression, the wheel in *De Homo Rodans* is more complex in its meaning and thus offers a wider range of possibilities of representation. *De Homo Rodans* is Varo's most multifaceted strap-on, loaded with invented words, made-up experts, and references to real and fabricated primary texts. In this way, her work recalls the short stories of Argentine author Jorge Luis Borges. While I initially hesitated to draw a connection between Varo and Borges, Inés Ferrero-Cándenas's 2011 book *Gendering the Marvellous* [*sic*] makes a compelling case for doing just that, as she engages in productive readings of Varo's assimilation of Latin American narratives in her own writing, particularly regarding *lo real maravilloso*. Varo also creates an alternate first-person male narrator (Hälikcio von Fuhrängschmidt) to give narrative voice to the text, adding extra layers of complexity as well as gender play.

The objective of *De Homo Rodans*, von Fuhrängschmidt tells us, is to correct a grave error in the classification of lumbar bones in a previous anthropological treatise. Before that mistake can be rectified, however, it must first be understood that "nuestro Universo conocido se divide en dos claras tendencias: la de aquello que tiende a endurecerse y la de aquello que tiende a ablandarse" (194; our known Universe is divided into two clear tendencies: the tendency to harden and the tendency to soften). A worried

von Fuhrängschmidt notes that "el endurecimiento cobra cada día más prestigio: músculos duros, carácter inflexible, ejercicios destinados a endurecer las superficies y volúmenes anatómicos femeninos, etc." (195; this hardening becomes more prestigious every day: hard muscles, inflexible character, exercises meant to toughen up surfaces and feminine anatomical volumes, etc.). Not surprisingly, in *De Homo Rodans*, this *endurecimiento* is closely tied to sexual desire. Varo relates this in the voice of von Fuhrängschmidt quoting Roman educator Quintilian's (nonexistent) *Narraciones tórbidas* (*Torbid Narrations*)[22] in a version of pseudo-Latin invented by Varo herself. Here I use Mendoza Bolio's translation to Spanish: "Habíase un anciano venerable que en su camino vislumbra a una mujer impúdica y turbadora, adornada con un par de turgentes globos que provoca que su apetito sensual arda en lujuria" (195). (Once upon a time there was a venerable old man who spied on his path a shameless and arousing woman adorned with a pair of turgid globes which caused his sexual appetite to burn with lust [trans. 57]).

This connection between hardness and exclusively male sexual desire continues throughout the essay, and while Varo adopts the alarmed tone of a sheltered and conservative European man of science, her underlying critique comes through clearly. She argues, in a deliberately absurd way, for the balance of and between these kinds of binaries: hard/soft, masculine/feminine, lust/chastity. Varo does not advocate for an elimination of this hardness, however, since an excess of softness also results in disaster: "tenemos muchos ejemplos de los terribles resultados del reblandecimiento trascendental de los abismos minerales cuanto éstos comenzaron a retroceder en su equivocado y audaz camino hacia la dureza absoluta" (195; we have many examples of the terrible results of the transcendental softening of mineral chasms when they began to retreat from their wrong-headed and daring path toward absolute hardness). The problem, then, is not hardness or softness but the lack of balance between the two. The impact of this excessive tendency toward hardening does not only impact human beings, but the whole of nature. Varo continues: "Desde la erupción de Moolookao en el África central, hasta nuestros días, ¡cuántas ruinas y desastres! Pompeya, Herculano, Pardis, Moscolawia, Bois-Colombes, El Pedregal, etc." (195; From the eruption of Moolookao [an invented volcano] in Central Africa to the present day, how many ruins and disasters! Pompeii, Herculaneum, Pardis, Moscolawia, Bois-Colombes, El Pedregal [the name of a neighborhood in Mexico City that also translates to "lava fields"], etc.)

In all this talk of hardness versus softness, the *Homo Rodans* statue may appear to be a distraction if we limit our reading to the essay and the two works of art associated with it. Considered in the overall scheme of Varo's artistic production, however, the statue bears a striking resemblance to the wheeled creatures of *Au bonheur des dames,* both of which portray beings with a tendency toward mechanization and disassociation from the consciousness and the true self. In *De Homo Rodans,* the wheeled creature is used as example of this tendency toward *endurecimiento,* as von Fuhräng-schmidt describes the discovery of an "inexplicable abundancia de huesos lumbares" (197; inexplicable abundance of lumbar bones) belonging to a single person. They had been categorized as *Homo Reptans,* a precursor to *Homo Sapiens.* This is a grave error, we are told; there was never a *Homo Reptans* but rather *Homo Rodans.* At this point one might expect the scientist to say more about this new species, but he refuses: he will only tell the reader that, along with the bones, there is a detailed description of the species that he will not repeat here, as it is in another (imaginary) text. Von Fuhrängschmidt then scolds his colleague W. H. Strudlees for his "lasciva suposición de reptalidad afrodisíaca con intensiones procreadoras" (197; lascivious supposition of aphrodisiac reptile-ness with procreative intentions), as if this wheeled creature lacked sexual urges in spite of its excessive hardness. If this creature is placed alongside Varo's other wheeled creatures, *Homo Rodans* (sculpture) and *Animal fantástico* (painting) provide a visual shorthand to reading her wheeled beings as a whole, as all are symbols of unconsciousness and disconnection from the self and from others.

Varo's depiction of the species as a skeleton indicates its death and possible extinction. In doing so, she warns against this sort of unconsciousness and disconnection from the self and proposes a search for a different plane of existence and interaction with society as well as the self. A failure to do so, she tells us in the voice of von Fuhrängschmidt, will result in "una época de dolorosa confusión en que toda materia será *Infernalia Híbrido-Maniaca*" (198; an epoch of painful confusion in which all material will be *Hybrid-Maniacal Infernalness*). The phrase "Infernalia Híbrido-Maniaca" does not exist in Spanish; it is a neologism that Mendoza Bolio describes as a play on words to refer to manic-depressive psychosis (198). In an essay connected to a nonhuman, apparently genderless body, Varo establishes a playful yet serious plea for societal integration and greater flexibility in gender roles. This focus on societal integration and gender roles forms a clear philosophical and conceptual line of thought that extends through

the years and connects her separate works into a series of increasingly developed and explored concepts and critiques on society and gender.

In *Visita al cirujano plástico*, Varo responds to pressures on her as a *femme-enfant* to look a particular way. The painting shows a woman who is running into a clinic and trying unsuccessfully to cover up a long, pointed nose. The model in the display window, who may be a mannequin, a robot, or a human model, has three pairs of breasts and an abnormally long, thin torso to accommodate the extra four breasts. She has neither hands nor feet, though it is not clear if they are simply hidden from the display or if they have been removed as a suggestion for another surgery. The lettering on the window says: "En nuestra gloriosa era plastinaylonítica, no hay limitaciones. Osadía, buen gusto, elegancia y turgencia es nuestro lema. On parle français." (In our glorious plasticine-ylonite era, there are no limitations. 'Audacity, good taste, elegance and turgidity' is our slogan. French spoken here.) At the top of the glass, as if imprinted across the mannequin/model's forehead, is "Superamos la naturaleza" (We overcome nature). All of this advertising insists that the only "naturaleza" that needs to be conquered or overcome is that of the surgically unaltered female body.

Philosopher Kathryn Pauly Morgan reminds us in her famous article "Women and the Knife" that elective plastic surgery does not only seek to defy nature, but also time and reality, since these procedures entail "the ultimate envelopment of the lived temporal *reality* of the human subject by technologically created appearances that are then regarded as 'the real.' Youthful appearance triumphs over aged reality" (28, original italics). Although Morgan's analysis has a broader geographical focus (North America) and a later temporal focus (the early 1990s) than Varo's painting, she offers a critique of technology in opposition to the "natural" that runs parallel to both *Visita al cirujano plástico* and her work in the *Homo Rodans* essay, painting, and sculpture. In Morgan's framing, "technology" and "unnatural" become synonyms with predominantly negative connotations. Butler contests this conflation as well when she asks, "why is it that what is constructed is understood as an artificial and dispensable character?" (*Bodies That Matter* xi). This, too, is a binary that need not exist, and Varo offers a striking visual representation of the potential results when the domain of technology is placed in opposition to the "natural" or organic body in her six-breasted windowfront mannequin/model. Her portrayal of a female body that requires constant mechanization and modification to correct its imagined deficiencies suggests that there is always something innately incorrect, unattractive, or broken about the body itself. As unnatural

as the mannequin/model in the window appears, she is still unmistakably female—excessively and impossibly so, if we consider her six breasts and her long, slim, armless (and possibly ribless) torso. Varo never indicates the identity of the surgeon, offering the tacit assumption that he is male. There is a long-standing tendency in plastic surgery in which, as Rhian Parker reminds us, "The patient base is predominantly women and the doctors are predominantly men," creating an "impossible tension" that contributes to "inconsistent, contradictory, and divergent assumptions about the nature of women's bodies and what constitutes female beauty and physical acceptability" (5–6). Neither Parker nor I would suggest that this means that men have complete control over these ideas, but the power imbalance present when it is mostly men performing these surgeries is equally undeniable.

Both Morgan and Haraway note the double-edged nature of the surgical knife to create these new and improved cyborgian beings and the double-edged nature of the beings themselves—that is, their capacity to harm as well as to heal (Morgan 32; Haraway 150). Varo's *Homo Rodans* and *Visita al cirujano plástico* communicate a plea and a warning regarding the dangers and possibilities of tilting too far in one direction or another during the years in which she was most artistically active.

Carrington and Varo both struggled with negative emotions related to their appearance, albeit in different ways. As previously mentioned, Carrington had a turbulent relationship with (mostly masculine) reactions to her own physical beauty. She responded by dressing badly and embracing the identity of an "old woman" while still in her late twenties. Varo, however, appears to have had the opposite problem. In her private correspondence, she rarely wrote about her perceived physical shortcomings, but when she did, it was with great detail and a self-deprecation that hovered between wry and sad. She lamented her inability to put on weight, her wrinkles, the size of her nose, and so on. Lois Parkinson Zamora suggests that *Visita al cirujano plástico* has a more purely satirical function as a critique of modern medicine, "en particular de las ciencias que *aspiran* a funciones transformadoras pero que no están en contacto con las fuerzas cósmicas necesarias para realizar una verdadera transformación de la conciencia humana" (61, original italics; particularly of the sciences that *aspire* to transformative functions but that are not in contact with the cosmic forces required to truly transform human consciousness). While I agree with Zamora regarding the humorously critical nature of the painting and its appeal for balance and equilibrium in aesthetics and the sciences, I would argue that *Visita al cirujano plástico* has more personal implica-

tions for Varo as well as cosmic, particularly given the amount of text in the painting. The text is difficult to read, requiring the viewer to be physically quite close to make it out (or to zoom in on a reproduction of the painting as I was able to do, but that would have been more difficult in the late 1950s). The veiled woman entering the storefront does not look at the blank-faced, six-breasted model with alarm but rather with longing. While Varo may have downplayed expressions of sexuality in her paintings to distance herself from Surrealist ideals of eroticism and female desire, in *Visita al cirujano plástico* she recognizes and grapples with the frequently internalized pressures to conform to aesthetic standards that are inconvenient, impossible, or dangerous to her physical, artistic, and spiritual well-being.

During these "Mexican years" of peak productivity for both artists, Carrington and Varo were frequent collaborators. They spent time in the kitchen to carry out culinary, alchemical, or magical experiments and both were active participants in the group "Poesía en voz alta" (Poetry Out Loud) in the 1950s. The women also cowrote and acted in absurd and grotesque short plays, though most of these latter works were only ever staged in their homes as a lark. These golden years ended as abruptly as they had begun when Varo died of a heart attack in 1963. Carrington, though heartbroken at the loss of her friend and confidante, continued to paint and sculpt in Mexico and the United States at an impressive clip for three more decades before easing into retirement. She spent her last days quietly in the Colonia Roma in Mexico City, living in an apartment that her cousin Joanna Moorhead could only describe to me as "dream-saturated," a space full of art and mementos in which Carrington's memories piled up in almost tangible fashion.[23] As the 1960s progressed, Carrington became more politically active, in part because her sons, Gabriel and Pablo Weisz, were active participants in the student movements of the time at the UNAM (Universidad Nacional Autónoma de México [National Autonomous University of Mexico]). Her relationship with Mexico would be challenged profoundly in the wake of the student massacre in the Plaza de Tlatelolco, and it is in the aftermath of 1968 in Mexico, in the attempts to read and make sense of the trauma and violence visited there, that I begin the next chapter.

# 3

## The Medicalized Muses of Tlatelolco

### Juan García Ponce's Mariana/María Inés and Fernando del Paso's Estefanía

Ya nadie sabe el número exacto de
los muertos,
ni siquiera los asesinos,
ni siquiera el criminal.
(No one knows the exact number of the dead,
not even the murderers,
not even the criminal.)
— Jaime Sabines, "Tlatelolco 68"

While Mexico City was in a flurry of renovations in preparation for country's bicentennial celebration in 2010, large green signs were placed at points of cultural significance around the city. All asked the same question: "*¿Quieres saber qué pasó aquí?*" (Do you want to know what happened here?). Underneath was a phone number to call from one's cell phone to get more information about the cultural site in question. When I visited the Plaza de las Tres Culturas/Tlatelolco on October 2, 2011, that green sign almost seemed to be mocking the punks, working-class parents, grandparents, and aging hippies who streamed by in protest, since all of them very much wanted to know exactly *qué pasó aquí*. It is still not entirely clear what happened, nor are there agreed-upon numbers as to how many were killed, detained, or disappeared. Jamie Sabines's point is well taken: even without all of the efforts to erase the massacre in the national imaginary over the decades, it would still be impossible to grasp the totality of "what really happened" in Tlatelolco.[1]

This chapter examines the literary response to the Tlatelolco massacre in two novels: Juan García Ponce's *Crónica de la intervención* (Chronicle of the intervention, first published in Spain in 1982) and Fernando del Paso's *Palinuro de México* (Palinuro of Mexico, 1976, trans. 1996). Since much of

the nation's response has proven difficult to interpret or understand, given that the Olympics were held shortly after the tragedy with little apparent protest or reaction from the general public, I think it productive to explore texts produced outside the immediate aftermath of the event.[2] Furthermore, much of the response has been in the form of testimonial, photomontage, documentary, or realistic cinematic re-creations, among them Leobardo López Arretche's *El grito* (The scream, 1968); Jorge Fons's *Rojo amanecer* (Red dawn, 1989); Alfredo Gurrola's *Borrar de la memoria* (To erase from memory, 2011); Carlos Bolado's *Tlatelolco, Verano de 68* (Tlatelolco, summer of '68, 2013); and José Manuel Cravioto's *Olimpia* (Olympia, 2019). In contrast, García Ponce and del Paso have responded to the event by producing work that falls under the rubric of high literature: difficult, phantasmagoric, Joycean (del Paso) and Proustian (García Ponce) by turns.

Del Paso's novel is hyperspecific in terms of its placement in Mexico City but does not mention dates or years, whereas García Ponce provides no explicit markers of time or place. However, as we saw in Estridentista and Contemporáneos narrative in the aftermath of the Revolution in chapter 1, both novels contain subtle indicators that these stories could only have taken place in Mexico City in 1968.[3] In this case, however, both novels were published years after the fact (*Palinuro de México* in 1976 and *Crónica de la intervención* in 1982), which permits greater emotional distance from the stories the authors wish to tell. Both García Ponce and del Paso were part of the Generación del Medio Siglo (Midcentury Generation), an intellectual generation known for its rebellion against bourgeois society, repressive social and cultural norms, and hypocrisy in general. Their rebellion is most clearly articulated by the abundance of exaggeratedly erotic tableaus in both novels. What interests me most is their departure from the rest of their generation's written responses to the events of that day, as well as from the norms of *la novela del 68* (the novel of 1968) that would soon emerge.

Ignacio Corona notes two major tendencies in post-68 political narrative: a "documentalista" vein that includes Poniatowksa's *La noche de Tlatelolco* (Massacre in Mexico, 1971); Luis González de Alba's *Los días y los años* (The days and the years, 1971); and Carlos Monsiváis's *Días de guardar* (Days to remember, 1970) and a more hybrid narrative genre that combines elements of *crónica, testimonio*, fiction, and autobiography. This latter vein includes works ranging from Vicente Leñero's *Los periodistas* (The journalists, 1975) to Carlos Montemayor's *Guerra en el paraíso* (War in paradise, 1991) (Corona 41–43). Jorge Aguilar Mora's *Si muero lejos de ti* (If I die far

away from you, 1979); Gerardo de la Torre's *Muertes de aurora* (Deaths of the dawn, 1980); and Emma Prieto's *Los testigos* (The witnesses, 1985) fit into Corona's second category as well, since all use realistic, linear narrative in strongly testimonial novels.[4] In contrast, Del Paso's *Palinuro de México* and García Ponce's *Crónica de la intervención* employ excessive, exuberant, and hypererotic imagery to write around the tragedy rather than about it. Del Paso does eventually arrive at Tlatelolco but presents the event in the guise of the Italian commedia dell'arte; García Ponce's two-volume, 1,500-page text does not discuss or refer specifically to Tlatelolco at all, and Mexico is mentioned only once.[5] Del Paso has been critiqued for writing about the events of 1968 in such a carnivalesque fashion, while García Ponce is generally not considered a political author, even in a text like *Crónica de la intervención*.[6] Even so, like the Mexican Revolution in Villaurrutia's *Dama de corazones* (Queen of hearts) and Owen's *Novela como nube* (*Novel like a cloud*), the event that is not discussed is written about, or, rather, written *around*, in such a way that its very absence draws the informed reader's attention.

To draw from Mark Kurlansky's book of the same title, 1968 is "the year that rocked the world;" Octavio Paz deemed it "un año axial" (a pivotal year) in which "la rebelión juvenil anuló las clasificaciones ideológicas" (*Posdata* [Postdata] 241; youthful rebellion annulled ideological classifications). Mexico's hosting of the 1968 Olympic Games marked a giant step toward increased participation on the world stage at a point when the entire world was teetering on the edge of globalization through advances in media technology, communication, and commerce. The counterculture movements of the time were closely linked to political protest and debates on sex, gender, and sexuality. As Luisa Passerini observes in the foreword to *Gender and Sexuality in 1968*, "all movements, including those that did not attend to gender, found their context in assumptions about gender and sexuality" (ix). These assumptions, in turn, form part of the construction and dissolution of hegemonic constructs and ideals of national identity at a time in which these constructs were fiercely attacked by the Movimiento Popular Estudiantil (Popular Student Movement, often called the Movement or the MPE-68), members of the working class, and the Mexican intellectual Left as a whole.

The young male body was at the core of the 1968 phenomenon. As Lessie Jo Frazier and Deborah Cohen observe in the introduction to *Gender and Sexuality in 1968*, "Patriarchal states made investments in youthful mas-

culinities, and representations of youthful male martyrs took on symbolic importance that crossed national borders" (1). Indeed, in the aftermath of Tlatelolco, the reigning image of the tragedy was that of a young male intellectual, martyred for taking a stand against a brutal and unjust government. The governmental repression of the Movement was also represented by male bodies—by the police, the army, and the *granaderos*, special police forces or riot squads that were so named for the grenades (*granadas*) they used as weapons. Thusly framed in religious and mystic discourse, these male bodies become angels and demons, martyrs and inquisitors, ghosts that haunt the collapse of the student movement in Mexico after October 1968.[7] While women were active in the student movement and the intellectual Left, they were often relegated, as happened in many countercultural movements at the time, to lesser roles in the organization, or at least in the historical narratives of the organization.

Many years later, the women who participated in the student movement were still often excluded from the memoirs of their male MPE-68 comrades. Activist Marcela Lagarde y de los Ríos recalls, "Escucho sobre todo a los hombres dirigentes enunciar sus experiencias como si hubiesen estado solos. Solos de nosotras." (176; I often hear the male leaders talk about their experiences as if they had been alone. Alone and apart from us [women].) She and the other women in the student movement were "cómodas y magníficas en las aulas, las asambleas y las brigadas, en las calles y los mítines" (176; comfortable and magnificent in the classrooms, the assemblies, and the brigades, in the streets and in the meetings), but the majority of "los hombres del 68" hardly speak of women when they recall their experiences in the movement. "¿Con quiénes la vivieron?" (176; Who did they live through it with?), Lagarde y de los Ríos asks sarcastically. These omissions were not individual acts of forgetfulness but a collective masculine amnesia, which speaks to the systemic nature of the women's exclusion.

This tacit erasure of female bodies, voices, and actions in counterculture and related studies extends beyond Mexico into the North American academy. Elaine Carey even goes so far as to suggest that "[w]hile both young men and women mobilized in the summer of '68, the Mexican government responded ferociously to young male activists" because their protests implied a rejection of the metaphorical revolutionary "family" ("Los dueños de México" [The owners of Mexico] 60). I question this assertion, since a young middle-class female protester would also fly directly in the face of the postrevolutionary national feminine ideal of a submissive, self-

The Medicalized Muses of Tlatelolco · 89

sacrificing maternal figure. Additionally, the suggestion that the government responded more harshly to young male protesters downplays the considerable risks undertaken by the other participants in the movement, suggesting that the women and the other activists who fell outside of the university student mold could not possibly have been in as much danger as their young male counterparts. It is also worth noting that Carey's account equates activists and middle-class university students, failing to fully recognize the class diversity of the movement.[8]

Revisiting the stories of Tlatelolco and its cultural aftermath through the intersection of the female muse body and medical discourse in García Ponce's and del Paso's novels allows me to sidestep the monopolizing religious–mystic–male martyr discourse and to offer alternative perspectives that emerge with these medicalized muse-bodies. In my analysis of these texts vis-à-vis their representations of and reactions to the events of 1968, I draw in part from Slavoj Žižek's theories in *Violence: Six Sideways Reflections,* in which he pleads for emotional detachment versus outrage in long-term analyses of acts of violence. "A step back," he suggests, "enables us to identify a violence that sustains our very efforts to fight violence and to promote tolerance" (1). This step requires a particular level of emotional detachment that is difficult in the face of such shocking events, hence the recommended sideways glances. While Samuel Steinberg does not refer directly to this aspect of Žižek in his work, his reference to the "encrypting violence" of Tlatelolco suggests a similar approach, since the sort of codebreaking required to (re)read such an event requires temporal, emotional, and spiritual distance to engage in the intellectual work of deciphering and interpreting that which is encrypted (*Photopoetics* 24).

Gender must form some part of this codebreaking process as well; it cannot be read separately from violence and trauma but rather must be considered in conjunction with it. In this chapter, I situate García Ponce's *Crónica de la intervención* and del Paso's *Palinuro de México* within a constellation of theories on violence in relation to gender, identity, and constructions and deconstructions of national history. Both authors make use of eroticism and sexuality in their female characters in ways that are as problematic as they are critically productive in establishing a clinical series of sideways glances at Tlatelolco and its intellectual, political, and cultural repercussions. The death of the historical avant-garde in 1968 marks a paradigm shift: these muses still interact with various technological discourses and developments to their own ends, but in these post-1968 texts,

it is the "meat" (to use William Gibson's term from his cyberpunk classic *Neuromancer*), the organic flesh, that is used as a form of subversion, disturbance, or escape.

The muses discussed in the first two chapters of this book adapt and appropriate technology to their own ends, principally to avoid losing ownership of the organic body. In the final two chapters, the equation is reversed; it is through her own physicality and corporeality that each muse speaks most clearly. In other words, while technology was previously used to escape the confines of the body in the rapidly modernizing city, in these post-'68 narratives the body is used to design strategies to combat the confines of the technological—of psychoanalytic discourse, of medical experimentation, and of increasingly cyborgian bodies. They do so in a Mexico City that is growing too fast for urban planning or infrastructure to keep up, in a country that is chafing under the increasingly authoritarian rule of the PRI as it prepares to step onto the world stage as host of the 1968 Olympics. The Mexican government and the Movement both felt themselves to be part of a larger global network: the government through its hosting of the Olympic Games and the Movement through its sense of connection to a network of other urban protest movements in Europe, Latin America, and the United States (Flaherty 23). Their responses to this sense of belonging to a large global network were telling: the Movement drew inspiration and support from protest movements all over the globe, whereas the Mexican government was much more concerned about the country's image with the world's eyes upon it. The resulting anxiety and the desire to keep up appearances and maintain a sense of order played a major role in the tragedy that was to come.

## Olympic Games, Global Unrest, and White Gloves: 1968 in Mexico and Beyond

The year 1968 was a chaotic time of global revolutions, with youth uprisings and large-scale political protests in sixty-five different countries— "almost as if they had made an appointment," Pablo Gómez noted (5, my translation). Octavio Paz's designation of 1968 as a "pivotal year" in *Postdata* is an apt one, as the world was irrevocably transformed by its events. These conflicts tend to be national rather than global, and they had little in common beyond the element of protest, as the objectives and expressions of each of these sixty-five "appointments" varied widely between countries. Even so, the total effect was transformative. Jeremi Suri's analogy is an apt

The Medicalized Muses of Tlatelolco · 91

one: "Like the window on a museum display case," he writes, "the year 1968 separates us—physically and symbolically—from a world that appears appreciably different" (xii). In Latin America, 1968 marked an important threshold in crossing "beyond a post-revolutionary horizon" (Bosteels 25) in terms of the Mexican and Cuban Revolutions, establishing it as a watershed moment of great hope with devastating aftereffects.

As the year began, Mexico was enjoying a period of economic growth and preparing to host the Summer Olympics in October. President Gustavo Díaz Ordaz publicly expressed confidence about Mexico's political and economic stability but privately feared that there was a global conspiracy of French and Cuban radicals who were out to spread disorder around the world. His paranoia was fueled by student protests in France in May of that year and the rise in Communist furor provoked by the assassination of the Argentine revolutionary Ernesto "Che" Guevara the previous year. Díaz Ordaz's sentiments were closely aligned with his political party, the Institutional Revolutionary Party (the Partido Revolucionario Institucional, or the PRI) in valuing stability over democracy. They had a decades-long history of infiltrating labor movements and repressing workers' strikes by buying off dissidents, locking them up, or killing them outright.[9]

It is in this tense, reactive environment that the Movement erupted in late July. As Paco Ignacio Taibo II recalls, "It is generally agreed that the Movement was ignited on 26 July 1968, but as always in real history, the igniters did not know at the time what it was they were igniting" (24). Four days before, a fight had broken out between two local high schools; the police and antiriot units, who had been called in to keep the peace, began to provoke the students instead. When the students tried to retreat, the military gave chase, assaulting students and teachers alike. On July 26, a group of students marching to protest the police brutality of a few days before ran into an annual march of Fidel Castro's supporters; the army again took the offensive against both groups in a battle that would continue for days. Taibo, who at nineteen was already a veteran of such protests, bore witness to the conflict. "This was not the first time we had been beaten up by the cops," he recalled. "It was one of the Mexican state's demented customs to give the students a bit of stick every now and again, just to show them who was boss" (27). Despite his bravado, he noted a change in the scale and scope of the official response to the student resistance movements that concerned him: "All the same, this was different: what were they cooking up now?" (27).

As the military violence increased, the student protest groups became more organized and more resistant, which made Díaz Ordaz increasingly nervous. He promised the world that the Olympics would be undisturbed, with the ominous declaration that "[w]e will do what we have to" in order to keep the peace (Kurlansky 338). On October 2, the National Strike Council (Consejo Nacional de Huelga, or CNH) met with the government to attempt to resolve the conflicts through dialogue. It ended badly: "Los cuatro enviados del CNH salieron de la conversación exactamente como entraron. Puras vueltas a lo mismo, el gobierno no admite el diálogo público en forma alguna." (P. Gómez 305; The four [representatives] from the CNH left the conversation exactly as they had entered into it. It's always the same; the government does not allow public dialogue in any form.) A rally was scheduled at Tlatelolco immediately afterward for the CNH representatives to share the results of the talk. A large crowd of CNH members had formed, but there was also foot traffic from passersby en route to work or home, as the plaza is flanked on two sides by large apartment complexes that are still in use today. It was not, as Kurlansky explains, an ideal setting for a rally: "The police had only to block a few passageways between buildings and the plaza would be sealed off" (340), which is exactly what they did.

As the CNH speeches began, helicopters appeared, members of the Batallón Olimpia (Olympic Battalion)—men in civilian clothing wearing a white glove on one hand and bearing weapons—burst out of the apartment buildings where they had been stationed, and gunfire erupted from the ground level and the balconies. The shooting, which Pablo Gómez describes as "el combate contra nadie" (313; the battle against no one), would continue for several hours. Soldiers went door to door in the two apartment complexes to round up any protesters who might have taken refuge there. To this day, no confirmed body count exists. The most reliable estimates hover around three hundred, with thousands detained, imprisoned, and tortured in the Palacio de Lecumberri in the northeastern part of Mexico City. Despite its misleading name, Lecumberri was actually a prison until 1976 and has been a national archive (Archivo General de la Nación) since 1980; the documents are kept in the old cells.[10] The anniversary date is commemorated each year by protests, speeches, and concerts in and around the plaza as well as a march from la Plaza de las Tres Culturas/Tlatelolco to the Zócalo in the city's Centro Histórico (Historic Center), with *2 de octubre no se olvida* (We will not forget October 2) as the predominant slogan scrawled on signs and shouted by marchers. Evidently, "not forget-

ting" is not the issue; however, debates still rage over who was behind it, how many were killed, and what the country should learn from it.

## Sideways Glances and Seeking Distance: Rethinking Responses to "Senseless" Violence

As mentioned, most of the responses to Tlatelolco have been direct and subjective, and most fell under the rubric of testimonial or *crónica* (literary journalism). Some of the more canonical offerings are Carlos Monsiváis's *Días de guardar* (Days to keep, 1970), Octavio Paz's *Postdata* (1970), and Elena Poniatowska's *La noche de Tlatelolco* (Massacre in Mexico, 1971), all of which look directly at the event to express pain and anger, denounce the government's acts, and preserve some of the stories of those who were there. While these are valuable and necessary reactions in the immediate aftermath of the tragedy, they are also what philosopher Slavoj Žižek might refer to as "direct gazes" at the situation, which produce a paradoxical reaction in the viewer. As Žižek describes it, a victim's account of violence feels the most true and convincing to the listener/reader when it is emotional and unreliable. On the contrary, he argues, "[i]f the victim were able to report on her painful and humiliating experience in a clear manner, with all the data arranged in a consistent order, this very quality would make us suspicious of its truth" (4). This places the victim in a terrible catch-22: to tell a coherent truth that will not be believed or to produce an inaccurate account rendered convincing by emotion.

This listener's paradox is frustrating at best and unfair at worst, as it puts performative expectations on the already traumatized narrator for their account to be believed (and then, presumably, acted on or remediated in some way). Žižek suggests that the way around this receptive paradox lies not so much in the delivery as in the genre used to relate it. Contradicting Adorno's famous declaration that it is barbaric to write poetry after Auschwitz, Žižek insists that it is realistic prose that fails instead, as it falls into the same trap as the victim's account of trauma, caught between suspicious truth and compelling unreliability (4–5). This paradox may be extended to the receptor as well: either they are unmoved by the account since its factual nature renders it cold or unconvincing, or they are so moved that they become overwhelmed and feel powerless to respond. Žižek proposes that more subjective forms such as music or poetry—forms that cannot pretend to be objective—are better equipped to evoke that which cannot be represented, thus neatly evading the storyteller's—and the receptor's—paradox.

To that end, while del Paso and García Ponce employ prose, neither author aims for realism, instead situating their novels on the periphery of literary canons in Mexico, Latin America, and Europe. Del Paso's phantasmagoric, exuberant, often overwhelming narrative and protagonists are drawn from Roman mythology (beginning with the titular character's name, as Palinurus was the helmsman of Aeneas's ship in Virgil's *Aeneid*) and its echoes in English literature, most notably Cyril Connolly's 1944 *The Unquiet Grave: A Word Cycle by Palinurus*, as it was Connolly's Palinurus that inspired del Paso's Palinuro.[11] The satirical tone of the novel was a deliberate choice on del Paso's part, particularly in chapter 24, which is told with the characters and the masks of the commedia dell'arte.[12] Del Paso explained his choice in a 1981 interview:

> The student movement itself had a great deal of farce about it. But it wasn't the students who were farceurs but rather many political groups, as well as individuals, who tried [. . .] to capitalize on the movement. [. . .] The confusion and panic that surrounded that frustrated attempt at revolution which led to nothing added a melodramatic and tragicomic tone to the situation. Farce, then, was the only road that I could take. (cited in Steele 72)

Del Paso obtains this distance a number of ways, some deliberate and some simply circumstantial. While he was living in Mexico in 1968, he did not participate directly in the student movement, nor did he leap to publish a book about the events of Tlatelolco. Instead, *Palinuro* was written some years later and outside of Mexico—primarily in London and in Iowa City. De Paso has said that the student movement marked him in spite of himself; to hear him tell it, the events of '68 snuck into and "took over" *Palinuro de México*, as if it were a story with a life force of its own, independent of the author's conscious thought (Ruffinelli 193).

García Ponce, like del Paso, makes no secret of his aesthetic and philosophical inclinations, with Georges Bataille, Pierre Klossowski, and Mexican Contemporáneo poet Xavier Villaurrutia at the forefront of his influences. Lines from Villaurrutia's nocturnes are scattered throughout *Crónica de la intervención*, circling around and around the line, "porque el sueño y la muerte nada tienen ya que decirse" (because sleep and death have nothing left to say to each other)—the last line of Villaurrutia's "Nocturno en que nada se oye." The philosophical nexus between del Paso and García Ponce is the German American philosopher Herbert Marcuse, particularly his 1955 *Eros and Civilization*, in which Marcuse interrogates and

ultimately opposes Freud's proposition that civilization is based upon the eternal repression of human instincts. For Marcuse, Eros is not that which opposes or hinders civilization; rather, it *is* civilization. Despite the significant philosophical differences between Marcuse and Žižek, *Eros and Civilization* and *On Violence* agree that eruptions of large-scale violence—what Žižek would call subjective violence—do not indicate a regression to barbarism but just the opposite. For Marcuse, these violent episodes are the result of "the unrepressed implementation of the achievements of modern science, technology, and domination" (4). He disputes the assumed connection between violence and barbarism when he asserts that "the most effective subjugation and destruction of man by man takes place at the height of civilization, when the material and intellectual attainments of mankind seem to allow the creation of a truly free world" (4). The solution, Marcuse proposes, is to return to the pleasure principle, to eroticism for its own sake—or rather, for the sake of the pleasure that is derived from eroticism. This sexualization of the "organism" (to use Marcuse's term) is intended to offset the desexualization and objectification that takes place when that organism is shaped into a socially useful instrument of labor (39). For del Paso and García Ponce, this subversive sexualization is principally shown through the erotic acts of female bodies. Male bodies participate in these acts as well, but they do not command the same level of narrative attention in either novel. This makes sense in connection with Marcuse's text, as it is female desire and sexuality that is most provocative. The pleasure principle alone becomes "frightful and terrifying" when confronted with the reality principle, but when a woman displays sexual power, she poses a danger *to the community itself* (Marcuse 67–68, my italics). The primary reaction to this fear has been to continually expand the power of the male-dominated state. As this state spreads and grows, so too does the exclusion of women from spheres of political and economic power in the name of progress and civilization.

All of these ideas can and should be questioned and problematized in greater detail, but my objective here is not to evaluate Marcuse's ideas from a contemporary point of view. Rather, I am more interested in how they influenced the philosophical and political framework from which del Paso and García Ponce wrote. To that end, I will be reading the ways in which the female muse-bodies in these texts are presented through medical discourse and how these medicalized bodies speak and are read in response to the Tlatelolco massacre and its aftermath. Their bodies are graphic (in various senses of the word) and pornographic, and their explicit nature invites

96 · Technified Muses

readers to reevaluate questions of identity on the intellectual Left after the massacre and to reexamine the confusing and conflicting official histories of Tlatelolco alongside the impossibility of coming to a full understanding of "what really happened" (to use Flaherty's term and scare quotes) in October 1968.

The slogan of the Tlatelolco massacre is "No se olvida ni se perdona" (We neither forgive nor forget), but these are negative acts—not forgetting rather than remembering. My intent is to focus on the ways in which these medicalized and eroticized muse-bodies emerge to "keep forceful watch" over the forms of art, memory, and identity construction that were produced in the wake of the student massacre. This may prove to be problematic in this chapter: La Señorita Etcétera, Mabelina, and Árqueles Vela's other female characters discussed in the first chapter were unsettling and anxiety-producing, but they were also independent, assertive, and proto-feminist (or, in the case of the señorita, a self-identified urban feminist). In a similar vein, Leonora Carrington and Remedios Varo battled their imposed status as male Surrealist–approved *femme-enfant* muses by forcefully articulating their own identities as artists and as women by way of mischievous, intelligently written, and unconventional characters and narrative personae. Meanwhile, del Paso's Estefanía and García Ponce's Mariana/María Inés are frequently presented as submissive, two-dimensional ciphers who are used physically and sexually by the male protagonists. Over the course of both novels, however, they evolve and take on a startling and revelatory three-dimensionality, particularly Estefanía. These female muse-bodies appear, act, and evolve in response to the events of Tlatelolco, highlighting the civilized barbarism (or perhaps barbaric civilization) of the massacre, and proposing alternative solutions for the future.

### Fernando del Paso: Estefanía in Wonderland

Despite the fact that the novel spans more than six hundred pages, *Palinuro de México* can be summed up fairly easily. It tells the life story and family history of Palinuro, a medical student who is shot and killed at a student protest in Mexico City's Zócalo on July 27, 1968, a day that is widely recognized as the official beginning of the student movement. This is not to imply that the novel is simple, however; it is frequently mentioned in the same critical breath with other "total novels" such as James Joyce's *Ulysses* and Thomas Pynchon's *Gravity's Rainbow*, and Latin American *novelas nuevas* (new novels) such as Julio Cortázar's *Rayuela* (*Hopscotch*, 1963);

Carlos Fuentes's *Terra nostra* (1975); Mario Vargas Llosa's *La guerra del fin del mundo* (*The War of the End of the World*, 1981), and Gabriel García Márquez's *Cien años de soledad* (*One Hundred Years of Solitude*, 1967). *Palinuro*'s narrative is winding, complex, and circular in its recounting of the protagonist's life, forming part of del Paso's literary journey toward the ideal of the *novela total*, or *novela totalizadora* (total novel, or totalizing novel) that he began with *José Trigo* in 1966.[13] Carlos Fuentes's explanation of a *novela total* is useful to me in reading del Paso since, as Fuentes puts it, these kinds of novels "inventa[n] una segunda realidad paralela" (invent a second parallel reality) that uses myths to create "un espacio para lo real" (a space for the real), which can recognize and offer insight into previously hidden truths (19). Del Paso was hardly an outlier in this sense, as the idea of a total novel was widespread in Latin American literary criticism by the 1960s. Even so, the idea of telling a greater or more complete truth through myth instead of realistic narrative is a compelling one, particularly in the case of a narrative-defying event such as Tlatelolco, as it allows the author to approach "the hidden half," the parts of the story that can never be known, only recognized and imagined. This mythic approach is particularly useful when considered alongside Joseph Campbell's assertion in *The Power of Myth* that the creation of a myth requires a connection to a physical body or bodies (28). As such, any myth that emerges from Tlatelolco in 1968 must be rooted in the bodies of those who were affected by it. Since so many of those myths are located in the male mestizo martyred bodies mentioned earlier in this chapter—and indeed, Palinuro and his double (also named Palinuro) fit that profile exactly—it is noteworthy that a significant part of del Paso's myth is told through and in connection with a female body: Estefanía, Palinuro's cousin and lover.

From the very beginning, Estefanía is established as a muse in terms of her beauty and her relationship with her cousin/lover Palinuro, as well as the fact that she is a recipient in various senses of the word. Throughout the novel, she is the primary audience for stories told by her uncle Esteban and Palinuro. These are not conversations; the men make it clear that her only role is to listen. Palinuro frequently uses her name and asks her questions, but this primarily serves to let the reader know that she is present and that he is not talking to himself, since she is rarely given the opportunity to respond. To be clear, there is nothing subversive about a self-centered man who rambles constantly while a patient woman listens . . . and listens . . . and listens. I find it significant, however, that the questions he directs to her are always requests for confirmation of her sight, hearing, and memory: *¿Lo*

98 · Technified Muses

*viste? ¿Escuchaste? ¿Te acuerdas?* (*Did you see it? Did you hear? Do you remember?*) In this respect, del Paso endows Estefanía with the muse-quality of memory, but he also underlines the fact that she is not a passive listener who will simply record and regurgitate what she is told. As a disappointed Palinuro observes, "Estefanía sí recordaba. Lo que sucedía es que no lo recordaba con las mismas palabras que yo, ni con la emoción, con la alegría o la nostalgia que yo esperaba" (435). (trans. 385; Estefanía certainly remembered. But she didn't remember with the same words as I did, nor with the excitement, happiness or nostalgia that I expected.) Estefanía is depicted with various physical and psychological shortcomings—she is nearsighted, suffers from writer's block, and becomes physically ill whenever she hears violent stories—but her memory is never called into question. Del Paso's brief description of two differing memories of the same event that are still both correct is congruent with Armando Bartra's observation that "there are many 68s" ("Revindicación de la política" [Revindication of politics]); both emphasize that there are many subjects, subjectivities, and narratives at play in the complex tapestry of a single event.

While Palinuro's stories are all oral narratives, it is Estefanía who writes things down for posterity; as such, it is she, not Palinuro, who has the power to choose what to write and how to write about it. In the end, she breaks through her writer's block and recaptures lost or disappeared adjectives in her book, which is discussed in the novel's final chapter. It is through her book that del Paso communicates the difficulties of recounting history: the title changes, the focus changes, and critiques from friends and the passage of time compel her to constantly update and edit the text without ever publishing the book. It is in her activity as a writer that Estefanía most strongly recalls Jean-Luc Nancy's muse as she both "excites" (as indicated by the reactions of those who read her drafts) and "keeps watch over the form" of the stories she tells. Ultimately, however, Estefanía realizes that a text that is constantly being updated and corrected can never be finished: any book she publishes will always be provocative, imperfect, and incomplete, as it can only provide one part of a narrative that can never be fully told. What matters is that she has told her story and preserved her truth as well as she can; her book, in turn, will spark other conversations, other memories, and other stories, bringing them into dialogue as an antidote against the deafening national silence in the days and weeks following Tlatelolco and contesting the stubbornly one-sided official discourses regarding the student movement that persist still, well into the twenty-first century.

It is also noteworthy that Estefanía is the only woman among a group of character-doubles closely connected to Palinuro. Palinuro Segundo, who looks exactly like his namesake, enters the story in the third chapter as an uninhibited and absurd counterpart to Palinuro's relatively reserved persona as a medical student, while his cousin Walter contributes a detached upper-class intellectual sensibility to the choir of voices in del Paso's text. This is done in an entirely parodical way: Walter, for example, is as socially inept as he is intelligent, rattling off long associative lists of literary, musical, and other popular culture references from his trips to Europe. His soliloquies allow him to avoid engaging with other people or topics that are not of his choosing—and he never discusses anything resembling politics.

My focus on the use of the double in *Palinuro de México* is influenced by Milica Živković's theorization of the double in literature as a product of its social and political context. Drawing from the Jungian doctrine of the shadow, in which the double is neither good nor bad but simply "a replica of one's own unknown face" (cited in Živković 126), she suggests that the double plays a slippery but nonetheless subversive role in that it suggests the desire for transformation and change. As such, the presence of the double (which may in fact be a series of doubles, as we see with Palinuro Segundo, Walter, and Estefanía) implies the recognition of other subjectivities, unknown elements of the unconscious, and memories that would be otherwise repressed or inaccessible. There is no unity of character any more than there is unity of Mexican identity or unity of a particular version of history, and del Paso's satirically constructed doubles communicate that clearly over the course of the novel.

The penultimate chapter, "Palinuro en la escalera o el arte de la comedia" (Palinuro on the stairs or the art of comedy), is perhaps the best known and most frequently studied part of the novel. In 1992, the chapter took on a life of its own when it was adapted and published separately as a stage play. *Palinuro en la escalera* has since been staged frequently in Mexico, most often in university theater programs.[14] Here, the doubles take on extra layers, as each of the characters in the novel is represented by a stock figure from the commedia dell'arte. Perhaps the most significant of these is Estefanía's pairing with the stock character Colombina, a trickster figure who is as intelligent and well-read as she is shrewd and sexually experienced.[15] In del Paso's carnivalesque chapter, Colombina is an active participant in the student movement who engages ironically and sarcastically with authority figures from the government as well as the police and

the military. Her brief appearance as the "crumbling" Mexican constitution suggests a connection between the rebellious female body and the written social code of the nation, again keeping a forceful and muse-like watch (recalling Nancy) over the form as she denounces the government attacks on the ideals contained within its own constitution. Colombina/Estefanía is the first character in the chapter to speak with protestors outside the university setting: "con los campesinos, con los obreros, con las amas de casa . . ." (598, original ellipses; with the farmers, with the workers, with the housewives . . .). She understands that the movement's failure to engage with these groups is a problem, and she organizes a powerful silent protest against the repressive push for quiet and order that is waged by the Dottore and Capitano Maldito [*sic*], using posters to relay messages from the group. Colombina's last act in the chapter is to engage in physical conflict with Capitano Maldito and Pantaleone, who represent the military and the *granaderos*, respectively. As the Capitano and Pantaleone approach Colombina and the other unarmed protesters with bayonets in hand, the final poster bears a short, ruefully fatalistic message: "¡Adiós!" (601–4). Through these stock figures, del Paso offers the reader emotional and even national distance from the tragedy by placing it in the frame of the Italian commedia and contests the notion of the young male intellectual as the canonical symbol of the tragedy at Tlatelolco. Through Colombina/Estefanía, del Paso reminds the reader that other classes, other sexes, other generations, and other bodies participated and were affected there as well.

The sexuality for which Colombina is known does not come to the forefront in chapter 24, but Estefanía is unashamedly and exuberantly sexual throughout the rest of the novel. The cousins engage in joyful and creative sexual acts without guilt or recrimination, which is very much in line with Marcusian philosophy. The only time Palinuro and Estefanía are concerned with the incest taboo is when they realize it may reflect badly on their child if their family connection is made known. They never express regret for their repeated violation of this taboo; their concern is for the social backlash that will be unleashed on the child if his parents' relationship is discovered. (The use of the masculine possessive pronoun is deliberate, as Palinuro and Estefanía always assume the child will be male.) Estefanía wishes to console Palinuro after the death of his mother, Clementina, and decides that the way to do that is to have a child with him in order to reincarnate his mother. After a struggle to conceive in which both worry about their fertility, Estefanía becomes pregnant. To her, the womb is a dangerous place that she cannot protect despite her best efforts; she spends a great deal

of time worrying about what would happen to the fetus if anything were to happen to her. Palinuro dismisses her concerns, but Estefanía's worries are rooted in her practical and professional experiences as a trained nurse (328). Palinuro may have read more medical textbooks than she has, but he passes out at the sight of blood and at autopsies, which hinders him from most actual medical practice. Estefanía, on the other hand, passes out if she reads about violent or bloody events but unflinchingly faces and treats all manner of wounds and sickness on the job. Consequently, she is not deceived by his wordplay or his stories that are intended to distract her, precisely because her knowledge of the situation is so corporeal in terms of her direct physical contact with her patients.

It is never made clear what might be wrong with the fetus. Estefanía fears that, "al igual que la Lilith del Talmud, estaba condenada a dar a luz a demonios" (328) (trans. 290; like Lilith from the Talmudic tradition, she was destined to give birth to demons), but neither she nor the text ever indicates how or why she might resemble Lilith.[16] Palinuro tries to convince her that there is no reason for anything to be wrong with the child: both parents are healthy, they have no family history of congenital defects, and they have taken all possible precautions. They track the fetus's growth and make touchingly absurd efforts to communicate with him, inserting a periscope into Estefanía's vagina so that he can have a look around outside the womb. They even decorate the room with small figures of monsters for him so that he will see the monstrous as normal. Despite their efforts, the child dies in utero in the eighth month of her pregnancy. This is the only time that Palinuro overcomes his normal queasiness; he takes on the job of extracting the lifeless fetus, which must be done in pieces. "Y así fue cómo vino al mundo nuestro primer hijo, que nació como mueren los reyes y los santos: decapitado" (335) (trans. 296; This is how our first child came into the world, born in the manner in which kings and saints die: beheaded). Drowsy from the anesthetic, Estefanía asks if the child was a monster. Palinuro responds with multisyllabic and pathological-sounding medical terminology to imply that he was, but she is not fooled. "Entonces, iba a ser un niño normal, ¿verdad?" (337) (trans. 297; So, he would have been a normal child then, wouldn't he?), she asks him sadly. Palinuro is forced to admit that he was. It is not clear exactly what "normal" means in this context, but their conversation has unsettling implications: even though a healthy woman is carrying an eight-month-old fetus with no apparent complications, illnesses, or deformities, the normality of the fetus and of the pregnancy still cannot ensure that the child will live.

102 · Technified Muses

Despite the child's mysterious death, the novel never indicates how or why the infant died, and no autopsy is ever performed on the fetus. This is particularly odd given that autopsies are commonplace in the novel before and after the miscarriage; Palinuro and his classmates Fabricio and Molkas conduct an autopsy/violation of an anonymous woman in the very next chapter. Estefanía's pregnancy and miscarriage take place in chapter 15, which begins part 2 of the novel and which closes with Estefanía crying and mourning her loss. This narrative arc foreshadows the commedia in chapter 24, which concludes with la Patria Fosforescente (Phosphorescent-Motherland) crying, much like the mythical Llorona, for her lost children who were killed or disappeared (620).

Del Paso's treatment of miscarriage, of the unexplained and unexplored death of what appears to be a perfectly healthy fetus, is significant for a number of reasons. While the pregnancy is the product of an incestual relationship between first cousins, the family does not believe in or enforce the incest taboo, though they are aware that society at large will not respond in kind. Given del Paso's interest in Marcusian ideas of societal advancement through open and often unconventional eroticism, it is unlikely that Estefanía's miscarriage is intended as any kind of moral punishment. The novel suggests various explanations for the child's death without confirming any of them, thus requiring an engaged and informed reader to reflect upon not only how the child died but what that sudden death might mean.

The child's death may be a sign of the impossibility of reincarnating the nurturing maternal figure of an ostensibly kinder and gentler past—particularly if this maternal reincarnation is to happen in a male body. Estefanía is in no way a *chingada* (following Octavio Paz's formulations of womanhood, maternity, and the violated mother/*madre patria* in *The Labyrinth of Solitude*), as her sexual relationships are entirely consensual. Neither is she presented as a holy Virgin of Guadalupe figure or a traitorous Malinche, though she does fear that she is like Lilith, Adam's rebellious and demonic first wife—who, in turn, is often linked to the Malinche. As social scientist Antonia Ávalos Torres suggests, "Los cuerpos femininos sexuados [. . .] se erigirán a emblema de la mujer pecadora, hechicera, bruja, maga y tentadora" (278; Sexed feminine bodies [. . .] become an emblem of the woman who is a sinner, enchantress, witch, magician, and temptress). Ávalos Torres establishes strong connections between Lilith, Eve, and the Malinche in Mexican culture, all of whom are linked by their "sexed feminine bodies" and often placed in opposition to the Virgin Mary (279). Despite Estefanía's concerns about being a Lilith-figure, in the novel she is

most often compared to Florence Nightingale, the British social reformer and the founder of modern nursing, creating associations that are professional in nature rather than national, mystical, or spiritual. While it might be argued that Estefanía takes on the role of La Llorona in her grief over the child's death, the connection is only partial, since she is not responsible for the child's death as La Llorona was. Neither has she been abandoned; the love that the cousins share is unconventional but constant and mutual. Estefanía's miscarriage might be considered as a nod to the idea of a "pueblo enfermo" (per the title of Alcides Arguedas's 1909 book), of a nation and a city afflicted by a societal illness that is so overwhelming that new life can no longer be produced and the memories of nurturing intergenerational relationships are difficult to sustain. Regardless of its meaning, the death of the unnamed child marks a shift in the novel, as he is the first of many characters to disappear or die under mysterious circumstances over the course of the second half. The novel ends with a stream of associative discourse from Palinuro to Estefanía, but the same three commands emerge over and over: ven, ve y avísale (go, see, and tell/warn [him/her]). As with her book, the charge of memory is passed on to her and her alone: it is Estefanía's responsibility to be present and observe, to relate and pass on the information that she has seen and the experiences that she and Palinuro have lived. Significantly, as Palinuro and del Paso indicate to us in chapter 21, we know that Estefanía will tell these stories from her point of view, not as Palinuro or anyone else wishes her to, but in her own voice, in her own words, and according to her own truth. Six years after *Palinuro de México* was published and fourteen years after the student massacre, Estefanía's female counterparts in Juan García Ponce's *Crónica de la intervención* are not as explicitly connected to political or historical events. Even so, like Estefanía, their bodies, voices, and words share the function of communicating and complicating the narratives surrounding those events.

### "Es difícil contestar a las balas" (It is difficult to respond to bullets): Female Bodies, Identities, and Circular Histories in Juan García Ponce's *Crónica de la intervención*

In Juan García Ponce's 1982 novel, as in a number of his other works, death operates as the disappearance of the body. There are many deaths and dead bodies in del Paso's *Palinuro de México*, but with the major exception of Palinuro and Estefanía's child, the bodies linger on after death as artifacts to be examined, alternately sacred, profane—that is, the opposite of spiritual,

as they are purely bodies with departed souls—and profaned by the scalpels of eager medical students. Like del Paso, García Ponce is well versed in the body, but his knowledge is drawn from his training as an artist and his work as a respected art critic.[17] As far as he is concerned, however, the body has no more stories to tell once its voice is silenced.

An analysis of *Crónica* must take the author's own body into consideration as well, which was increasingly weakened and limited after he was diagnosed with multiple sclerosis in 1966. García Ponce gradually lost the ability to walk, to write, and, near the time of his death in 2003, to speak clearly. His mind, however, remained active, and he maintained a dizzyingly busy schedule as a prolific essayist, novelist, translator, letter writer, professor, and public speaker for more than three decades after his initial diagnosis. In spite of his active academic and creative presence in Mexico City, García Ponce was considered as an author about whom "it is useless to speak of [his] political position or of the political meaning of his work" (Martré 81, translated by and cited in Johnson 47). I agree with David E. Johnson's assertion that this is inaccurate as well as unfair on Martré's part, as García Ponce's personal correspondence, notes, and newspaper essays published in the aftermath of the massacre all indicate intense personal and political concerns for the state of the nation. Like the Contemporáneos, who in many ways were his intellectual and aesthetic forebears, García Ponce drew his inspiration principally from European literature and thought, though his embrace of Marcuse, Klossowski, and Musil delved into the sort of explicit sexuality that the Contemporáneos either avoided entirely in favor of (sometimes ironic) elegies to poetry and aesthetics (as in Gilberto Owen's "Pureza" [Purity]) or would hint at indirectly (as with Xavier Villaurrutia's sailor-angels in "Nocturno de los ángeles" [Nocturne of Angels/Los Angeles]). Also like the Contemporáneos, García Ponce was more political in his writings and concerned about the state of the nation than he preferred to admit, despite the fact that he often mentioned his abhorrence of all things political in his personal correspondence, his talks, and his invited lectures—protesting, perhaps, a bit too much as he did so.

My principal focus here is on two pairs of women in *Crónica de la intervención*: Mariana and María Inés, physically identical women whose subjectivities are strangely fluid and interchangeable over the course of the novel; and Francisca and María Elvira, characters who are initially unconnected but eventually become trapped together in a psychiatric hospital on the order of the deceptively benevolent Dr. Raygadas. Both sets of doubles interact with medical discourse, primarily of a psychiatric nature, over the

course of the novel. As mentioned at the beginning of the chapter, both del Paso and García Ponce draw from Herbert Marcuse's equation of Eros and civilization, particularly when the desire and sexuality on display are female. García Ponce is explicit in his presentations of eroticism and desire, with sexual episodes repeated so frequently that the reader grows tired and desensitized to scenes that appear to have been written with the intent to titillate.[18] Upon consulting Pierre Klossowski, another of García Ponce's greatest influences, this repetition of the erotic is deliberate and serves a specific function beyond the self-indulgence of the writer or the reader. As Klossowski puts it in his readings of the Marquis de Sade, "Reiteration is at first the condition required for the monster to remain on the level of monstrosity" (30). If an erotic act is a monstrous one and its participants also monsters, this, in turn, recalls the etymology of the word "monster," which, as Donna Haraway reminds us, shares a root with "demonstrate," leading her to the suggestive conclusion that not only do monsters show, reveal, or demonstrate; additionally, "*[m]onsters signify*" (*Simians, Cyborgs, and Women* 2, my italics). This leads to a dual reading that is all the more productive if its ambiguity remains unresolved: a signifying monster may contain meaning, it may exist to communicate meaning, or it may do both at once. Furthermore, the repetition of the monstrous act must eventually lose all passion to remain transgressive (Klossowski 30), suggesting that the monster is best equipped to reveal and to signify when the viewer/reader has lost all passion (or excitement) related to its acts.

For Marcuse, redundancy was a deliberate device employed to void "two tactics of the reality principle: linear cause and effect and clear, commonsensible exposition" (Bruce-Novoa, "Eroticism" 12). This tradition of repeated, passionless, and demonstrative erotic acts as political and social critique emerges in various generations of writers, from Sade to Klossowski to Austrian writer Robert Musil (another of García Ponce's influences) in response to political upheaval and violence. The mis/behaving sexual/ized female body is frequently at the center of these texts. Her acts and desires defy the social and political order and by extension the structural violence required to maintain said order, but she tends to do so while following the orders of the male protagonist, which complicates and problematizes the subversive potential of her actions. De Sade's Juliette, Klossowski's Roberte, and Musil's Bonadea are, in many ways, literary predecessors to García Ponce's María Inés/Mariana as well as most of the female protagonists in his oeuvre. Here I encounter a problem similar to that which Angela Carter confronts in her 1979 essay *The Sadeian Woman*, albeit in a radically dif-

ferent context: *can* such representations of the female body—as available, obedient, and highly sexual—truly be read as subversive from a gendered viewpoint as well as a political and economic perspective? While exploring the relationships between these female bodies and psychiatric discourse, I am also interested in the productive and problematic possibilities that emerge upon reading García Ponce as a "moral pornographer" seeking to present a critique of the current relations between the sexes in the mid-/post-1968 context.[19] Although Marcuse and others do not consider the notion of abjection in their reflections on the erotic, the female muse-bodies discussed in this chapter all contain elements of abjection in double-edged fashion. Their abjection does not manifest as misery or shame; rather, it is more in line with Julia Kristeva's reflections in *Powers of Horror* as she declares, "It is thus not lack of cleanliness or health that causes abjection but what disturbs identity, system, order. What does not respect borders, positions, rules. The in-between, the ambiguous, the composite" (4). In this respect, the muses of this chapter—and, indeed, of this book—can be considered abject in Kristeva's double-edged and disruptive construction.

*Crónica's* first and last chapters are both titled "Con Esteban" (With Esteban), suggesting circular repetition and drawing the reader closer—the reader is *with* Esteban rather than merely reading *about* him. As the novel opens, Esteban, a photographer and cousin of the wealthy business owner José Ignacio Gonzaga, is enjoying a sexual encounter with Mariana and his best friend, Anselmo. The infamous first words of the novel are spoken by Mariana: "Quiero que me cojan todo el día y toda la noche" (I.3; I want you [both] to fuck me all day and all night long). At first it appears that García Ponce has chosen her to speak first as she vocalizes her desire, but in fact her voice and declaration are recalled by Esteban and filtered through his perception and memory, which he promptly destabilizes as he vacillates between defending and doubting his own narrative. "Lo dijo, eso fue lo que dijo. [. . .] No sé qué puedo recorder." (I.3; She said it, that's what she said. [. . .] I don't know what I remember.) Even so, the reader learns her name several pages before Esteban, as the first-person narrator, reveals his identity. As the chapter draws to a close, he ponders Mariana's words again: "Nada es real, nada existe. Todo se inventa. Pero ella lo dijo, eso fue lo que dijo. [. . .] Y fui yo." (I.28; Nothing is real, nothing exists. Everything is made up. But she said it, that's what she said. [. . .] And it was me.)

That which is affirmed at the end of the first chapter is denied at the beginning of the last chapter: "No fui yo. Y tampoco es ella la que se acostó conmigo la primera noche." (II.1538; It wasn't me. Neither is she the one

who slept with me that first night.) As in the first chapter, Esteban contradicts himself: "Pero sí es ella. Siempre es ella." (II.1538; But it *is* her. It's always her.) Esteban begins and ends the novel in the same cycle of affirmation and negation, presence and absence, certainty and doubt. He is back where he began, but his return implies no sense of stability or renewal: Mariana is dead, and thus his own identity, once so closely connected to hers, is undone and incomplete. Esteban and the country are more fragmented than ever, and the victims of the various forms of violence implied or narrated in the intervening pages have vanished without a trace.

As García Ponce narrates his novel in circular and nonlinear fashion, I find it useful to read and analyze the novel in a similar fashion. Raúl Rodríguez-Hernández draws a convincing comparison of the structure of *Crónica de la intervención* to the convolutes of Walter Benjamin's *Arcades Project* and proposes reading concentrations or constellations of episodes instead of a strictly linear reading (*Mexico's Ruins* 55–56). I have found this approach helpful in organizing my own interpretation of the novel as well. Due to its length and polyphonic nature, *Crónica de la intervención* defies easy summation, but one of the novel's principal centers of gravity and action is found in the family of José Ignacio Gonzaga, Esteban's cousin. The son of landowners who have moved from their hacienda in the countryside to own and operate a lucrative textile plant near Mexico City, José Ignacio now lives in an upscale and secluded part of the capital with his wife, María Inés, and their two children, Luis and Mercedes. Rodríguez-Hernández suggests that the family has relocated to a neighborhood that was either up-and-coming or under renovation, such as Navarte or Coyoacán (76). The family has abandoned the countryside for the metropolis, though not without nostalgia for a sense of purity, family values, and closeness that never actually existed.

The Gonzaga family's relocation, as Rodríguez-Hernández notes, "takes place in the modernizing schema of the social and economic structure of the Mexican nation, commencing in the 1950s and continuing through the 1960s and after" (*Mexico's Ruins* 76), reminding us of the socioeconomic foundation on which their story is built. José Ignacio's storyline intersects with Esteban's shortly after the novel's opening chapter, when Esteban photographs the First Communion of his cousin's children. It is there that he meets José Ignacio's wife, María Inés, who looks exactly like Mariana. Rodríguez-Hernández identifies three major axes around which the novel's fragmentary ruminations and episodes revolve: the clash of mythologies of identity and modernity when bourgeois families migrate from the coun-

tryside to the city; intergenerational conflicts and power struggles over political and social ideologies as they strive to reach or maintain a particular economic status; and finally, the class divisions between the Gonzaga clan and their servants (70). These constellations or "moving panels" of stories play out during the buildup to the 1968 Olympics and to the Tlatelolco massacre, but they generally serve as cultural wallpaper, as distant events that can easily be ignored or avoided . . . until they cannot. To quote Cantinflas, "Aquí no pasa nada, hasta que pasa" (Nothing happens here, until it happens). *Crónica's* length and numerous philosophical and erotic digressions lull the reader into a similar state of *aquí no pasa nada*, making the passage of time elastic and subjective.

The student movement, preparations and public relations for the Olympic Games (barely camouflaged here as "la Festival de la Juventud" [Youth Festival]), and the Tlatelolco massacre play out in the background, even when the events of October 2 result in the deaths of two of the main characters, Mariana and Anselmo. The buildup to state-sponsored violence runs parallel to the buildup of class violence: Evodio Martínez, chauffeur for the Gonzaga family, is plagued by auditory hallucinations of ambulance sirens and becomes increasingly obsessed with María Inés, who is barely aware of his existence. His dreams and fantasies are vivid, but his memory is porous; he quickly forgets dreams and real-life encounters in equal measure. In each of Evodio's episodes or convolutes, he becomes more disturbed and less attached to reality and to a sense of self, planted like a ticking time bomb into the textual fabric of the novel.

It is not surprising, then, when Evodio finally blows up and takes action. Near the end of the novel, as he enters the Gonzaga home and heads upstairs to claim María Inés as his own, he decides that he must kill José Ignacio first, so he goes back downstairs to find him. Evodio is aided by the invisibility granted him by his chauffeur's uniform: by the time José Ignacio registers his presence and recognizes him as a threat, it is too late. Rather than going back for María Inés, however, Evodio flees—from their home, from his home, from the city, and possibly to death by his own hand, leaving behind only his bloodstained uniform at his childhood home. The other characters express sadness over the deaths of Anselmo, Mariana, and José Ignacio, but their lack of anger at the agents of their deaths is surprising. Indeed, the bodies are largely erased regardless of the roles they played in the novel: María Inés knows that Evodio Martínez killed her husband, but she does not call the police or interact with them at all when they come

The Medicalized Muses of Tlatelolco · 109

to investigate. She tries to remember Evodio and cannot envision his face, even though he had worked as their chauffeur for years.

Ultimately, María Inés decides she does not wish to know anything else about Evodio. For her, "ya no existía, su propia historia era la que había desaparecido, cada uno de sus detalles se había borrado para siempre" (II.1500; he no longer existed, his own story had disappeared; each of its details had been erased forever). There is a police investigation, but a perfunctory one that, as the novel suggests, is obligatory due to José Ignacio's social status. His widow, family, and friends do not engage with the police and do not demand justice for his death. Evodio's siblings and acquaintances, most of whom are involved in the student movement, tell the police as little as possible. They do not do this out of class-related hatred toward José Ignacio or familial loyalty to Evodio but out of simple distrust of the police and the oppressive state that they serve. The most disturbing element of Evodio's apparent evaporation is that it is not only corporeal; it is *he*, his sense of self, and his very history that are wiped out. García Ponce does this *grammatically*, erasing him via an implacable string of pluperfect subjunctive clauses: "era como si nunca hubiera jugado en su antiguo barrio miserable [. . .] como si nunca hubiera ido a la escuela [. . .] como si nunca, jamás, hubiera visto a María Inés" (II.1500–501; it was as if he had never played in his miserable old neighborhood [. . .] as if he had never gone to school [. . .] as if he had never, ever seen María Inés). The book offers various possibilities as to who or what has erased him: it might have been María Inés from her position of greater socioeconomic power, the simple passage of time, Evodio's poor memory, his working-class status, his mental illness, or a combination of all of these factors. He ceases to exist, the narrator tells us, "no sólo porque quizás Evodio hubiera muerto sino también porque, si no había muerto, él mismo había perdido todo recuerdo de su persona" (II.1501; not only because Evodio might have died, but also because, even if he had not died, he had lost all memory of himself). Evodio's loss of memory goes far beyond the act of violence he committed to eclipse his entire existence. Even so, the results of his actions remain, as no amount of erasure, self-imposed or otherwise, can bring José Ignacio back from the dead.

Interestingly, *Crónica de la intervención* presents the deaths and consequent disappearances of Anselmo and Mariana in parallel fashion to Evodio's departure, as if to contrast the two situations. In spite of their status as innocent victims gunned down by soldiers in Tlatelolco, Anselmo and

Mariana's bodies evaporate after death much as Evodio's did. Although Esteban mourns their deaths, they, like Evodio, lose their individuality and subjectivity upon dying. It is clear that they are dead, but their bodies are never found. After a long and fruitless search, Esteban ends up at a makeshift morgue near the Plaza de Tlatelolco with a number of unidentified cadavers. He concludes that

> [t]odos eran nadie; eran una sola persona en la que se reunían las edades, los sexos, la condición social; las víctimas, sólo eran las víctimas de un horror sin nombre: el horror de la muerte, el horror que rehúye y niega toda posibilidad de significado.
>
> (II.1437; [t]hey were nobody; they were a single person made up of all ages, sexes, and social conditions; the victims were only the victims of a nameless horror: the horror of death, the horror that avoids and denies all possibility of meaning.)

There is no anger, no blame, no accusation, no call for justice, and no singling out of any responsible individuals or parties. The dead become a single person, but the individuals responsible for those deaths are not even described as people but a "nameless horror" that strips any meaning from the deaths they cause. The dead are not sacrifices for any particular cause or ideology; death is nothing more or less than a great equalizer.

Despite the notion that the murderers and the murder victims are united and conflated by their acts and experiences, *Crónica* singles out at least one agent of state violence. Earlier in the novel, García Ponce described the face of the decaying and unsuccessful Revolution as "un abogaducho con gruesos lentes que parecía tener hacia fuera su propia calavera" (a second-rate lawyer with thick glasses and a skull-like face) in a clear reference to President Díaz Ordaz, but this rumination is made by the unnamed third-person narrator, a voice that occasionally reveals a meta-awareness of itself and its role in constructing the novel (II.1340). There is no such anger or mockery in Esteban, only resignation. He is convinced that the student movement is destined to the same fate as the anonymous dead: "Toda organización social, toda institución civil tenía como único fin negarse a sí misma y esa irrealidad era su realidad como muy pronto la realidad de la protesta estudiantil sería su disolución en una serie de contradicciones." (II.1439; All social organizations, all civil institutions could only deny themselves in the end. This unreality was their reality, just as the reality of the student movement would soon dissolve into a series of contradictions.)

The Medicalized Muses of Tlatelolco · 111

This dissolution of the dead can be traced back to the book's earliest chapters as García Ponce draws from Sor Juana Inés de la Cruz's Sonnet #145 ("Este que ves" [The object which you see]): "detrás del simulacro, del *cauteloso engaño del sentido* que pretende *excusar los años de horrores,* [. . .] no se encuentran más que el polvo, la sombra, la nada" (I.150, original italics; behind the simulacrum, the *careful subversion of meaning* that attempts to *excuse the years of horrors,* [. . .] you will find nothing more than dust, shadow, nothingness). The ongoing erasure of perpetrators and victims alike forms the novel's philosophical foundation and is explored over and over again in circular and ultimately resigned fashion. In the end, the only character who defies this dissolution is Mariana. Esteban spends the last pages of the novel remembering all he can about her. Strikingly, his evocation of her memory is intermingled with memories of the Tlatelolco massacre.

> Ha habido un asesinato colectivo y muchos sucesos y muertes particulares. Por eso igual que acabo de verte mía sin ser mía y encontrándome sin embargo en ti, yo podría suponer que te llamabas Mariana o María Inés e imaginar que te vi por primera vez.

> (II.1559–60; There had been a collective murder and many individual events and deaths. As such, in the same way that I have just seen you as mine without being mine and nonetheless finding myself in you, I could imagine that your name was Mariana or María Inés and imagine that I had seen you for the first time.)

Esteban then erases *himself* from his memories of her and starts over; he imagines Mariana in great detail as if they had met under different and more decorous circumstances than the sexual romp outlined in the first pages of the novel.

Esteban's revised narrative hews more closely to Mexican middle-class conventions, at least at first: they meet when she stops by the office where he and Anselmo work. Anselmo is reshaped as well; rather than being presented as Esteban's childhood friend, he is now Mariana's husband. Esteban and Anselmo are different in this reimagining of events, but Mariana and María Inés remain the same, which establishes the women's identities and selves as a singular yet dual locus of gravity for the formation of Esteban's own history and sense of identity. Their sexual affair—the word "love" almost never comes up in the novel, avoided even more scrupulously than the word "Mexico"—is presented as inevitable, as an encounter that can-

112 · Technified Muses

not be erased through violence, death, or the passage of time. "[I]nventán-
dote me inventaría" (By inventing you, I would invent myself) is a frequent
refrain uttered between José Ignacio, María Inés, Esteban, and Mariana
at various points in the novel, establishing a feedback loop of identity in
which the origin is unclear. Esteban repeats the phrase in the final chapter
as he recalls Mariana's physical body—and as such, María Inés's body—in
great detail. If their history were to unfold this way instead, he declares,
"ésa sería otra novela. Y también la misma." (II.1562; this would be another
novel. And also the same one.) The implications of this statement are sig-
nificant: the nation is doomed to continue on its destructive path, yet it
establishes María Inés/Mariana and their erotic inclinations as the only
enduring elements in this downward spiral of fragmentation and erasure.
Desire, particularly female desire, is the only constant.

Esteban fleshes out these ideas of desire and connection early in the
novel:

> Me sorprende la inclinación que sin advertirlo tenemos todos de ver
> realizados nuestros deseos en otros. Es como si, entonces, los otros
> nos afirmaran. Y a su vez, el que realiza el deseo, de un modo igual-
> mente inconsciente, procede por imitación. O sea, juega a ser el otro.

> (I.124; I am surprised by the unconscious tendency we all have to see
> our desires fulfilled in others. It is, then, as if others affirmed us. At the
> same time, in an equally unconscious way, one who fulfills this desire
> does so by imitation. That is to say, he plays at being the other.)

As a result of these acts of desiring and offering affirmation through imi-
tation, Esteban concludes, "De esto podría inferirse que no somos nadie"
(I.124; We can infer from this that we are no one). This strange feedback
loop of identity construction in relationships appears to be a dead end,
doomed to destruction and fragmentation like everything else in the
novel: the city's residents and buildings, the institutions and myths of the
nation, and the nation itself. Esteban recognizes the dead-end potential
of this feedback loop but insists that "ocurre lo contrario. La sociedad, la
civilización, la cultura están construidas sobre una inversión de nuestros
auténticos deseos." (I.124; the opposite happens. Society, civilization, and
culture are built upon the reversal of our own authentic desires.) Drawing
from Marcuse's proposal that Eros is a path to civilization rather than a
disruptive element that opposes it, García Ponce establishes desire as the
foundation upon which civilization and society may be successfully built.

Admittedly, the idea that the desiring and subversive erotic female body and subjectivity must be shaped by the projections of the desiring male gaze does not sound particularly progressive at first blush. Despite the problematic portrayals of María Inés and Mariana, García Ponce also creates the possibility for equality by setting up identity construction (which is the basis of a peaceful and nonoppressive civilization) as a simultaneous and ongoing series of feedback loops between desired and desiring subjects in which the point of origin is never explicitly established.

To circle back one last time: as mentioned earlier in this section, psychiatric discourse is a thread that connects nearly all of the upper-middle-class female characters in the novel, and they all see the same psychiatrist: Dr. Raygadas. María Inés attempts to seduce him (more out of habit than desire) but never succeeds. He is presented as a scrupulous and dedicated professional, with a disconcerting insistence on his own neutrality and invisibility as part of the therapeutic process. For Raygadas, "el psicoanálisis es un diálogo entre el lenguaje, que sale involuntariamente [. . .] y un sillón que lo escucha impávido e inconmovible" (II.1216; psychoanalysis is a dialogue between language, which comes out involuntarily [. . .] and a chair, which listens without reacting or showing emotion). He believes that his job begins after the patient has departed, when he listens to the tape recording of her session so as not to be distracted by her appearance. His only male patient is Esteban, who attends one session and refuses to return despite Raygadas's numerous and increasingly insistent requests that he do so.

Two of Raygadas's female patients are, in a sense, the antidoubles of Mariana and María Inés: Francisca Pimentel, an editor, writer, and drug addict who is married to the poet Enrique Alcocer, and María Elvira Pedrales, whose primary identity appears to be her role as the wife of Rodrigo Pedrales, head of public relations for various industries in which José Ignacio Gonzaga is a stockholder. Francisca is the more developed of the two characters and as such is the one who interests me most for the purposes of this thread of my analysis.[20] If we consider Živković's proposal that the double in literature is an expression of a desire for social change (as we did with the doubles in *Palinuro de México*), Francisca is the most suggestive and unsettling of the desired and desiring female muse-bodies in *Crónica de la intervención*. She frequently creates chaos in her own life and the lives of others, but unlike the other female characters in the novel, she "forcefully keeps watch" over her own form, her own story, and, most notably, her own written production.

114 · Technified Muses

Through Francisca, her husband, Enrique, and the members of their intellectual and social circle, García Ponce establishes a pointed critique of the writing establishment in Mexico. Enrique Alcocer considers himself to be the poet and the writer in the relationship and spends most of his time reading his long, mediocre poems to one captive audience after another. We soon learn, however, that Francisca is the better writer of the two, as indicated by the critical and commercial success of her first collection of short stories, which she publishes under the portentous title *El triunfo envenenado* (Poisoned triumph). Enrique, unsettled by the birth of their two children and her professional success, becomes increasingly withdrawn and sullen. Francisca is upset by his behavior and tells Dr. Raygadas that "yo hubiera cambiado hasta eso [su éxito como escritora] porque me mirase realmente y nuestros hijos existieran para los dos" (I.534; I would have even changed that [her success as a writer] so that he would really look at me and our children would exist for both of us). Power struggles between writing couples are nothing new, nor is the idea of writing as a so-called masculine activity that can negate or clash with a woman's supposedly innate marital and maternal instincts. Even so, this is the first and only time this sort of dynamic occurs between a couple in García Ponce's novel, which indicates that Francisca has an entirely different function in the novel than María Inés/Mariana. Francisca and María Elvira engage in sexual acts with various partners, but their acts are never on display for the reader as María Inés's and Mariana's are, nor do they conform to the Klossowski-inspired paradigm for the eternally available and seductive female figure.

García Ponce creates a unique relationship between Francisca and her own story and voice, as captured during her recorded sessions with Dr. Raygadas. Her twice-weekly hourlong monologues "abrían para ella [. . .] un tiempo mental del que le era imposible tocar el fondo" (opened for her [. . .] a mental time that seemed bottomless), plunging her into a "confuso abismo de recuerdos, sueños, deseos frustrados, deseos realizados, transgresiones, inexplicables obediencias, imperdonables desobediencias, inocentes y culpables vuelos de la imaginación" (I.495; a confusing abyss of memories, dreams, frustrated desires, fulfilled desires, transgressions, inexplicable acts of obedience, unforgivable acts of disobedience, innocent and guilty flights of fancy). She goes to therapy to seek help for her drug abuse, but the sessions do not uncover the reasons behind her actions or provide her with a path to sobriety. Instead, Francisca develops a paralyzing case of writer's block, takes a series of lovers (Esteban among them),

quits her job, leaves her husband, and returns to her hometown with her children to find more time to write, all while her drug addiction spirals more and more out of control. There is no implication of hedonism, spiritualism, quests for creativity in her drug usage; rather, she seems to be trying to self-medicate her way to functionality with a variety of stimulants and depressants, exhibiting behavior that looks very much like clinical depression and anxiety. Andrea Nicki's work on feminist theory, psychiatric discourse, and trauma offers a useful framework from which to read García Ponce's representations of mental illness. Nicki poses that mental illness is both "difficulties in social adaptation" (a term she borrows from Thomas Szasz's 1975 essay *The Myth of Mental Illness*) *and* a biochemical disorder that can be provoked or exacerbated by external, structural factors (80–82). Initially, we are not sure if Francisca is mentally ill or if she is simply being treated as such by the men in her life and the patriarchal and ableist structure of the society she occupies. There may or may not have been a biochemical disorder to begin with, but it soon becomes clear that her health is severely compromised by the toxic social and medical environments she occupies.

Francisca's return to her hometown provides no relief and has no effect on her writer's block; instead, she sinks into a near-catatonic state and is involuntarily institutionalized in a public hospital in Mexico City. Esteban, summoned by Francisca's unnamed sister, helps her turn Francisca over to Dr. Raygadas and Dr. X, though they do so with a great deal of trepidation. Their concerns are justified: Esteban and Francisca's sister soon learn that the responsibility for Francisca's care has been signed over to the hospital, meaning that the doctors have sole authority over her diagnosis, treatment, and date of discharge. As she is being checked in, Francisca comes back to herself and tries to leave, but she is quickly drugged into submission. While it would be easy to read this episode as merely one more example of an institution swallowing up an individual, García Ponce upholds the institutional critique while warning against its depersonalization. "Lo malo es no creer en las instituciones" (II.1270; It is a mistake to not believe in institutions), he warns us through Esteban, "porque todos nosotros somos una institución, cercada y creada por nuestro cuerpo en último extremo" (because all of us are an institution, ultimately surrounded and created by our own bodies). Esteban's statement complicates the narrative, avoiding simplistic binaries of good/evil and oppressor/oppressed. Magda Díaz y Morales has noted that García Ponce creates a sense of complicity in the

reader as voyeur to the erotic and artistic elements of the narrative in all of his works (23), but this complicity is heightened and more explicitly political in *Crónica*. If we are all an institution, then we are all responsible for that which happens as a result, despite the tendency—which García Ponce himself displays in other parts of the novel—to read institutions (the hospital, the police, the government) as nameless, faceless forces of nature.

The apparent safety and vulnerability of each of the pairs of women come into play throughout *Crónica* as well. María Inés and Mariana are presented as untouchable in the sense that they are never mistreated or abused: their sexual encounters are completely consensual, and their relationships are symbiotic, functional, and mutually satisfying. There is a sense of invulnerability about them, as they are never at risk of rape, assault, disease, or undesired pregnancy. Francisca, meanwhile, is frighteningly vulnerable, and becomes even more so once she enters the hospital. She cannot check herself out, and neither can any of her friends or family. Only the doctors have that authority, and it soon becomes clear that they have no intention of releasing her. Her diagnosis of insanity disenfranchises her before the check-in process is even completed: she is ignored, restrained, drugged, and placed in a room with no locks on the doors.

Francisca's counterpart, María Elvira Pedrales, is similarly drugged and committed to the same institution after two suicide attempts (II.1278). Their hospital stay recalls, at least in part, Surrealist painter Leonora Carrington's real-life institutionalization as recounted in *Down Below*.[21] The women are drugged without their awareness or consent, sexually assaulted, and physically mistreated. Eventually, both take refuge in a fantasy world and in each other: María Elvira believes herself to be Queen of Navarre while Francisca decides that she is Saint Teresa of Ávila, and the two women, who were chilly acquaintances at best in the outside world, become lovers.

When Esteban is finally allowed to visit Francisca, he discovers the two of them together and realizes that "no lo reconocieron y no parecían dispuestos a aceptar regalos de cualquier extraño" (II.1289; they did not recognize him and did not seem inclined to accept gifts from a stranger). The primary difference is that Carrington regains her sanity and escapes to tell her story. Francisca and María Elvira, meanwhile, are abandoned by Esteban and the narrator; he never returns to visit them again. As perceived by Esteban, the scene conforms to André Breton's assertion that madness is a pleasant state for those who are insane, and that it is precisely these

"regressed" individuals who best represent the battle against the Cartesian subject of bourgeois liberal ideology (*Manifestoes* 5). While García Ponce might appear to be extending this tradition into a later Mexican context as he plays up the romance of their madness, he ultimately turns Breton's idea of insanity-as-rebellion on its head by leaving them, unprotected and disconnected from reality, in the clutches of the public sanitarium—that is, in another regulatory institution of the state. When Mariana leaves Esteban for the last time (before she is killed in Tlatelolco), he notes a feeling of unease similar to that which he felt upon leaving Francisca and María Elvira—that Mariana, like the other two women, had become "ausentes de la realidad" (II.1360; absent from reality), implying the presence of grave trauma in each situation. To become absent from reality, then, implies no resistance or transgression, only erasure.

Additional parallels may be drawn between Francisca's and María Elvira's experiences and André Breton's *Nadja*, in which the initially beguiling titular character reaches inappropriate, alarming, or uninteresting levels of insanity and falls victim to psychiatry. Breton unleashes a diatribe against the medical institution that has imprisoned her, but he makes no attempt to free her or even to see her again. In her analysis of Breton's novel, Natalya Lusty suggests that "Nadja serves as a prop to unite Breton with the collective social past represented by Parisian revolutionary history [. . .] [and] brings Breton closer to the key intellectual and social paradigms of his life up to this point" (*Surrealism* 4). García Ponce, meanwhile, takes an opposing stance: the women who are driven mad (or merely labeled as such) by a public institution can tell no stories. Nor can they connect with the past, at least in the revolutionary sense. Instead, in a quixotic gesture, Francisca and María Elvira take refuge from reality, from the present, and from the country itself by assuming the identities of two sixteenth-century Spanish women—a mystic nun-saint and a queen. Like Don Quixote, however, their mental departures from reality do not guarantee them any physical protection from the institute they still must inhabit.

## Conclusion

*Palinuro de México* and *Crónica de la intervención* stress the importance of individual, subjective, and contradictory versions of events to recount, recall, and reassess traumatic events. Del Paso and García Ponce provide the reader with a number of Žižekian sideways glances at the buildup to and

the fallout from Tlatelolco rather than facing it dead-on, from Marcusian Eros to the Italian commedia dell'arte to Joyce- and Klossowski-inspired characters and prose. The characters are storytellers who struggle to narrate their own versions of events and who are hindered by a variety of factors that detach them from reality or from a sense of self: exterior criticism and internal anxiety (as in the case of Estefanía's text); class-driven invisibility (Evodio and the women connected to him); state-sponsored madness (Francisca and María Elvira); and apathetic avoidance (Palinuro, Esteban, José Ignacio, María Inés, and Mariana). This sense of detachment will only increase in the final chapter, in which the physical body and consciousness are increasingly distanced from one another and from their sociopolitical environment. This distance does not imply a sense of protection or safety, however—indeed, with this distance and lack of awareness comes a heightened sense of vulnerability and danger to the bodies involved.

# 4

# Muses of the Virtual Metropolis

## Fragmented Bodies, Cities, and Selves in Bernardo Fernández (BEF)'s *Gel azul*, Guadalupe Nettel's *El huésped*, and Karen Chacek's *La caída de los pájaros*

### Years 1968–1994: In the Interim

In the lead-up to the 1968 Olympic Games, Mexico strove to present itself as a nation "that was modern and cosmopolitan as well as steeped in culture and tradition" (Witherspoon 6). Although the Olympics themselves went off with hardly a glitch (Tlatelolco notwithstanding) and Mexico won praise from a number of world leaders and the pope himself for the way the Games were organized, the long-term economic effects, particularly on Mexico City, were less positive. The country had come up short by at least $60.7 million when ticket sales, advertising, and other sources of income were figured into the total spent ($153.2 million) (Witherspoon 144). It is debatable how much of an impact the overspending on the Olympics had on the nation's economy as a whole, but Mexico's plunge into a series of economic crises in the 1970s and 1980s, driven largely by a various oil crises and ever-growing foreign debt, is without dispute.[1] As Jennifer Lewis astutely observes, even though the student protests cracked open the political system in such a way as to make it impossible for the Mexican state to claim the sort of paternal authority it had in the past,[2] the only result was "a new, aggressively anti-egalitarian structure [. . .] founded on state-sanctioned corruption" (137). Samuel Steinberg takes Lewis's analysis one step further and questions the extent to which the political system was "cracked open" at all. Rather, he asserts, "the PRI's endurance *benefitted* from the massacre" (*Photopoetics* 14, my italics), an argument bolstered by the fact that the PRI would remain in power for the rest of the twentieth century.

By the 1990s, Mexico's economy had declined to the point that it ultimately resulted in the devaluation of the peso in 1994. Luis Donaldo Colosio, the heir apparent to the presidency, was assassinated in Tijuana in March of the same year, and the torch was uneasily passed to Ernesto Ze-

120 · Technified Muses

dillo. The day that NAFTA was implemented—January 1, 1994—also marks the Zapatista uprising in Chiapas as Subcomandante Marcos declared war on the Mexican state from the Lacandón Jungle. As Thea Pitman notes, the Zapatistas swiftly pivoted from violent protest to "social netwar" (82), a concept developed by military strategists David Ronfeldt and John Arquilla in their analysis of the Zapatistas. Netwar, by their definition, is "an emerging mode of conflict and crime at societal levels, [. . .] in which the protagonists use network forms of organization and related doctrine, strategies, and technologies" (cited in Pitman 88). "Social netwar" is a form of netwar conducted by members of civil society. This is not unique or particular to the internet, of course, and Pitman is careful to note that while the internet is used to create new forms of social protest and nonhierarchical networks, it is a tool, not the entire battlefield (88). Nonetheless, the term "cyberguerrilla" was so tempting for journalists to apply to the Zapatistas that many of them did so anyway.

This fourth and final chapter offers an analysis of three literary responses to the post-NAFTA era. Here, the muses emerge from post-1994 novels that draw from various aspects of what might be categorized as "genre" literature: cyberpunk, detective fiction, science fiction, and the fantastic genre, all of which are well-suited to explore the (mostly) post-PRI twenty-first century in Mexico City. *Gel azul* (2005) by Bernardo (BEF) Fernández, *El huésped* (2006) by Guadalupe Nettel, and *La caída de los pájaros* (2014) by Karen Chacek offer important counterpoints to existing anthropological, sociological, and cultural studies on a number of issues facing contemporary urban Mexico: overcrowding, violence, globalization, imperialism, drug wars, and the influence of the internet and other developing technologies that impact and transform the ways in which people interact, work, and create.

All three novels work from the margins of the literary canon and across postmodern and posthuman representations of the female figure to construct a nuanced interrogation of national culture, class structure, and ways of being in an ever-changing urban context. Unlike the members of the McOndo movement across Latin America or the Crack movement in Mexico, these authors do not operate from a literary manifesto platform or form part of a traditional literary generation. Born in the early 1970s, they are part of what Emily Hind has denominated "la Generación XXX," a label that "capta el cosmopolitismo, el individualismo y el desánimo generacional de estos pensadores mexicanos algo soliario" (12; captures the

cosmopolitism, the individualism, and the generational disillusionment of these somewhat solitary Mexican thinkers) who were born in that decade.

All three novels utilize a wide variety of genres and intertextual references to present violence and trauma in ways that complicate and subvert what Glen S. Close and Ignacio Sánchez Prado refer to as "a long-standing foreign identification of Latin America as a realm of 'exotic violence'" (Close 56). Without denying or diminishing the very real impact of violence in its various forms, this approach provides another of the Žižekian "sideways glances" at the situations described, as was discussed in chapter 3. In contrast with the events of Tlatelolco, which are firmly rooted in a specific date, these twenty-first-century texts present time as undeclared, uncertain, and multilayered; historical events that actually happened years apart are described or referenced as if they had occurred simultaneously, or very nearly so. There is no single central episode of violence in the texts as there was in the 1968 novels. While one could argue that 1994 constitutes another singular episode, this is belied by the ways in which violence is represented in these post-1994 texts. Rather than portraying violence as an anomaly or shocking departure from everyday life, in these narratives it is constant, capricious, and unremarkable. All three texts display a distinct shift of focus from a single, catastrophic event to a series of explorations of the social, political, economic, and urban structures that permit and even facilitate this kind of quotidian trauma.

The textual representations of the urban space of Mexico City and the geographic and cultural borders of Mexico are especially interesting to me here as well. In the first chapter, the Estridentistas and the Contemporáneos tended to write around the country rather than about it, naming few or no names (but leaving enough hints in the narrative that those who were familiar with Mexico City and Mexico would recognize them) even as they created largely symbiotic relationships with the technological infrastructure that was taking shape in the capital city. Carrington and Varo, meanwhile, hardly focused on the urban landscape at all, preferring instead to shape their surroundings to match their dreamscapes. Del Paso presents a microscopically detailed re-creation of the city's streets and plazas, while García Ponce draws from his Contemporáneos forebears, describing a place that must be Mexico City and a country that must be Mexico without ever explicitly naming them as such.

In this chapter, the authors engage with the city in very different ways. Fernández unmoors Mexico City from the country and transforms it into

a *Blade Runner*–style dystopia even as he implies, somewhat sardonically, that this futuristic nightmare is not so different from the present in which he writes. Nettel, on the other hand, delves into the very fabric and cartography of the city to create a multileveled itinerary through its streets, its apartment buildings, and its metro stations to situate and disorient the reader in time and space. Chacek's city is an impossible dream-space that cannot possibly be Mexico City and yet cannot possibly be anywhere else, always explored on foot or on public transport and at eye level. For every specific anchoring detail in the protagonist Violeta's travels through the metropolis, another one emerges that contradicts it or calls it into doubt, keeping the first-person narrator and the reader off-balance and on guard.

In this chapter, the female body serves as the center of gravity for each of the texts in my corpus, as do the spaces and contexts in which those bodies operate, keeping in mind that all of these bodies are intimately connected to virtual or imagined spaces. The idea of a body separated from its conscious mind is not unusual; indeed, as discussed in chapter 3, García Ponce's *Crónica de la intervención* toyed with the idea of two identities that could pass between one identical body and another, thus creating the philosophical bedrock of the entire novel. The mind-body separation is different in each work; in Nettel's *El huésped*, the narrator is forcibly and unpredictably separated from her body by a rebellious alter ego called La Cosa. Fernández's Gloria, meanwhile, initially appears as a spoiled little rich girl who spends her time disconnected from her body while her mind roams through cyberspace, a privilege granted by her upper-class status. Fernández reminds us, however, that the privilege that permits her to engage in this mind/body division is precisely that which leaves her body most vulnerable to harm. Lastly, Chacek's young freelance journalist Violeta is divided in two as she comes face to face with her younger self after surviving a terrible subway accident.

In their physical and mental separations and schisms, all three characters recall Deleuze and Guattari's schizophrenic bodies produced by late twentieth-century capitalism, as explained in *Anti-Oedipus*. This is not a dismissal of the female body as hysterical, unreliable, or otherwise unstable, as the category of the schizophrenic is defined by corporeality and not sex or gender. Rather, these bodies transform constructions and possibilities of time in narrative, which is particularly suggestive when they are read through a gendered lens. Deleuze and Guattari assert that the "either . . . or . . . or" of the schizophrenic takes over from the "and then" (12), which allows for simultaneity, creativity, complexity, and something closer

to a collection of mosaic stories (rather than a single monolithic Truth) to interpret that which we see or read, particularly in terms of historical narrative.

The final question that I wish to explore here is how to read injury and trauma when the subjects are separated from pain (and thus awareness) of the harm that has been done. What does it mean when the body is injured but no wound is perceived? How can one process that which is not felt, and when is it productive to confront (and therefore feel) the physical or emotional trauma that one has (either deliberately or inadvertently) avoided for so long? Each muse body provides the author with a launching pad from which to explore issues of violence, memory, and the physical and psychological spaces in which these events occur. Each text engages with well-known elements of various genres (cyberpunk, detective fiction, popular fiction, and the fantastic) to address violence in a way that, coincidentally or not, lines up with posthuman frameworks of reading violence. As Rosi Braidotti, Shela Sheikh, and other posthuman scholars have posed, these frameworks encompass the hypervisible (with a direct line between the aggressor and the victim) and the hyperinvisible (violence that is nonlinear and may not have a visible agent, weapon, or witness) (Sheikh 449–50). As these posthuman constructions challenge and expand conventional modes of understanding violence and trauma, so too do they challenge and expand concepts of post/humanity.

## The (Organic) Agony and the (Virtual) Ecstasy: Anesthetized Amputations and Desiring Avatars in Bernardo Fernández's *Gel azul*

In the *Bhagavad Gita,* Krishna explains, "When goodness grows weak, when evil increases, I make myself a body" (50). He appears, in other words, as an avatar, which in Sanskrit means "descent" and refers to the descent of a divinity from heaven to earth. While the average cyberspace avatar is generally far from sacred, the idea of an avatar as a body created for the purpose of addressing evil is a useful starting point from which to read Fernández's explorations of injustice, violence, dis/embodiment, and identity.

The characters in *Gel azul* are divided, essentially, into those who have access to cyberspace and those who do not. As in most fictional virtual worlds, that access is granted or restricted along socioeconomic class lines, since its inhabitants are either the very rich (primarily businessmen and their families) who use it for entertainment, or those who enter cyberspace

124 · Technified Muses

for work, mainly journalists.[3] This privilege involves a great deal of vulnerability, however; while the mind roams cyberspace, the physical body is abandoned, encased in a clear Plexiglas container filled with blue proteinic gel and hooked up to wires and microbots that maintain the body. Thus, the users are left helpless and unaware in the face of trauma, since the controls are located outside the cylinder and out of the user's reach. Thanks to the rising demand for prosthetic limbs, which was created by the global war that broke out when drugs were legalized and the world's economy collapsed, it is increasingly common for cybernauts to return from cyberspace to find one or more limbs amputated, harvested to be sold on the black market as organic prosthetics.[4]

At the beginning of the *Gel azul*, Gloria Cubil, the daughter of the CEO of a large transnational corporation, meanders through cyberspace, changing physical forms as it suits her. Back in the physical world, a technician's visit to the apartment finds her in the tank with the body of her drowned infant floating alongside her. Despite Gloria's intense focus on the physical sensations of the various forms she assumes, her rape, impregnation, gestation, and labor are almost beyond the realm of her perception. Though Gloria suspects that something has happened to her body, she has no desire to find out what has happened to her, and she is never required to do so. Despite her disengagement, it is her trauma that sets off the entire novel, and it is her body around which the plot revolves.

The case falls to J. Crajales, a cranky private detective and former hacker who seems directly descended from private detective Héctor Belascoarán Shayne, one of writer Paco Ignacio Taibo II's best-known recurring characters in his Mexico City–based noir fiction,[5] as well as William Gibson's computer cowboy/hacker Case in *Neuromancer*.[6] Like Case, Crajales was caught committing a crime in cyberspace and was punished by being physically injured so that he would never be able to enter it again. Fernández's Crajales, like Taibo's Belascoarán, may be read as homage, departure, and parody by turns of famous North American hard-boiled noir detectives of previous generations, most notably Raymond Chandler's Philip Marlowe and Dashiell Hammett's Sam Spade. Once Crajales takes Gloria's case, the captain with whom he first speaks (Capitán Barajas, another classic hard-boiled figure) is *deactivated* shortly thereafter (*dar de baja* is the term used in the novel), drugged so that his ability to speak and think coherently is permanently destroyed. With Barajas out of the way, his incompetent (or perhaps more easily bribed) assistant, Martínez, is promoted to captain. Eduardo Anaya, the technician who first found Gloria and her child float-

ing in the tank, is *averiado* (broken down) and is incapacitated in similar fashion before Crajales can interview him. The doctors at the hospital assure Crajales that Anaya is simply in a severe state of shock, but the detective confirms through a series of underground connections that Anaya and Barajas have been drugged to silence them, their minds forever damaged, deactivated like rogue machines.

Gloria's situation provokes a number of questions. If, as Sadie Plant has asserted, cyberpunk has disrupted the Cartesian opposition of mind to body so that "the brain *is* body [. . .] virtually interconnected with matters of other bodies [such as] traffic flows, city streets, [and] data streams" (2), how might one read the physical dismemberment of those who most actively participate in this brave new world? Second, Mexico City, like any large urban area, is a place in which everyone, particularly the very wealthy, is focused on self-protection. If the act of entering the tank (and by extension cyberspace) leaves the body so utterly helpless, why do so in the first place? What does it mean that one of the greatest markers of wealth and privilege leaves its users so vulnerable?

Edmundo Paz Soldán explored similar questions in the context of Bolivian history and memory in his Río Fugitivo novels (*Sueños digitales* [Dreamprints], 2001, and *El delirio de Turing* [Turing's delirium], 2003). Generally speaking, the characters in Paz Soldán's novels escape to his virtual Playground for two reasons: to incite rebellion or to distance themselves from the historical guilt of the past.[7] The connections between Paz Soldán's cybernauts and the state are more clearly drawn than in Fernández's novel; there is little guilt or rebellion in Fernández's version of cyberspace. Furthermore, the vulnerability of Fernández's cybernauts is heightened since the user cannot enter or leave cyberspace independently; someone else must put them in the tube, send them into cyberspace, bring them back, and let them out again. The other virtual reality (VR) worlds that I have mentioned here—Stephensen's Metaverse, Paz Soldán's Playground, and Gibson's cyberspace—allow their users to connect and disconnect on their own. In Fernández's cyberspace, however, the user is dependent on someone else for survival from the moment they step into the tube, underlining the fragility of the human body and the complex networks of relationships and power that connect citizens within and across socioeconomic strata.

In the profane sense, Fernández turns Krishna's statement inside out: the body sent down is Gloria's, and it is her body—and the violation and impregnation thereof—that serves as a springboard for the entire novel. Gloria's body is not there to save anyone, however; instead, it is an endur-

ing symbol of her retreat from the physical world. At the same time, her body is simultaneously eroticized and sanctified by the men who observe her, as demonstrated by an early description offered by Eduardo Anaya, the technician who tends to Gloria's body and tank: "Con los ojos cerrados, su expresión es serena; la figura desnuda debajo del azul traslúcido luce frágil; la piel, empalecida por falta de sol, tiene un aspecto etéreo" (14; With her eyes closed, her expression is serene; her naked body under the translucent blue gel looks fragile; her skin, pale from the lack of sun, has an ethereal aspect to it). She becomes a profane and profaned saint statue, as indicated by the body of the newborn child floating next to her. Religious associations intermingle with the wires in the tube to unsettling effect as "cientos de microconductas y fibras ópticas [. . .] aguijonean el cuerpo del usuario como un san Sebastián suspendido en el gel azul" (13–14; hundreds of microconductors and fiberoptics [. . .] pierce the user's body like a Saint Sebastian [statue] suspended in blue gel). Gloria is not unique in her saintlike appearance; all cybernauts must submit to the same fiberoptic "arrows" to gain entry to cyberspace. It is notable, however, that she is the only cybernaut left alive and physically intact at the end of the novel, as the rest have fallen victim to a series of amputations or are simply unplugged and left to drown.

The dangers of separating the body from the conscious mind are frequently addressed in cyberpunk. As such, Fernández is able to mine a long history of tropes and imagery that began with William Gibson's 1984 novel *Neuromancer*, in which significant help and harm may be enacted in cyberspace from the physical world and vice versa, either by or to the "cowboy" who is jacked in. Associations between a VR experience and amputations have been well explored in real life as well, such as when John Perry Barlow, former lyricist for the Grateful Dead and cofounder of the Electronic Frontier Foundation, observed in his essay "Being in Nothingness" that using a virtual reality system is "like having your everything amputated" (n.p.). Indeed, VR users can become so disoriented and so dissociated from their own bodies and the physical world that there is a large corpus of several decades of research devoted to the aftereffects of simulator and VR use, particularly simulator sickness and cybersickness.[8] The idea of self-amputation through technology goes back to Marshall McLuhan's eerily prescient 1964 text *Understanding Media*, in which he argues that humans seek to maintain equilibrium (that is, to reduce stress and to maximize pleasure) by withdrawing from the world in a process that

he referred to as autoamputation. This, McLuhan asserts, is how the central nervous system protects itself: "Whatever threatens its function must be contained, localized, or cut off, even *to the total removal of the offending organ* (42–43, my italics). This amputation results in numbness, which alarms McLuhan, since with the lack of physical sensation also comes lack of self-recognition" (43). To take McLuhan's formulations a step further: if we cannot recognize ourselves, we cannot recognize others in ourselves either, which converts them into completely foreign Others.

This process of Othering and self-amputation reduces empathy and tolerance and increases isolation, fear, and the justification of mistreatment of these constructed Others. Susana Rotker expresses worry over this point in her essay "We Are the Others," asking, "[W]hen there is no solidarity, no civil society, [. . .] what is left, aside from a group of people sharing a geographic space [and] distrusting one another?" (227–28). This distrust, she argues, is the price of self-induced numbness, and the ensuing lack of empathy is not simply unpleasant but potentially deadly on a broad social scale. Héctor Fernández L'Hoeste has a more practical question related to *Gel azul's* self-amputations: "si en un mundo en que los seres más privilegiados [. . .] buscan a toda costa la posibilidad de sumirse en un mundo imaginario, ¿qué destino le espera al imaginario nacional?" (182; if [we are] in a world where the most privileged beings [. . .] seek to immerse themselves in an imaginary world at all costs, what is the future of the national imaginary?) More to the point, if the nation's elite are plugged in and absent from earthly affairs, that begs Fernández L'Hoeste's next question: "¿quién demonios está al mando?" (182–83; who the hell is in charge?). The numbing process is not only psychological, emotional, and physical: it is also political, with significant consequences regarding any sense of nation or national identity.

To break through the physical and virtual obstacles erected by this numbing process, Fernández has set his story firmly in cyberpunk territory, a genre that, as Bruce Sterling famously declared, "has no patience with borders" (xii). This impatience proves useful in the rendering of *Gel azul*, since that suggests that borders—physical, psychological, social, political, or otherwise—can be destroyed, disregarded, or at least damaged enough to become permeable. As Emily Hind aptly notes, the cyberpunk tendency toward transnational corporations that replace or overshadow countries and governments allows Fernández to turn Mexico City into a geographically isolated microcosm with the sinister, omnipresent Huma-

Corp ("The Second Order Queer," n.p.). The history and mythology that accompany the construction of the Mexican nation-state are destabilized to the point of dissolution, as is the United States. This, in turn, disintegrates the relationship between the two countries that relied in large part on its geographical and political borders in order to exist.

Globalism, however, has endured in *Gel azul*, as exemplified by the view from Crajales's office window—a large hologram of the Coca-Cola logo projected onto the dome of the Castle of Chapultepec. The castle, built on a sacred Aztec hilltop in the late eighteenth century, served as the seat of power of the Mexican nation, a military academy, and an observatory before becoming the National Museum of History in 1939. Imperialism, political power, historical memory, and the fine arts coexist in this building that in Fernández's Mexico City is overshadowed, quite literally, by the large red-and-white Coca-Cola logo. The most well-to-do residents and major corporations occupy the center of the city in the same upscale neighborhoods that exist today—Gloria's apartment, for example, is in the high-rent *colonia*, or neighborhood, of Polanco—and the socioeconomic status of its residents decreases the farther they live from that center.

Fernández's description of the city's concentric zones and its inhabitants is arresting; however, as Fernández L'Hoeste reminds us, it does not actually correspond to the layout of Mexico City (180). It does, however, line up neatly with characteristics of the cyberpunk genre as Fernández offers a clear visual image of the city's rigidly stratified inequality (Fernández L'Hoeste 180–81). The outermost zone is named "los Tiraderos, tierras de nadie, basureros tóxicos que prolongan el desierto que rodea al monstruo. Más allá no hay nada." (29; the Scrap Heaps, a no-man's-land of toxic landfills that stretch out into the desert around the monster. Beyond that, there is nothing.) To paraphrase Luis de Góngora, the city decays until it ultimately evaporates completely: En ciudad, en colmena, en tiradero, en nada (In city, in beehive, in scrap heap, in nothing). On medieval maps, the words "here there be lions" (*hic sunt leones*) were used to indicate dangerous or unexplored territory. "Más allá no hay nada" (Beyond that, there is nothing) is bleaker still: there are not even *leones*, since the land beyond the Tiraderos has either become unlivable or—as Fernández's phrasing suggests—has disappeared completely.

Despite her location at the center of the novel's plot, Gloria does not lend herself to a particularly feminist reading, at least at first glance. Her

naked body is objectified and fetishized by the men who can see her float-ing in the tube; Anaya, the infatuated technician, has been looking forward to contemplating his "madonna personal" (personal Madonna or Virgin) for weeks. Her unconscious state arouses him, and he frequently fanta-sizes about climbing into the tank and doing what he likes with her. While he quickly dismisses the idea, it is never made clear whether he does so out of respect for her or fear of her rich and powerful father. As it turns out, someone has already beaten him to it when he finds the dead fetus floating in the tank with Gloria. While I am not entirely convinced by Annette Lapointe's assertion that "the meat-puppet model becomes po-tentially useful to women" in cyberpunk novels like *Neuromancer* since it allows the mind to be free while the body suffers (generally some sort of unwanted sexual act or assault), I am intrigued by her suggestion of self-disembodiment as a way of cheating death (138–39). Gloria has spent the last nine years in cyberspace, perhaps as her way of cheating death—not by avoiding unwanted sex or sexualization, as Lapointe poses, but by removing herself from her wild, drug-addicted adolescence. There are vir-tual drugs, of course, as there are in many fictional virtual spaces,[9] but she avoids them with minimal difficulty in a way that she could not in the physical world.

Gloria never manages to disconnect herself from her body completely—when she is frustrated, lost, or sad in cyberspace, the body in the tank of blue gel is still capable of producing tears (24). Since she can take on any physical form she likes in cyberspace, it is rare for her to assume her own form there, though that is the form she takes when she sets out to quiet her existential angst with a number of delightfully named alternative reli-gions such as la Iglesia del Cristo Extraterrestre (the Church of Christ the Extraterrestrial) or los Kennedytas (the Kennedyites) (38). The tension in Gloria's relationship with her body, her avatar, and her sense of self is a common theme in cyberpunk, with warring ideas about the consequences of inhabiting VR worlds. Feminist and female-authored cyberpunk tends to treat embodiment as a grounding, essential element of identity, whereas male-authored cyberpunk generally celebrates the idea of disembodiment as a triumph of the mind over the body (Lavigne 75–77). Fernández, for his part, offers a character who cannot quite leave her body behind and who will never find satisfaction in any cyber-religion. In the end, she meets a depressed Kafkian cockroach who guides her to yet another quest: to find the city of dreams (109–13).

130 · Technified Muses

## "But Isn't Cyberpunk Dead?": Genre and Gender in Mexican Cyberpunk

Cyberpunk has been rumored dead for decades. Its obituary was published in *Wired* in 1993, though the magazine issued a short retraction of sorts in 2015.[10] The growing international body of critical work on the genre indicates that cyberpunk has not so much died as it has adapted and evolved.[11] The backbone of the genre, however—the focus on high tech and lowlife, of human consciousness intertwined with electronic spaces, of dark, urban dystopias intermingled with elements of noir fiction—has remained constant, and these elements constitute a useful narrative toolbox that can be adapted to a variety of contexts. I agree with Geoffrey Kantaris's assertion that Latin American narrative appropriations of the U.S.-based cyberpunk genre "[focus] sharply on the power structures inherent within the disciplinary regimes of global power-knowledge networks, for which the urban is the principal stage" (54) and the metropolis as synecdoche for the nation as a whole.

Cyberpunk, properly speaking, did not emerge as a genre in Mexico until the mid-1990s. In *Expedición a la ciencia ficción mexicana* (2001), Ramón López Castro suggests that this is because the work of William Gibson, Rudy Rucker, Bruce Sterling, and other founding cyberpunk authors did not reach Mexico in Spanish translation until well into the 1990s (146). While I do not dispute the difficulty in accessing the texts, I hesitate to place the blame entirely on the late arrival of Spanish-language translations, since many of the authors and scholars with whom I spoke regarding science fiction (SF) and cyberpunk in Mexico City (including Fernández) know the North American canon well and prefer to read it in the original English due to the highly idiomatic nature of the language used.[12] Nonetheless, I am intrigued by José Luis Ramírez's suggestion that cyberpunk texts emerged in Mexico before it occurred to anyone to designate them as such, and that authors such as Isidro Ávila, Rodrigo Pardo, Gerardo Horacio Porcayo, and José Luis Zárate had been writing work that could be classified as cyberpunk in the 1980s and early 1990s without ever having read William Gibson. As Ramírez puts it, "nosotros abordamos el presente de México de los noventa—crisis económica, globalización, revolución, violencia urbana, narcotráfico, internet" ("El Movimiento," n.p.; we addressed the present in Mexico in the 1990s—economic crisis, globalization, revolution, urban violence, drug trafficking, internet).[13] Interestingly, the birth-

place of Mexican cyberpunk was not Mexico City but Puebla: Mexican science fiction and the early manifestations of cyberpunk were nurtured in large part by the Premio Puebla de Ciencia Ficción (Puebla Science Fiction Prize) in the 1980s (H. García 3). The genre has since put down roots in the capital (Bernardo Esquinca, Fernández, Malú Huacuja del Toro) as well as Tijuana (Pepe Rojo) and Monterrey (Isidro Ávila). Hernán García observes that Mexican cyberpunk as an organized movement did not emerge until 1997, which marked the publication of the first two anthologies dedicated to the genre: *Cuentos compactos cyberpunk,* a result of the combined efforts of the online journals *Fractal'zine* and *La langosta se ha posado* (The lobster has landed), and *Silicio en la memoria* (Silicon in the memory), compiled and edited by Porcayo (H. García 1–2). While few (if any) Mexican authors dedicate themselves exclusively to the genre, many have worked with steampunk, biopunk, neuropunk, and other offshoots of cyberpunk (López Castro 179; Córdoba 220; Darío González 259; H. García 11).

The near-complete lack of women on this list of cyberpunk writers in Mexico has not escaped me. To my knowledge, as with the men, there are none who exclusively write cyberpunk, though Liliana Blum, Bibiana Camacho, Raquel Castro, Ana Clavel, Karen Chacek, Gabriela Damián, Cecilia Eudave, and Claudia Guillén are among those who have appeared in three twenty-first century anthologies of Mexican SF: *Los viajeros* (The travelers, 2010); *Three Messages and a Warning* (2011), which included a foreword by Bruce Sterling; and *La imaginación: La loca de la casa* (Imagination: The madwoman of the house, 2015), an anthology of SF composed entirely of women authors that was compiled by Fernández. I do find it interesting that the shift in feminist science fiction in North America toward dystopic visions of the future (such as Canadian author Margaret Atwood's *The Handmaid's Tale,* 1986) and Octavia Butler's *Xenogenesis* trilogy (1987–2000, published as a single volume under the title *Lilith's Brood* in 2000) roughly coincides with the emergence of dystopic cyberfiction in Mexico.[14] The introduction to Mary Flanagan and Austin Booth's edited collection *Reload: Rethinking Women + Cyberculture* draws productive parallels drawn between cyberfeminist concerns and the interactions between women and technology (Booth and Flanagan 11). While they limit their focus to the English-language North American canon, they and Donna Haraway recognize that these interactions are double-edged in nature and may be oppressive or freeing. These double-edged interactions are particu-

larly present in Fernández's narrative as well, as BEF explores aspects of freedom and oppression in *Gel azul* through Gloria and Crajales.

Fernández has made good use of urban dystopias and secular avatars in a cyberpunk milieu in other texts as well, as in his 1998 short story "Ya no hay lugar libre" (No space left) from *Bzzzzzzt! Ciudad interface.* The protagonist's fight for survival in a postapocalyptic urban ruin turns out to be a video game, as revealed when his avatar is killed, but the real world to which he is returned upon his virtual death is identical to the hellish game-world. The story came to be, Fernández said, while he was writing a story for consideration in an anthology about Mexico City in 2025 (*Bzzzzzzt!* 110). In his 2010 study of Latin American SF, *¿Extranjero en tierra extraña?*, Antonio Córdoba turns his attention to various urban Mexican SF texts, including Fernández's 1998 short story. In the end, Córdoba argues, "la mejor forma de enfrentarse al reto de escribir una ciudad monstruosa es desde la suposición que el DF es efectivamente CF" (215; the best way to confront the challenge of writing a monstrous city is from the assumption that the DF [Distrito Federal or Federal District] is essentially SF). This DF = SF equation (which, sadly, can no longer be written with the same efficiency since the official abbreviation was changed to CDMX [Ciudad de Mexico] in 2016) carries through to *Gel azul*, though its ending is more hopeful and open than the vicious closed circle of "Ya no hay lugar libre." Fernández's description of his stories in the epilogue of *Bzzzzzzt!* could just as well apply to *Gel azul*: "Este es un libro de historias de ciudad. No pudieron haber sido en otro entorno, ni siquiera en otra ciudad." (109; This is a book of city stories. They could not have been written in any other environment, or even in any other city.)

Along with the dissolution of physical, geographic, and genre-related boundaries, the use of cyberpunk allows Fernández to sidestep a number of issues that come with the representation of violence or trauma in Latin America. Silence is not an option, yet (as discussed in chapter 3) the artistic or aesthetic representation of violence poses its own problems. There is, of course, an important time, place, and function for emotionally provocative art and literature that seeks to move its audience to feel outrage, compassion, or sadness. However, the effects of such work have limited effectiveness in long-term views on and analyses of acts of violence. With the distraction and the distance provided by tropes of science fiction and detective fiction, Fernández demonstrates another way of avoiding the receptive paradox that so concerns Žižek (*Violence* 4–5). These tactics to represent violence without exploiting or overwhelming the listener became

increasingly commonplace as Mexico entered the twenty-first century. As Ignacio Sánchez Prado argues, "this destabilized culture has produced new images of violence that allegorize the sense of uncertainty which is a product of the fall of [. . .] the ideas attached to revolutionary nationalism" (*"Amores perros"* 39). Glen S. Close cites the same article by Sánchez Prado in his *Contemporary Hispanic Crime Fiction* (2008) to support his warning that the uncritical acceptance of this discourse of violence as an integral part of the Latin American experience "may rearticulate in neocolonial fashion the discourse of civilization and barbarism" (Close 52). Indeed, if Latin America is considered innately violent, this can be used to justify any number of oppressive acts on a national and global level, directed at a "naturally violent" populace that cannot control or protect itself. The equation of violence and a particular region or country also distracts from an examination of the national and international systemic and structural elements that facilitate or produce precarity, uncertainty, vulnerability, and, as such, violence.

Fernández's *Gel azul* employs three techniques to subvert a neocolonial repositioning of violence as the Latin American norm: first, the aforementioned cyberpunk erasure and blurring of physical, geographic, and social boundaries destabilizes the possibility of a colonizer/colonized dynamic, since the very idea of the nation (and by extension the sizable corpus of Mexican narrative, film, and literature dedicated to its construction) has been dissolved. This world is run by corporations, not governments. Second, the separation between the injured body and the awareness of the harm done affords the reader greater emotional distance and space for the contemplation of what has happened, rather than trying to shock with violence porn. Third, the drug war in the novel that results from *legalizing* drugs lays bare the neoliberal underpinnings of the drug trade on a global scale, revealing the level of complicity at all levels of society, since it is the global economy that collapses when the black market for these substances is eliminated. There are no more narcos or cartels to blame; only a grim and constant exchange of limbs that are amputated and grafted onto another damaged body. It is never made clear who is at war with whom or why, and it does not seem to matter. The information about the war is given to us through Salgado, Crajales's childhood friend and fellow hacker turned reporter. Salgado explains to the puzzled detective that the change from illicit drug trade to war is nothing more than a shift from one "negociazgo" (big business) to another (Fernández 72); the brisk trade in organic limbs and prosthetics is merely an aftereffect.

134 · Technified Muses

To return to the second point on the separation between the physical body and trauma, Fernández explores this separation and its consequences with various cybernaut characters in the novel, particularly Gloria. It could be argued that he is proposing an updated version of Octavio Paz's *La Chingada* in *The Labyrinth of Solitude*: Gloria has indeed been violated and impregnated, but she is only a mother in the sense that her body has gestated and given birth to a child who died immediately postpartum. There is no suggestion of innate maternal instincts or of any desire to have children of her own. Gloria's class and racial privilege make her potentially less sympathetic—she is not a long-suffering, virtuous maternal figure but rather a rich white girl with a history of juvenile delinquency and substance abuse. There is no indication that she is being punished for her wild past; the attack on her is in retaliation against her father for his capitalistic sins, not for anything she herself has done. In this context, Gloria is simply collateral damage.

Looking at Gloria as part of the chronology of muses from the postrevolutionary period to the post-2000 era, she, like her predecessors, is susceptible to physical harm and trauma even as she exhibits the ability to disturb and to unsettle the histories that she observes and influences. Her vulnerability and unsettling presence highlight the importance of the muses as corporeal figures and emphasize embodiment as a vital element of cyber/feminist readings of posthumanism, as rigorously debated and explored by Balsamo, Braidotti, Halberstam, Lavigne, du Preez, and others. These muses are not ethereal beings floating above the fray; on the contrary, they inhabit deeply vulnerable bodies that are physically and psychologically invested and engaged in the creation and narrativization of historical events. Far from distant observers, they are all the more forceful and watchful since they all have something to gain—and something to lose.

Circling back to the third and final point, Fernández turns Mexico's war on drugs inside out; the events of *Gel azul* play out alongside an ongoing international war that is fought for the sole purpose of supporting the global economy, which collapsed when drugs were legalized. These wars are fought *with* drugs, not against them, and the standard strategy is to chemically "deactivate" enemies. This battle tactic is used on civilians as well, as in the case of the maintenance man Anaya and Captain Barajas. The objective of this new form of battle is to turn their opponents into mentally incapacitated vegetables rather than killing them outright so as to preserve their limbs, which may then be harvested for use as prosthetics.

The amputations and prosthetics in this novel are all organic in nature, which adds an interesting twist to McLuhan's theories on amputations and prosthetics: the organic prosthetic comes from an unknown other, maimed for the purpose of repairing another injured body. Presumably, the amputee will require a prosthetic from someone else, creating a chain reaction of injuries administered to one body to treat the wounds of another. This brings a deeply pathological slant to the idea of healing or being made whole again, given that the process generally involves the sacrifice of one or more limbs without the knowledge or consent of another body. Despite the tremendous amount of technological expertise in Fernández's world, it does not seem to occur to anyone to invent or develop mechanical prostheses to replace the organic ones. Aside from installing a neural interface in order to access the Net (27), Fernández's characters do not modify themselves in the physical world, and it does not occur to them to try. This is particularly curious, given that high-end prosthetics—such as the carbon-fiber blades used by some amputee athletes—already exist and may actually be more effective than biological limbs. In the profoundly cyberpunk world of Fernández's novel, it is striking that the bodies within are so persistently analogue—even to the detriment of their fellow humans.

While Fernández uses cyberpunk to create the borderless Mexico City, his use of the *novela negra* in addition to the undeniable elements of cyberpunk are what allow him to read and respond to the now-isolated city. As mentioned previously, Detective Crajales, the protagonist of *Gel azul*, is clearly descended from the detectives of the *novela negra mexicana* (Mexican noir novel) as well as the *neopoliciaco* (neo-detective) genre. Like Héctor Belascoarán Shayne, the detective who appears in many of Paco Ignacio Taibo II's detective novels, Crajales explores Mexico City by foot and by public transport in order to be as close to the city and its rhythms as possible. An intelligent misanthrope, Crajales, like Belascoarán before him, is "a dynamic, violent, and intrusive body" (Close 33) who accesses physical and virtual spaces through adroit negotiation with the established hegemonic structures of power (here, the corrupt megacorporation HumaCorp and the failed state's police apparatus). Both Belascoarán and Crajales are gifted and highly observant investigators who tend to find themselves in climactic confrontations with the perpetrators. As Close observes, they reach these places "not due to virtuosic feats of deductive reasoning, but rather to a stubborn and sometimes reckless commitment to action, to putting [themselves] in harm's way to shake up the action" (34). There is no

136 · Technified Muses

Sherlock Holmes–style performative brilliance in their work; rather, the adrenaline rush of conflict is their raison d'être, and it almost seems to be of secondary importance that they make a living and solve crimes this way.

Significantly, Crajales's death at the end of the novel results not from the danger involved in his investigative work but his desire to reenter cyberspace and separate himself from his body. He solves the case, confronts the person responsible for raping Gloria and killing her newborn child, and suggests that his silence can be bought on one condition: *if* he is repaired so that he can return to cyberspace. The villain, an unscrupulous lawyer named Beltrán, allows Crajales a few hours in the virtual world before bringing him back and leaving him in the tube to drown, ensuring his silence and securing one more body from which to harvest limbs. Crajales's death is not entirely in vain, however; his last act before getting into the tank is to send an email to Arceo Cubil, Gloria's father, informing him of what has happened and who is responsible. Even so, Crajales got into that tube knowing he would never get out, performing the most final of autoamputations. The novel ends as it began: with a dead body floating in a cylinder of blue proteinic gel.

At first glance, the novel's ending is depressing and unsatisfying: Gloria enters yet another zone of the Net in yet another attempt to find fulfillment in her virtual dreams while Crajales dies swimming "hacia el fondo sabiendo que en algún lugar [. . .] los mares son más azules" (Fernández 130; to the bottom knowing that in some other place [. . .] there are bluer seas). The avatar bodies of *Gel azul* have all been victims; the only survivor is Gloria, whose physical life is no more than a dream. "Soñé que tenía un bebé" (100; I dreamed that I had a baby), she writes on a virtual computer in a virtual bar from the depths of cyberspace. Her journey to the city of dreams with the Kafkian cockroach may be read as one more fruitless attempt at escape unless we recall that Gloria's dreams from her own subconscious mind are the only connection she has to her physical body. As such, finding an entire city of dreams might not be an escape at all but rather a series of oneiric threads that pull her back into her body from the safe but unsatisfactory virtual dreams in which she has taken refuge. The novel, then, is not so much hopeless as it is open-ended; Fernández leaves Gloria and the reader in a clearing with no signposts, wondering where to go from here.

In his "Manifesto for Avatars," Gregory Little notes that while both avatar and cyborg facilitate operation in other environments that the organic body cannot access, "the cyborg [is] [. . .] a unified but hybrid 'other,'

whereas the avatar is born of a telematic split; the original remains in its originary environment while sending a tool of signification, an avatar, into the second" (195). Gloria and any other cybernauts in these VR worlds fit into both categories. Thusly defined, the avatar becomes double-edged in a way that McLuhan did not foresee: the doubled and divided condition that facilitates isolation, separation, and domination also allows for "polymorphic, bi-gendered, unstable, nomadic [. . .] representations of the self" (195), which lines up nicely with Lapointe's and Flanagan's reconfigurations of the situation of knowledge in a self-created hyperbody (Flanagan 433; Lapointe 138–39). As such, Little concludes, these representations have tremendous subversive potential as "trickster figures [and] potent wild cards to undermine the [multinational monster of exchange and capitalism] from the inside out" (195).[15] It is no accident, then, that Fernández has appropriated this trickster figure/cyborg/avatar body as a launchpad from which to address social, political, and economic concerns during a newly post-PRI Mexico—a body surrounded in blue gel, which happens to be the color of the PAN (Partido Acción Nacional [National Action Party]), the conservative party in power that had finally unseated the PRI for two six-year terms, or *sexenios*. At the end of the novel, Gloria has not reintegrated—the mind-body split remains—but so does her potential to emerge as a double-edged trickster figure. She and the reader of *Gel azul* are left not at an ending but a crossroads, a position that holds no answers but that asks many questions, one that encourages forward motion and individual choice.

## Whistling in the Dark: Cities and Bodies under Siege in Guadalupe Nettel's *El huésped*

Ana, the young narrator-protagonist of *El huésped* (The guest) (2006), spends her life between extremes: light and dark, life and death, sight and blindness, and obedience and rebellion. Nettel situates Ana in an increasingly dangerous and complicated political environment in which historical events pile up atop one another, both literally (above- and belowground) and figuratively in late twentieth-/early twenty-first-century Mexico City. At the same time, Ana struggles not to lose herself to La Cosa (The Thing), the blind *huésped* (host/guest) of the title, an incorporeal but powerful being that possesses her and makes her do things against her will. By making Ana's body the battleground in, on, and through which to grapple with the personal and political crises of the protagonist and the country, Nettel establishes a connection between the female body, the state, and its history

that is as deep and intimate as it is uncomfortable, creating a platform from which to approach issues of guilt, memory, the desire for autonomy and the consequences of rebellion for a female "citizen of fear."[16]

There are three primary questions that I wish to delve into here: First are Nettel's presentations of time and space in Mexico City, as well as the specific spaces and times that she chooses. By looking at the issues explored in the novel in its social, political, and historical context(s), one quickly realizes that the information provided by Nettel (related through Ana, who tells us everything in the first person) does not always match up, producing mobile urban cartographies and geographies that present us with a vision of the city that is blurry, impossible, and yet entirely subjective, since it is the experience lived by Ana herself. Despite the hyperspecific descriptions of the urban environment that follow later in the novel, the narrator takes about thirty pages to mention Mexico City at all, so it becomes evident that her first objective is not to orient the reader in time and space but rather to expose them to the most immediate and subjective elements of her story.

The second question, then, emerges from the first: Given the deliberately confused way in which time and space are organized in the subjective presentation of a city that nonetheless remains severely and starkly real in Nettel's text, I wish to consider the ways in which violence and first-person female narrative interact as a way of communicating or telling a story/history. In the introduction to *Citizens of Fear*, Susana Rotker observes that "[w]hether to exorcise their trauma or to explain the political and economic situation that caused it, the complexity of violence can only be comprehended when spoken of between two people" (8). In *El huésped*, the first-person narrative is extremely oral in nature, which serves to initiate a conversation with the reader, or at least to encourage a more (inter) active reading of the text.

The third question weaves its way through the first two: La Cosa's blindness is at the heart of Ana's explorations of her body, the city, and constructions of dis/ability that separate or connect her from others as well as her own identity and sense of self. The explorations of sight and blindness, as has been widely noted in the ample critical corpus devoted to Nettel in general and *El huésped* in particular, are drawn from Nettel's own corporeal experiences, as she was born with a cataract in her right eye. Her childhood was defined by the various medical treatments she endured as part of her mother's attempts to correct her "defects," which she has described in *El cuerpo en que nací* (2011) and in many interviews. I am interested in the ways in which Nettel employs the representation of disability and gender

to critique normative societal paradigms and to explore Ana's relationship with her identity, her community, and her sociopolitical environment.[17] Rosemarie Garland-Thomson's definition of disability as "the attribution of corporeal difference" is fundamental to my analysis here as well, since the construct is "a comparison of bodies that structures social relations and institutions." It is not, Garland-Thomson notes, "so much a property of bodies as a product of cultural rules about what bodies should be or do" (6). In more specifically postcolonial contexts, Antebi and Jörgensen draw upon Murray and Barker's work to note that "the common disability studies practice of criticizing associations between disability and trauma or loss" can be problematic if that critique does not also consider the economic inequality or systemic violence that may contribute to the acquisition of a disability (13–14). Nettel addresses both sides of this critique over the course of *El huésped,* exploring the ways in which disability can be a source of political awareness and resistance and/or the result of structural inequality or oppression. These explorations provide a fundamental underpinning to her representations of time, space, and history.

La Cosa's intentions toward Ana are plainly laid out in the novel's first paragraph: to dominate her and in doing so condemn her to "a la oscuridad más absoluta" (13–14; the most absolute darkness), making her Ana's worst enemy. In Freudian terms, La Cosa is pure id, all instinct and impulsive action, and always overwhelms Ana's desperate attempts to function as superego as she strives to help her mother, to make friends, and to fly under the radar. Both La Cosa and Ana have quite a bit in common with Deleuze and Guattari's schizo. By engaging the "code of delirium or of desire," as so frequently happens with both characters over the course of the novel, they "deliberately [*scramble*] *all the codes,* by quickly shifting from one to another, [. . .] never recording the same event in the same way" (15, original italics). In this way, then, La Cosa and Ana are two sides of a coin, eventually coming together to form a monster-muse. This is, as I have noted, a characteristic of the muse in general—she is monstrous in that she shows, reveals, and signifies that which might not otherwise be evident. The difference here lies in Nettel's focus on Ana's resistance of her own "monstrosity" and her interest in the ways in which (to paraphrase Simone de Beauvoir) Ana is not born a muse but rather becomes one. The battle and ultimate resolution between her two selves allows her to find and join an activist community that resists corruption and state-sponsored violence and, as Carina González argues, "señala otras leyes para la constitución con la comunidad" (106; suggests other laws for creating community). Ana's ex-

periences with disability in general and blindness in particular prove fundamental to her own evolution and awakening, as I will explore in greater detail shortly.

This negotiation and evolution of the divided self are not immediately evident in the novel, however. In the early chapters, based on what is known of Ana and La Cosa, it would seem that there is no intervening ego to moderate. Ana cannot prevent La Cosa from acting out; she is only allowed back into her body after the fact, leaving her to take the blame for whatever mess La Cosa has inevitably made. As Ana approaches puberty, La Cosa's strength and presence increase and her periods of acting out become more serious, such as when she uses Ana's body to physically assault a classmate with no apparent provocation. When her brother Diego dies under mysterious circumstances, Ana holds herself and La Cosa responsible: she and Diego are close and she wishes him no harm, but La Cosa mounts her mysterious attack through Ana's eyes, turning her into the unwitting and involuntary instrument of a strange assault that seems to destroy Diego's very soul. That attack and Diego's resulting illness correspond exactly with Ana's first menses (*El huésped* 39), which is a nod to a long history of narratives about young girls whose monstrous abilities emerge or become more powerful after they begin to menstruate.[18] Diego cannot defend himself against this newly strengthened monster; after the death of his soul, his body operates on autopilot for a few months, winds down, and dies. Their bourgeois parents do not notice the death of his spirit, only that of his body.

Shortly after Diego's death, Ana sees that he has a strange mark on his arm that looks like an insect bite. She draws it to try to capture the image in her memory but quickly loses the paper. Years later, she discovers that the mark is her own name written in Braille, "pero invertido" (but inverted), as if reflected back by a mirror (111). She deduces that La Cosa is blind and sets out to learn all she can about blindness, believing this will help her know more about her enemy so as to defeat her parasite and avenge her brother's death. Ana and La Cosa are, as Oswaldo Estrada has noted, profoundly uncomfortable doubles (*Ser mujer* 255): despite the abundance of analyses of Ana's search for her other self through La Cosa, few if any dwell on the unpleasant fact that one or the other has committed fratricide as part of the journey toward self-discovery. Stranger still, Ana and Diego have a perfectly amicable relationship—there is no suggestion of sibling rivalry between them.

Given that it makes little sense to read Diego as a three-dimensional character, I think it more productive to read his murder as a symbolic sacrifice for two reasons. First, if we read *El huésped* as a bildungsroman (as Adriana López-Labourdette, Carina González, and others have proposed), his death serves as the requisite tragedy that propels Ana out of the house to begin her journey of maturation and self-realization. Diego's death sparks vengeful rage in her even as it weakens her parents' strength and authority in a way that "[le] confirió una libertad ilimitada" (*El huésped* 48; granted [her] unlimited freedom). Second, the body that is generally at the center of narrative quests for national identity, particularly in the context of postrevolutionary Mexico, is an able-bodied male adolescent mestizo, with race intimately linked to physical dis/ability and the capacity for assimilation into the national body (Dalton 3; Latinez 22). By eliminating Diego—precisely the sort of body that historically anchored Mexican bildungsroman narrative—Nettel decenters the able-bodied adolescent male mestizo subject from her explorations of Mexican social issues, politics, and identity.

After years of study and preparation, Ana takes action and finds a job at an institute for the blind in the Colonia Roma. There she meets El Cacho, a one-legged man who introduces her to a mysterious anarchist group that lives in the vast network of tunnels and tracks of the Mexico City metro system. Inspired by Madero, the group's blind leader, Ana helps them to enact a creative protest against electoral corruption in the city: the distribution of thousands of envelopes of human excrement in the voting booths in the capital on election day. When the police detain Marisol, Ana's partner in distributing the envelopes, the situation takes a tragic turn. Marisol's body, bearing clear signs of torture, turns up a month later, and Ana ends up giving in to blindness and melding with La Cosa, retreating underground to take up permanent residence with her fellow anarchists in the metro.

In the novel's representation of time and space, Nettel creates an urban geography and itinerary of a metropolis that is always in flux, always in motion. She uses concrete details from the city, interweaving the names of streets, cafés, neighborhoods, cemeteries, and metro stops into the novel's narrative framework. Indeed, I found it useful to read *El huésped* with either Google Maps or the Guía Roji map of the city at my side to follow Ana's and La Cosa's itineraries through Mexico City. Upon doing so, it became clear that some of these mappings have minor errors that undo the connection with the idea of an objective and concrete reality, and that also

142 · Technified Muses

remind us that we are reading the city as seen or imagined by Ana. Often, the existence of these places depends very much on *when* we are in the course of the city's history, since Nettel never explicitly indicates the year in which the story is set. By doing so, she constructs a text that requires the active participation of the reader, as well as a certain level of prior knowledge of the city and its history.

Nettel's representation of Mexico City stands in marked contrast to the urban spaces constructed by del Paso and García Ponce and discussed in chapter 3. All three authors are extremely precise in constructing their respective cartographies of the city, albeit in different ways. Del Paso insisted on naming as much of the city as possible, including long lists and descriptions of streets, plazas, stores, and landmarks. García Ponce is more deliberately nebulous in terms of the physical details of his novel, preferring to focus on interior spaces, both physically and psychologically. Nevertheless, when del Paso's Palinuro is on the stairs in the penultimate chapter, and when García Ponce's Anselmo and Mariana are shot in the plaza during a peaceful student demonstration during the lead-up to the Festival de la Juventud (Youth Festival), del Paso and García Ponce could not have been any more specific as to when the events took place.

The continuation of doubles between the texts from both eras is also noteworthy—Estefanía/Colombina in *Palinuro de México,* María Inés/Mariana in *Crónica de la intervención,* and Ana/La Cosa in *El huésped.* The connections and constructions of Estefanía/Colombina and María Inés/Mariana were more playful and symbiotic, however, and one of each of the doubles met with a violent end that was caused by an act of state-sponsored violence. Colombina appears to have died in "Palinuro en la escalera," as indicated by the final poster she shows the audience ("¡Adiós!"); Mariana is gunned down with Anselmo while walking through the plaza where the massacre takes place. The relationship between Ana and La Cosa, meanwhile, is murkier and initially more hostile. As two personalities sharing the same body, they struggle to decide which version of life to see and to perceive within these layers of history, and this struggle for perception and perspective is enriched and complicated by La Cosa's blindness.

In her essay on her own experience with temporary loss of sight, Chilean author Lina Meruane explains blindness as something that "threatens all of our assumptions," as a state of existence that *detonates* questions that must be confronted (30).

The idea of detonation and confrontation resonate strongly in Nettel's La Cosa, another explosive presence who cannot be ignored; she refuses to

allow Ana to take refuge in her complacent and physically comfortable life. La Cosa does precisely that which Meruane vows to do in her own writing: "Cut the distance between the healthy and the sick, between the sighted and the blind. [. . .] Turn the mirror on the healthy and make them face their own illness" (36–37). Oswaldo Estrada sees a similar mirroring function in his analysis of Nettel's work; her writing holds up "un espejo cruel de lo que verdaderamente somos y no queremos ser" (*Ser mujer* 255; a cruel mirror to who we really are and do not want to be). Nettel does this on an individual and national scale, forcing self-recognition and a confrontation between what Octavio Paz and Carolyn Wolfenzon call "the two Mexicos"— the official Mexico and the oppressed Mexico (Wolfenzon 43). For Paz and Wolfenzon, the official/oppressed binary emerged in the aftermath of the 1968 Tlatelolco massacre.[19] Nettel does not eliminate this possibility, but she also offers another formulation of these "two Mexicos." As Nettel recalls in an interview, "lo ocurrido en Chiapas en 1994, puso en evidencia la mascara del PRI cuya política neoliberal se hace evidente" (Wolfenzon 44; what happened in Chiapas in 1994 stripped off the PRI's mask to reveal their neoliberal politics). It stands to reason, then, that Nettel's interrogation of "two Mexicos" is primarily rooted in the 1994 Zapatista uprising, which was very much on her mind as she wrote *El huésped*.

Nettel does not limit herself to the Zapatista rebellion, however; she explores and stacks up other historical events that can all be connected to various presidential elections in Mexico, all of which were corrupt. The violence depicted by Nettel is largely structural in nature, and as such is less visible but more constant. Recalling Živković's theory of the double from chapter 3, the idea of the double as "a replica of one's unknown face" (126) is relevant here as well, since the presence of the double implies the desire for transformation and change. The hostility and lack of communication between Ana and La Cosa suggest a greater emphasis on the ambivalence felt by the profoundly divided subject as she vacillates between complacent detachment and political engagement. Their awareness of each other and their apparent partnership at the end do not quite fit into Živković's paradigm, but their long history of separate personalities caught in an intense state of flux indicates that the political, historical, and personal struggle has only begun.

Ana and La Cosa must constantly navigate various and circular layers of space as well as time over the course of the novel, and the kinds of space employed by Nettel are just as important as her use of time. Gradually, Ana and the story leave or are forced out of public spaces and move toward in-

creasingly public ones. The story begins in Ana's home and later is located in institutions (Ana's school, and later the institute for the blind) before ending up in the street and the metro. In other words, its final spatial destinations are what the anthropologist Marc Augé calls "non-places," that is, "a space that cannot be defined as relational, or historical, or concerned with identity" (*Non-Places* 77–78). As such, the most important space in the novel is the metro; its status as a non-place decenters official discourses and histories even as its underground location places it in touch with precolonial history and mythology, as I will explore in greater detail later on.

The metro is the place in which the nameless anarchist group operates and where its leader, Madero, lives. His name is not coincidental; like his revolutionary namesake, this Madero is the driving force behind the group's revolution. Unlike Francisco Madero, however, he is a blind man who refuses to live in any kind of institution, establishing himself outside the boundaries of state control as he seeks to break them down. Madero, el Cacho, and the others from the group spend their days begging in the metro cars in an outright rejection of the capitalist system. They also play with and against hegemonic notions of dis/ability: Antebi and Jörgensen point out that in Latin America, begging was traditionally one of the few activities in which disabled people were publicly visible (3), but Madero and his group do so as a cover for their true antihegemonic vocation. As such, they trick the oblivious surface inhabitants of Mexico City into funding their mission to set off a social revolution. When the metro closes at night, they take refuge in the broom closets of the nearest metro stop, frequently accessed with the help of the janitors who work there.

The metro is, in many senses, a space without barriers, as Marc Augé indicates: "[There is] no hermetic barrier separating [. . .] the life of the individual from that of others, our private life from our public life; our story from that of others" (*In the Metro* 9). In the metro, nothing stands between Ana and the others, which significantly contrasts with her situation at the beginning of the novel in which she lived apart from those who were not of her class, always driving rather than taking public transportation and refusing to take the subway, as that would expose her to the crush of people that any metro rider will encounter during morning and afternoon rush hour. In the end, the last barriers to fall are the notions of separation between Ana and La Cosa and between Ana and the group after her partner Marisol was disappeared by the police. Lorenzo, a former resident of the institute for the blind and a student of Ana's, assures her that he, el Cacho, and the others had sensed La Cosa in her all along, "Una magnífica

persona, disfrazada de cretino" (178; A magnificent person disguised as a cretin). Ana is furious at hearing herself described as a false, masked cretin, but even as her anger rises, she senses La Cosa purring contentedly at his words.

The division between aboveground and belowground, obedience and rebellion, is embodied by the residents of the institute for the blind on the one side and by Madero and his revolutionary group on the other. When Ana first meets the residents, they are timid, submissive, and afraid of the unknown. They have become completely institutionalized, so used to the constraints of the medical establishment that they believe they cannot function outside of it and do not wish to try. The subway dwellers, meanwhile, are fiercely independent and value the freedom granted them by their position on the very margins of society, even as they lament their difficult economic situation. Oswaldo Estrada, aware that el Cacho was inspired by el Subcomandante Marcos, notes that he and his group "metafóricamente representan a esa parte oscura del país que sale a la luz con el levantamiento zapatista en 1994" (*Ser mujer* 259; metaphorically represent that obscure part of the country that emerged into the light of day with the 1994 Zapatista uprising). While Nettel's inspiration was clearly drawn from the Zapatista uprising, El Cacho and his group may also be read as part of a larger historical tapestry that is woven of various social, cultural, and political revolutions in the country that will strengthen and inform the growing movement for yet another uprising, this time literally from below (recalling Mariano Azuela's 1915 novel *Los de abajo,* which is translated as *The Underdogs* but literally means "those from below"). As Madero reminds Ana, "Piensa en los colonizados de cualquier imperio, los esclavos, los campesinos, los leprosos, los prisioneros de guerra. En este país el subterráneo tiene una historia larga." (131; Think of the colonized people of any empire, the slaves, the peasants, the lepers, the prisoners of war. The underground has a long history in this country.) Through Madero, Nettel takes advantage of the fact that "subterráneo" can refer to that which is underground (subterranean) or to the subway, thus always implying various and overlapping layers of history and use of space in regard to either one.

Compared to other metro systems in large urban centers, the Mexico City metro is much younger than its counterparts in London (1863), Paris (1900), New York (1904), or Buenos Aires (1913). The Mexico City subway system was inaugurated in 1969, planned and constructed in the intense push for modernization that began in the 1950s, which, in its turn, was further stimulated by the knowledge that the country would be hosting the

146 · Technified Muses

Olympic Games as the following decade drew to a close.[20] Indeed, Ana and el Cacho, her blind anarchist guide in the metro, take their final refuge in the underground space that was created as part of the rush to the Olympic Games, creating a tenuous but significant connection with the events of 1968. In contrast to the badly injured Palinuro, who died trying to climb up the stairs to his apartment building in the famous penultimate chapter of del Paso's novel, Ana, badly shaken by the death of her friend Marisol at the hands of the police, climbs downward instead, fully dedicating herself to the underground community and their struggle for revolution. In regard to the underground, Juan Villoro takes the idea of "deep Mexico" literally in his essay "La ciudad es el cielo del metro" (a more direct translation is "The City Is the Metro's Sky," though it is published in English as "The Metro"). He explains that "bajo la tierra están los muertos y el origen; las principales leyendas del mundo indígena [. . .] narran viajes al inframundo" (141; the dead and our origins are buried underground; the primary legends of the indigenous world [. . .] recount trips to the underworld). All of this history is implied, if only implicitly, in *El huésped*.

Nettel never allows the reader to dream too much, however: alongside the stories of the underground as a mythic place dominated by the nation's indigenous figures (humans and gods), its rebels and its underdogs (in the Azuelian sense of *Los de abajo/The Underdogs*), she also shows us the prosaic and sometimes harsh reality of traveling by metro in Mexico City. The impossible crowds, the pushing and shoving, the sounds, the smells, and the ways in which bodies, stories, and public and private lives crush against and overlap one another to disconcerting effect might well lead one to echo Carlos Monsiváis's question as to when this distinctly limited and finite space will finally reach its limits ("El metro" 155; "The Metro" 143). In Nettel's text, slight but significant errors in describing the metro system—its stops, lines, and connections—imply that nothing is permanent or stable, and that this state of impermanence extends belowground. This is particularly disturbing since, if Villoro and Nettel are to be believed, that is where the oldest, most powerful, and most liberating memories are still housed, which emphasizes the importance of fighting to protect and preserve them.

Above- or belowground, the presentation of space and place in *El huésped* is nearly always connected with history. For example, the excrement-filled envelopes can easily be read as a critique of the corruption of the Mexican electoral system, but this then begs the question: to which election is she referring? No names of candidates or political parties are mentioned; we only know that this is an *elección de diputados* (election of representa-

tives), which occurs every three years. It is at this point that the attentive reader becomes aware that the dates, as mentioned previously, do not always match up, creating a dizzying perspective of time and space in the megalopolis.

One of the clearest temporal references is also one of the most absurd: on the night of November 1, Madero brings Ana to the Panteón de Dolores, the largest cemetery in the country. A group of the city's poor has gathered there, eating and drinking whatever offerings had been left on the altars for Día de los Angelitos, a day set aside to remember those who had died as children. El Cacho arrives shortly thereafter, bearing manatee tacos from Xochimilco (134–35). This is the first clear indicator of time in the novel, and Nettel establishes it via manatee tacos: in 1975, manatees were introduced into the canals of Xochimilco in the hope that they would eat the invasive water hyacinths that were choking its waters. As winter approached, the unfortunate animals contracted pneumonia and died, since manatees cannot survive in temperatures below 60°F. This means that we are most likely talking about the elections of 1976, the year in which presidential candidate José López Portillo received 90 percent of the vote by dint of being the only candidate. In such an election, the gesture of voting with envelopes of human excrement makes sense, wordlessly articulating that those envelopes were as valuable or as useful as the paper votes that year.

Nevertheless, there are other indicators in the text that contradict the date initially established by the unlucky manatees in taco form. For example, some of the metro stops that Ana mentions did not exist in 1976, which becomes clear when El Cacho shows her a stone column in a station upon which the names of the stops are written in Braille to help guide blind metro riders. They are in Indios Verdes-Universidad, on the green Line 3, but the line did not encompass those two stops until August 1983, only a year after the economic crisis that marked the beginning of the *sexenio* of Miguel de la Madrid. Shortly thereafter, during the long night that Ana and Marisol spend passing out envelopes in their "modesta contribución a la democracia" (151; modest contribution to democracy), Ana catches a glimpse of a store with its television turned on to *The Simpsons*, a program that debuted in the United States in 1987 and arrived in Mexico a few years later. As such, it could represent two dates: the election of the PRI's Carlos Salinas Gortari over the heavily favored Cuauhtémoc Cárdenas of the PRD (Partido de la Revolución Democrática [Party of Democratic Revolution]) in 1988—an election that De la Madrid later admitted was fraudulent—or the 1994 election, which coincides with the election of Ernesto Zedilla and

the approval of TLC (NAFTA) by Canada, the United States, and Mexico, as well as the previously discussed Zapatista uprising and its declaration of war against the Mexican government, with their First Declaration and Revolutionary Laws deliberately stated from the Lacandón Jungle and not from or in any (urban, institutional) center of power.

In *El huésped*, events, places, and dates pile atop and become intermingled with one another, thus emphasizing the state of constant change in the city as well as the state of permanent crisis in which its residents live. "México ya no nos pertenece" (Mexico does not belong to us any more), Ana tells us at the novel's end. "La ciudad que elegimos ver es una fachada hueca que cubre los escombros de todos nuestros temblores" (175; The city we choose to see is a hollow façade that covers the debris from all our earthquakes). Indeed, Oswaldo Estrada convincingly argues that "la obra entera es una forma de combatir la ceguera mental" (*Ser mujer* 262; the entire novel is a way to combat mental blindness), of forcing Ana and by extension the reader to look directly at issues of poverty, corruption, or violence in a way that demands responsibility and action. In this way, it may be possible to reclaim and truly reoccupy the Mexico that "no longer belongs to" Ana and its inhabitants. Rather than continue to deceive herself with the emotional blindness that Estrada and Nettel mention, Ana chooses to fully see by merging with La Cosa, cutting all ties with her family and giving herself over to the world of the metro with a Zen-like level of acceptance and detachment. The sound of the metro cars blends together to sound like one, "como un mismo tren que regresa sin cesar" (189; like the same train that returns over and over again), implying that the cycles she has been tracing throughout the novel have happened before and will happen again.

### Excavations of Memory: Karen Chacek's *La caída de los pájaros*

The implication of a cyclical revolution in Nettel's *El huésped* is appropriate in regard to Chacek's *La caída de los pájaros* (The fall of the birds) as well, as we transition from a novel that ends in the metro to one that essentially begins there. Violeta, a young reporter and freelance writer, is the lone survivor of a terrible metro crash and lies in a coma for four months. The crash takes place in a city that has neither children nor birds—two months before the accident, as we find out in flashback, all of the birds fell dead from the sky, covering the streets in feathery corpses. Parents all over the city saw their children watching from their windows and ordered them to

bed, hoping to spare them any further trauma. The children obey, but they never wake up again. They are not dead but also cannot be awakened and so are interned in the Hospital Amistad (Friendship Hospital). As the days turn into weeks and the children remain asleep, the government orders for cameras to be installed in the hospital rooms so that a live video stream of each child can be sent to each parent's cell phone. This allows them to continue to keep an eye on their offspring while not missing any more work— and, since they can always see them, the parents no longer feel compelled to visit them (Chacek, *La Caída de los pájaros* 21).

After her accident, for reasons that are not explained to her or to the reader, Violeta is placed in the children's ward in the hospital during her months-long coma. After regaining consciousness, she begins to hear the voice of an eight-year-old girl speaking and singing to her. In an attempt to convince herself of her own sanity and good luck postaccident, she thinks, "¡Soy una suertuda de putamadre!" (18; I'm one lucky son of a bitch!), which provokes the following reaction from the child:

> —¡Dijiste putamadre!
> —No.
> —Sí. Yo te oí.
> —No.
> —¡Sí!
> —¡No me hables!

> (18; —You said son of a bitch!
> —No.
> —Yes. I heard you.
> —No.
> —Yes!
> —Don't talk to me!)

This exchange frightens and irritates Violeta all the more: "En una ciudad sin aves y niños, ¡a mí una niña de ocho años me habla y me da instrucciones!" (19; In a city with no birds and no children, there's an eight-year-old girl talking to me and ordering me around!). She is still in the hospital when this conversation takes place, so she does not dare tell anyone about it for fear that it will delay her discharge from the institution. Despite her own fears for her mental health and attempts at self-diagnosis, it is clear that this institution is not a place she trusts to help her understand what is happening to her.

The metro crash, the catalyst to the novel's plot, has clear connections to the underground as well as to the underworld, recalling again Juan Villoro's observations on the metro: "bajo la tierra están los muertos y el origen; las principales leyendas del mundo indígena [. . .] narran viajes al inframundo" (141; the dead and our origins are buried underground; the primary legends of the indigenous world [. . .] recount trips to the underworld). While neither Nettel nor Chacek engage explicitly with indigenous legends or mythology, the implication in both novels is that each protagonist must go underground to tap into a deeper, more communal well of knowledge and history that predates her. In contrast with Nettel's Ana, who is drawn down and back to her revolutionary origins at the end of *El huésped*, Violeta's experience begins in the underground and the underworld. Her subsequent awakening or rebirth enables her to see and hear the spirits of the sleeping children—not only the eight-year-old who is her most constant companion but the others who wander around the city, following their parents and grandparents and trying to communicate with the adult world. They scribble on walls, move furniture in the night, and shout in an effort to make themselves heard. As such, Violeta becomes the unwitting and unwilling repository for the collective memories and voices of an entire generation of children.

Her search for help and information is limited, however, since she is desperately frightened of being considered mentally ill and reinstitutionalized. Her quest to liberate the younger generation is aided by Magda, an elderly friend with dementia, whose condition allows her to see and hear the children and other ghostly presences who are never described in detail. She offers Violeta some aviator's goggles that allow her to see birds, provoking a series of encounters that eventually lead her to an eccentric older male artist who is only known as the Fabricante de Aves (The Maker/Creator of Birds). He can also see and speak with the children but has been confined to his apartment after a series of assassination attempts on his life, so the job falls upon Violeta to awaken the children—or, perhaps, to awaken the adults. As the Fabricante puts it, "Por eso los niños son tan importantes: ellos conservan intactas sus habilidades de clarividencia y telepatía" (93; This is why the children are so important: they have kept their capacity for clairvoyance and telepathy). It is never explained who is after the Fabricante or why. His fears are justified, however; he is found dead in his apartment after his first conversation with Violeta (121–22).

Chacek's use of telepathy plays deftly with the several of the major veins of telepathy or psi topics in SF and speculative fiction,[21] but the conversa-

tion with the Fabricante de Aves she focuses on the idea that misuse of technological capabilities suppresses innate psychic abilities in humans, creating an increasingly isolated and conflicted society.[22] The cameras in the hospitals connected to the parents' phones create a false sense of connection between the parents and the now-silenced children even as the video stream keeps them from any meaningful contact with their children and their children's innate telepathic abilities. There are a few adult telepaths who have retained their powers, but they are all required (we are never told by whom) to live underground in a labyrinthine structure that Violeta describes as "un monumento a la paranoia adulta" (153; a monument to adult paranoia). This further reinforces the connection between the underground and collective history and memory, since it was Violeta's experience in the metro that put her in touch with the dreaming children and her own latent psi abilities in the first place.

The adult telepaths confined to their underground dwelling are not there voluntarily, but it is never quite made clear what it is that they do. As seen through Violeta's eyes, they spend their time staring at different screens that display a series of images that are never described. The telepaths pay scant attention to Violeta and David, her sinister ex-boyfriend who had insisted on taking her down there. When one does stop to look at and speak to them, David scolds him for abandoning his work (157). The workers are strongly reminiscent of the precogs in Philip K. Dick's 1956 short story "The Minority Report," beings who are kept isolated, plugged into machines, and forced to use their psychic abilities to arrest and convict criminals before they can actually commit whatever crimes they may be thinking about. The idea of precrime in Dick's story is not presented as such in Chacek's novel, but Violeta's short encounter with the telepaths and their screens heightens the sense of living in a city under constant surveillance, not only with security cameras (which are omnipresent) but also with the mysterious presence of adult telepaths who appear to be observing and reporting what the cameras cannot see (153–57). Although La caída is more firmly rooted in the fantastic than Nettel's, Chacek's novel also offers representations of disability that are subversive in nature, presenting situations in which a disability may prove to be an advantage rather than an impediment (such as when Magda's dementia allows her to see the children and as such to be more aware of the situation than most of the younger, neurotypical adult residents of the city). The scenes with the adult telepaths serve to illustrate the dangerous slippage between difference, disability, and marginalization that can be imposed by hegemonic or official

152 · Technified Muses

discourses: they are only "others" because their isolation and exploitation support the city's projects of order and economic prosperity.

Like BEF's Gloria and Nettel's Ana, Violeta's positioning in this brave new childless city puts her in a situation similar to that of Deleuze and Guattari's schizo/phrenic, a being that combines metaphysical and historical aspects of process. The metaphysical process, they argue, "puts us in contact with the 'demoniacal' element in nature or in the heart of the earth," while the historical process "restores the autonomy of the desiring-machines in relation to the deterritorialized social machine" (38). Their schizo suggests strong links between the metaphysical, the subterranean, autonomy, social connection, and history, which could be a powerful form of resistance to a national and urban environment that seems designed to disconnect its inhabitants from its historical roots and from each other.

Violeta is very much in touch with that which is considered "demoniacal" in her contact with these children and the remnants of her own telepathy, as indicated early in the novel through a conversation with a fanatically religious cab driver. He insists that "los niños siempre han sido la vía principal a la maldad a las mentes adultas. [. . .] [A]l Diabólico le gusta soplar pensamientos en sus cabezas y ver cómo los infantes torturan a sus padres leyéndoles la mente." (39; children have always been the main path to evil for adult minds. [. . .] [T]he Devil likes to whisper thoughts into their heads and to see how the little ones torture their parents by reading their minds.) Violeta speaks to him because he has a tattoo of a bird on the back of his neck, leading her to think that he will appreciate her aviator goggles that allow her to see birds. Instead, she is surprised by his extremist ideas and his fear of children. His religion is never specified; we only know that he is orthodox, extremist, and frightened. Only the sound of religious music on the radio can calm his agitated state (39–40).

Earlier in the novel, Violeta explains how the government has employed religion to calm the frightened masses after the birds fall to their deaths and the children fall into a mysterious collective slumber. She does not call religion an opiate in so many words, but the meaning is clear enough:

> Por todos los medios nos fue asegurado a la población adulta que lo sucedido en la ciudad [. . .] [había sido] un acto divino para reorientarnos hacia la salvación. [. . .] Casi todos nos contentamos con la idea de dejar de pensar en que las aves algún día existieron y aceptar los designios de las escrituras.

(24; The media assured the adult population that what had happened in the city [...] [was] a divine act to reorient us toward salvation. [...] Nearly all of us were content with the idea of forgetting that birds had once existed and accepting the designs of the scriptures.)

This mass complacency is hardly innocuous, however, as Violeta notes that there were also consequences for those who dared to question the official version of events: "Los que opusieron resistencia terminaron ingresando por su propio pie a los Sanatorios Subterráneos o, como el Fabricante de Aves, confinados en casa" (24; Those who resisted ended up checking themselves into the Underground Sanatoriums or, like the Maker of Birds, confined to their homes). The cab driver's fanaticism and fear, as well as the national manipulation of vaguely religious scriptures and prophecies, recall the bizarre virtual churches that Gloria encountered in *Gel azul*. Both Fernández and Chacek present religion with a wide brush: it can be a place to find comfort in a difficult, dangerous world, but this comfort may come at the cost of separating oneself from the realities of everyday life. This separation, both warn, can result in abandonment of responsibilities. As such, Fernández L'Hoeste's question about cyberspace in *Gel azul* applies here also: if everyone is checked out, either in cyberspace or wrapped up in their technology-driven religion, who the hell is in charge? If practitioners are too absorbed in their virtual faith, the threat to the national imaginary and well-being is significant: the political class refuses to lead; the parents no longer feel compelled to be with their sleeping children—to raise a new generation of Mexican citizens—because it is now sufficient to watch them on their phones. Indeed, such a separation leaves its participants vulnerable, either to physical harm through amputation, as in *Gel azul*, or to manipulation and worker exploitation, as in *La caída de los pájaros*. Recalling Sheikh's posthuman framework on violence, the residents of Chacek's city live in an atmosphere of hyperinvisible violence in which the perpetrator and the weapon never appear and in which the only witnesses—the sleeping children—have been rendered silent and invisible.

Violeta's quest, however, is more profound than simply allowing the adults of the city to get back in touch with their inner children and their own biological children. As the Maker of Birds points out, the city's economy has benefited significantly from the children's absence: "No hay nada más productivo que una comunidad de creyentes hedonistas que trabajan y consumen. El gobierno es el primer interesado en mantener a los niños

'dormidos.'" (95; There is nothing more productive than a community of hedonistic believers who work and consume. The government has a vested interest in keeping the children "asleep.") As a result, the novel walks a fascinating tightrope that flirts with various literary and filmic tropes and branches out into other threads of what has been dubbed *PsiFi* (Lowentrout) or Psience Fiction (Stratton). Are the children actually sinister creatures, à la *Village of the Damned* (Wolf Rilla's 1960 film adapted from British author John Wyndham's 1957 novel *The Midwich Cuckoos*), whose catatonia prevents them from torturing and psychologically manipulating their parents? Or have they been put to sleep by a totalitarian government to create a hedonistic *Brave New World* (à la Aldous Huxley) in which the adults are too busy working and consuming to think about anything else?

Chacek puts all of these possibilities into play without resolving any of them. At the end of the novel, Violeta awakens the children "para que se detone la reinvención del mundo" (181; so that they will set off the reinvention of the world), but never tells us how this reinvention will play out. We know that this detonation comes at a cost, as David, her on-and-off boyfriend and sometime antagonist, is detained and, it is suggested, tortured and perhaps even killed by government workers (180–81). We are never told what, if anything, his sacrifice or Violeta's efforts actually yield. I am inclined, however, to an optimistic reading of the children's awakening, particularly if the telepathic abilities of Violeta and the children are read as "a means of overcoming the alienation that is endemic in a technological society," a tendency that Susan Stratton argues is increasingly common at the end of the twentieth century (333) and that has only become more so in the twenty-first with the rise of smart phones and social media, making us both more and less connected than ever before. While Stratton's focus is on the late twentieth-century North American canon in English, her proposal still offers a productive reading of Chacek's early twenty-first-century Mexican urban context, particularly since a significant part of the novel is dedicated to scenes of ghost-children desperately striving to get their parents' attention, often while their parents are distracted by televisions, cell phones, casino gambling, or other technological entertainment.

All of this takes place in a very particular setting, and it is with a discussion of Chacek's use of space in the novel that I close this chapter. My reading of Nettel's *El huésped* was still fresh in my mind as I began Chacek's novel, which partially influenced my assumption that *La caída de los pájaros* was set in Mexico City, though this was also due to the Mexicanisms in the text and to the fact that Mexico City is the only city in the Republic

with a subway network big enough to encompass Violeta's travels throughout the city. I also knew that Chacek, a tireless walker, or *flâneuse*, herself, is intimately familiar with the capital city and strongly resembles her protagonist in that regard. Even so, my method of reading the novel alongside a city map quickly fell apart, as some places existed with different names, or existed in other cities in the Republic, or not at all. When I had the opportunity to interview Chacek in the summer of 2016, she described the city space of *La caída de los pájaros* as "un DF de los sueños," a Federal District of dreams. Just as Bernardo Fernández reshaped Mexico City into a legibly stratified cyberpunk urban space, just as Nettel presented a capital city in which time and history intersect and overlap in chaotic simultaneity to strengthen her political and social critique, the dream-logic of Chacek's urban space serves to lay bare the potential consequences when a society that is too distracted to notice the panopticonic surveillance they live in.

In Michel de Certeau's *The Practice of Everyday Life*, he proposes two methods of approach to large urban spaces, suggesting that they may be read in terms of maps and itineraries. Maps allow us to see the whole, to have the pleasure of the sense of looking down from above and getting the big picture, whereas itineraries are ground-level, tracing routes and twists and turns and interactions with the spaces and places one encounters along the way (92–93). These itineraries are intimately tied to the act of walking, which, combined with the use of proper names to make sense of the place, creates "liberated spaces that can be occupied" (105), and this tendency runs through all three texts covered in this chapter. BEF's Detective Crajales, Nettel's Ana, and Chacek's Violeta are all active walkers through a cityscape peppered with proper names of streets, buildings, and metro stops, liberating and occupying segments of an often-unwelcoming city one step, one word, one metaphor at a time.

This process of walking and naming allows the reader to enter into the liberated, occupied urban spaces of the texts as well. Guadalupe Nettel's itineraries in *El huésped* do not point explicitly to maps (except through small, strange details such as manatee tacos to tip off the observant reader), but they are very much there, with points that can be easily plotted and that offer the engaged reader a chance to see a bigger picture in the novel and in the political message of the narrative. Chacek's dream-twisted urban cartography, however, denies the reader a map or an overhead view of the spaces in the novel. In doing so, Chacek reinforces (but never resolves) the question that underpins the entire novel: the question of who is really asleep, and who is really awake.

156 · Technified Muses

## Conclusion

The muses at the center of each of the texts in this chapter—Gloria Cubil, Ana/La Cosa, and Violeta as well as her younger self—provide a center of gravity or an axis for the plots in which they appear, even as they unsettle and disrupt the fictional worlds they inhabit. This tendency, in turn, spurs Crajales, Ana, and Violeta to act and to question their initial perceptions of the political and cultural environments they must navigate. In the final two chapters of this book, the muses are particularly indicative of the state of political and economic crisis in which Mexico finds itself. The preparations for the Olympic Games were to have propelled Mexico into an unquestioned position of power and prestige on the global stage; instead, the institution-dominated state destroys or traumatizes those who would apparently most be needed to build it: Palinuro (doctor), Estefanía (nurse), Colombina (Estefanía's trickster double and student worker/protester) and their unborn child in *Palinuro de México*, and Mariana (schoolteacher), Anselmo (intellectual), and Francisca (writer and journalist) in *Crónica de la intervención*. In this situation, the agents of harm are often evident: we know that Palinuro, Colombina, Mariana, and Anselmo were killed by soldiers during peaceful protests and that Francisca fell victim to an oppressive and dysfunctional medical institution. In the case of Estefanía's child, however, the source of trauma becomes more nebulous and, as such, frighteningly vague, particularly if one reads her miscarriage as a result of a dysfunctional state system that cannot successfully produce a new nation or new citizens.

This difficulty in identifying the agents or sources of trauma carries forward into the neoliberal and post-1994 era, in which it becomes increasingly less clear who has done what to whom, though the aftereffects are every bit as tangible. As Susana Rotker suggests, the feared Other may, in fact, be us, complicating the placing of guilt, blame, or retribution, much less the reestablishment of justice (229). Indeed, as in the case of Fernández's amputees in *Gel azul*, the damage done may only result in more damage, when the only solution allowed is to disfigure healthy bodies to repair previous harms to bodies injured in war. Surrounded by blue gel— the color of the ruling party, PAN, at the time the story was written—the novel's cybernauts are trapped in the structure of a dissolving state, unable to enter or leave without outside assistance. The solution, for Fernández as well as for Nettel, is to go underground. Gloria delves deeper into cyberspace and into her consciousness as she reflects on who she is, where

she has been and what has happened to her, while Ana/La Cosa descends into the tunnels of the metro and the "other Mexico" in a decisive rejection of a capitalist neoliberal society. Chacek's Violeta also ends her story in a place of awakening and detonation, acting as a human catalyst to shatter the complacency and alienation of the aboveground world. Her actions are inspired by her experiences underground, first in the metro accident and later among the subterranean telepaths. As a journalist, Violeta is the ultimate agitator-muse as she "keeps forceful watch" over the city and the younger generation and, in a sense, the future of the city, which she may have either set free or doomed in the final paragraph. In all three novels, it is not that hope has been abandoned; it is that all of these muse characters are left in open-ended situations in which the next chapter remains to be written.

# Conclusion

## Of Crossroads, De/Constructions, and Choices

The pleasures and challenges of writing about postrevolutionary Mexico, and particularly the post-NAFTA period, lie in confronting a history that is only beginning to establish itself as such. The most common element among the texts discussed here is the consistently open-ended nature of the narratives. In some texts, particularly from the post-1994 period, there is a promise of later action, as when Ana/La Cosa ventures underground to plan the next revolution in Nettel's *El huésped* and when Chacek's Violeta awakens the sleeping children of the city to "detonate" the reinvention of the world. More frequently, however, the characters and the muses end up headed in directions unknown. Vela's Mabelina joins and then quits the boys' club of her own accord as she inscribes her name into the list of Estridentista members and then walks out of the Café de nadie and into the sunlight to be la que es ([the woman] that she is), to be visible and to choose her own destiny. In *Down Below*, Leonora Carrington shapes her own narrative of her involuntary commitment to a mental institution that she, like Mabelina, ultimately leaves of her own free will and on her own two feet. At the end of *Palinuro de México*, Estefanía emerges with her own written version of events and with a charge from Palinuro (ven, ve y avísale [go, see, and tell]), but we do not know where she chooses to go from there, what she sees, or what she tells or to whom. Fernández's Gloria is poised on the verge of another quest at the end of *Gel azul*, though whether she returns to her body and to the physical world or delves deeper into the consensual hallucination of Fernández's cyberspace remains to be seen. Much like Haraway's cyborg, these muses are firmly situated in the present looking to the future as well as the past, but there is a general refusal to predict where that future path will lead, whether to happiness or sadness, success or failure, life or death.

Conclusion: Of Crossroads, De/Constructions, and Choices · 159

If we follow Jérôme Bindé's assertion that "[m]odern societies suffer from a distorted relationship to time" (51) in that they live entirely in the present, it then becomes possible for a society to become trapped in a permanent state of emergency that is easily manipulated and exploited.[1] Given that postulation, the increasingly empty spaces in which these novels conclude are all the more significant, creating temporary oases for the characters as well as the reader. Action needs to be taken but not immediately; emotions and reactions are not denied, but neither are they provoked or demanded of the characters or the reader. These open endings provide a reprieve from the increasingly intensive nature of what Jeffrey T. Nealon calls "the cultural logic of 'just in time,'" allowing the reader the necessary time and emotional space to respond in a more thoughtful (and ideally more effective) fashion to events on a local, national, and global scale.

In the face of the constructive hegemonic narrative of "Revolution to Evolution" and the creation of *lo mexicano,* Mexican cultural critic Roger Bartra responds with concern, noting that "the nationalist path is one of the most dangerous ways for achieving [hegemony]" and asserting that, in Mexico, it has led "to the institutionalization of a pernicious authoritarian system" (115). Pedro Ángel Palou agrees and goes one step further, noting that what Bartra has diagnosed as symptoms of the post-Mexican condition in the late 1990s "no son sino manifestaciones del colapso definitivo del contrato social mestizófilo que sostuvo el Estado mexicano" (*El fracaso* 29; *Mestizo Failures* 39; are nothing more than the manifestations of the definitive collapse of the mestizophilic social contract that sustained the Mexican state). While we have seen this most distinctly in the last two chapters' discussion of the post-1968 era, Bartra's and Palou's concerns reach further back, as the Mexican state attempted various iterations of itself and constructions of the nation in the aftermath of the Revolution as it sought to fully enter modernity. Bartra perceives the fragmentary discourses produced by a nation entering postmodernity (or postpostmodernity, recalling Nealon) as a sign of hope in battling oppressive monolithic narratives of national history and identity. Palou nods toward Judith Butler and Donna Haraway, particularly Haraway's work on cyborgian and posthuman identity, as a productive exit strategy from those same monoliths. He suggests that the elimination of organic and confining barriers "puede servirnos para cuestionar la misma lógica *esencialista* de la mexicanidad" (209, 305; may better allow us to question the essentialist logic of Mexicanness). I have made similar arguments here in recounting

the individual and subjective accounts from the Estridentistas to twenty-first-century works from the XXX Generation (per Emily Hind), all delivered from the margins of political and cultural power. Fernández is the only self-declared punk of the group, but the punk sensibility of rebellion, renewal, and constant reinvention to avoid institutionalization could be traced back to those very Estridentistas. My suspicions were confirmed upon reading a 1995 interview with Germán List Arzubide in which he declared that he and the Estridentistas were "los *punks* de [su] época" (127; the punks of our era) as they improvised a cosmopolitan literary "cure" for the Mexico's stagnating intellectual scene, one that was equipped to engage with the excitement and ambivalence that accompanied the rapid onslaught of modernity in the capital city.

My objective has been to establish a parallel discourse of postrevolutionary culture and history in Mexico using these same fragmentary accounts with particular attention to gender in shaping these individual, nonhegemonic versions of events. Specifically, I have revisited events that have traditionally been read as foundational or generative events in the nation's history—the Mexican Revolution, the beginning of the Mexican Miracle and post–World War II prosperity in the 1940s, the hosting of the Olympic Games and the country's entrance onto the global economic and cultural stage in 1968, and the implementation of NAFTA/TCL in 1994, which was to have marked Mexico's emergence from the economic crises of the 1980s into neoliberal prosperity in the 1990s. I do so from the narratives enunciated from urban spaces in the nation's capital, since that is where the crisis originated and where national identity is most concentrated and most contested. Through the articulation of a parallel cultural history in which these moments of foundation are read as moments of fragmentation, trauma, and crisis, my goal is to provoke productive tensions between these contradictory and coexistent versions of history and identity. An immense body of work is devoted to the generative and frequently utopic works that sought to shape *lo mexicano* or the evolving hegemonic constructions of the postrevolutionary nation, and, as Horacio Legrás has ruefully observed, the more the archive grows, the more difficult it becomes to grasp the totality of the Revolution and the narratives produced afterward (5). By creating constant friction between canonical and noncanonical voices and stories, the writing and assessment of history becomes wider, more inclusive, and unavoidably contradictory in a mosaic of subjective accounts. In a way, I am simply carrying out a reading of Marshall McLuhan's four laws of media in this postrevolutionary context, recognizing that which is lost

as well as gained, positive and negative developments in the introduction of new media, new messages, and new technology.[2]

In a similarly anti-establishment vein, the texts in *Technified Muses* work deliberately against utopic ideals for the nation. Vela's male narrators are anxious and increasingly fragmented by their exposure to very environment and the technology that his own movement so fervently embraced. La Señorita Etcétera, the women of "Un crimen provisional," and Mabelina do not celebrate the brave new world, but they adapt to it more easily than do the men around them, as do Villaurrutia's Aurora and Owen's Rosa Amalia. Carrington and Varo, the exiled Surrealists, similarly present themselves as having successfully navigated political, economic, and cultural obstacles to escape being tied to the André Breton's Surrealist ideal of the *femme-enfant* or the Mexican ideal of the ethereal Woman-as-Other proposed by Octavio Paz. In the post-1968 era, the utopic resistance becomes more evident as the texts shift from confronting national and identitarian ideals to frankly recognizing the political, economic, and institutional crises of the Mexican state. By the time we reach the post-NAFTA era and Fernández's postapocalyptic beehive, Nettel's corrupt and multilayered city, and Chacek's dream-capital, all sense of utopia has been shattered.

I agree with Miguel López Lozano's suggestion that dystopian fiction, particularly in the Mexican context, provides the intellectual and literary tools with which "to question fundamental tenets of Latin American culture such as the Western model of industrialized capitalism as the only possible pattern for the economic development of the hemisphere" (4), which, in turn, projected long-term consequences of colonization, modernization, and globalization (232). The rejection of utopia and of official histories is also a way of combating the erasures of gender, race, class, sexuality, and dis/ability within these ideals. As such, I do not conflate rejection of utopia with pessimism. López Lozano ends his book on a cautiously optimistic note, recognizing that even as the apocalyptic novels that he analyses recognize and critique national issues, their endings still "express confidence in the Mexican people's ability to use knowledge of history to transcend their differences and join together to forge a new future" (237–38). Fernández, Nettel, and Chacek do not quite express the same level of confidence, but they refuse to negate the possibility of success, the possibility that the situation might still improve.

The victory of MORENA (Movimiento Regeneración Nacional [National Regeneration Movement]) president Andrés Manuel López Ob-

rador (AMLO) in July 2018 seems to support López Lozano's assertion; both the PRI and PAN candidates were soundly defeated in what English-language news outlets universally described as "Mexico voting for change" and which the Mexican newspaper *Excélsior* called "un nuevo respirar para México" (a breath of fresh air for Mexico) in the hours after the election results had been confirmed. At a press conference in February 2019, López Obrador proposed a version of modernity that was "forjada desde abajo y para todos" (forged at the grassroots level and for everyone), referring to Carlos Salinas de Gortari's largely failed modernization project (1988–94). Even a landmark victory like AMLO's cannot be read as the realization of utopia: public and critical opinion of his policies is sharply divided, and the Zapatista army has been opposed to López Obrador and his social platforms for years.[3] The dystopic narratives and authors that López Lozano and I write about are just as useful in moments of hope as they are in moments of crisis—perhaps even more so. They all share the same clear-eyed view of the nation as it is while carving out a textual and literary space for the nation as it could be, leaving the particulars of the project to be developed by the individual needs and requirements of those who would carry it out.

# NOTES

## Introduction

1 The female Mexican body has a long history of exclusion from national narrative, as seen (or rather, not seen) in fundamental works devoted to idealized nations of the national body, from José Vasconcelos's *La raza cósmica* [The cosmic race] (1925) to Samuel Ramos's *El perfil del hombre y la cultura en México* [Profile of man and culture in Mexico] (1934). When she does appear, she does so as a *chingada* [a fucked, violated single mother] in Octavio Paz's *El laberinto de la soledad* [*The Labyrinth of Solitude*] (1950), or she must articulate her sense of self through her literary writing instead of her body (as seen in Margo Glantz's 1990 essay "Las hijas de la Malinche" [Malinche's daughters]). Alternatively, as Emily Hind observes in *Femmenism and the Mexican Woman Intellectual from Sor Juana to Poniatowska* (2010), her body is expected to be a maternal body or an incorporeal intellectual—a false choice, to be sure, but one that evidences deeply rooted social conventions that either link the female body to heteronormative motherhood or deny that body entirely in favor of intellectual production (27).

2 See, for example, the introduction to *Fragments of a Golden Age* by Joseph, Rubinstein, and Zolov (2001).

## Chapter 1. Mechanized Muses of the New Metropolis

1 For more detailed information and statistics, see Aguilar Camín and Meyer 87–89.

2 See Legrás 5.

3 As Yanna Haddaty Mora observes during this period (1921–32) in *La ciudad paroxista* [The paroxysmal city], "sorprende la constante polarización al imaginar la ciudad: las representaciones oscilan entre la visión del orden y la del caos, la construcción y la destrucción, el registro epifánico y el apocalíptico" [13; it was surprising how imagining the city provoked constant polarization: representations oscillated between visions of order and of chaos, construction and destruction, epiphanic and apocalyptic registers].

4 See Quirarte's *Elogio de la calle* (357–422) and Ignacio Sánchez Prado's *Naciones intelectuales* [Intellectual nations] (16).

5 As Jorge Aguilar Mora and others have noted, the end of the conflict was not as clear-cut as my use of the year 1920 would indicate. Although 1910 is an uncontroversial and agreed-upon starting date, as Aguilar Mora and others have stated, "los años que se dan [en varios libros] para su término varían" [13; (different books) offer a variety of years to mark its end].

164 · Notes to Pages 15–18

6 As Pedro Ángel Palou astutely observes about the 1920s, "Son estos años donde fluye la preocupación por encontrar una identidad de la nación, una filosofía e incluso una estética mexicanas" [*La casa del silencio* 94; These years were underlined by the desire to find an identity for the nation, a philosophy and even an aesthetic that were specifically Mexican]. Palou would go on to write about the Mexican state's attempt to base this identity on the racialized figure of the mestizo as defined (and redefined) by the state itself, and the sociopolitical failures that resulted (*El fracaso* 14–15).

7 Palou, *La casa del silencio* 85.

8 See also Palou, *La casa del silencio* 81.

9 While Maples Arce's manifestos were certainly inspired by and dialogued with Italian and Russian futurisms (see Flores, "Clamoring"; and Gallo, "Maples Arce") and unjustly accused of being a mere imitation of those movements by a number of critics, including Contemporáneos Xavier Villaurrutia and Jaime Torres Bodet (Corte Velasco 25), the *actualismo* of Estridentismo is none of those things. Árqueles Vela summed it up best when he told Roberto Bolaño that "el Estridentismo era un asistir a la realidad inmediata, una conviviencia con lo inmediato de la existencia" [87; Stridentism was being present in immediate reality, a coexistence with the immediate nature of existence].

10 "From its beginnings [in the early twentieth century]," Rocío Guadalupe Guerrero Mondoño reminds us, "the machine aesthetic is closely associated with the artistic and literary avant-garde, one of various responses to the process of mechanization that impacted every aspect of human feeling and experience. In its turn, the aesthetic model had an expansive quality that touched simultaneously, in varying degrees, different aspects of intellectual, socio-cultural, and political life" (20).

11 Huidobro's advice in his 1916 poem *Arte poética* (Poetas, no cantáis a la rosa; / hacedla florecer en el poema [Poets, do not sing to the rose; / make it bloom in the poem]) struck Maples Arce as entirely too timid. His retort: "Esto es un consejo, no un conjuro poético. ¿En dónde está la floración?" [121; That is advice, not a poetic incantation. Where is the bloom?]

12 Among the excellent and comprehensive sources on Latin American avant-gardes are Jorge Schwartz's *Las vanguardias latinoamericanas* [Latin American avant-gardes] (1991, 2002); Vicky Unruh's *Latin American Vanguards: The Art of Contentious Encounters* (1994); Hugo Verani's *Narrativa vanguardista hispanoaméricana* [Avant-Garde Hispanic American narrative] (1996); and the five-volume *Vanguardia latinoamericana: Historia, crítica y documentos* [Latin American avant-garde: History, criticism, and documents], published between 2000 and 2015.

13 As previously mentioned, the Estridentistas' critical reception was deeply mixed in the press (Palou, *La casa del silencio* 85), and this would continue in Mexican literary criticism until the early 2000s. Among the more famous detractors are Antonio Alatorre, Carlos Monsiváis, José Joaquín Blanco, Vicente Quirarte, and Guillermo Sheridan (which Evodio Escalante pointedly indicates in *Elevación y caída del Es-*

*tridentismo* [Rise and fall of Stridentism] 9–40). See also Corte Velasco 35–74; and Curiel 145–57.

14 Fernando Curiel convincingly argues, for example, that the Estridentistas were reincarnated in the multidisciplinary countercultural movement La Onda (literally, The Wave) in the mid-late 1960s in Mexico (154). Elissa J. Rashkin makes an excellent case for the ongoing impact of the Estridentista movement in the last chapter of *The Stridentist Movement* (223–44) and, along with Carla Zurián, offers a compelling reflection on various and ongoing efforts to reconstruct the Estridentista archive over the past sixty years (Rashkin and Zurián). I have argued elsewhere that the Estridentista movement laid the groundwork for the emergence of the Infrarealist poetry movement in the late 1970s and shaped authors such as Infrarealist founding member Roberto Bolaño (Potter, "From Post-Revolutionary Cosmopolitanisms").

15 I originally associated the term "Estridentópolis" with Xalapa, the city where the Estridentistas occupied positions in the local government beginning in 1925. I was intrigued, however, to read Silvia Pappe's suggestion that Estridentópolis was, instead, a literary city, one constructed of texts rather than skyscrapers (*Estridentópolis* 11). While neither she nor I dispute the movement's roots in the capital, the idea of Estridentópolis as a textual and discursive construction is a useful one, as it permits greater flexibility in terms of its geographical location and facilitates its expansion to other parts of the Republic.

16 See Gallo, *Mexican Modernity.*

17 See, for example, Irwin 121; Macías-González and Rubenstein 7–12; and Domínguez-Ruvalcaba 97–111.

18 Carlos Monsiváis offers an excellent overview of the early history of the feminist movements in Mexico beginning in the mid-nineteenth century ("When Gender Can't Be Seen" 1–20), as do Gabriela Cano's "Más de un siglo de feminismo en México" [More than a century of feminism in Mexico] (1996) and Mexican historian Julia Tuñón Pablos's introduction to the anthology *Voces a las mujeres: Antología del pensamiento feminista mexicano 1873–1953* [The voices of women: Anthology of Mexican feminist thought, 1873–1953] (2011).

19 Their meeting, as fictionalized by Germán List Arzubide in *El movimiento estridentista*, portrays them as two strangers drawn to one another in the Café de nadie, exchanging seemingly nonsensical statements that both understand perfectly (272).

20 I would like to emphasize the distinction between *El café de nadie* (the title under which all three texts are often published) and the short novel "El café de nadie."

21 Interestingly, "Mabelina" is a variation on "Mabel," which means "happy" or "beloved." Given that names like Angustias and Dolores (anguishes and pains, respectively) are fairly common women's names in Spanish, I find it significant that Vela has chosen a name that evokes happiness for this character. In her 2014 article on marginalized masculinities in postrevolutionary avant-garde movements, Ángela Cecilia Espinosa observes the etymology of the character's name as well, but with an additional and potentially paradoxical association: the U.S. makeup brand Maybel-

166 · Notes to Pages 21–30

line, which ran ads in photographic magazines designed for feminine consumption in urban centers in Mexico (314). While this might suggest that the character is no more than a consumer who is herself an object of consumption for the men around her, the brand name reference stands in striking contrast to the etymology of the character's name and to her refusal to be defined or consumed by anyone else.

22 While calling an early twentieth-century character a cyborg is not without its problems, I agree with Gray, Figueroa-Sarriera, and Mentor that it can still be a productive way of assessing "the central stories of our age," particularly what they call "cyborg myths, *attempts to understand the broader implications of human/machine co-evolution*" (6, original italics). In that sense, Vela's work, and indeed much Estridentista poetry and art, are very much cyborg myths.

23 See Potter 124.

24 Estridentismo is not entirely unique in this aspect; across the Atlantic, the Spanish avant-garde writer Ramón Gómez de la Serna also used "etcétera" and ellipses in many of his famed *greguerías*, brief poetic statements that were written through free association or automatic writing.

25 Vela's Señorita, according to Silvia Pappe, fits the paradigm of the typically Estridentista character: "no aparecen de cuerpo entero ni suelen tener rasgos definidos. [. . .] Con frecuencia se confunden—ya sea con otros personajes, ya sea con ellos mismos en un espacio o tiempo distintos." [95; their entire bodies do not appear and they do not tend to have defined features. (. . .) They are frequently mistaken for other people—either with other characters or with themselves in a difference time or space.] The women, meanwhile, are idealized, childless, artificial, and change with the landscape. Thus, it is all the more noteworthy that the female characters become less and less "typically Estridentista" over time in Vela's novels.

26 Vela's narrator's attitude of nonjudgmental discomfort toward his Señorita(s) is even more remarkable when placed in contrast with other avant-garde texts of the period. While texts such as Contemporáneo Salvador Novo's *El joven* also indicate anxiety at the presence of independent women in the capital city, as Gabriela Romero-Ghiretti notes in her article on "La Señorita Etcétera" (261–62), Novo's stance is purely negative, declaring that "tanto mal ha producido el individualismo en las mujeres" [8; so much illness has made women individualistic]; for him, women's independence is purely pathological.

27 The success of Vela's texts as "functionally feminist" is further bolstered by the exaggerated and anxious response it provoked from fellow Estridentista Germán List Arzubide, as discussed in the previous few paragraphs. I do not know if Vela ever responded directly to List Arzubide's mockery in "El movimiento estridenista," but I do note that Vela dedicated "Un crimen provisional," a story full of panicked men and capable women, to him in 1924.

28 Katherina Niemeyer, *Subway de los sueños* [Subway of dreams] 78.

29 Taken out of context, the sentence is ambiguous due to its lack of an explicit subject. In the novel, however, it is clear that it is she who has tattooed him, just as it is she who has "quemado hondamente su silueta en el fondo de mi corazón" [Vela 96;

Notes to Pages 32–42 · 167

burned her silhouette deep into the bottom of my heart], leaving him branded as well as tattooed.

30  In a 1976 interview with Roberto Bolaño, Vela recalled three books that had shaped him as a young man: the Comte de Lautréamont's *The Songs of Maldoror*; Friedrich Nietzsche's *Thus Spoke Zarathustra*; and Viliers de l'Isle-Adam's *The Future Eve*. They were, Vela said, "los decisivos para formar un nuevo espíritu" [n.p.; the decisive (texts) to form a new spirit] in himself as a young reporter and writer in the last years of the Revolution and the early years of Estridentismo.

31  In her work on fragmentation in Mexican narrative, Carol Clark D'Lugo offers a useful reminder of just how far Vela had strayed from the literary norms of the time with "La Señorita Etcétera": when the text was first published in *El Universal* in 1922, the newspaper's editor prefaced the text with a note about Vela's iconoclastic style, warning that it was "despojado de todos los lugares communes literarios" [51l; free of all literary commonplaces].

32  The French Surrealists hung a mannequin from the ceiling of La Centrale Surréaliste, their first workshop. Life-sized, headless, armless, and naked, "[h]er function was evidently to inspire the 'anxious men' who came there to unburden themselves of their secrets" (Suleiman 21).

33  Indeed, Álvaro Contreras, Jorge Mojarro, and Rodrigo Leonardo Trujillo-Lara are among those who not only label Vela's work a parody of the detective genre but insist that it only makes sense when read as such (Trujillo-Lara 65).

34  The question of exactly how many female characters there are in "Un crimen provisional" has been an ongoing debate in the corpus on this text, though both Mojarro Romero and Trujillo-Lara appear more interested in the number of servants questioned by the detective rather than the number of women involved (Mojarro Romero 114–15; Trujillo-Lara 71).

35  This reading was inspired in part by Puerto Rican author Rosario Ferré's 1976 short story "La muñeca menor" ["The Youngest Doll"]. Ferré leaves us with the same questions that Vela does in "Un crimen provisional": Did the woman escape, leaving the doll in her place? Or was she turned into a doll after years of being treated as one?

36  I limit my analysis to the Estridentistas and the Contemporáneos since those groups were in direct literary conflict during this period; for more on the Virreinalistas [Viceroyalists], another active literary group from this era, see Sánchez Prado, *Naciones intelectuales*.

37  See, for example, Palou, *Escribir en México* [Writing in Mexico] 46.

38  See Palou, *La casa del silencio* 61–76; Palou *Escribir en México*: 58–66; Sheridan *Los Contemporáneos ayer* 32–82; and García Gutiérrez's "Jóvenes y maestros: Los Contemporáneos bajo la tutela de José Vasconcelos, Pedro Henríquez Ureña y Alfonso Reyes" [Young men and teachers: The Contemporaries under the Tutelage of José Vasconcelos, Pedro Henríquez Ureña and Alfonso Reyes], *Anales de Literatura Hispanoamericana* (Annals of Hispanic American literature), no. 27 (1998): 275–96.

39  Palou (*La casa del silencio*; 1997) speaks most clearly to this schism.

168 · Notes to Pages 49–59

40  Evodio Escalante makes an excellent case for the timeline that Villaurrutia suggests in *Dama de corazones*, which I will address in greater detail later on. Salvador Oropesa makes the suggestive argument that Villaurrutia employs baroque models to "escape the temptation of converting the Revolution into a master narrative;" giving him a way to "write free literature in a context of oppression" (5–6).

41  See Palou, *La casa del silencio* 108.

42  See M. Schwartz 9–18.

43  For further discussion of the Estridentista presence in Xalapa, see Pappe's *Estridentópolis* 74–90 and "La historia"; as well as Rashkin, *The Stridentist Movement* 113–32, 157–86.

44  Hadatty Mora and Sheridan coincide on this point, whereas Oropesa extends the group's existence through the 1940s.

45  Elissa J. Rashkin and Carla Zurián offer an excellent overview of the Estridentista legacy in "The Estridentista Movement in Mexico." I also discuss the impact of the Estridentista and Contemporáneos' activities on late twentieth- and early twenty-first-century world literature authors such as Roberto Bolaño and Valeria Luiselli in "From Post-Revolutionary Cosmopolitanisms to Pre-Bolaño Infrarealism."

## Chapter 2. Surrealist Muses in Exile

1  For a comprehensive overview of Mexican history and politics during those years, see Aguilar Camín and Meyer's *A la sombra de la Revolución Mexicana* [*In the Shadow of the Mexican Revolution*], particularly 189–235 (159–98 in the English translation). There are abundant sources on Cardenismo in Spanish, but relatively few in English; Friedrich Engelbert Schuler's *Mexico between Hitler and Roosevelt: Mexican Foreign Relations in the Age of Lázaro Cárdenas, 1934–1940* is an excellent resource.

2  For more on the 1940 election and the cultural-political environment, see, among others, Davis 63–101; and Joseph, Rubenstein, and Zolov 8–11.

3  Emilio Fernández was fully aware of (and perhaps overconfident in) his role in shaping the postrevolutionary national imaginary through his films. As he once said in an interview, "Sólo existe un México: El que yo inventé" [There is only one Mexico: the one I invented] (cited in Dalton 100).

4  A sizeable corpus exists on this topic that, while important, lies outside the focus of this chapter. Excellent sources include Sebastiaan Faber's *Exile and Cultural Hegemony: Spanish Intellectuals in Mexico, 1939–1975* (2002); Clara E. Lida's *Inmigración y exilio: Reflexiones sobre el caso español* (1997); and Martí Soler Vinyes's *La casa del éxodo: Los exiliados y su obra en la Casa de España y el Colegio de México* (1999).

5  See Agustín 36. For a more complete historical overview and analysis of the relationship between Mexico and the United States during and after World War II, see Thomas M. Leonard and John F. Bratzel's *Latin America during World War II* (2007); and Monica Rankin's *¡México, la patria!: Propaganda and Production during World War II* (2009).

6  In Breton's *Surrealism and Painting*, Frida Kahlo is the one of only two female artists to whom he dedicates one of his "Fragments" (the other is Hungarian painter Judit Reigl). Written in 1938, he titles it "Frida Kahlo de Rivera," thus insisting on her

Notes to Pages 59–71 · 169

relationship to Diego Rivera (141–44). Remedios Varo does not appear at all, and Leonora Carrington is only mentioned briefly, when Breton notes the similarities between her art and that of Romanian painter Victor Brauner (76).

7  See, for example, Claudia Schaefer's chapter on Kahlo in *Textured Lives: Women, Art, and Representation in Modern Mexico* (3–36); and Margaret A. Lindauer's *Devouring Frida: The Art History and Popular Celebrity of Frida Kahlo* (1999).

8  There has long been an association between Surrealists and mannequins. The rue Surréaliste in the 1938 *International Exhibit of Surrealism* was lined with them, each one decorated by a different member of the group. "The history of the surrealist mannequin has been a movement from the specific (as effigies) to the general [. . .] and the figures carry this signification with them. They are the objects of fantasy, akin to automatons of literature" (Warwick vii).

9  See Durozoi 63–186.

10  See Durozoi 258; and Rosemont xxix–lvii. Melanie Nicholson also makes a compelling case for the persistence of Surrealist influence (if not the organized movement itself) worldwide and most particularly in Latin America (15–29).

11  Indeed, when I first Googled "María Teresa León surrealism," the entire first page of links was dedicated not to her but to her husband, the poet and artist Rafael Alberti.

12  Mexico was not the only "non-Western" country or culture that attracted the interest of the Surrealists; their interest in the so-called "primitive" also encompassed regions of Russia, Alaska, Labrador, and Oceania (see Gilbert 9–77).

13  Nicholson's assessment agrees with that of Luis Mario Schneider, who declares in *México y el surrealismo* [Mexico and Surrealism] that Artaud's 1936 arrival brought Mexican and French artists and intellectuals together in truly collaborative artistic relationships (37).

14  As Inés Amor, Carolina's sister, recounts in her memoirs, "No había en ese tiempo [en 1934] muchos pintores en México. La Academia de San Carlos tenía una población bastante reducida. [. . .] [N]o creo que llegara a veinte el número de pintores." [27; At that time (in 1934), there were not many painters in Mexico. The Academy of San Carlos had a fairly small population. (. . .) I do not think the number of painters even reached twenty.]

15  Elena Poniatowska's novel *Leonora* makes a similar point, though it is unclear who is speaking—the anonymous third-person narrator, Poniatowska as an authorial side comment, or Carrington herself. As such, it could be any or all of them who ask, "¿Y por qué no es Breton el de la belleza convulsiva, por qué siempre una mujer?" [276; And why is Breton not a being of convulsive beauty; why is it always a woman?]

16  Carrington had written dark and mischievous short stories as a young woman prior to her institutionalization, but none were more than a few pages long. These received a great deal of attention in 2017 to celebrate the centenary of her birth, but they were often mentioned in the same breath as *Down Below*, suggesting (inaccurately) that the text was as fantastic and as fictional as her earlier stories.

17  In *The Holy Grail: Its Origins, Secrets, and Meaning Revealed*, Malcolm Godwin organizes the various Grail myths and legends into three major branches: Celtic,

170 · Notes to Pages 73–87

Christian, and Chymical [*sic*]. While the emphases and strains vary within each branch, there is no single authoritative version but rather a "nest of narratives; many versions circling a central theme" (Godwin 14–5).

18 See Baring and Cashford's *The Myth of the Goddess*; and Godwin.

19 Arcq indicates that Ouspensky was not a target of Carrington's satire as Gurdjieff was, since he had distanced himself from his former teacher years before ("The Esoteric Key" 36).

20 Like Varo and Carrington, Buñuel was poised for a kind of success in Mexico that he could not have achieved in Europe during the immediate postwar period (Acevedo-Muñóz 32).

21 For several years, Varo's archives were in the Colonia Cuauhtémoc in Mexico City, stored in the home of the late Alexandra Varsoviano Gruen (1927–2015). I remain extremely grateful for the opportunity to speak with Mrs. Gruen and to consult the archives on various occasions during the fall of 2011 and the spring of 2012. At this writing, they are housed in the Museo del Arte Moderno in Mexico City.

22 The adjective "tórbida" does not exist in Spanish or Latin, though "torbido/a" does exist in Italian. It may be a compound word: *tórrido* (torrid) + *turbido* (turbid). As such, it seemed appropriate to use "torbid" in the translation of the title, as this combination denotes something that is both provocative (torrid) and confusing (turbid).

23 Personal interview, July 1, 2010.

### Chapter 3. The Medicalized Muses of Tlatelolco

1 See Flaherty 34; Rojo 1–18; and Steinberg, "Tlatelolco me bautizó" 2–14. Rojo devotes an entire chapter to the search for the "truth" of the events of Tlatelolco that includes long lists of honest mistakes, moments of confusion, and historical texts that deliberately erase or minimize the massacre (5).

2 In Elena Poniatowska's *La noche de Tlatelolco* (1971, published in English as *Mexican Massacre*), Claude Kiejman, a journalist from *Le Monde,* confided, "What in any other country would have been quite enough to unleash a civil war has resulted here in Mexico in nothing more than a few tense days immediately following. [. . .] I don't understand it. What was the reason for it? Nor do I understand why everyone has remained silent" (314).

3 The very beginning of *Crónica de la intervención* is peppered with lines from Contemporáneo Xavier Villaurrutia's *Nocturnos* [*Nocturnes*], particularly "Nocturno en que nada se oye" [Nocturne in which nothing is heard], which emerges as a leitmotif throughout the novel and further underlines the literary genealogy between the Contemporáneos and the Generación del Medio Siglo.

4 In his 2016 book *Photopoetics at Tlatelolco*, Samuel Steinberg makes a strong case for Jorge Volpi's 2003 novel *El fin de la locura* [The end of insanity] as another "novel of '68" that approaches the status of the total or totalizing novel (149–50). In this book, however, I am focusing on texts by authors who were professionally active during the traumatic events they address through literature, which eliminates Volpi (born in 1968) from the scope of this particular project.

Notes to Pages 87–105 · 171

5 Originally, I had written that Mexico was never mentioned and said so in a presentation at a Mexicanist conference at UC-Irvine several years ago. Juan Pellicer, a friend of Juan García Ponce and author of *El placer de la ironía: Leyendo a Juan García Ponce* [The pleasure of irony: Reading Juan García Ponce], offered a friendly correction, noting that that the word "Mexico" does indeed appear once (but only once) in the novel. I would like to believe, as Dr. Pellicer has kindly assured me, that it was a careless mistake on the author's part.

6 See Bruce-Novoa, "*Noticias del imperio*," regarding del Paso and Johnson regarding García Ponce.

7 In *The Mexican Exception*, Gareth Williams recognizes and pushes back against the "essentially Christian narrative of 1968 as inescapable martyrdom, sacrifice, and social trauma" (133). Samuel Steinberg continues Williams's critique in what he calls a secularization of the reading(s) of 1968 (*Photopoetics* 15).

8 It must be noted that some women were complicit in their own historical erasure as well. Frazier and Cohen—the coeditors of the volume in which Carey's chapter is published—had coauthored an article six years earlier that focused on narratives about and contributions to the student movement that were not from elite men. Even as they gathered oral testimonies from many of the women in the movement, the women themselves did not consider their own participation important and agreed with the editors that their real names should not be used in the article in a "mutual agreement to protect their privacy" (637, 621).

9 See Kurlansky 328; Williams 124–25; and Steinberg, *Photopoetics* 11–14, among others.

10 For a more detailed account of Lecumberri and its history, see Flaherty 42–65.

11 See Ruffinelli; and Sánchez Prado's "Dying Mirrors."

12 Del Paso draws from a sixteenth-century tradition of Italian improvised drama that uses stock characters (among them the Doctor, the Harlequin, Colombina, the Captain, and the Zanni, or jesters) and intermingles scandal, romantic intrigue, and farce. For more information, see Henke's *Performance and Literature in the Commedia dell'arte*.

13 See Ryan Long's chapter on José Trigo in *Fictions of Mortality* (35–66).

14 Rebeca Pérez Vega, "Palinuro se despierta para recordar Tlatelolco" [Palinuro awakens to remember Tlatelolco], *Milenio*, September 30, 2008.

15 See Radulescu.

16 While an in-depth reflection on the Talmud and the multiple manifestations of Lilith goes far beyond the scope of this chapter, Reiss and Ash's "The Eight-Month Fetus: Classical Sources for Modern Superstition" offers an excellent historical account as to why the eighth month (when Estefanía miscarried) was long considered less viable than the seventh month in sacred texts such as the Talmud.

17 García Ponce is not generally recognized as an artist, but a number of pencil-and-ink drawings in his older notebooks in the Princeton Archives reveal him to be a very competent sketch artist. As he developed multiple sclerosis and his fine motor skills were diminished by the disease, he could not draw as he had before, but his eye clearly retained its training.

172 · Notes to Pages 106–124

18 Indeed, Beatrice Faust asserts in *Women, Sex, and Pornography* that the "half-life" of pornography (that is, of its power to provoke or excite) is generally very short (13).

19 Carter defines a moral pornographer as "an artist who uses pornographic material as part of the acceptance of the logic of a world of absolute sexual license for all the genders, and projects a model of the way such a world might work. A moral pornographer might use pornography as a critique of current relations between the sexes" (19). Her moral pornographer is explicitly and exclusively male, but he has the ability "to penetrate to the heart of the contempt for women that distorts our culture" (20). She provides no concrete examples of any moral pornographers currently at work, suggesting that the category is not descriptive of what is but rather an articulation and a reminder of what *could be.*

20 García Ponce establishes the opposition between Francisca and María Elvira about a third of the way through the novel; at a party, Esteban becomes acutely aware of an abyss between the two women that seems to consume space and time (I.552).

21 The leap from García Ponce to Carrington is not such a distant one, as his personal documents include a number of essays about her in which he praises her work and declares that it must be considered part of the Mexican artistic landscape (Untitled document, *ARTE: Ensayos diversos escritos en los '60*, box 14, folder 8, Princeton University Archives, Princeton, NJ).

### Chapter 4. Muses of the Virtual Metropolis

1 See Bazdresch and Levy 1991.

2 Lewis bases her assessment on her reading of Enrique Krauze's *Mexico: Biography of Power* (1997). See also Ignacio Corona's analysis of President Echeverría's rhetorical strategies to restore political legitimacy for the presidency in the wake of the Díaz Ordaz's administration (93–157).

3 An exception to access-as-privilege may be found in Alex Rivera's 2008 film *Sleep Dealer*, as the ability to plug in is not necessarily an indicator of power or social status. Much of the node worker population must obtain that ability at great personal and financial risk in order to work as *cybraceros*, providing their brainpower and labor across the United States and other borders while their "illegal bodies" remain in Mexico.

4 Fernández is riffing here on an urban legend of organ trafficking in Mexico and other Latin American countries that emerged in early 1987—that is, that children were being kidnapped in various Latin American countries and their organs harvested to be sold on the black market to wealthy families in the United States (see Campion-Vincent; and Leventhal). Variations of the legend have been treated in the *novela negra* as well, including Paco Ignacio Taibo II's *La bicicleta de Leonardo* (1993); Eugenio Aguirre's *Los niños de colores* (1993); and Gabriel Trujillo Muñoz's *Loverboy* (2002).

5 In *Antiheroes: Mexico and Its Detective Novel* Ilán Stavans observes that Belascoarán is unique "from the rest of the Mexican detectives [. . .] in [his] passion for deciphering national history" (109).

Notes to Pages 125–140 · 173

6 Gibson was the first person to use the term "cyberspace" in his 1982 short story "Burning Chrome"; he would employ the term again in the 1984 *Neuromancer* to describe the "consensual hallucination" of virtual reality in computer networks. It remains the most widely read cyberpunk novel in and beyond the SF canon (Heuser 4).

7 See Andrew Brown, "Hacking the Past" (2006); and Rosario Ramos González, "La fábula electrónica" (2003). I am not the first to notice the similarities between the two novels; Ignacio Sánchez Prado suggested that *El delirio de Turing* and *Gel azul* might be read in dialogue with one another in "Ending the World with Words" (126).

8 To delve into specifics goes far beyond the scope of this chapter, and the body of research on the physical, psychological, and philosophical effects of VR is enormous. Some good starting points are Grigore Burdea and Philippe Coiffet's multivolume *Virtual Reality Technology* (Hoboken, NJ: Wiley & Sons 2003), Karen McMenemy and Robin Stuart Ferguson's *A Hitchhiker's Guide to Virtual Reality* (New York: CRC Press, 2007), and Jason Jerald's *The VR Book: Human-Centered Design for Virtual Reality* (San Rafael: Morgan & Claypool, 2015).

9 Edmundo Paz Soldán's Playground in *El delirio de Turing* (2003) and Neal Stephenson's Metaverse in *Snow Crash* (1992) are two examples that come to mind.

10 Klint Finley, "Cyberpunk's Not Dead: In Fact, We're Living It," *Wired*, June 27, 2015.

11 While I focus on cyberpunk for the purposes of this chapter, I do not wish to discount the role of the SF tradition in Latin American literature from the nineteenth century to the present. Andrew Brown and Elizabeth Ginway offer an excellent overview of SF production and scholarship in the introduction to *Latin American Science Fiction: Theory and Practice* (2012). Other key works in English are Rachel Haywood Ferreira's *The Emergence of Latin American Science Fiction* (2011) and Andrea L. Bell's and Yolanda Moliva-Gavilán's *Cosmos Latinos*, an anthology of Latin American and Spanish SF in English translation (2003).

12 Personal interview, July 29, 2010. See also Hind 236 in *Generación XXX*.

13 See also Córdoba 216–27.

14 See Sánchez Prado, "Ending the World with Words" 121.

15 M. Elizabeth Ginway makes a similar proposal in "The Politics of Cyborgs in Mexico and Latin America," where she makes a convincing argument for the particular defiance of Mexican cyberpunk through the figure of the unruly trickster cyborg (162).

16 The term is borrowed from *Citizens of Fear*, edited by Susana Rotker (2002).

17 Here, I draw on a long history of disability studies that goes back to at least the 1970s and establishment of the social model of disability that posits disability as a social construct rather than an individual failure or misfortune, with a particular focus on disability studies in Latin America (see Antebi and Jörgensen 1–26).

18 The best-known pop culture example of a girl whose monstrous nature emerges or gains strength when she reaches puberty is likely Stephen King's *Carrie* (1974). The fear of monstrous, menstruating women dates back to the beginning of humanity

174 · Notes to Pages 143–162

(or at least the biblical version thereof) if we consider that Eve's painful menstruation, pregnancy, and birth were punishments from God for being disobedient and curious. The corpus on the topic is vast, but more recent contributions include Iris Marion Young's reflections on feminism, womanhood, menstruation, and Simone Beauvoir in "Menstruation Meditations" (2005) and Eugenia Tarzibachi's *Cosas de mujeres: Menstruación, género y poder* [Women's affairs: Menstruation, gender, and power] (2017) and *Menstrual Bodies and Gender: The Transnational Business of Menstruation from Latin America* (2021).

19  See also David Dalton's *Mestizo Modernity*, particularly chapter 4.

20  The metro was scheduled to be completed for the 1968 Olympics but was not completed until nearly a year later. See Castañeda's "Choreographing the Metropolis."

21  "Psi" in science fiction or speculative fiction refers to what are also referred to as psychic powers. The term "psi" has been more widely used for the last quarter century or so, since, to quote Susan Stone-Blackburn, "it is more economical [. . .] and less wedded to the notion that 'power' is the main attraction of paranormal abilities" (242).

22  See Lowentrout 392–93; Stone-Blackburn 243, and Stratton 325.

### Conclusion

1  Bindé is not alone in his preoccupation; critics from Giorgio Agamben to Walter Benjamin to Susana Rotker to Slavoj Žižek have expressed similar concerns about being caught in a constant and easily manipulated state of emergency.

2  See McLuhan and McLuhan.

3  See, for example, María Inclán's "The Zapatistas vs. AMLO," *Berkeley Review of Latin American Studies* (Fall 2020).

# BIBLIOGRAPHY

Aberth, Susan L. *Leonora Carrington: Surrealism, Alchemy and Art.* Burlington, VT: Lund Humphries, 2004.

Acevedo-Muñoz, Ernesto R. *Buñuel and Mexico: The Crisis of National Cinema.* Berkeley: University of California Press, 2003.

Ades, Dawn. "Orbits of the Savage Moon: Surrealism and the Representation of the Female Subject in Mexico and Postwar Paris." *Mirror Images: Women, Surrealism, and Self-Representation.* Ed. Whitney Chadwick. Cambridge, MA: MIT Press, 1998. 106–27.

Aguilar Camín, Hector, and Lorenzo Meyer. *A la sombra de la Revolución Mexicana.* 1989. Mexico City: Cal y arena, 2005.

———. *In the Shadow of the Mexican Revolution: Contemporary Mexican History, 1910–1989.* Trans. Luis Alberto Fierro. Austin: University of Texas Press, 1993.

Aguilar Mora, Jorge. *El silencio de la Revolución y otros ensayos.* Mexico City: Ediciones Era, 2011.

Agustín, José. *Tragicomedia mexicana 1: La vida en México de 1940 a 1970.* 1990. Mexico City: Planeta, 2007.

Amor, Inés. *Una mujer en el arte mexicano: Memorias de Inés Amor.* 1987. Ed. Jorge Alberto Manrique and Teresa del Conde. Mexico City: UNAM–IIE, 2005.

Andrade, Lourdes. *Siete inmigrados del surrealismo.* Mexico City: Instituto Nacional de Bellas Artes, 2003.

Antebi, Susan, and Beth E. Jörgenson, eds. *Libre Acceso: Latin American Film and Literature through Disability Studies.* Albany: State University of New York Press, 2016.

Arcq, Tere. "The Esoteric Key: In Search of the Miraculous." De Orellana 21–87.

———. "In the Land of Convulsive Beauty: Mexico." Fort, Arcq, and Geis 65–87.

———. "Remedios Varo and Her Work for Bayer." De Orellana 6–11.

Arquilla, John, David Ronfeldt, and Michele Zanini. "Networks, Netwar, and Information-Age Terrorism." *Rand Publications* (1999): 75–112.

Augé, Marc. *In the Metro.* 1986. Trans. Tom Conley. Minneapolis: University of Minnesota Press, 2002.

———. *Non-Places: Introduction to an Anthropology of Supermodernity.* Trans. John Howe. New York: Verso, 1995.

Ávalos, Etna. "Discapacidad y construcciones de género en *Después del invierno* de Guadalupe Nettel." *iMex: México Interdisciplinario* 7.13 (2018): 113–26.

Ávalos Torres, Antonia. "La Malinche, una Eva indígena: Asociaciones misóginas y subversiones simbólicas." *Asparkía* 39 (2021): 277–89.

176 · Bibliography

Badmington, Neil. "Theorizing Posthumanism." *Cultural Critique* 53.1 (2003): 10–27.

Balderston, Daniel. "Poetry, Revolution, Homophobia: Polemics from the Mexican Revolution." *Hispanisms and Homosexualities*. Ed. Sylvia Molly and Robert McKee Irwin. Durham, NC: Duke University Press, 1998. 57–75.

Balsamo, Anne. *Technologies of the Gendered Body: Reading Cyborg Women*. Durham, NC: Duke University Press, 1996.

Baring, Anne, and Jules Cashford. *The Myth of the Goddess: Evolution of an Image*. 1991. London: Penguin, 1993.

Barlow, John Perry. "Being in Nothingness: Virtual Reality and the Pioneers of Cyberspace." 1990. Electric Frontier Foundation. https://www.eff.org/pages/being-nothingness.

Barthes, Roland. *The Pleasure of the Text*. Trans. Richard Miller. New York: Hill and Wang, 1975.

Bartra, Armando. "Revindicación de la política." *La Jornada* October 2, 1998.

Bartra, Roger. *Blood, Ink, and Culture: Miseries and Splendors of the Post-Mexican Condition*. Trans. Mark A. Healey. Durham, NC: Duke University Press, 2002.

———. *La jaula de la melancolía: Identidad y metamorfosis del mexicano*. Mexico City: Grijalbo, 1987.

Bazdresch, Carlos, and Santiago Levy. "Populism and Economic Policy in Mexico, 1970–1982." *The Macroeconomics of Populism in Latin America*. Ed. Rudiger Dornbusch and Sebastian Edwards. Chicago: University of Chicago Press, 1991. 233–62.

Belton, Robert. *The Beribboned Bomb: The Image of Woman in Male Surrealist Art*. Calgary, Alberta: University of Calgary Press, 1995.

Benjamin, Walter. "On the Concept of History." *Walter Benjamin: Selected Writings*. Ed. Michael W. Jennings et al. Trans. Rodney Livingstone et al. 4 vols. Cambridge, MA: Belknap Press of Harvard University Press, 2002. 4:389–400.

Bindé, Jérôme. "Toward an Ethics of the Future." *Public Culture* 12.1 (2000): 51–72.

Biron, Rebecca E. *Murder and Masculinity: Violent Fictions of Twentieth-Century Latin America*. Nashville, TN: Vanderbilt University Press, 2000.

Bixler, Jacqueline E. "Re-Membering the Past: Memory-Theatre and Tlatelolco." *Latin American Research Review* 37.2 (2002): 119–35.

Bolaño, Roberto. "Arqueles Vela." *La Palabra y el Hombre* 23.40 (1981): 85–89.

Bordo, Susan. *Unbearable Weight: Feminism, Western Culture, and the Body*. 1993. 2nd ed. Berkeley: University of California Press, 2003.

Bosteels, Bruno. *Marx and Freud in Latin America: Politics, Psychoanalysis, and Religion in Times of Terror*. London: Verso, 2012.

Bradu, Fabienne. *André Breton en México*. Mexico City: Fondo de Cultura Económica, 2012.

Braidotti, Rosi. "Mothers, Monsters, and Machines." *Writing on the Body: Female Embodiment and Feminist Theory*. Ed. Katie Conboy, Nadia Medina, and Sarah Stanbury. New York: Columbia University Press, 1997.

———. *The Posthuman*. Cambridge, UK: Polity, 2013.

Breton, André. "Manifesto of Surrealism." Breton, *Manifestoes of Surrealism*.

———. *Manifestoes of Surrealism*. Trans. Richard Seaver and Helen R. Lane. Ann Arbor: University of Michigan Press, 1972.

———. *Nadja*. Trans. Richard Howard. New York: Grove, 1960.

———. *Surrealism and Painting*. Trans. Simon Watson Taylor. New York: Harper and Row, 1972.

Brown, J. Andrew. *Cyborgs in Latin America*. New York: Palgrave Macmillan, 2010.

———. "Hacking the Past: Edmundo Paz Soldán's *El delirio de Turing* and Carlos Gamero's *Las Islas*." *Arizona Journal of Cultural Studies* 10 (2006): 115–29.

———. "Tecno-escritura: Literatura y tecnología en América Latina." *Revista Iberoamericana* 73.221 (2007): 735–41.

Brown, Stephen. "The Brand Stripped Bare by Its Marketers, Even." *Marketing the Arts: A Fresh Approach*. Ed. Daragh O'Reilly and Finola Kerrigan. New York: Routledge, 2010. 257–66.

Bruce-Novoa, Juan. "Drama to Fiction and Back: Juan García Ponce's Intratext." *Latin American Theatre Review* 16.2 (1983): 5–13.

———. "Elena Poniatowska and the Generación de Medio Siglo: Lilus, Jesusa, Angelina, Tina . . . y La errancia sin fin." *América sin Nombre* 11–12 (2008): 70–78.

———. "Eroticism, Culture, and Juan García Ponce." *CR: The New Centennial Review* 5.3 (2005): 1–33.

———. "*Noticias del imperio*: La historia apasionada." *Literatura mexicana* 1.2 (1990): 421–38.

Butler, Judith. *Bodies That Matter: On the Discursive Limits of "Sex."* 1993. New York: Routledge, 2011.

Campbell, Joseph. *The Power of Myth*. New York: Doubleday, 1988.

Campion-Vincent, Véronique. "Organ Theft Narratives as Medical and Social Critique." *Journal of Folklore Research* 39.1 (2002): 33–50.

Capistrán, Miguel. *Los 'Contemporáneos' por sí mismos*. Mexico City: CONCULTA, 1994.

Carey, Elaine. "Los dueños de México: Power and Masculinity in '68." Frazier and Cohen 59–83.

———. *Plaza of Sacrifices: Gender, Power and Terror in 1968 Mexico*. Albuquerque: University of New Mexico Press, 2005.

Carrington, Leonora. *Down Below*. Trans. Victor Llona. Chicago: Black Swan, 1983.

———. *The Hearing Trumpet*. Boston: Exact Change, 1996.

Carroll, Rachel. "'Something to See': Spectacle and Savagery in Leonora Carrington's Fiction." *Critique* 39.2 (1998): 154–66.

Carter, Angela. *The Sadeian Woman: An Exercise in Cultural History*. 1979. New York: Penguin, 2001.

Castañeda, Luis. "Choreographing the Metropolis: Networks of Circulation and Power in Olympic Mexico." *Journal of Design History* 25.3 (2012): 285–303.

Caulfield, Carlota. "Textual and Visual Strategies in the Work of Remedios Varo." *Corner* 2 (1999): unpaginated.

178 · Bibliography

Caws, Mary Ann. *The Surrealist Look: An Erotics of Encounter.* Cambridge, MA: MIT Press, 1997.

Caws, Mary Ann, Rudolf E. Kuenzli, and Gwen Raaberg, eds. *Surrealism and Women.* Cambridge, MA: MIT Press, 1991.

Certeau, Michel de. *The Practice of Everyday Life.* Trans. Steven Rendall. Berkeley: University of California Press, 1984.

Chacek, Karen. *La caída de los pájaros.* Mexico City: Alfaguara, 2014.

———. Personal interview. July 13, 2016.

Chadwick, Whitney. *Women Artists and the Surrealist Movement.* Boston: Little, Brown, 1985.

Chave, Anna C. "New Encounters with *Les Demoiselles d'Avignon*: Gender, Race, and the Origins of Cubism." *Art Bulletin* 76.4 (1994): 596–611.

Chávez, Daniar, and Vicente Quirarte, eds. *Nuevas vistas y visitas al estridentismo.* Toluca, Mexico: Universidad Autónoma del Estado de México, 2014.

Chávez, Daniel. "The Eagle and the Serpent on the Screen: The State as Spectacle in Mexican Cinema." *Latin American Research Review* 45.3 (2010): 141–55.

Cixous, Hélène. "The Laugh of the Medusa." Trans. Keith Cohen and Paula Cohen. *Signs* 1.4 (1976): 875–893.

Close, Glen S. *Contemporary Hispanic Crime Fiction: A Transatlantic Discourse on Urban Violence.* New York: Palgrave Macmillan, 2008.

Cohen, Jeffrey Jerome. "Monster Culture (Seven Theses)." *Monster Theory: Reading Culture.* Ed. Cohen. Minneapolis: University of Minnesota Press, 1996. 3–25.

Córdoba Cornejo, Antonio. *¿Extranjero en tierra extraña?: El género de la ciencia ficción en América Latina.* Seville: Universidad de Sevilla, 2011.

Corona Gutiérrez, Ignacio. *Después de Tlatelolco: Las narrativas políticas en México (1976–1990).* Guadalajara: Universidad de Guadalajara, 2001.

Corte Velasco, Clemencia. *La poética del estridentismo ante la crítica.* Puebla: Benemérita Universidad Autónoma de Puebla, Dirección General de Fomento Editorial, 2003.

Curiel, Fernando. "Vanguardias autóctonas: Recordando a Luis Mario Schneider." *Nuevas vistas y visitas al estridentismo.* Ed. Daniar Chávez and Vicente Quirarte. Toluca: Universidad Autónoma del Estado de México, 2014. 141–66.

Dalton, David S. *Mestizo Modernity: Race, Technology, and the Body in Post-Revolutionary Mexico.* Gainesville: University of Florida Press, 2018.

Davis, Diane E. *Urban Leviathan: Mexico City in the Twentieth Century.* Philadelphia: Temple University Press, 1994.

de Lauretis, Teresa. *Technologies of Gender: Essays on Theory, Film, and Fiction.* Bloomington: Indiana University Press, 1987.

Deleuze, Gilles, and Félix Guattari. *Anti-Oedipus: Capitalism and Schizophrenia.* Trans. Helen R. Lane, Robert Hurley, and Mark Seem. Minneapolis: University of Minnesota Press, 1983.

del Paso, Fernando. *Palinuro de México.* 1977. Mexico City: Editorial Diana, 2003.

——. *Palinuro of Mexico.* Trans. Elisabeth Plaister. Normal, IL: Dalkey Archive Press, 1996.

de Orellana, Margarita, ed. *Five Keys to the Secret World of Remedios Varo.* Mexico City: Artes de México, 2008.

Díaz Arciniega, Víctor. *Querella por la cultura "revolucionaria."* Mexico City: Fondo de Cultura Económica, 1989.

Díaz y Morales, Magda. *El erotismo perverso de Juan García Ponce.* Xalapa: Universidad Veracruzana, 2006.

D'Lugo, Carol Clark. *The Fragmented Novel in Mexico: The Politics of Form.* Austin: University of Texas Press, 2010.

Domínguez Michael, Christopher. "Los hijos de Ixión." *Los Contemporáneos en el laberinto de la crítica.* Ed. Rafael Olea Franco and Anthony Stanton. Mexico City: El Colegio de México, 1994. 225–36.

Domínguez-Ruvalcaba, Héctor. *Modernity and the Nation in Mexican Representations of Masculinity: From Sensuality to Bloodshed.* New York: Palgrave Macmillan, 2007.

du Preez, Amanda. *Gendered Bodies and New Technologies: Rethinking Embodiment in a Cyber-era.* Newcastle upon Tyne: Cambridge Scholars Publishing, 2009.

Durozoi, Gérard. *History of the Surrealist Movement.* Trans. Alison Anderson. Chicago: University of Chicago Press, 2002.

Eburne, Jonathan P. *Surrealism and the Art of Crime.* Ithaca, NY: Cornell University Press, 2008.

Escalante, Evodio. *Elevación y caída del estridentismo.* Mexico City: Conaculta/Ediciones Sin Nombre, 2002.

——. "Espectralidad y eficacia de la Revolución en *Dama de corazones* de Xavier Villaurrutia." *Signos Literarios* 5 (2007): 97–107.

Espinosa, Ángela Cecilia. "La masculinidad marginada en la vanguardia postrevolucionaria: El caso de *El Café de Nadie* de Arqueles Vela." *Mexican Studies/Estudios Mexicanos* 30.2 (2014): 397–420.

Estrada, Oswaldo. *Ser mujer y estar presente: Disidencias de género en la literatura mexicana contemporánea.* Mexico City: Universidad Nacional Autónoma de México, Coordinación de Difusión Cultural/Dirección de Literatura, 2014.

——. *Troubled Memories: Iconic Mexican Women and the Traps of Representation.* Albany: State University of New York Press, 2018.

Faust, Beatrice. *Women, Sex, and Pornography: A Controversial and Unique Study.* New York: Macmillan, 1980.

Fernández, Bernardo (BEF). *¡¡Bzzzzzzt!! Ciudad interfase.* Mexico City: Times Editores, 1998.

——. *Gel azul.* 2004. Mexico City: Saneillana Ediciones Generales, 2009.

Fernández L'Hoeste, Héctor. "Ciencia-ficción y configuración identitaria en *Gel azul:* En torno a una mexicanidad futura." *Revista Iberoamericana* 78.238–39 (2012): 179–92.

Ferrero Cárdenas, Inés. *Gendering the Marvellous: Remedios Varo, Elena Garro and Carmen Boullosa.* Guanajuato: Universidad de Guanajuato, 2011.

180 · Bibliography

———. "Geografía en el cuerpo: El otro yo en *El Huésped*, de Guadalupe Nettel." *Revista de literatura contemporánea mexicana* 41 (2009): 55–62.

Fiddian, Robin W. "Fernando del Paso y el arte de la renovación." *Revista Iberoamericana* (2009): 143–58.

———. *The Novels of Fernando del Paso*. Gainesville: University Press of Florida, 2000.

Finley, Klint. "Cyberpunk's Not Dead: In Fact, We're Living It." *Wired* June 27, 2015.

Flaherty, George F. *Hotel Mexico: Dwelling on the '68 Movement*. Oakland: University of California Press, 2016.

Flanagan, Mary. "Hyperbodies, Hyperknowledge: Women in Games, Women in Cyberpunk, and Strategies of Resistance." Flanagan and Booth 425–60.

Flanagan, Mary, and Austin Booth, eds. *Reload: Rethinking Women + Cyberculture*. Cambridge, MA: MIT Press, 2002.

Flores, Tatiana. *"Actual No 1,* or Manuel Maples Arce's Fourteen Points." *Vanguardia Estridentista: Soporte de la estética revolucionaria*. Ed. Monserrat Sánchez Soler. Mexico City: Conaculta/INBA, 2010. 37–81.

———. "Clamoring for Attention in Mexico City: Manuel Maples Arce's *Manifesto No 1*." *Review: Literature and Arts of the Americas* 37.2 (2004): 208–20.

———. *Mexico's Revolutionary Avant-Gardes: From* Estridentismo *to* ¡30–30! New Haven, CT: Yale University Press, 2013.

———. "Starting from Mexico: *Estridentismo* as an Avant-Garde Model." *World Art* 4.1 (2014): 47–65.

Fort, Ilene Susan, Tere Arcq, and Terri Geis, eds. *In Wonderland: The Surrealist Adventures of Women Artists in Mexico and the United States*. New York: Prestel, 2012.

Foster, Hal. *The Return of the Real: The Avant-Garde at the End of the Century*. Cambridge: MIT Press, 1996.

Foucault, Michel. *The Order of Things: An Archeology of Human Sciences*. Trans. Alan Sheridan. New York: Vintage, 1994.

Franco, Jean. *Plotting Women: Gender and Representation in Mexico*. New York: Columbia University Press, 1989.

Frazier, Lessie Jo, and Deborah Cohen, eds. *Gender and Sexuality in 1968: Transformative Politics in the Cultural Imagination*. New York: Palgrave Macmillan, 2009.

Fuentes, Carlos. *La nueva novela hispanoamericana*. 1969. Mexico City: Joaquín Mortiz, 1976.

Gabara, Esther. *Errant Modernism: The Ethos of Photography in Mexico and Brazil*. Durham, NC: Duke University Press, 2008.

Gallo, Rubén. "Maples Arce, Marinetti and Khlebnikov: The Mexican *Estridentistas* in Dialogue with Italian and Russian Futurisms." *Revista Canadiense de Estudios Hispánicos* 31.2 (2007): 309–24.

———. *Mexican Modernity: The Avant-Garde and the Technological Revolution*. Cambridge, MA: MIT Press, 2005.

———, ed. *The Mexico City Reader*. Trans. Lorna Scott Fox and Rubén Gallo. Madison: University of Wisconsin Press, 2004.

———, ed. *México DF: Lecturas para paseantes*. Madrid: Turner, 2005.

Gambrell, Alice. *Women Intellectuals, Modernism and Difference: Transatlantic Culture, 1919–1945.* New York: Cambridge University Press, 1997.

García, Hernán M. "Texto y contexto del cyberpunk mexicano en la década del noventa." *Alambique: Revista académica de ciencia ficción y fantasía* 5.2 (2018): 1–15.

García, Miguel. "Urbes corruptoras y visiones apocalípticas en dos novelas ciberpunk latinoamericanas." *Chasqui* 44.2 (2015): 138–48.

García Ochoa, Gabriel. "*The Hearing Trumpet:* Leonora Carrington's Feminist Magical Realism." *Colloquoy: Text, Theory, Critique* 20 (2010): 121–43.

García Ponce, Juan. *Crónica de la intervención*, vols. 1–2. 1982. Mexico City: Fondo de Cultura Económica, 2001.

———. "La utopía de Herbert Marcuse." *Entrada en materia.* Mexico City: UNAM, 1968. 136–41.

Garland Thomson, Rosemarie. *Extraordinary Bodies: Figuring Physical Disability in American Culture and Literature.* 1997. New York: Columbia University Press, 2017.

Gibson, William. *Neuromancer.* 1984. New York: Ace, 2000.

Gilbert, Courtney. "The (New) World in the Time of the Surrealists: European Surrealists and Their Mexican Contemporaries." Diss. University of Chicago, 2001. Ann Arbor: UMI, 2001.

Ginway, Mary Elizabeth. *Cyborgs, Sexuality, and the Undead.* Nashville, TN: Vanderbilt University Press, 2020.

———. "The Politics of Cyborgs in Mexico and Latin America." *Semina: Ciências Sociais e Humanas* 34.2 (2013): 161–72.

Godwin, Malcom. *The Holy Grail: Its Origins, Secrets, and Meaning Revealed.* New York: Viking, 1994.

Gómez, Pablo. *1968: La historia también está hecha de derrotas.* Mexico City: Porrúa, 2008.

Gómez de Unamuno, Aurelia. "Narrativas marginales y guerra sucia en México." Diss. University of Pittsburgh, 2008.

González, Carina. "La potencia de los cuerpos corrompidos: *El huésped* como *Bildungs* político." *Hispanófila* 174 (2015): 97–115.

González, Jennifer. "Envisioning Cyborg Bodies: Notes from Current Research." Gray, Figueroa-Sarriera, and Mentor 267–79.

Good, Carl. "The Reading of Community in the Early Novels of Juan García Ponce." *CR: The New Centennial Review* 5.3 (2005): 105–41.

Gray, Chris Hables, Heidi Figueroa-Sarriera, and Steven Mentor, eds. *The Cyborg Handbook.* New York: Routledge, 1995.

Grosz, Elizabeth. *Space, Time, and Perversion: Essays on the Politics of Bodies.* New York: Routledge, 1995.

Guerrero Mondoño, Rocío Guadalupe. "Technological Revolution *vs.* Mexican Revolution Aesthetic and Supports of the Estridentista Vanguard." Trans. Gregory Dechant. *Vanguardia Estridentista: Soporte de la estética revolucionaria.* Ed. Monserrat Sánchez Soler. Mexico City: Conaculta/INBA, 2010. 17–35.

## 182 · Bibliography

Hadatty Mora, Yanna. *La ciudad paroxista: Prosa Mexicana de vanguardia (1921–1932).* Mexico City: IIFL/UNAM, 2009.

Haraway, Donna. "The Persistence of Vision." *Writing on the Body: Female Embodiment and Feminist Theory.* Ed. Katie Conboy, Nadia Medina, and Sarah Stanbury. New York: Columbia University Press, 1997. 283–95.

———. *Simians, Cyborgs, and Women: The Reinvention of Nature.* New York: Routledge, 1991.

Harradine, David. "Abject Identities and Fluid Performances: Theorizing the Leaking Body." *Contemporary Theatre Review* 10.3 (2000): 69–95.

Hayles, N. Katherine. *How We Became Posthuman: Virtual Bodies in Cybernetics, Literature, and Informatics.* Chicago: University of Chicago Press, 1999.

———. "The Life Cycle of Cyborgs: Writing the Posthuman." Gray, Figueroa-Sarriera, and Mentor 321–35.

Heliodoro Valle, Rafael. "Diálogo con Andre Breton." *Universidad: Mensual de cultura popular* 5.29 (June 1939): 5–8.

Henke, Robert. *Performance and Literature in the Commedia dell'arte.* Cambridge: Cambridge University Press, 2002.

Heuser, Sabine. *Virtual Geographies: Cyberpunk at the Intersection of the Postmodern and Science Fiction.* Amsterdam: Rodopi, 2003.

Hind, Emily. *Dude Lit: Mexican Men Writing and Performing Competence.* Tucson: University of Arizona Press, 2019.

———. *Femmenism and the Mexican Woman Intellectual from Sor Juana to Poniatowska: Boob Lit.* New York: Palgrave Macmillan, 2010.

———. *La Generación XXX: Entrevistas con veinte escritores mexicanos nacidos en los 70. De Abenshushan a Xoconostle.* Mexico City: Ediciones Eón, 2013.

———. "The Second Order Queer: Esquinca and Bef." MLA Convention, Philadelphia, 26–28 December 2009. 1–11.

Hoyos, Héctor. *Beyond Bolaño: The Global Latin American Novel.* New York: Columbia University Press, 2015.

Huyssen, Andreas. *Present Pasts: Urban Palimpsests and the Politics of Memory.* Stanford, CA: Stanford University Press, 2003.

———. "The Vamp and the Machine: Fritz Lang's *Metropolis*." *After the Great Divide: Modernism, Mass Culture, Postmodernism.* Bloomington: Indiana University Press, 1986. 65–81.

Ibáñez Moltó, María Amparo. "Humor surrealista en *Palinuro de México.*" *Anales de la literatura hispanoamericana* 15 (1986): 159–68.

Irwin, Robert McKee. *Mexican Masculinities.* Minneapolis: University of Minnesota Press, 2003.

Janzen, Rebecca. *The National Body in Mexican Literature: Collective Challenges to Biopolitical Control.* New York: Palgrave Macmillan, 2015.

Johnson, David E. "Invitation to Politics: Juan García Ponce and the Promise of Availability." *Discourse* 27.2 & 3 (2005): 41–67.

Joseph, Gilbert M., Anne Rubenstein, and Eric Zolov, eds. *Fragments of a Golden Age:*

*The Politics of Culture in Mexico since 1940.* Durham, NC: Duke University Press, 2001.

Kantaris, Geoffrey. "Cyborgs, Cities, and Celluloid: Memory Machines in Two Latin American Films." *Latin American Cyberculture and Cyberliterature.* Ed. Claire Taylor and Thea Pittman. Liverpool: Liverpool University Press, 2008. 50–69.

Kaplan, Janet. "Remedios Varo: Voyages and Visions." *Women's Art Journal* 1.2 (1980): 13–18.

———. *Unexpected Journeys: The Life and Art of Remedios Varo.* London: Virago, 1988.

Kirkup, Gill, et al., eds. *The Gendered Cyborg: A Reader.* New York: Routledge, 2000.

Klossowski, Pierre. *Sade My Neighbor.* 1947. Trans. Alphonso Lingis. Evanston, IL: Northwestern University Press, 1991.

Kristeva, Julia. *Powers of Horror: An Essay on Abjection.* 1980. Trans. Leon S. Roudiez. New York: Columbia University Press, 1982.

Kunny, Clare. "Leonora Carrington's Mexican Vision." *Art Institute of Chicago Museum Studies* 22.2 (1996): 166–79 and 199–200.

Kurlansky, Mark. *1968: The Year That Rocked the World.* New York: Ballantine, 2004.

Lagarde y de los Ríos, Marcela. *El Feminismo en mi vida: Hitos, claves y topías.* Mexico City: Gobierno de la Ciudad de México and Instituto de las Mujeres del Distrito Federal, 2012.

Lamas, Marta. *Feminismo: Transmisiones y retransmisiones.* Mexico City: Taurus, 2006.

Lambright, Anne, and Elisabeth Guerrero, eds. *Unfolding the City: Women Write the City in Latin America.* Minneapolis: University of Minnesota Press, 2007.

Lapointe, Annette. "The Machineries of Uncivilization: Technology and the Gendered Body in the Fiction of Margaret Atwood and William Gibson." Diss. University of Manitoba, 2006.

Latinez, Alejandro. *Developments: Encounters of Formation in the Latin American and Hispanic/Latino Bildungsroman.* New York: Peter Lang, 2014.

Lavigne, Carlen. *Cyberpunk Women, Feminism, and Science Fiction: A Critical Study.* Jefferson, NC: McFarland, 2013.

Legrás, Horacio. *Culture and Revolution: Violence, Memory, and the Making of Modern Mexico.* Austin: University of Texas Press, 2017.

Leventhal, Todd. "The Child Organ Trafficking Rumor: A Modern 'Urban Legend.'" *U.S. Information Agency Report to the United Nations Special Rapporteur.* Washington, DC: U.S. Information Agency, 1994.

Lewis, Jennifer. "'Sympathetic Traveling': Horizontal Ethics and Aesthetics in Paco Ignacio Taibo's Belascoarán Shayne Novels." *Detective Fiction in a Postcolonial and Transnational World.* Ed. Nels Pearson and Marc Singer. Burlington, VT: Ashgate, 2009. 135–55.

Lindauer, Margaret A. *Devouring Frida: The Art History and the Popular Celebrity of Frida Kahlo.* Middletown, CT: Wesleyan University Press, 1999.

Linhard, Tabea Alexa. *Fearless Women in the Mexican Revolution and the Spanish Civil War.* Columbia: University of Missouri Press, 2005.

List Arzubide, Germán. "El movimiento estridentista." *El estridentismo: México, 1921–*

184 · Bibliography

*1927*. Ed. Luis Mario Schneider. Mexico City: Universidad Nacional Autónoma de México, 1985. 268–73.

Little, Gregory. "A Manifesto for Avatars." *Intertexts* 3.2 (Fall 1999): 192–209.

Long, Ryan F. *Fictions of Totality: The Mexican Novel, 1968, and the National-Popular State*. West Lafayette, IN: Purdue University Press, 2008.

López Castro, Ramón. *Expedición a la ciencia ficción mexicana*. Mexico City: Editorial Lectorum, 2001.

López Lozano, Miguel. *Utopian Dreams, Apocalyptic Nightmares: Globalization in Recent Mexican and Chicano Narrative*. West Lafayette, IN: Purdue University Press, 2008.

López Velarde, Ramón. *Song of the Heart: Selected Poems by Ramón López Velarde*. Trans. Margaret Sayers Peden. Austin: University of Texas Press, 1995.

Lowentrout, Peter M. "*PsiFi*: The Domestication of *Psi* in Science Fiction." *Extrapolation* 30.4 (1989): 388–400.

Lusty, Natalya. *Surrealism, Feminism, Psychoanalysis*. Burlington, VT: Ashgate, 2007.

———. "Surrealism's Banging Door." *Textual Practice* 17.2 (2003): 335–56.

Lyford, Amy. *Surrealist Masculinities: Gender Anxiety and the Aesthetics of Post-World War I Reconstruction in France*. Berkeley: University of California Press, 2007.

Macías-González, Victor M., and Anne Rubenstein, eds. *Masculinity and Sexuality in Modern Mexico*. Albuquerque: University of New Mexico Press, 2012.

Maples Arce, Manuel. *Soberana juventud*. Madrid: Editorial Plenitud, 1967.

Marcuse, Herbert. *Eros and Civilization: A Philosophical Inquiry into Freud*. 1955. Boston: Beacon, 1966.

Martínez, Elizabeth Coonrod. *Before the Boom: Latin American Revolutionary Novels of the 1920s*. New York: University Press of America, 2001.

Martré, Gonzalo. *El movimiento popular estudiantil de 1968 en la novela mexicana*. Mexico City: Universidad Nacional Autónoma, 1998.

McLuhan, Marshall. *Understanding Media: The Extensions of Man*. 1964. Cambridge, MA: MIT Press, 1994.

McLuhan, Marshall, and Eric McLuhan. *Laws of Media: The New Science*. Toronto: University of Toronto Press, 1988.

Mendoza Bolio, Edith. *"A veces escribo como si trazase un boceto": Los escritos de Remedios Varo*. Madrid: Iberoamericana, 2010.

Meruane, Lina. "Blind Spot (Notes on Reading Blindness)." Trans. Beth E. Jörgensen. Antebi and Jörgensen 29–46.

Minge, Jeanine, and Amber Lynn Zimmerman. "Power, Pleasure, and Play: Screwing the Dildo and Rescripting Sexual Violence." *Qualitative Inquiry* 15.2 (2009): 329–49.

Mojarro Romero, Jorge. *Multánime: La prosa vanguardista de Arqueles Vela*. Ciudad Quezón: Academia Filipina de la Lengua Española, 2011.

Monsiváis, Carlos. *Aires de familia: Cultura y sociedad en América Latina*. Barcelona: Editorial Anagrama, 2000.

———. *Días de guardar*. Mexico City: Era, 1971.

———. "El metro: Viaje hacia el fin del apretujón." Gallo 2005 155–56.

———. "The Metro: A Voyage to the End of the Squeeze." Gallo 2004 143–45.

Bibliography · 185

———. "When Gender Can't Be Seen amid the Symbols: Women and the Mexican Revolution." *Sex in Revolution: Gender, Politics, and Power in Modern Mexico.* Ed. Jocelyn Olcott, Mary Kay Vaughn, and Gabriella Cano. Durham, NC: Duke University Press, 2006, 1–20.

Morgan, Kathryn Pauly. "Women and the Knife: Cosmetic Surgery and the Colonization of Women's Bodies." *Hypatia* 6.3 (1991): 25–53.

Mraz, John. *Looking for Mexico: Modern Visual Culture and National Identity.* Durham, NC: Duke University Press, 2009.

Nagel, Joane. "Masculinity and Nationalism: Gender and Sexuality in the Making of Nations." *Ethnic and Racial Studies* 21.2 (1998): 242–69.

Nancy, Jean-Luc. *The Muses.* Trans. Peggy Kamuf. Stanford, CA: Stanford University Press, 1997.

Nealon, Jeffrey T. *Post-Postmodernism, or, The Cultural Logic of Just-in-Time Capitalism.* Stanford, CA: Stanford University Press, 2012.

Nettel, Guadalupe. *El cuerpo en que nací.* Barcelona: Editorial Anagrama, 2011.

———. *El huésped.* Barcelona: Editorial Anagrama, 2006.

Niemeyer, Katherina. Subway *de los sueños, alucinamiento, libro abierto: la novela vanguardista hispanoamericana.* Madrid: Iberoamericana Vervuert, 2004.

Nicholson, Melanie. *Surrealism in Latin American Literature: Searching for Breton's Ghost.* New York: Palgrave Macmillan, 2013.

Nicki, Andrea. "The Abused Mind: Feminist Theory, Psychiatric Disability, and Trauma." *Hypatia* 16.4 (2001): 80–104.

Nochlin, Linda. "Art and the Conditions of Exile: Men/Women, Emigration/Expatriation." *Poetics Today* 17.3 (1996): 317–37.

Orenstein, Gloria Feman. "Down the Rabbit Hole: An Art of Shamanic Initiations and Mythic Rebirth." Fort, Arcq, and Geis 173–83.

Oropesa, Salvador A. *The Contemporáneos Group: Rewriting Mexico in the Thirties and Forties.* Austin: University of Texas Press, 2003.

Ortega, Gregorio. "Conversación en un escritorio con Xavier Villaurrutia. *México en 1932: La polémica nacionalista.*" Ed. Guillermo Sheridan. Mexico City: Fondo de Cultura Económica, 1999. 151–58.

Osorio T., Nelson, ed. *Manifiestos, proclamas y polemicas de la vanguardia literaria hispanoamericana.* Caracas: Biblioteca Ayacucho, 1988.

Owen, Gilberto. "Novela como nube." *Obras.* 1979. Mexico City: Fondo de Cultura Económica, 2014. 146–86.

———. *Poesía y prosa.* Mexico City: Imprenta Universitaria, 1953.

Palou, Pedro Ángel. *En la alcoba de un mundo.* Mexico City: Fondo de Cultura Económica, 1992.

———. *La casa del silencio: Aproximación en tres tiempos a Contemporáneos.* Zamora, Michoacán: El Colegio de Michoacán, 1997.

———. *Escribir en México durante los años locos: El campo literario de los Contemporáneos.* Puebla: Universidad Autónoma de Puebla, 2001.

———. *El fracaso del mestizo.* Mexico City: Ediciones Culturales Paidós, 2014.

186 · Bibliography

———. *Mestizo Failure(s): Race, Film, and Literature in Twentieth Century Mexico.* Trans. Sara Potter, Irene Routté, and Joaquín Terrones. Boston: Art Life Lab, 2016.

Pappe Willenegger, Silvia. *Estridentópolis: Urbanización y montaje.* Mexico City: UAM-Azcapotzalco, 2006.

———. "La historia como manifiesto: Un breve ensayo sobre la distorción." Chávez and Quirarte 79–94.

Parker, Rhian. *Women, Doctors, and Cosmetic Surgery: Negotiating the 'Normal' Body.* New York: Palgrave Macmillan, 2010.

Passerini, Luisa. Foreword. Frazier and Cohen ix–xii.

———. *Palinuro of Mexico.* Trans. Elizabeth Plaister. Normal, IL: Dalkey Archive Press, 1996.

Paul, Marcie. "The Search for Identity: The Return to Analytic Detective Fiction in Mexico." *Hispanic and Luso-Brazilian Detective Fiction: Essays on the Género Negro Tradition.* Ed. Renée W. Craig-Odders, Jacky Collins, and Glen S. Close. Jefferson, NC: McFarland, 2006. 180–203.

Paz, Octavio. *Postdata.* 1970. Mexico City; Fondo de Cultura Económica, 1981.

———. *Xavier Villaurrutia en persona y en obra.* Mexico City: Fondo de Cultura Económica, 1978.

Paz, Octavio, and Roger Caillois. *Remedios Varo.* Mexico City: Ediciones Era, 1966.

Paz-Soldán, Edmundo, and Debra A. Castillo, eds. *Latin American Literature and Mass Media.* New York: Garland, 2001.

Pérez Firmat, Gustavo. *Idle Fictions: The Hispanic Vanguard Novel, 1926–1934.* Durham, NC: Duke University Press, 1993.

Picasso, Pablo. *Les Demoiselles d'Avignon.* 1907. Museum of Modern Art, New York. Museum of Modern Art, Collection Archives.

———. "Discovery of African Art: 1906–1907." *Primitivism and Twentieth-Century Art: A Documentary History.* Ed. Jack Flam and Miriam Deutch. Berkeley: University of California Press, 2003. 35.

Pitman, Thea. "Latin American Cyberprotest: Before and after the Zapatistas." Taylor and Pitman 86–110.

Plant, Sadie. *Zeros + Ones: Digital Women + The New Technoculture.* New York: Doubleday, 1997.

Poniatowska, Elena. *Leonora.* Mexico City: Planeta, 2011.

———. *Massacre in Mexico.* Trans. Helen R. Lane. New York: Viking, 1975.

———. *La noche de Tlatelolco: Testimonios de historia oral.* Mexico City: Ediciones Era, 1971.

Potter, Sara. "From Post-Revolutionary Cosmopolitanisms to Pre-Bolaño Infrarealism: Mexican Avant-Garde Literatures in/as World Literature." *Mexican Literature as World Literature.* Ed. Ignacio M. Sánchez Prado. New York: Bloomsbury, 2021. 117–31.

Quirarte, Vicente. *Elogio a la calle: Biografía literaria de la Ciudad de México, 1850–1992.* Mexico City: Cal y Arena, 2001.

Prabhavananda, Swami. *Bhagavad Gita—The Son of God.* Redditch: Read Books, 2013.

Raaberg, Gwen. "The Problematics of Women and Surrealism." Caws, Kuenzli, and Raaberg 1991. 1–10.

Radulescu, Domnica. "Caterina Biancolelli: Seventeenth-Century Trickster and Parisian Coquette." *Women's Comedic Art as Social Revolution: Five Performers and the Lessons of Their Subversive Humor.* Jefferson, NC: McFarland, 2012. 69–118.

Ramírez, José Luis. "Cyberpunk: El movimiento en México." *Ciencia Ficción Mexicana.* 2005. http://cfm.mx/?cve=11:09.

Ramos González, Rosario. "La 'fábula electrónica': Respuestas al terror político y las utopías informáticas en Edmundo Paz Soldán." *MLN* 118.2 (2003): 466–91.

Rankin, Monica. ¡*México, la patria!: Propaganda and Production during World War II.* Lincoln: University of Nebraska Press, 2009.

Rashkin, Elissa J. "Estridentópolis: The Public Life of the Avant-Garde in Veracruz, 1925–1927." *Studies in Latin American Popular Culture* 25 (2006): 73–94.

———. *The Stridentist Movement in Mexico: The Avant-Garde and Cultural Change in the 1920s.* Lanham, MD: Lexington, 2009.

Rashkin, Elissa J., and Carla Zurián. "The Estridentista Movement in Mexico: A Poetics of the Ephemeral." *International Yearbook of Futurism Studies* 7 (2017): 309–33.

Reiss, Rosemary E., and Avner D. Ash. "The Eight-Month Fetus: Classical Sources for a Modern Superstition." *Obstetrics and Gynecology* 71.2 (1988): 270–3.

Reyes, Alfonso. "Literatura nacional, literatura mundial." *La Gaceta del Fondo de Cultura Económica* 422 (February 2006): 23–24.

Rodríguez-Hernández, Raúl. "All Streetcars Are Named Desire: The Lost Cities of Juan García Ponce's *Personas, lugares y anexas.*" *CR: The New Centennial Review* 5.3 (2005): 35–64.

———. *Mexico's Ruins: Juan García Ponce and the Writing of Modernity.* Albany: State University of New York Press, 2007.

Rodríguez Pampolini, Ida. *El Surrealismo y el arte fantástico en México.* Mexico City: UNAM/IIE, 1969.

Rojo, Juan J. *Revisiting the Mexican Student Movement of 1968: Shifting Perspectives in Literature and Culture since Tlatelolco.* New York: Palgrave Macmillan, 2016.

Romero-Ghiretti, Gabriela. "Representación femenina y canon vanguardista: Mirada feminizante en 'La Señorita Etcétera' de Arqueles Vela." *Chasqui* 44.2 (2015): 258–71.

Rosado Zacarías, Juan Antonio. "El erotismo en la obra de Juan García Ponce." *Contribuciones desde Coatepec* 4.7 (2004): 11–43.

Rosemont, Penelope, ed. *Surrealist Women: An International Anthology.* Austin: University of Texas Press, 1998.

Rotker, Susana, ed. *Citizens of Fear: Urban Violence in Latin America.* New Brunswick, NJ: Rutgers University Press, 2002.

Rubin, William S. *Dada and Surrealist Art.* New York: Abrams, 1985.

Ruffinelli, Jorge. *El lugar de Rulfo y otros ensayos.* Xalapa: Universidad Veracruzana, 1980.

Ruisánchez Serra, José Ramón. *Historias que regresan: Topologías y renarración en la*

188 · Bibliography

*segunda mitad del siglo XX mexicano.* Mexico City: Fondo de Cultura Económica, 2012.

Ruiz, Iván. "La pornografía del otro." *Elementos: Ciencia y cultura* 10.051 (2003): 53–57.

Sabines, Jaime. "Tlatelolco 68." *Dein Körper neben mir: Gedichte.* Frankfurt am Main: Vervuert 1987. 102–9.

Sáenz, Inés. *Hacia la novela total: Fernando del Paso.* Madrid: Pliegos, 1994.

Saldaña Portillo, María Josefina. "Dying Mirrors, Medieval Moralists, and Tristram Shandies: The Literary Traditions of Fernando del Paso's *Palinuro de México.*" *Comparative Literature* 60.2 (2008): 142–63.

———. "In the Shadow of NAFTA: *Y tu mamá también* Revisits the National Allegory of Mexican Sovereignty." *American Quarterly* 57.3 (2005): 751–77.

Sánchez Prado, Ignacio M. "*Amores perros:* Exotic Violence and Neoliberal Fear." *Journal of Latin American Cultural Studies* 15.1 (2006): 39–57.

———. "Dying Mirrors, Medieval Moralists, and Tristram Shandies: The Literary Traditions of Fernando del Paso's *Palinuro de México.*" *Comparative Literature* 60.2 (2008): 142–63.

———. "Ending the World with Words: Bernardo Fernández (BEF) and the Institutionalization of Science Fiction in Mexico." *Latin American Science Fiction: Theory and Practice.* Ed. M. Elizabeth Ginway and J. Andrew Brown. New York: Palgrave Macmillan, 2012. 111–32.

———. *Naciones intelectuales: Las fundaciones de la modernidad literaria mexicana (1917–1959).* West Lafayette, IN: Purdue University Press, 2009.

Schaefer, Claudia. *Textured Lives: Women, Art, and Representation in Modern Mexico.* Tucson: University of Arizona Press, 1992.

Scharm, Heike, and Natalia Matta-Jara, eds. *Postnational Perspectives on Contemporary Hispanic Literature.* Gainesville: University Press of Florida, 2017.

Schneider, Luis Mario, ed. *El estridentismo: La vanguardia literaria en México.* 1999. Mexico City: Universidad Nacional Autónoma de México, 2007.

———. *El estridentismo: México 1921–1927.* Mexico City: Universidad Nacional Autónoma de México, 1985.

———. *El estridentismo: O, una literatura de estrategia.* Mexico City: Institutio Nacional de Bellas Artes, 1970.

———. *México y el surrealismo (1925–1950).* Mexico City: Arte y Libros, 1978.

Schuler, Friedrich Engelbert. *Mexico between Hitler and Roosevelt: Mexican Foreign Relations in the Age of Lázaro Cárdenas, 1934–1940.* Albuquerque: University of New Mexico Press, 2000.

Schwartz, Jorge, ed. *Las vanguardias latinoamericanas: Textos programáticos y críticos.* 1991. Mexico City: Fonto de Cultura Económica, 2002.

Schwartz, Marcy. "Short Circuits: Gendered Itineraries in Recent Urban Fiction Anthologies from Latin America." Lambright and Guerrero 3–26.

Sefchovich, Sara. *México: País de ideas, país de novelas: Una sociología de la literatura mexicana.* Mexico City: Grijalbo, 1988.

Shapiro, Eve. *Gender Circuits: Bodies and Identities in a Technological Age.* 2010. New York: Routledge, 2015.

Sheikh, Shela. "Violence." *The Posthuman Glossary*. Ed. Rosi Braidotti and Maria Hlavajova. New York: Bloomsbury Academic, 2018. 448–52.

Sheridan, Guillermo. *Los Contemporáneos ayer*. 1985. Mexico City: Fondo de Cultura Económica, 1993.

———. *México en 1932: La polémica nacionalista*. Mexico City: Fondo de Cultura Económica, 1999.

Sluis, Ageeth. *Deco Body, Deco City: Female Spectacle and Modernity in Mexico City, 1900–1939*. Lincoln: University of Nebraska Press, 2016.

Sorenson, Diana. "Tlatelolco 1968: Paz and Poniatowska on Law and Violence." *A Turbulent Decade Remembered: Scenes from the Latin American Sixties*. Stanford, CA: Stanford University Press, 2007. 54–77.

Stavans, Ilan. *Antiheroes: Mexico and Its Detective Novel*. Trans. Jesse H. Lytle and Jennifer A. Mattson. Madison, NJ: Fairleigh Dickinson University Press, 1997.

Steele, Cynthia. *Politics, Gender, and the Mexican Novel, 1968–1988: Beyond the Pyramid*. Austin: University of Texas Press, 1992.

Steinberg, Samuel. *Photopoetics at Tlatelolco: Afterimages of Mexico, 1968*. Austin: University of Texas Press, 2016.

———. "'Tlatelolco me bautizó': Literary Renewal and the Literary Tradition." *Mexican Studies/Estudios mexicanos* 28.2 (2012): 265–86.

Sterling, Bruce. Preface. *Mirrorshades: The Cyberpunk Anthology*. Ed. Sterling. New York: Arbor House, 1986. ix–xii.

Stone-Blackburn, Susan. "Conscious Evolution and Early Telepathic Tales." *Science Fiction Studies* 20.2 (1993): 241–50.

Stratton, Susan. "Psi and Technology in Science Fiction." *Journal of the Fantastic in the Arts* 9.4 (1998).

Suleiman, Susan Rubin. *Subversive Intent: Gender, Politics, and the Avant-Garde*. Cambridge, MA: Harvard University Press, 1990.

Suri, Jeremi. *Power and Protest: Global Revolution and the Rise of Détente*. 2003. Cambridge, MA: Harvard University Press, 2005.

Swanson, Cecily. "'The Language of Behavior': Gurdjieff and the Emergence of Modernist Autobiography." *Modernism/modernity* 24.4 (2017): 695–721.

Taibo II, Paco Ignacio. *'68*. Trans. Donald Nicholson-Smith. New York: Seven Stories, 2004.

Tambling, Jeremy. "Prologue: City-Theory and Writing, in Paris and Chicago: Space, Gender, Ethnicity." *The Palgrave Handbook of Literature and the City*. Ed. Tambling. New York: Palgrave Macmillan, 2016. 1–22.

Tarzibachi, Eugenia. *Cosas de mujeres: Menstruación, género y poder*. Buenos Aires: Sudamericana, 2017.

———. *Menstrual Bodies and Gender: The Transnational Business of Menstruation from Latin America*. New York: Palgrave Macmillan, 2022.

Taylor, Claire, and Thea Pitman. *Latin American Identity in Online Cultural Production*. New York: Routledge, 2013.

Taylor, Diana. *The Archive and the Repertoire: Performing Cultural Memory in the Americas*. Durham, NC: Duke University Press, 2003.

190 · Bibliography

Torres Bodet, Jaime. "Reflexiones sobre la novela." *Contemporáneos: Nota de la crítica.* Mexico City: Herrero, 1928. 7–21.

Trujillo-Lara, Rodrigo Leonardo. "Parodia de un crimen: Lectura de 'Un crimen provisional' de Arqueles Vela." Chávez and Quirarte 63–78.

Trujillo Muñoz, Gabriel. *Biografías del futuro: La ciencia ficción Mexicana y sus autores.* Mexicali: Universidad Autónoma de Baja California, 2000.

Tuñón, Julia. *Mujeres en México: Una historia olvidada.* Planeta, 1987.

Ubilluz, Juan Carlos. *Sacred Eroticism: Georges Bataille and Pierre Klossowski in the Latin American Erotic Novel.* Lewisburg, PA: Bucknell University Press, 2006.

Unruh, Vicky. *Performing Women and Modern Literary Culture in Latin America.* Austin: University of Texas Press, 2006.

Valdés, María Elena de. *The Shattered Mirror: Representations of Women in Mexican Literature.* Austin: University of Texas Press, 1998.

Vargas, Margarita. "Staging Identity through Art." *CR: The New Centennial Review* 5.3 (2005): 65–82.

Varo, Remedios, and Ricardo Ovalle. *Remedios Varo: Catálogo razonado.* 1994. Mexico City: Ediciones Era, 2002.

Vela, Árqueles. *El café de nadie.* 1926. Mexico City: Lecturas mexicanas, 1990.

———. "La sonrisa estridentista." *Xilote* 34 (1973): 9.

Verani, Hugo J., ed. *Las vanguardias literarias en Hispanoamérica (Manifiestos, proclamas y otros escritos).* 1986. Mexico City: Fondo de Cultura Económica, 1990.

Villaurrutia, Xavier. "Carta a un joven (Edmundo Valadés)." Capistrán xi–xii.

———. *Cartas de Villaurrutia a Novo, 1935–1936.* Mexico City: Instituto Nacional de Bellas Artes, Departamento de Literatura, 1966.

———. "Dama de corazones." *Obras* (2006): 571–96.

———. *Obras.* 1953. Mexico City: Fondo de Cultura Económica, 2006.

Villoro, Juan. "La ciudad es el cielo del metro." Gallo 137–45.

Warwick, Acacia Rachelle. *Prefabricated Desire: Surrealism, Mannequins, and the Fashioning of Modernity.* Diss. University of California Los Angeles, 2006. Ann Arbor: UMI, 2007.

Williams, Gareth. *The Mexican Exception: Sovereignty, Police, and Democracy.* New York: Palgrave Macmillan, 2011.

Witherspoon, Kevin B. *Before the Eyes of the World: Mexico and the 1968 Olympic Games.* DeKalb: Northern Illinois University Press, 2008.

Wolfenzon, Carolyn. "El fantasma que nos habita: *El huésped* y *El cuerpo en que nací* de Guadalupe Nettel como espejo político de México." *Latin American Literary Review* 44.88 (2017): 41–50.

Yehya, Naeif. *El cuerpo transformado: Cyborgs y nuestra descendencia tecnológica en la realidad y en la ciencia ficción.* Mexico City: Editorial Paidós, 2001.

Young, Dolly J. "Mexican Literary Reactions to Tlatelolco 1968." *Latin American Research Review* 20.2 (1985): 71–85.

Young, Iris Marion. *On Female Body Experience: "Throwing Like a Girl" and Other Essays.* New York: Oxford University Press, 2005.

Zamora, Lois Parkinson. "Misticismo mexicano y la obra mágica de Remedios Varo." *El*

*laberinto de la solidaridad: Cultura y política en México (1910–2000).* Ed. Kristine Vanden Berghe and Maarten van Delden. Amsterdam: Rodopi, 2002. 57–87.

Živković, Milica. "The Double as the 'Unseen' of Culture: Toward a Definition of Doppelganger." *Facta Universitatis* 2.7 (2000): 121–28.

Žižek, Slavoj. "Are We in a War? Do We Have an Enemy?" *London Review of Books* 24.10 (May 23, 2002): 3–6.

———. *Violence: Six Sideways Reflections.* New York: Picador, 2008.

# INDEX

Aberth, Susan, 61
Academia de la Pintura (Academy of Painting), 18
Academia de San Fernando, 74
*Actualismo,* 17, 164n9
*Actual No. 1* (Maples Arce), 15, 39
*Actual No. 2* (Maples Arce), 17, 26, 41
Adorno, Theodor, 93
*Aeneid* (Virgil), 94
Agrarian law, 15
Agricultural development, 13
Aguilar Camín, Hector, 57
Aguilar Mora, Jorge, 86–87, 163n5
Alchemy, 67
Almazán, Juan Andrew, 56
American cinema, 48
Amor, Carolina, 65
Amor, Inés, 65
Amputations, 135
Anaya, Eduardo, 126
*Andamios interiores* (Interior scaffoldings) (Maples Arce), 17, 20
*Animal fantástico* (Fantastic animal) (Varo), 76, 78, 81
Antebi, Susan, 139, 144
Antifeminism, 63
*Anti-Oedipus* (Deleuze and Guattari), 122
Apollinaire, Guillaume, 61
*Arcades Project* (Benjamin), 107
Archaeological discourse, 79
Arcq, Teresa, 61, 65, 74, 76–77
Arquilla, John, 120
Artaud, Antonin, 62–63
Asturias, Manuel Angel, 15
Ateneo de México (Mexican Cultural Association), 16, 39

Atwood, Margaret, 131
*Au bonheur des dames* (The ladies' delight) (Varo), 9, 75–79, 81
Augé, Marc, 144
Ávalos Torres, Antonia, 102
Avant-garde, 2, 6–7, 18–19, 49, 54, 62–63
*A veces escribo como si trazase un boceto* (Sometimes I write as If I were sketching) (Mendoza Bolio), 79
Ávila, Isidro, 130
Ávila Camacho, Manuel, 56–57
Azuela, Mariano, 145

Badmington, Neil, 6
Balam, Chilam, 73
Balsamo, Anne, 4, 6, 22, 28, 32, 134
Barbarism, 95
Barker, 139
Barlow, John Perry, 126
Barthes, Roland, 43–44
Bartra, Armando, 98
Bartra, Roger, 159
Bataille, Georges, 94
Batallón Olimpia (Olympic Battalion), 92
Bayer (pharmaceutical company), 74
Beauty, physical, 83
de Beauvoir, Simone, 139
Beery, Wallace, 48
"Being in Nothingness" (Barlow), 126
Belascoarán Shayne, Héctor, 135
Belton, Robert, 62–63
Benjamin, Walter, 107
*Bhagavad Gita,* 123
Bindé, Jérôme, 159
Biron, Rebecca, 13
Blanco, Alberto, 79

194 · Index

Blindness, 142
Blue gel (*Gel azul*) (Fernández, B.), 4, 10, 120, 123–29, 132–36, 153, 156
Blum, Liliana, 131
*Bodies That Matter* (Butler, J.), 30, 75–76
Bolado, Carlos, 86
Bolano, Roberto, 167n30
Booth, Austin, 131
Bordo, Susan, 30
Borges, Jorge Luis, 15, 79
*Borrar de la memoria* (To erase from memory) (Gurrola), 86
Bosque de Chapultepec (Chapultepec Forest), 55
Bradu, Fabienne, 63
Braidotti, Rosi, 6, 123, 134
*Brave New World* (Huxley), 154
Breton, André, 9, 55, 58, 61–66, 79, 116; *Manifesto of Surrealism*, 59, 67; *Nadja*, 68–69, 70, 117; *Notes on Poetry*, 63; *Surrealism and Painting*, 168n6
Brown, J. Andrew, 4, 22
Buñuel, Luis, 74, 170n20
Bürger, Peter, 2
"Burning Chrome" (Gibson), 173n6
Butler, Judith, 30, 75–76, 159
Butler, Octavia, 131

"Café de nadie, El" (Nobody's café) (Vela), 9, 20–21, 36–38
*Caída de los pájaros, La* (The fall of the birds) (Chacek), 4, 10, 120, 148–55
Caillois, Roger, 60
Camacho, Bibiana, 131
Campbell, Joseph, 97
Cantinflas, 56
Capital city, 17
Capitalism, 122
Carey, Elaine, 88–89
*Carrie* (King), 173n18
Carrington, Leonora, 54–56, 58, 61–62, 64, 69–70, 83, 96; *Down Below*, 9, 66, 67, 68, 71, 116, 158, 169n16; *The Hearing Trumpet*, 9, 66–67, 71–73; Holy Grail and, 71–74; *How Doth the Little Crocodile*, 55
Carter, Angela, 105, 172n19
Castells, Isabell, 79

Castro, Fidel, 91
Castro, Raquel, 131
Chacek, Karen, 4, 10, 120, 122, 131, 148–55, 157
Chadwick, Whitney, 61
Chandler, Raymond, 124
Chapultepec Forest (Bosque de Chapultepec), 55
Chave, Anna, 22, 26
Chávez, Daniel, 56–57
Chile, 18
*Chingada, La* (Paz), 134
Chronicle of the intervention (*Crónica de la intervención*) (García Ponce), 9–10, 85, 87, 89, 103–17, 122
Church of Christ the Extraterrestrial (la Iglesia del Cristo Extraterrestre), 129
Cinema, American, 48
*Citizens of Fear* (Rotker), 138
"Ciudad es el cielo del metro, La" (Villoro), 146
Cixous, Hélène, 71
Clavel, Ana, 131
Close, Glen S., 121, 133, 135
CNH. *See* Consejo Nacional de Huelga
Cohen, Deborah, 87, 171n8
Cohen, Johnny, 6
Colosio, Luis Donaldo, 119
Connolly, Cyril, 94
Consejo Nacional de Huelga (CNH, National Strike Council), 92
Contemporáneos (Contemporaries), 8, 38–53, 59, 62, 86, 104, 121
*Contemporáneos* (magazine), 54
Córdoba, Antonio, 132
Corona, Ignacio, 86, 87
Cortázar, Julio, 96
Crack movement, 120
Cravioto, José Manuel, 86
*Creacionismo* (creationism), 18
"Crimen provisional, Un" (Vela), 20, 33–36, 59
*Crisol* (Crucible) (publication), 18
*Crónica de la intervención* (Chronicle of the intervention) (García Ponce), 9–10, 85, 87, 89, 103–17, 122
Cuban Revolution, 91
Cubism, 22
*Cuentos compactos cyberpunk* (anthology), 131
*Cuerpo en que nací, El* (Nettel), 138

Cuesta, Jorge, 39–40
Cultural power, 5
Cultural transformations, 38
Curiel, Fernando, 165n14
Cyberpunk, 126–27, 130–37, 173n11
Cyberspace, 125, 173n6
"Cyborg Manifesto, The" (Haraway), 4, 21, 76
*Cyborgs in America* (Brown), 4
*Cyborgs in Latin America* (Brown), 22

Dalton, David S., 21, 48, 57
*Dama de corazones* (Queen of hearts) (Villaurrutia), 9, 42–47, 49, 52–53, 87
Damián, Gabriela, 131
Davis, Diane, 13
Days and the years, The (*Los días y los años*) (González de Alba), 86
Days to remember (*Días de guardar*) (Monsiváis), 86, 93
*Los de abajo* (*The Underdogs*) (Azuela), 145
Deaths of the dawn (*Muertes de aurora*) (de la Torre), 87
De Certeau, Michel, 155
*Deco Body, Deco City* (Sluis), 8
*De Homo Rodans* (Varo), 78–80
De la Madrid, Miguel, 147
De la Torre, Gerardo, 87
Deleuze, Gilles, 122, 139, 152
Del Paso, Fernando, 9, 85–87, 89, 94, 96–103, 142, 158
Del Río, Dolores, 56
*Demoiselles d'Avignon, Les* (Picasso), 21–23, 26–27
Desire, 113; female, 84, 95, 105, 112; male sexual, 80
*Días de guardar* (Days to remember) (Monsiváis), 86, 93
*Días y los años, Los* (The days and the years) (González de Alba), 86
Díaz Ordaz, Gustavo, 91, 110
Díaz y Morales, Magda, 115
Dick, Philip K., 151
Dickenson, Emily, 67
Disability, 138
Disorientation, of readers, 23
D'Lugo, Carol Clark, 43, 167n31
Domínguez Michael, Christopher, 44

Domínguez-Ruvalcaba, Héctor, 14
Dos Passos, John, 15
Double, the, 99, 143
Double allegiance, 66, 74, 77
*Down Below* (Carrington), 9, 66–68, 71, 116, 158, 169n16
Du Preez, Amanda, 6, 134
Durozoi, Gérard, 62
Dystopic cyberfiction, 131

"Eagle and the Serpent on the Screen, The" (Chávez), 56
Education, public, 15
*Elección de diputados* (election of representatives), 146
*Elevación y caída del estridentismo* (Rise and fall of Stridentism) (Escalante), 19
Éluard, 63
*Enamorada* (film), 57
End of insanity, the (*El fin de la locura*) (Volpi), 170n4
"Envisioning Cyborg Bodies" (González, Jennifer), 52
Ernst, Max, 67, 69
*Eros and Civilization* (Marcuse), 94–95, 105, 112
Eroticism, 105
Escalante, Evodio, 19–20, 21, 47, 168n40
Escuela Libre de Derecho (Free University Law School), 15
Escuela Nacional Preparatoria (National Preparatory School), 39
Esotericism, Russian, 78
Espinosa, Ángela Cecilia, 26, 165n21
Estrada, Oswaldo, 143, 145, 148
Estridentistas (Stridentists), 8–9, 15–33, 41–42, 59, 121, 160, 164n13, 165n14
Eudave, Cecilia, 131
*Excélsior* (newspaper), 162
*Expedición a la ciencia ficción mexicana* (López Castro), 130

Fall of the birds, The (*La caída de los pájaros*) (Chacek), 4, 10, 120, 148–55
Fantastic animal (*Animal fantástico*) (Varo), 76, 78, 81, 120
Fatherland (*Patria*) (film), 48

196 · Index

*Fearless Women in the Mexican Revolution and the Spanish Civil War* (Linhard), 8
Félix, María, 56
Female body, 4, 82, 105–6, 122, 163n1; Carrington on, 72; rebellious, 100; subjectivity and, 113; technological discourses and, 1
Female cyborg, 28
Female desire, 84, 95, 105, 112
Feminism: antifeminism, 63; First Feminist Congress, 20; spectral, 20
Feminist science fiction, 131
*Femme-enfant*, 60, 68, 72, 82, 161
*Femmenism and the Mexican Woman Intellectual from Sor Juana to Poniatowska* (Hind), 163n1
*Femme-sorcière*, 60
Fernández, Bernardo, 121–22, 155; *Gel azul*, 4, 10, 120, 123–29, 132–36, 153, 156; *The Labyrinth of Solitude*, 134
Fernández, Emilio "El Indio," 57, 168n3
Fernández L'Hoeste, Héctor, 127, 128, 153
Ferré, Rosario, 167n35
Ferrero-Cándenas, Inés, 79
*Fin de la locura, El* (The end of insanity) (Volpi), 170n4
First Declaration, 148
First Feminist Congress, 20
First-person plural, 24
Flanagan, Mary, 131, 137
Fons, Jorge, 86
*Forma* (Form) (publication), 18
Foster, Hal, 2
Foucault, Michel, 33
*Fractal'zine* (online journal), 131
Franco, Jean, 41
Franco dictatorship, 58
Frazier, Lessie Jo, 87, 171n8
Frederson, Joh, 31
Free University Law School (Escuela Libre de Derecho), 15
Free women, 25
Freud, Sigmund, 61, 95
*Frottage*, 78
*Fruits of the Earth, The* (*Les Nourritures terrestres*) (Gide), 50

Fuentes, Carlos, 97
*Future Eve, The* (de l'Isle-Adam), 30

Galería de Arte Mexicano (Gallery of Mexican Art), 64–67, 76
Galería Diana, 76
Gallardo, Salvador, 19, 34
Gallo, Rubén, 38
García Ponce, Juan, 9–10, 85–89, 94, 103–17, 142, 171n17
Garland-Thomson, Rosemarie, 139
Gauthier, Renée, 62
*Gel azul* (Blue gel) (Fernández, B.), 4, 10, 120, 123–29, 132–36, 153, 156
Gender, 89, 138; binaries, 76; in cyberpunk, 130–37; female desire and, 84, 95, 105, 112; identity, 30; male sexual desire and, 80; norms, 76; roles, 44, 59, 66, 79, 81
*Gender and Sexuality* (Passerini), 87
*Gendering the Marvellous* (Ferrero-Cándenas), 79
Generación del Medio Siglo (Midcentury Generation), 86
Genre, in cyberpunk, 130–37
Germany, 58
Gerzso, Gunter, 55
Gibson, William, 90, 126, 130, 173n6
Gide, André, 44, 50
Gilbert, Courtney, 64
Ginway, M. Elizabeth, 28
Globalism, 10, 128
Globalization, 87
Godwin, Malcolm, 169n17
Golden Age, of Weimar Republic, 32
Golem mythology, Jewish, 30
Gómez, Pablo, 90, 92
Gómez de la Serna, Ramón, 166n24
Góngora, Luis de, 128
González, Carina, 139, 141
González, Jennifer, 52
González de Alba, Luis, 86
González Martínez, Enrique, 15, 16
Gorostiza, José, 16, 39
*Gravity's Rainbow* (Pynchon), 96
Greek mythology, 3

Index · 197

*Grito, El* (The scream) (López Arretche), 86
Grosz, Elizabeth, 8
Gruen, Walter, 76, 79
Guattari, Félix, 122, 139, 152
*Guerra en el paraíso* (War in paradise) (Montemayor), 86
Guerrero, Elisabeth, 7
Guest, The (*El huésped*) (Nettel), 10, 120, 122, 137–48, 150, 158
Guevara, Ernesto "Che," 91
Guillén, Claudia, 131
Gurdjieff, G. I., 73–74, 77–78
Gurrola, Alfredo, 86
Guzmán, Martín Luis, 41

Halberstam, 134
Hammett, Dashiell, 124
*Handmaid's Tale, The* (Atwood), 131
Haraway, Donna, 29, 32, 83, 105, 131, 158, 159; "The Cyborg Manifesto," 4, 21, 76; "The Persistence of Vision," 61; *Simians, Cyborgs, and Women*, 6, 27
Hardness, 80–81
Hayles, N. Katherine, 4, 32
*Hearing Trumpet, The* (Carrington), 9, 66–67, 71–73
Heliodoro Valle, Rafael, 17, 58
Hermaphroditic literature, 40
Hind, Emily, 20, 38, 120, 127, 160, 163n1
Hoff, Ann, 69
Hoffmann, E. T. A., 30
Holmberg, Eduardo, 30
Holy Grail, 71–74
*Holy Grail, The* (Godwin), 169n17
Homophobia, 41
*Homo Rodans* (Varo), 9, 75, 78, 81, 83
"Horacio Kalibang or the Automata" (Holmberg), 30
Horna, José, 65
Horna, Kati, 58, 65
*How Doth the Little Crocodile* (Carrington), 55
*How We Became Posthuman* (Hayless), 4
*Huésped, El* (The guest) (Nettel), 10, 120, 122, 137–48, 150, 158
Huidobro, 18

Huxley, Aldous, 154
Huyssen, Andreas, 30–31

Idealism, 39
Identity, 32; gender, 30; transformation of, 24
If I die far away for you (*Si muero lejos de ti*) (Aguilar Mora), 86–87
Iglesia del Cristo Extraterrestre, La (the Church of Christ the Extraterrestrial), 129
Illustrated universal, The (*El Universal Ilustrado*) (Maples Arce), 17, 20
Injury, 123
Institutional Revolutionary Party. *See* Partido Revolucionario Institucional
Intellectual nations (*Naciones intelectuales*) (Sánchez Prado), 41, 57
Interior scaffoldings (*Andamios interiores*) (Maples Arce), 17, 20
*International Exhibition of Surrealism*, 65, 76
Irwin, Robert McKee, 14
Italy, 58
Itineraries, 155
Izquierdo, María, 65

Janzen, Rebecca, 11
Japan, 58
Jara, Horacio, 53–54
Jewish golem mythology, 30
Johnson, David E., 104
Jörgensen, Beth E., 139, 144
Joseph, Gilbert M., 78
Journalists, The (*Los periodistas*) (Leñero), 86
*Joven, El* (Novo), 166n26
Joyce, James, 96, 118
Juárez, Benito, 40

Kahlo, Frida, 59, 65, 168n6
Kahn, Simone, 62
Kantaris, Geoffrey, 130
Kaplan, Janet, 61, 64, 66, 76–77, 79
Kennedytas, Los (the Kennedyites), 129
Kiejman, Claude, 170n2
King, Stephen, 173n18
Klossowski, Pierre, 94, 104–5, 118
Krishna, 123, 125

198 · Index

Kristeva, Julia, 106
Kurlansky, Mark, 87, 92

Labyrinth of Solitude, The (Fernández, B.), 134
Ladies' delight, The (Au bonheur des dames) (Varo), 9, 75–79, 81
Lagarde y de los Ríos, Marcela, 88
Lambright, Anne, 7
Lang, Fritz, 30, 31, 32
Langosta se ha posado, La (The lobster has landed) (online journal), 131
Lapointe, Annette, 129, 137
"Laugh of the Medusa, The" (Cixous), 71
Laughter, 34
Lavigne, Carlen, 28, 134
Leduc, Renato, 70
Legrás, Horacio, 7, 160
Leñero, Vicente, 86
León, María Teresa, 62
Leonora (Poniatowska), 169n15
Lévy, Denise, 62
Lewis, Jennifer, 119
Library of Mexico, 55
Lilith's Brood (Butler, O.), 131
Linhard, Tabea, 8
List Arzubide, Germán, 15, 17, 19, 25–26, 34, 160
"Literatura nacional, literatura mundial (National literature, world literature)" (Reyes), 5
Little, Gregory, 136, 137
Llona, Victor, 70
Lobster has landed, The (La langosta se ha posado) (online journal), 131
López Arretche, Leobardo, 86
López Castro, Ramón, 130
López-Labourdette, Adriana, 141
López Lozano, Miguel, 161–62
López Obrador, Andrés Manuel, 2, 161–62
López Portillo, José, 147
López Velarde, Ramón, 17
Lusty, Natalya, 61, 67, 68, 117
Lyford, Amy, 63

Mabille, Pierre, 70
Machine aesthetic, 18

Male body, 87, 95
Male gaze, 26
Male sexual desire, 80
"Manifesto for Avatars" (Little), 136
Manifesto of Surrealism (Breton), 59, 67
Maples Arce, Manuel, 15–33, 34, 39, 41, 53–54
Maps, 155
Marcuse, Herbert, 94–95, 104–6, 112
María Candelaria (film), 57
Martínez, Elizabeth Coonrod, 35
Masculinities, 14, 19, 26, 40, 49–50
Massacre in Mexico (La noche de Tlatelolco) (Poniatowksa), 86, 93, 170n2
Maximilian I (Emperor), 41
McLuhan, Marshall, 126–27, 135, 137, 160
McOndo movement, 120
Megnen, Jeanne, 70
Memory, 46
Memory of the Valkyries (Recuerdo de la Walkyria) (Varo), 65
Mendoza Bolio, Edith, 61, 79, 80, 81
Mental illness, 115
Meruane, Lina, 142
Mestizo Modernity (Dalton), 21, 57
Metaphysical process, 152
Metropolis (film), 30–31, 32
Mexican Cultural Association (Ateneo de México), 16, 39
The Mexican Exception (Williams), 171n7
Mexicanidad, 49
Mexican Labor Party, 13
Mexican Miracle, 2, 54, 56, 57
Mexicanness, 5, 42
Mexican noir novel (novela negra mexicana), 135
Mexicano, Lo, 1, 5, 13, 15, 40, 56–58, 159
Mexican Revolution, 1, 10, 21, 33, 42–43, 87, 91, 110
Mexican Revolutionary Party. See Partido de la Revolución Mexicana
Meyer, Lorenzo, 57
Midcentury Generation (Generación del Medio Siglo), 86
Migration, urban, 7, 8
Minge, Jeanine, 75
"Minority Report, The" (Dick), 151

Mnemosyne (Greek mythology), 3
Modernismo, 15–16, 44, 49
Modernistas, 27
Modernity, 42
Modernization, 3, 9, 19, 145
Modotti, Tina, 15
Mondragón, Carmen, 15
Monsiváis, Carlos, 8, 56, 86, 93, 146, 165n18
"Monster Culture" (Cohen, J.), 6
Montemayor, Carlos, 86
Moorhead, Joanna, 84
Mora, Yanna Haddaty, 163n3
Moral pornographer, 172n19
MORENA. *See* Movimiento Regeneración Nacional
Morgan, Kathryn Pauly, 82, 83
Moro, César, 65
"Movimiento estridentista, El" (The Stridentist movement) (Maples Arce), 17
*Movimiento estridentista, El* (List Arzubide), 25
Movimiento Popular Estudiantil (MPE-68, Popular Student Movement), 87–88
Movimiento Regeneración Nacional (MORENA, National Regeneration Movement), 2, 161
MPE-68. *See* Movimiento Popular Estudiantil
*Muertes de aurora* (Deaths of the dawn) (de la Torre), 87
Murray, 139
Muses (Greek mythology), 3
Musil, Robert, 104, 105
*Myth of Mental Illness, The* (Szasz), 115
Mythology, Greek, 3

*Nacional, Lo,* 14
*Naciones intelectuales* (Intellectual nations) (Sánchez Prado), 41, 57
*Nadja* (Breton), 68–69, 70, 117
NAFTA. *See* North American Free Trade Agreement
Nagel, Joane, 14
Nancy, Jean-Luc, 3, 44, 98
National Action Party. *See* Partido Acción Nacional
National Autonomous University of Mexico.

*See* Universidad Nacional Autónoma de México
*National Body in Mexican Literature, The* (Janzen), 11
Nationalism, 7
"National literature, world literature (Literatura nacional, literatura mundial)" (Reyes), 5
National Museum of History, 128
National Preparatory School (Escuela Nacional Preparatoria), 39
National Regeneration Movement. *See* Movimiento Regeneración Nacional
National Strike Council. *See* Consejo Nacional de Huelga
Nation-building projects, 13
Nealon, Jeffrey T., 159
Neocolonialism, 133
*Neopoliciaco* (neo-detective) genre, 135
Neruda, Pablo, 15
Nettel, Guadalupe, 10, 120, 122, 137–48, 150, 158
Netwar, social, 120
Neue Sachlichkeit (New Objectivity), 32
*Neuromancer* (Gibson), 126, 129
New novels (*novelas nuevas*), 96
New Objectivity (Neue Sachlichkeit), 32
Nicholson, Melanie, 63, 65
Nicki, Andrea, 115
Nightingale, Florence, 102
"Nobody's café (El café de nadie)" (Vela), 9, 20–21, 36–38
*Noche de Tlatelolco, La* (Massacre in Mexico) (Poniatowksa), 86, 93, 170n2
Nochlin, Linda, 64
"Nocturno de los ángeles (Nocturne of Angels/ Los Angeles)" (Villaurrutia), 104
Non-places, 144
*Norte* (North) (publication), 18
North American Free Trade Agreement (NAFTA), 3, 10, 120, 148
*Notes on Poetry* (Breton and Éluard), 63
*Nourritures terrestres, Les* (The Fruits of the Earth) (Gide), 50
*Novela como nube* (Novel like a cloud) (Owen), 9, 42–44, 47–48, 51–52, 87
*Novela negra,* 135

200 · Index

*Novela negra mexicana* (Mexican noir novel), 135
*Novelas nuevas* (new novels), 96
*Novela total, novela totalizadora* (total novel, totalizing novel), 97
Novo, Salvador, 16, 39, 166n26

Obregón, Álvaro, 13
*Olimpia* (Olympia) (Cravioto), 86
Olin, Nahui, 15
Olympic Battalion. *See* Batallón Olimpia
Olympic Games (1968), 3, 87, 90, 108, 119, 146, 156
Onda, La, 165n14
*100 años de una artista* (100 years of an artist) (exhibit), 55
*On Violence* (Žižek), 95
*Order of Things, The* (Foucault), 33
Organ trafficking, 172n4
Ouspensky, P. D., 73–74, 77
Owen, Gilberto, 39, 49–50, 53, 78, 161; *Novela como nube*, 9, 42–44, 47–48, 51–52, 87; "Pureza," 104

Paalen, Wolfgang, 55, 64, 65
Palacio de Lecumberri, 92
*Palinuro de México* (Palinuro of Mexico) (del Paso), 9, 85, 87, 89, 94, 96–103, 142, 158
Palou, Pedro Ángel, 16, 44, 49, 159, 164n6
PAN. *See* Partido Acción Nacional
Pappe, Silvia, 166n25
Pardo, Rodrigo, 130
Parisot, Henri, 72
Parker, Rhian, 83
Parkinson-Zamora, Lois, 61
Partido Acción Nacional (PAN, National Action Party), 2, 137, 156, 162
Partido de la Revolución Democrática (PRD, Party of Democratic Revolution), 147
Partido de la Revolución Mexicana (PRM, Mexican Revolutionary Party), 56–57
Partido Revolucionario de Unificación (PRUN, Revolutionary Party of National Unification), 56
Partido Revolucionario Institucional (PRI, Institutional Revolutionary Party), 2, 5, 56, 90, 91, 119, 137, 162

Party of Democratic Revolution. *See* Partido de la Revolución Democrática
Paseo de Reforma, 55
Passerini, Luisa, 87
*Patria* (Fatherland) (film), 48
Paz, Octavio, 39, 79, 87, 90, 102, 143, 161; *La Chingada*, 134; *Postdata*, 93; *Remedios Varo*, 60
Paz Soldán, Edmundo, 125
Pellicer, Carlos, 16, 39
Peña González, Carlos, 15
Penrose, Valentine, 62
Péret, Benjamin, 55, 64–65, 70
Pérez Firmat, Gustavo, 43
*Periodistas, Los* (The journalists) (Leñero), 86
"Persistence of Vision, The" (Haraway), 61
*Photopoetics at Tlatelolco* (Steinberg), 170n4
Physical beauty, 83
Picasso, Pablo, 21–23, 26–27
Pitman, Thea, 120
Plant, Sadie, 125
Plaza de las Tres Culturas (Plaza of the Three Cultures), student massacre at, 9, 84, 85–89, 108; Mexico in 1968 and, 90–93; del Paso and, 96–103; senseless violence and, 93–96
*Pleasure of the Text, The* (Barthes), 43
*Plotting Women* (Franco), 41
Plurality, 7
Political power, 5
Political transition period, 2
Poniatowska, Elena, 70, 86, 93, 169n15, 170n2
Popular Student Movement. *See* Movimiento Popular Estudiantil
Porcayo, Gerardo Horacio, 130–31
*Postdata* (Paz), 93
Posthumanism, 6, 134
Postmodernity, 159
Post-NAFTA revolution period, 2
"Post No Bills (*Se prohíbe fijar carteles*)," 15–33
Post-Revolution, 2, 3, 5
Post-World War II era, 3
Post-Zapatista revolution period, 2
"Power, Pleasure, and Play" (Minge and Zimmerman), 75
*Power of Myth, The* (Campbell), 97
*Powers of Horror* (Kristeva), 106

*Practice of Everyday Life, The* (de Certeau), 155
PRD. *See* Partido de la Revolución Democrática
Premio Puebla de Ciencia Ficción (Puebla Science Fiction Prize), 131
PRI. *See* Partido Revolucionario Institucional
Prieto, Emma, 87
Princeton Archives, 171n17
PRM. *See* Partido de la Revolución Mexicana
Prosthetics, 135
PRUN. *See* Partido Revolucionario de Unificación
"Psi," 174n21
Psychiatry, 113, 117
psychoanalysis, 61
Public education, 15
Puebla Science Fiction Prize (Premio Puebla de Ciencia Ficción), 131
"Pureza (Purity)" (Owen), 104
Pynchon, Thomas, 96

Queen of hearts (*Dama de corazones*) (Villaurrutia), 9, 44–47, 49, 52–53, 87
Quintanilla del Valle, Luis, 15, 19
Quirarte, Vicente, 14

Raaberg, Gwen, 62
Rahon, Alice, 55, 58, 64
Ramírez, Ignacio, 40
Ramírez, José Luis, 130
Rashkin, Elissa J., 28, 38, 165n14, 168n45
*Rayuela* (Cortázar), 96
*Real maravilloso, Lo,* 79
*Recuerdo de la Walkyria* (Memory of the Valkyries) (Varo), 65
Red dawn (*Rojo amanecer*) (Fons), 86
"Reflexiones sobre la novela" (Reflections on the novel) (Torres Bodet), 43
*Reload* (Flanagan and Booth), 131
*Remedios Varo* (Paz and Caillois), 60
Renarration, 4
*Return of the Real, The* (Foster), 2
Revolutionary Laws, 148
Revolutionary Party of National Unification. *See* Partido Revolucionario de Unificación
*Révolution surréaliste, La* (The Surrealist Revolution) (journal), 62

"Revolution to Evolution" narrative, 5
Reyes, Alfonso, 5, 40, 41, 42
*Río Escondido* (film), 57
Rise and fall of Stridentism (*Elevación y caída del estridentismo*) (Escalante), 19
Rivera, Alex, 172n3
Rivera, Diego, 15
Rodríguez-Hernández, Raúl, 107
Rodríguez Pampolini, Ida, 64
*Rojo amanecer* (Red dawn) (Fons), 86
Ronfeldt, Davis, 120
"Rosa-Fría, patinadora de la luna (Rosa-Fría, moon skater)" (León), 62
Rotker, Susana, 127, 138, 156
Rubenstein, Anne, 78
Rucker, Rudy, 130
Ruisánchez Serra, José Ramón, 4
Russian esotericism, 78

Sabines, Jaime, 85
Sade, Marquis de, 105
*Sadeian Woman, The* (Carter), 105
Salinas Gortari, Carlos, 147
Sánchez Prado, Ignacio, 41, 57, 121, 133
*Sandman, The* (Hoffmann), 30
Schizophrenic bodies, 122
Schneider, Luis Mario, 16, 18
Schwartz, Marcy, 7
Science fiction (SF), 130–31, 150, 173n11
Scream, The (*El grito*) (López Arretche), 86
Sefchovich, Sara, 43
Sennett, Mack, 48
"Senorita Etcétera, La" (Vela), 1, 20, 22–23, 25, 31–33, 35, 52
Senseless violence, 93–96
*"Se prohíbe fijar carteles* (Post No Bills)," 15–33
Sexual desire, 80
Sex workers, 26
SF. *See* Science fiction
Shadow, the, 99
Shakespeare, William, 50
*Shattered Mirrors, The* (de Valdés), 26
Sheikh, Shela, 123, 153
Sheridan, Alan, 33
Sheridan, Guillermo, 43–44, 47
*Simians, Cyborgs, and Women* (Haraway), 6, 27
*Simpsons, The* (TV series), 147

*Si muero lejos de ti* (If I die far away for you) (Aguilar Mora), 86–87
Situated knowledges, 61
*Sleep Dealer* (film), 172n3
Sleepwalking, 28
Sluis, Ageeth, 7–8, 26
Smith, Rodney Collin, 73
Social change, 113
Social netwar, 120
Social transformation, 4, 22, 32
Societal integration, 81
Socrates, 50
Softness, 80–81
Somatophobia, 30
Sometimes I write as If I were sketching (*A veces escribo como si trazase un boceto*) (Mendoza Bolio), 79
Sommer, Doris, 14
Somnambulism, 28
Sonnet #145 (de la Cruz), 111
"Sonrisa estridente, La (The Stridentist smile)" (Vela), 33–34
Sor Juana Inés de la Cruz, 111
Spanish Civil War, 54, 58, 62, 64
Spectral feminism, 20
Speculative fiction, 150, 174n21
State violence, 110
Steinberg, Samuel, 89, 119, 170n4
Sterling, Bruce, 127, 130
Stratton, Susan, 154
"Stridentist movement, The" (El movimiento estridentista) (Maples Arce), 17
Stridentists. *See* Estridentistas
"Stridentist smile, The" (La sonrisa estridente) (Vela), 33–34
Student massacre. *See* Plaza de las Tres Culturas
*Suave Patria, La* (*Suave Patria*) (Maples Arce), 17, 39
Subjective violence, 95
Suleiman, Susan Ruben, 66, 74
Suri, Jeremi, 90
Surrealism, 9, 33, 54, 55–60, 67–70, 167n32; Galería de Arte Mexicano and, 64–67; Holy Grail and, 71–74; in Mexico, 63–64; origins in Europe, 61–63; Varo and, 74–84
*Surrealism and Painting* (Breton), 168n6

Surrealist Revolution, The (*La Révolution surréaliste*) (journal), 62
Szasz, Thomas, 115

Tablada, José Juan, 41
Taibo, Paco Ignacio, II, 91, 124, 135
Tambling, Jeremy, 7
Teatro Ulíses (Ulysses Theater), 39, 54
Technological elements, 2–3
*Technologies of the Gendered Body* (Balsamo), 22
Telepathy, 150
*Terra nostra* (Fuentes), 97
*Testigos, Los* (The witnesses) (Prieto), 87
"Texts of bliss" (textos de goce), 43
Tichenor, Bridget, 55, 58, 64
Time, 32
*Tlatelolco, Verano de 68* (Tlatelolco, summer of '68) (Bolado), 86
"Tlatelolco 68" (Sabines), 85
To erase from memory (*Borrar de la memoria*) (Gurrola), 86
Topology, 4–5
*Torch, The* (film), 57
Torres Bodet, Jaime, 39, 40, 43
Total novel, totalizing novel (*novela total, novela totalizadora*), 97
Trauma, 10, 123
"Two Mexicos, The," 143

*Ulysses* (Joyce), 96
Ulysses Theater (Teatro Ulíses), 39, 54
UNAM. *See* Universidad Nacional Autónoma de México
*Unbearable Weight* (Bordo), 30
*Underdogs, The* (*Los de abajo*) (Azuela), 145
*Unfolding the City* (Lambright and Guerrero), 7
*Universal Ilustrado, El* (The illustrated universal) (Maples Arce), 17, 20
Universidad Nacional Autónoma de México (UNAM, National Autonomous University of Mexico), 84
*Unquiet Grave, The* (Connolly), 94
Urban centers, 145
Urban development, 17–18
*Urban Leviathan* (Davis), 13

Urban migration, 7, 8
Urban space, 7, 155
"Urbe" (Maples Arce), 41
Ureña, Pedro Henríquez, 39
Usigli, Rodolfo, 39

Valdés, María Elena de, 26, 41
Vargas, Margarita, 43–44
Varo, Remedios, 54–56, 58, 60–62, 64, 66, 96; *Animal fantástico,* 76, 78, 81; *Au bonheur des dames,* 9, 75–79, 81; *De Homo Rodans,* 78–80; *Homo Rodans,* 9, 75, 78, 81, 83; *Recuerdo de la Walkyria,* 65; social critique in works of, 74–84; *Visita al cirujano plástico,* 76, 82, 83–84
Vasconcelos, José, 15, 39, 163n1
Vela, Árqueles, 15, 17, 19, 24–29, 37; "El café de nadie," 9, 20–21, 36–38; "Un crimen provisional," 20, 33–36, 59; "La Senorita Etcétera," 1, 20, 22–23, 25, 31–33, 35, 52; "La sonrisa estridente," 33–34
Villaurrutia, Xavier, 9, 38–49, 52–53, 78, 87, 94, 104, 161
Villiers de l'Isle-Adam, 30
Villoro, Juan, 146
Violence, 10, 89, 121, 133; senseless, 93–96; state, 110; subjective, 95
*Violence* (Žižek), 89
Virgil, 94
Virgin of Guadalupe, 102
Virtual reality (VR), 125–27, 137
*Visita al cirujano plástico* (Visit to the plastic surgeon) (Varo), 76, 82, 83–84
Volpi, Jorge, 170n4
VR. *See* Virtual reality
*VVV* (journal), 67

War in paradise (*Guerra en el paraíso*) (Montemayor), 86
"We Are the Others" (Rotker), 127
Weimar Republic, Golden Age of, 32
Weisz, Chiqui, 70
Weston, Edward, 15
Williams, Gareth, 171n7
*Wired,* 130
Witnesses, The (*Los testigos*) (Prieto), 87
Wolfenzon, Carolyn, 143
"Woman and the Knife" (Morgan), 82
Womanhood archetypes, 38
World War I, 18, 47, 61–63
World War II, 54, 58, 64, 67

Xalapa, 34, 38, 53
*Xenogenesis* trilogy (Butler, O.), 131
XXX Generation, 160

Yehya, Naeif, 2–3

Zamora, Lois Parkinson, 83
Zapatistas, 10, 120, 145, 148
Zárate, José Luis, 130
Zedilla, Ernesto, 147
Zeus (Greek mythology), 3
Zimmerman, Amber Lynn, 75
Živković, Milica, 99, 113, 143
Žižek, Slavoj, 89, 93, 95, 117, 121, 132
Zola, Émile, 78
Zolov, Eric, 78
Zurián, Carla, 165n14, 168n45

Sara A. Potter is associate professor of Spanish
at the University of Texas at El Paso.

Printed in the United States
by Baker & Taylor Publisher Services